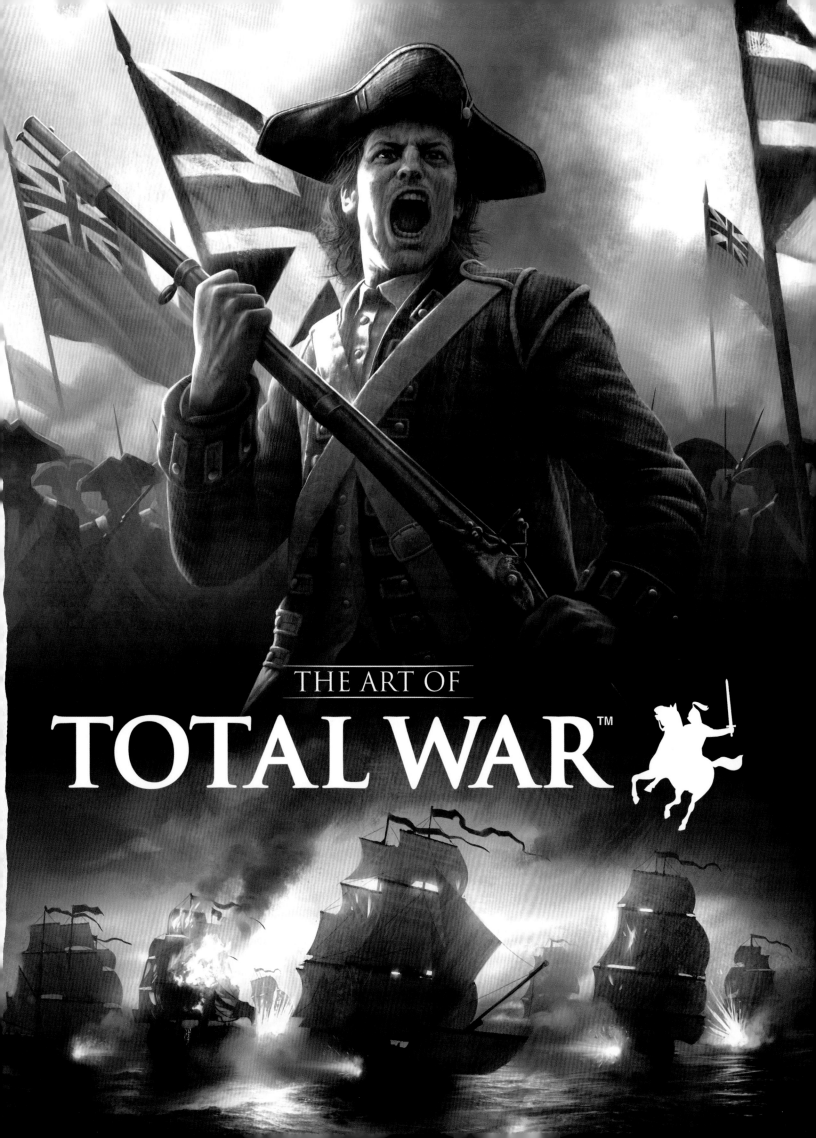

THE ART OF
TOTAL WAR™

THE ART OF TOTAL WAR
ISBN: 9781783292165

Published by Titan Books
A division of Titan Publishing Group Ltd.
144 Southwark St.
London
SE1 0UP

First edition: January 2015
10 9 8 7 6 5 4 3 2 1

To receive advance information, news, competitions, and exclusive offers online,
please sign up for the Titan newsletter on our website: **www.titanbooks.com**

Did you enjoy this book? We love to hear from our readers. Please e-mail us at:
readerfeedback@titanemail.com or write to Reader Feedback at the above address.

A CIP catalogue record for this title is available from the British Library.

THE ART OF
TOTAL WAR™

MARTIN ROBINSON

FOREWORD BY JAMES RUSSELL

TITANBOOKS

CONTENTS

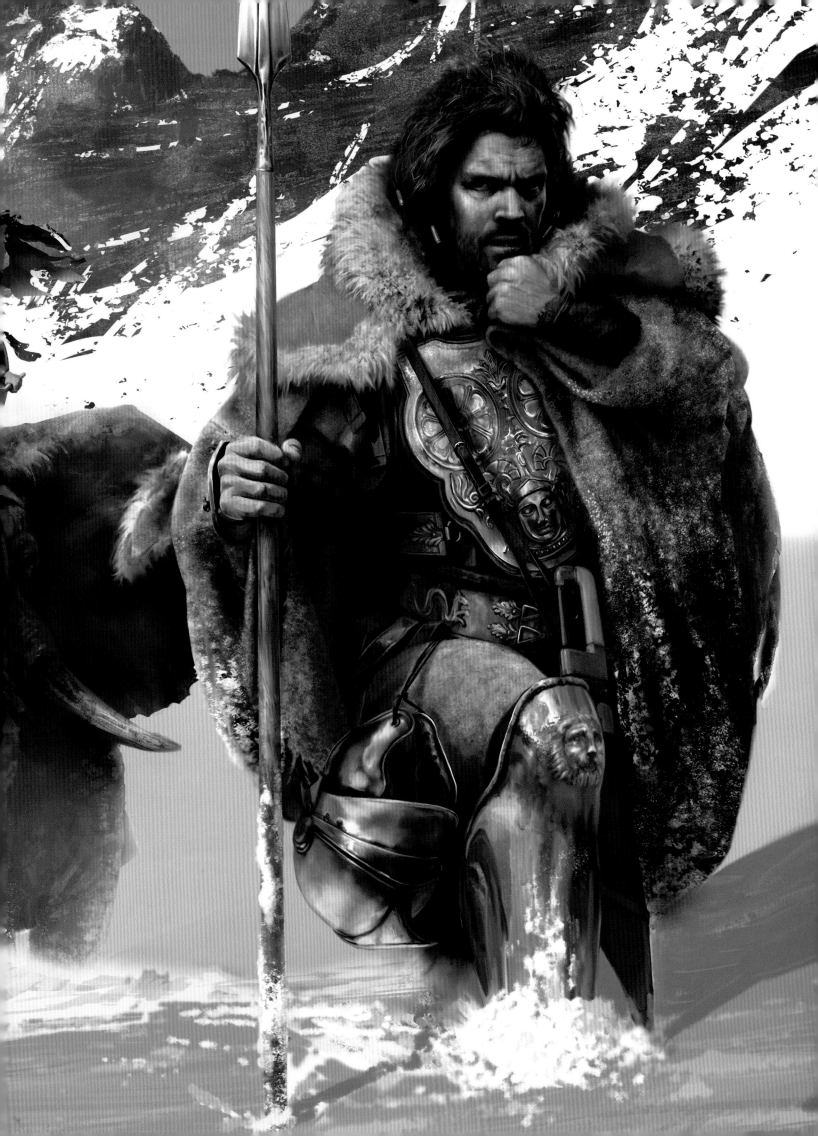

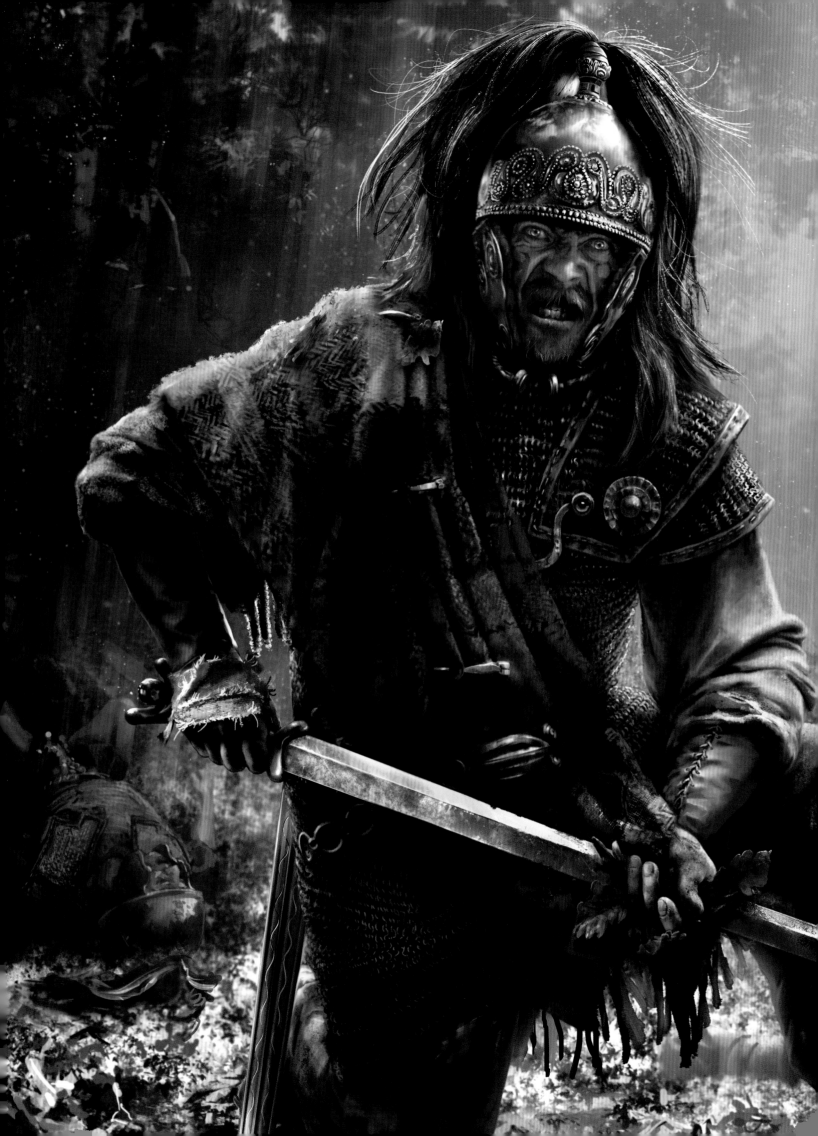

THE ART OF TOTAL WAR

BY JAMES RUSSELL, LEAD DESIGNER

Games are arguably the most sophisticated and complex forms of software in existence, and *Total War* games each have millions of lines of code and a myriad of gameplay features. Yet everything you interact with in a game is mediated by the visuals on the screen – it is the art of a game, the 3D models and animations, and the 2D user interface and images, that defines the experience. It is the view on screen that is the window to the world of the game. Without art, games would be reduced to lumbering grey blocks sliding around, and millions of numbers churning away in the background.

In SEGA and Creative Assembly's *Total War* games, everything is designed to immerse the player in the world of the game, to authentically and vividly recreate an epic historical era. Everything we do and show should make the player feel like the Emperor of Rome, or a warlord of medieval Japan. Beautiful artwork that brings the historical setting to life is core to *Total War* games, be it Shogun's homage to Japanese woodblock print styles for displaying game event images, or recreating Roman architecture for vast city battlefields.

At the heart of what *makes Total War* games truly unique is the breathtaking portrayal of the massed battles of history, with thousands of soldiers onscreen at once. Zoomed out, you survey whole battlefields and the clash of mighty armies. But you can zoom in to see individual men fighting their guts out for you – be they fearsome samurai, 18th century line infantry firing their muskets in the face of cannon-fire and grapeshot, or disciplined Roman legions facing down a Carthaginian cavalry charge. Recreating these epic scenes takes a huge amount of research and painstaking attention to the details of ancient armour and weaponry, but the result is a stunning visual feast of warfare in the ancient world.

THE HISTORY OF TOTAL WAR

By Mike Simpson, Creative Director, Total War Series

Tim Ansell set up Creative Assembly in 1987, porting games from the Amiga to DOS and some other strange computers that were around at the time. There was a machine called the FM Towns made by Fujitsu, which was the first computer ever to have a CD drive, and Psygnosis did a whole bunch of ports onto that. I was actually working at Psygnosis at the time as Tim's Producer.

At that point, Tim *was* CA; it was just him. After a few of those ports – games like *Shadow of The Beast* and *Microcosm* – Tim started doing sports games for EA. That was when he hired the first CA programmers. They did the very first version of FIFA on PC, and one of the things they introduced was play-by-play commentary. It's such an integral part of modern sports games, you can't imagine it ever not being there, and this was the first time it had ever been done. In 1996 I left Psygnosis and joined Tim at CA, with the intention of setting up a second team. We already had the sports team, who by this point were working on an Australian-rules football game.

Right about then, the Singaporean government was offering huge subsidies for developers to set up in Singapore. We started gathering people together to build a team, guys like Anthony Taglioni, who I'd worked with before at Psygnosis and Mirrorsoft.

We were planning on doing an RPG based on the Monkey legends (as featured in *Journey To The West* by Wu Cheng'en, which was adapted into a cult 70's TV show).

We seriously started looking into the opportunity in Singapore, and it looked too good to be true... because it was! There were so many strings attached that it was never actually going to work. There were lots of complications so it worked out much easier for us to find skilled people here. We weighed up all the pros and cons and eventually decided against it.

Another couple of things happened around then which really informed the direction in which we were heading. The first is that *Command & Conquer* hit the streets. All of a sudden, there were a lot of people making very quick C&C clones, such as KKnD (*Krush Kill 'n' Destroy*), and they were selling pretty well. We thought we could do something really good in that genre, and quickly, while we got the rest of the team established.

Set on our course, we chose medieval Japan as our setting. Our USP initially was flocking behaviour. We wanted to make an RTS game on a huge scale, with men the size of ants that flocked together in movement. It would have a top-down view, looking at the battlefield from a great height. So we did some prototype algorithms for flocking behaviour, and it looked pretty cool.

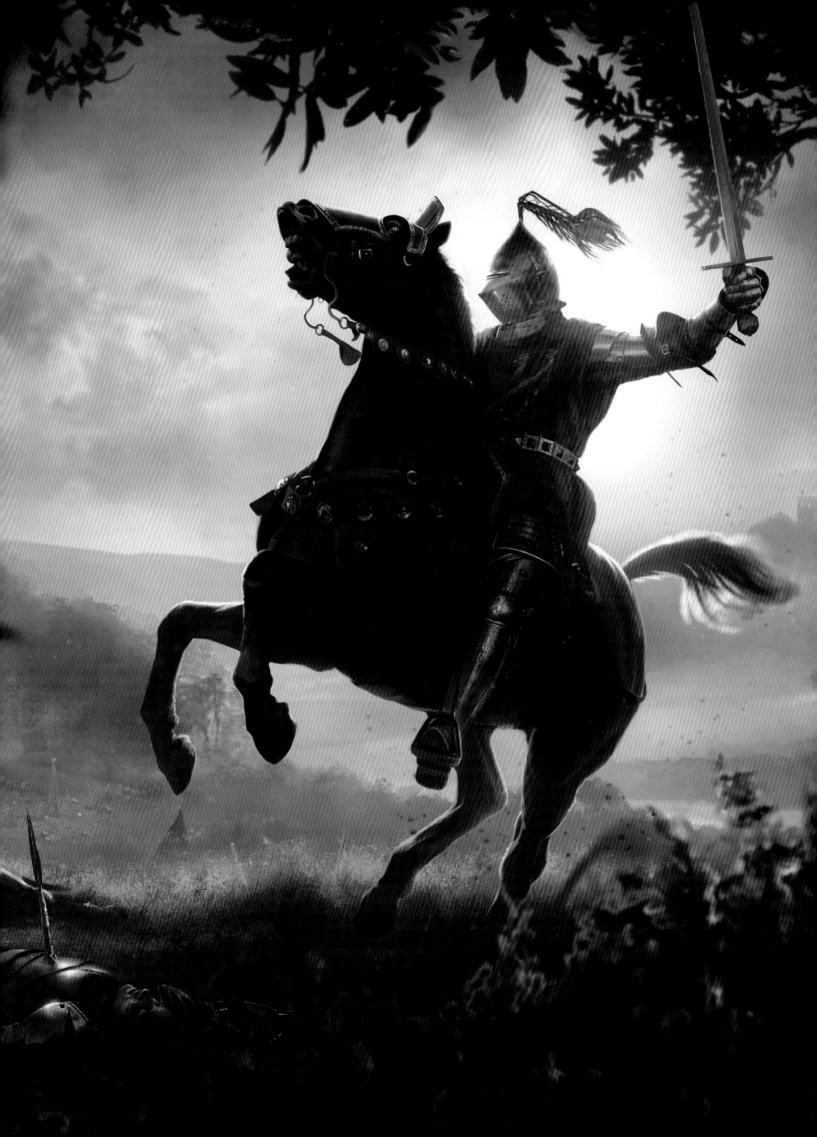

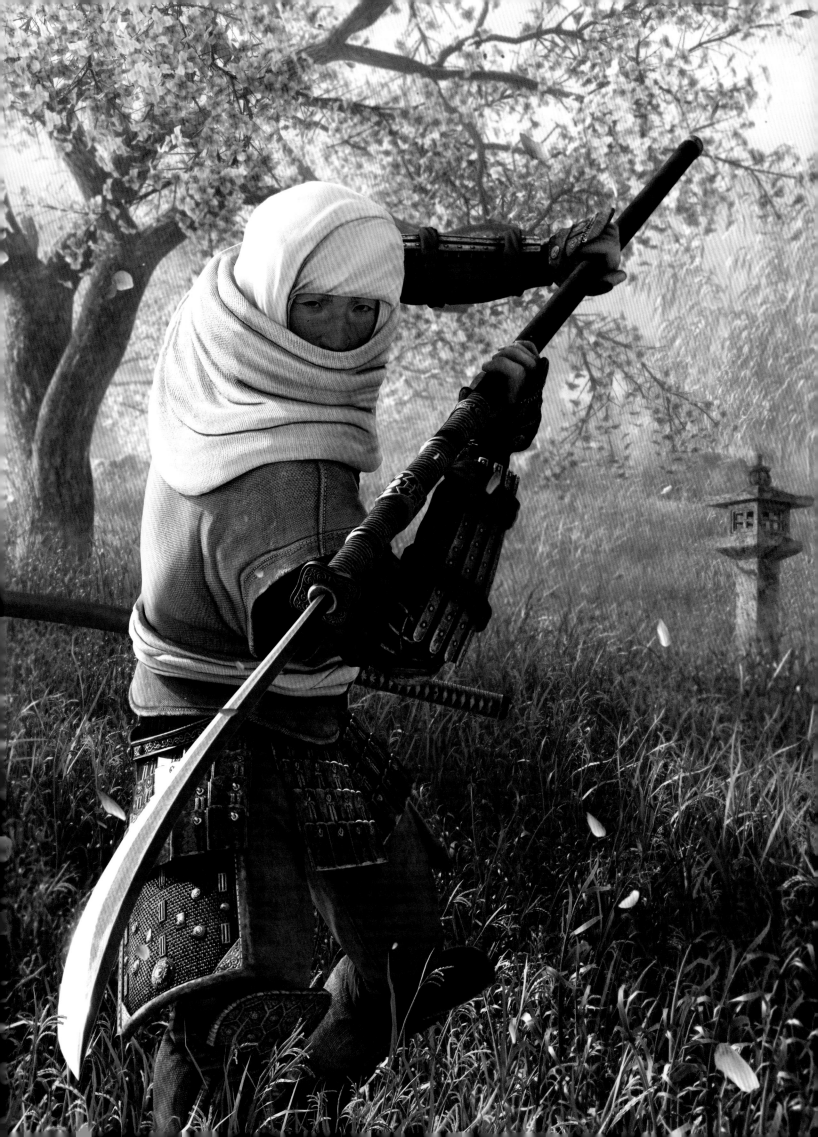

And then, the very first graphics cards launched. Up until that point, all we had were software renderers. This new technology changed everything. Anthony Taglioni figured out it would be possible to do a spline-based landscape featuring curves rather than straight lines, so we could define hills, valleys and so on. So he gave it a go and he made it work. Voila: we had a true 3D landscape, with hundreds of guys running around. Then we brought the camera down to the general's eye level, and the first *Total War* battlefield was born. It really had come about through a sequence of interesting accidents.

We realised that the battles on their own were never really going to be enough. They were fun and interesting, sure, but you need to have a reason to care about those battles, especially if you're going to have lots of them. There are various ways of dealing with that; multiplayer is one. Beating other humans is always fun, so you always care about the result. But in a single-player context, you've got to have some kind of wrapper driving you from one battle to the next, making you more deeply invested in the outcome. Plus, we all really loved deeper strategy games such as *Civilization*, so combining something that offered rich, turn-based gameplay with these great real-time battles seemed like a great idea. So that's what we did, and it really worked.

We knew we had the bones of something unique, but getting it funded was probably the hardest thing. We came up with a small demo that we took around to a number of publishers, and it was actually the EA Australia guys we were working with on the sports titles who picked it up and ran with it. From their point of view, it was a fairly covert development. They were a marketing operation for a big publisher after all; they weren't supposed to do development. But they found the budget somehow. There was also a third party involved, a group of Australian investors called Dreamtime Interactive. So in a complicated sort of arrangement, we managed to get SHOGUN funded.

We took it to ECTS (the European Computer Trade Show, a London games expo which went belly-up in 2004) in its first year of development, and it got a great deal of interest from the press, even though people didn't quite get it at first. It broke the genre mould, so we got a lot of questions along the lines of "Is it like Civ? Or is it like *Command & Conquer*?" The number of times we got asked that! To which we replied: "No! It's neither! It's either. It's both. It's its own thing."

And we were finding our way still. Initially we called it Taisho, which meant 'General' in medieval Japanese. What we didn't realise was that in modern Japanese, its meaning has evolved

somewhat, and is closer in essence to 'boss' – or perhaps more accurately, 'gaffer'. So the guy who runs the fish-and-chips shop? He's the Taisho. Needless to say, we had to backpedal and find another name for it.

We launched SHOGUN: Total War in 2000 and it did really well, but to EA it was still a small game. It wasn't a franchise yet, it was still a single product, and EA were building their business around big franchises so we decided to shop around. We met with Activision, who were really keen about the game so we ended up switching publishers.

Tim Ansell was dealing with the publishers, and he was a tough man to deal with. When you're an indie developer you need someone who's made of steel to handle that side of things and not get pushed around. His philosophy was simple and direct: he would close the company rather than sign a bad deal. He would rather just shut everything down and go home than take us into something he didn't think was right for us, and he would have no bones about telling people that. Sometimes they didn't believe him; in fact every time we changed publisher, it was because they didn't think he was serious when he said "I am going to sign with these other people. You really need to improve your offer." It wasn't a bluff. He was very, very straight and honest.

So we signed with Activision, and we embarked on an evolution/revolution process with *Total War*. When we finished SHOGUN, we actually started *ROME: Total War* and *MEDIEVAL: Total War* at the same time. MEDIEVAL, our evolutionary title, was to be built using SHOGUN's tech. ROME threw it all away and started again from scratch, based on lessons that we'd learned. But it turned out the revolution approach wasn't entirely perfect. We worked for a little over a year on ROME and it dawned on us that we'd thrown too much away. We had to reintegrate a lot of older code that was still valid and useful, and that added a year to ROME's development. But it did mean that we ended up with a much cleaner codebase, and something which is enduring today. In fact there's probably some code in *Total War* now that goes all the way back to SHOGUN. It gradually gets taken out, but some lines have survived.

In terms of general success, each *Total War* game has exceeded the last, but ROME was the first game that got noticed in a really big way. This was partly because the Roman era was more familiar to most people than some of the other periods we've worked in, so I think it made a bit more of a splash. Plus, around that time we were involved in two TV shows – *Time Commanders* and *Decisive Battles* – which used the ROME engine

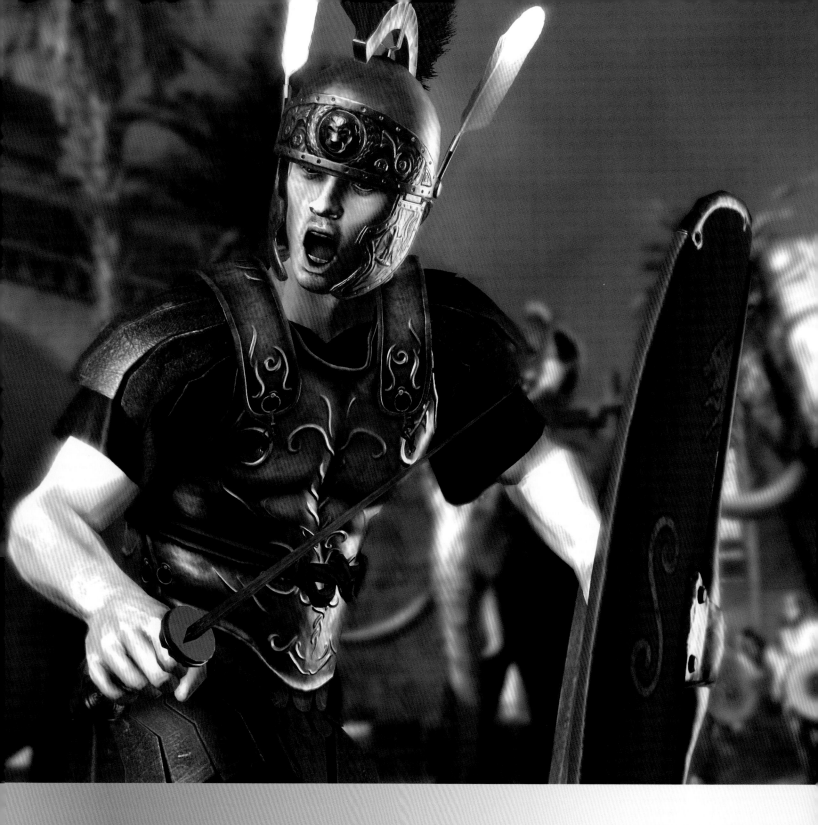

to render battles. It was one of the earliest examples of 'proper' crossover between TV and games. We had so much going on, it's hard to figure out how we actually had time to do that.

As we went through the evolution/revolution process, we learned a lot, and we came to realise that it was really quite difficult for one studio to manage. We decided it would be better to add a dedicated second team into the mix; a more content-focused group devoted to the evolution games in the cycle, building new games with the tech we'd developed in the revolution phase. Around this time, EA Australia had a small studio working on a surfing game. Now we knew a lot of these guys quite well as they'd worked on a lot of the sports titles with

us, and we knew they were good. So when EA canned the game and closed the studio, we thought "Let's start up in Australia". We brought four or five of their core tech guys over to our UK studio for six months and embedded them in the team. Building on the ROME tech, they built the graphics engine for MEDIEVAL II, then headed back to Oz. They did an amazing job on MEDIEVAL II under the CA banner, but after that, the evolution idea started to break down for them. They really wanted to embark on their own project, which would later become *Stormrise*.

In 2005, Tim Ansell sold the company to SEGA. At that time, life as an independent developer could be brutal and fairly short, because every time you did a project, you bet the whole company

on that project. You'd rarely survive one failure, and never survive two. By this point, many of our UK team who'd been working on the sports games for EA had moved onto making console games for Activision. They were working on a game called *Legend of The Spartans*, which later became *Spartan: Total Warrior*. But at that time, Activision had too many projects on the boil, so they culled a third of everything they had, and *Spartan* was caught up in that cull. We'd invested a lot of ourselves and our budget in *Spartan*, and we wanted it to finish it, so we shopped around. SEGA were interested, and picked it up. And rather than work for two publishers at the same time, it seemed to everyone's advantage that SEGA take the lot.

This was probably Tim Ansell's game-plan all along. Back then, as an independent developer, you rarely made any real money making games: you made money by building a studio and selling it to a publisher. That's when Tim cashed in, and he left shortly after. It's probably one of the best things that could've happened to the studio. The buyout brought us stability, steady funding, and a very smart publisher who respects what we do and lets us get on with doing it. It made life a lot less risky for us. In short, it's a fantastic relationship that works for both parties.

If *ROME: Total War* was a big technological step forward for us – we'd moved to fully animated 3D models – then *EMPIRE: Total War* was a huge stride. It was probably the biggest single

rid of the three or four-year elapse between titles. *NAPOLEON: Total War* came shortly after, and that was a great refinement of EMPIRE's ideas and features. It gave us the opportunity to polish up a lot of factors which were the result of working on such a huge and difficult game.

In 2011, we returned to medieval Japan for *Total War: SHOGUN 2* because we loved the period, and our technology had moved on to such an extent that we realised we could really do it justice. We were also driven by the idea of making an art game, or rather a game driven by the art. Which is hard to wrap your head around when you're making a game like *Total War*, something that generally isn't driven by artwork. But when you take that strong, distinctive Japanese art style, and the idea of simplicity, and you fold those into the equation, you have this vision for a game which is pure and simple, and I think we did a great job of delivering that vision. Artistically, it's a wonderful-looking game and there's a zen-like simplicity to it which I think we would like to try and emulate more in future games. It's geographically compact, the feature-set is pretty tight, and it manages to have lots of depth without too much complexity.

That's always the challenge with *Total War*; trying to produce a game that's deep but not overly complicated. And by deep, I mean a game you can play for 80 hours, and still find something new that you've never noticed before, or formulate a plan you've never executed before. Complexity comes from having lots of different concepts to deal with. You can have a game where there are relatively few concepts but which has a lot of depth, and boardgames are a great example of this. Generally speaking, the really great boardgames, the ones that sit perennially at the top of the boardgame top-ten lists, are technically simple games which are incredibly difficult to master, and someone who's really good at them will thrash you every time.

With SHOGUN 2 behind us, in 2013, we expanded our ambition again with ROME II. We really wanted to let rip; go big, and bold, and deep, and work in some new features we'd been thinking about. In scale terms, it was up there with EMPIRE, and in some regards bigger. As well as picking eras and geographical scope and a range of units for each *Total War* game, we also have to deal with technological inflation; poly-counts in models are up by a factor of five since EMPIRE. All of that takes extra time. Projects just get bigger and bigger, and as a result, there are a lot more of us these days. ROME II was a great example of this.

With ROME II, we delivered on the scale and scope, and the iconic Roman content. We let you play as a Caesar basically, and

step we've ever made. It arguably added a third game to the battle/campaign mix with naval battles, which offered an entirely different experience requiring different tactics. Doing it in the age of sail was also quite demanding – there are lots of twiddly bits in a sailing game! Ropes and sails, and tacking and wind… it was all new to us and it was a big but really fun challenge. We also had a completely new graphics engine, a new battle engine, and it was the first time we'd come this close to a truly global scope, with the different theatres of The East, The Americas, Europe and so on.

It was very much a revolution title, but it was probably the last one. The major engine rewrite we went through for EMPIRE put things on a much sounder engineering footing; it made the entire engine modular, so now, we can revolutionise individual components rather than do the whole lot at once. It allows us to spread our revolutions out across multiple cycles, and get

that's really what we were aiming for. We also pushed forward in a lot of different areas from a technological point of view; we didn't make the same game again, which is an easy thing to do with a long-standing franchise, particularly with strategy games. Buildings worked differently; we had a totally new province system, army system, recruitment system… you name it. There's a lot of stuff in there that's really quite radically different from previous games. Some of that opened up new avenues for us, which we'll exploit as we go forward into new games such as *Total War: ATTILA*, coming out in 2015. That's one of the interesting things; you'll produce a game and along the way, you'll push to try and achieve something which will open up the possibility of doing something even greater, which you may not be able to do in the current project – or even in the next. But you're adding to that list of things you're trying to achieve. Take realistic behaviour on the battlefield – we've been constantly trying to achieve that and getting a bit better each time. None of which is easy, of course. There are very few other games out there do the kind of full-AI behaviours that we do.

We achieved much of what we aimed for with ROME II, but it took us a long time to get there. As developers go, I think we offer an uncommon level of post-launch support through balancing and tweaks, feature improvements and new content, both free and premium. The way things used to be, you'd rush to get a game into the box because you're constantly under pressure to hit your deadlines. If you don't make a commercial success out of it, you go out of business and you don't get to make any more games, so there's genuine pressure. But once the game was out of the door, it was over. You got on with the next one.

Things have changed radically since then, not least the ease with which you can patch games. In the old days, you might hear about a patch for your game, or you might not. You'd have to hunt it down, or get it off a CD on the cover of a magazine. Being able to release DLC also helps enormously, as it can help fund the ongoing development of the game, and that means the game doesn't need to die; you can keep offering your players new experiences, or change and improve the game over time. We'd love to go back to some of our previous games and pick those up and start working on them again, but the tech wasn't quite so friendly in those days, so it's not necessarily easy to do.

We've been doing this a long time now; we celebrated our 25th birthday in 2013 and there are more than 300 of us at work on various projects now. With that inevitable expansion, there's an ongoing effort to keep our company culture – one of creativity and individual contribution – alive. We try to foster that small, friendly atmosphere we had when we first started, and give the individual developer doing his job on a day-to-day basis a sense of belonging, and that his work can make a real difference.

In general, there are two different approaches you can take to making games: process-focused and craft-focused. The first

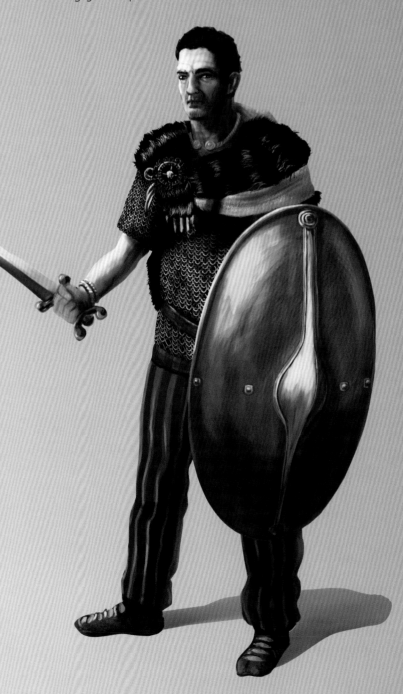

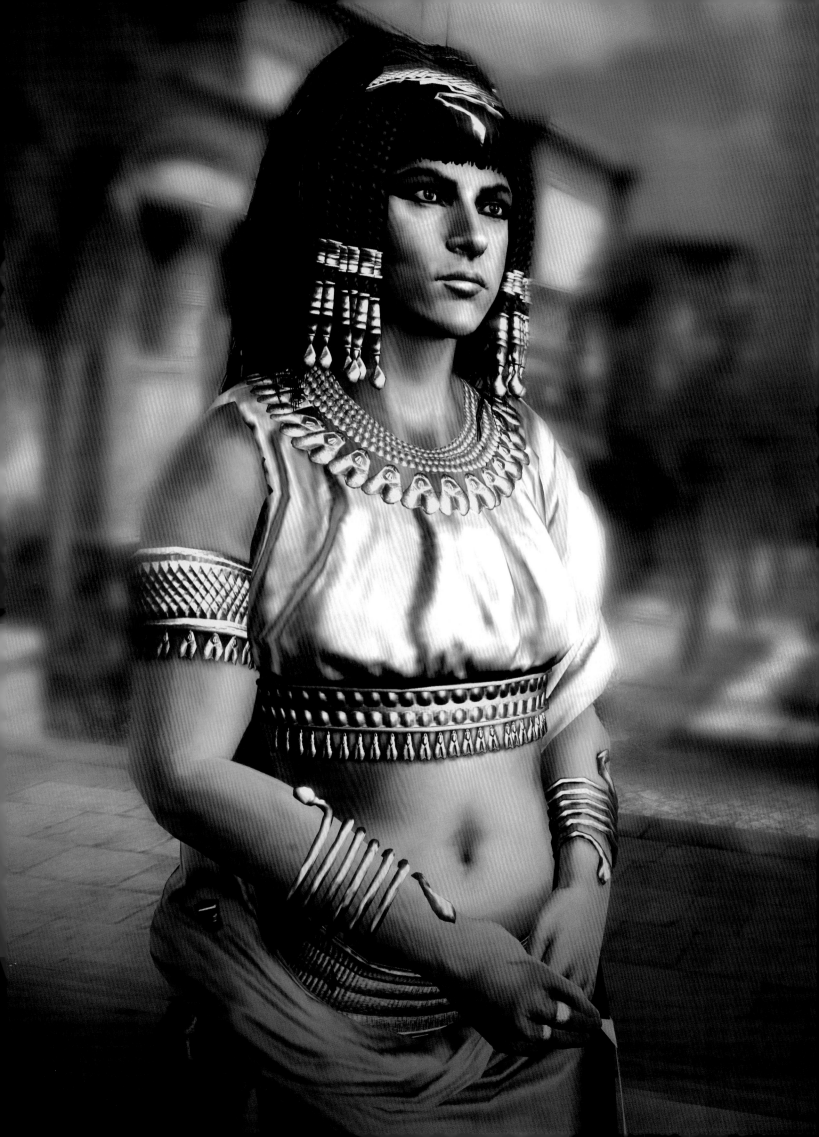

requires you to build a process for making games. The individual game becomes less important; you spend a lot of time making the process of development as efficient as you can. Some of the bigger studios are masters of this form, as it's geared towards regular franchises. Some never modify their engine while building a game. They use the previous year's engine, and have a dedicated engine team working independently for next year's title, so the games themselves are always built on known technology. This process tends to chop the making of the game into fragments, and deskills it to the point where you're never reliant on any one individual being particularly brilliant – It takes all the risk out. You're guaranteed to deliver a solid game every year, and you end up with a machine that can't really make a bad game. But because there's no room for individual flair, it struggles to make a really *great* game.

The craft focus is about making sure the particular game you're working on right now is the best thing ever. That's something that small teams do. You rely a lot on the individual talents of individual people, and most really great games are made that way. But it's a slightly more risky way of making games. You can do great work, but if people are ill, or move on to pastures new, or some other bad luck befalls the project, you can end up in a difficult place.

Organisations tend to use one or the other, as the two don't mix very well. Craft is crucial for brilliance, but process helps to keep the train on the tracks. We try to do both, and it's not easy. As we've learned through experience, the bigger the game and the bigger the team, the harder it becomes to maintain a focus on craft, and we've jumped through hoops to keep our team working in that way. Some of the game-content inevitably becomes more process orientated, so you end up doing a mixture. We juggle the two, making those two things work at the same time, but we always make sure craft is at the core. We're capable of making brilliant games, but try to ensure the process is reliable enough to work across a big team.

Ultimately, to me the craft approach offers more job satisfaction. People get the chance to exercise their talents and make a difference, and when it works well, you make something brilliant. We'd rather be in that ambitious area where we're pushing forward and trying to do great stuff all the time. And if we occasionally stumble, we carry on; we make it better, then we get it right the next time.

Something else that sets us apart is that we don't iterate very much. *Total War* is quite systems-driven, and from a game design perspective, the *Total War* team is very strong analytically. We've

been doing this a long time and we really do understand the kind of games we're making. We can read a feature description and model the system in a spreadsheet to prove it's going to work before we actually put it in the game. That gives us a huge advantage over teams that are sailing off into the wild blue yonder and don't know where they're going to end up. We almost always know where we're going to end up, and we generally get 90% of it right first time. We have to; *Total War* games are really big, so we don't always have time to iterate, or work out that a feature isn't perfect.

What this means is that occasionally a feature will turn up that doesn't work as well as we'd hoped, but generally the games are so rich and feature packed, they can cope with a weak one. We're constantly pushing forward, so we'll modify that feature through patches or pick up it up again in the next game. We'll end up with a strong feature, and add it to our bank of existing strong features. I think that's quite unusual; I don't think many studios can do that. There's generally a theme in games development that iteration is king, and really, iteration is dumb. People iterate because they have no choice; it's impossible to get it right first time if you're sailing into uncharted waters. Iterating means chucking stuff away, which isn't the best way of doing things. It's good to work out the details on paper first, and aim to get it right first time.

The future is interesting. As a games player I find myself playing games for longer than I ever used to. Games-as-a-service is already a reality. There are games I've been playing for literally years now (*Eve Online* is a great example) which continue to grow and evolve. What we play affects the way we think about what we want to do for the future, such as making games which people can play for longer periods, or looking at ways to pull more social aspects into the game. Multiplayer has never been *Total War's* strong point in the past, and that's something we're looking to radically change with *Total War: ARENA*. For most strategy games, multiplayer is almost all of the experience or, at the very least, a sizeable chunk of it. We're also experimenting with this in the mobile space, with *Total War: KINGDOM*, and taking the series to a fantasy setting with *Total War: WARHAMMER*.

There's also the constant march of technology which can lead to grander scales, greater fidelity, and more human behaviour. We want to push forward in all of those directions too. At the very least, our plan is to keep making great games, and remain true to the things that made *Total War* unique in the first place: innovation, depth, authenticity and fun.

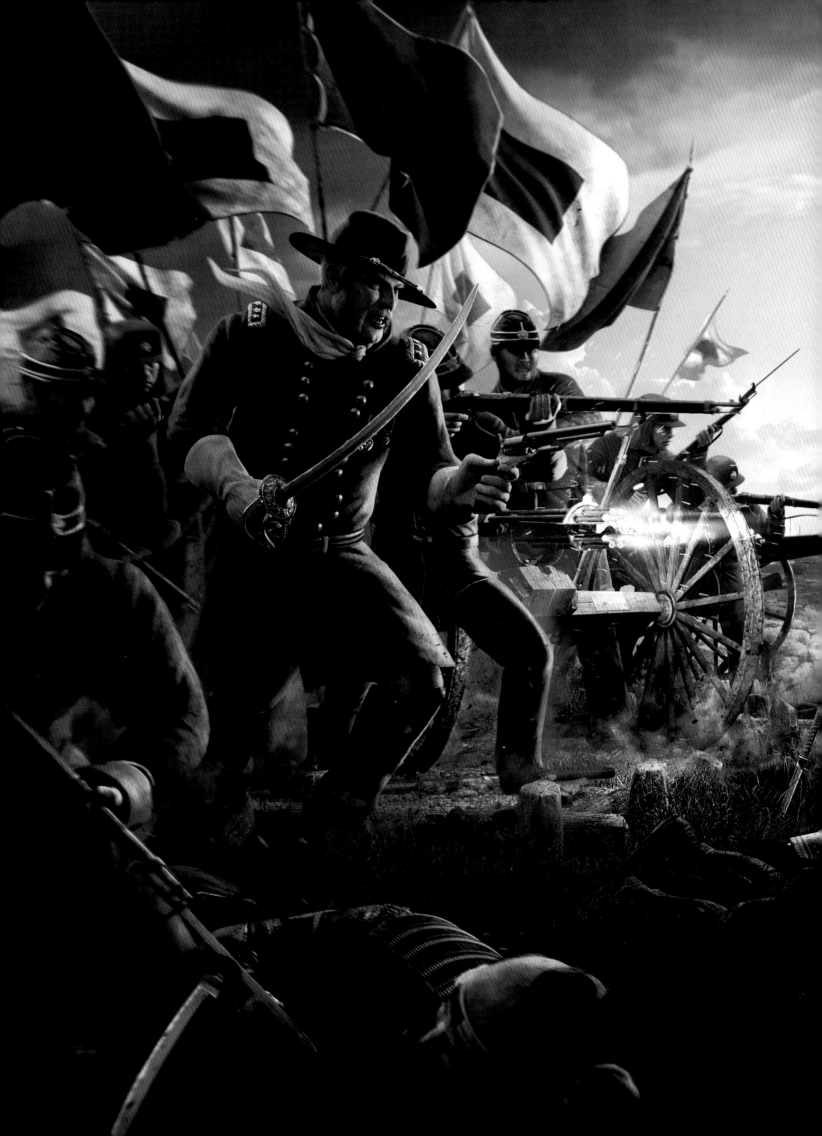

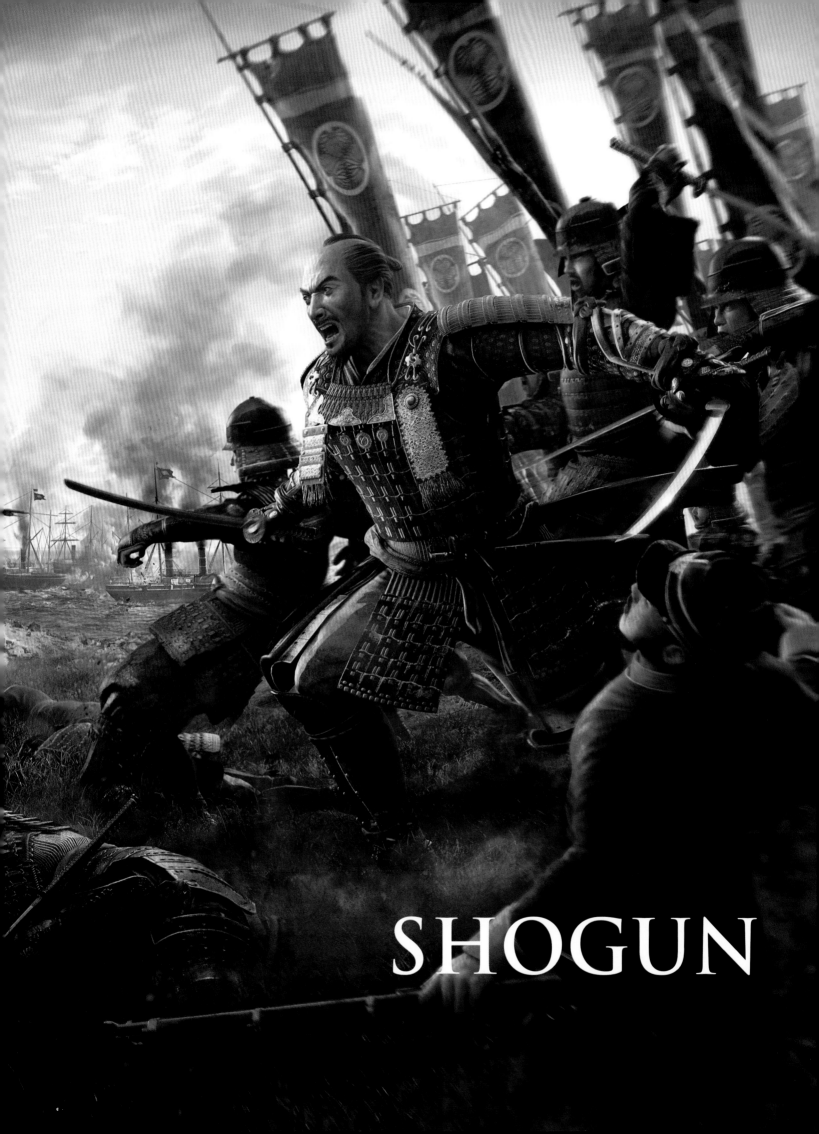

SHOGUN

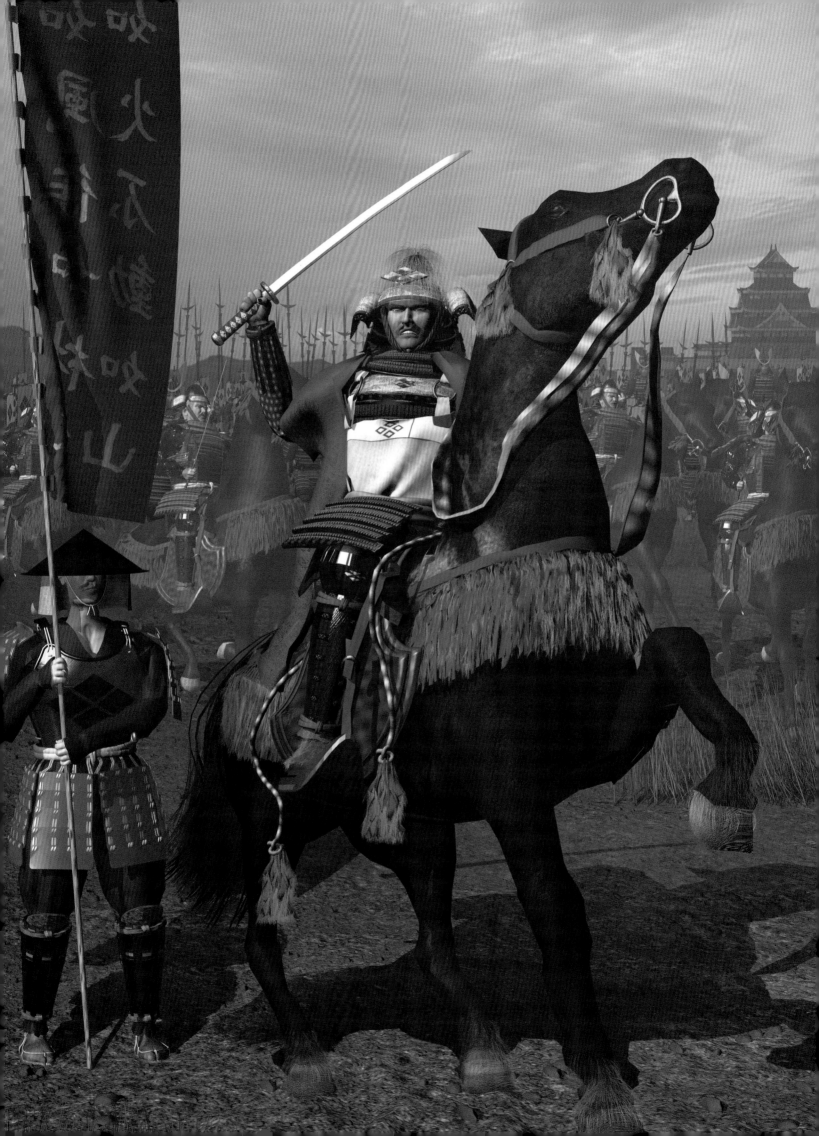

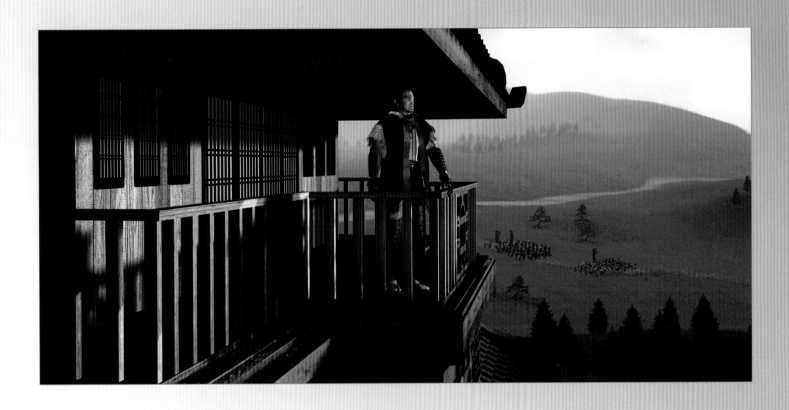

SHOGUN

Every epic empire has more modest beginnings, and so it was with Creative Assembly's first strategy game, *Shogun: Total War*. At the time the fidelity was impressive, built to exploit the first dedicated graphics cards that were being installed in PCs back in 2000, but from a contemporary perspective the art can look comparatively crude – a rock thrown in a more modern game such as *Total War: Rome II* boasts as many polygons as one of the original characters. "I think it's the same with any game that's made 10, 20 years ago," says lead artist Joss Adley. "You think you're cutting edge and in many ways you are, but things move on. We're still proud of it."

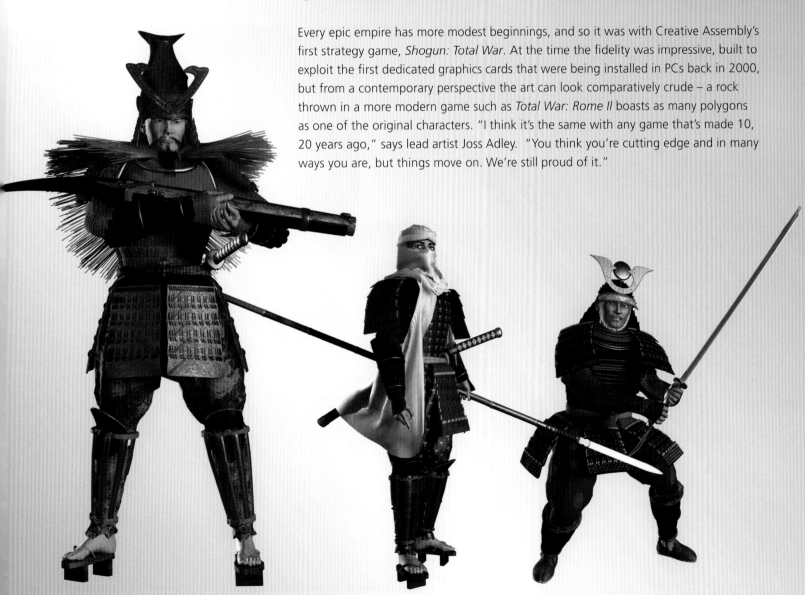

Whereas now Creative Assembly draws upon up to 80 artists to build its worlds, as the *Total War* series was establishing itself in 2000 the team was smaller, and more stretched. Developers and artists went from working on ports of sport games to fleshing out Sengoku-era Japan, leaning on iconic imagery of samurai to create a relatable, immersive vision of history. The majority of the miniscule development team from *Total War: Shogun* remains at Creative Assembly – several within the *Total War* team, while others have made the journey from feudal fields to the abandoned space stations of *Alien: Isolation*.

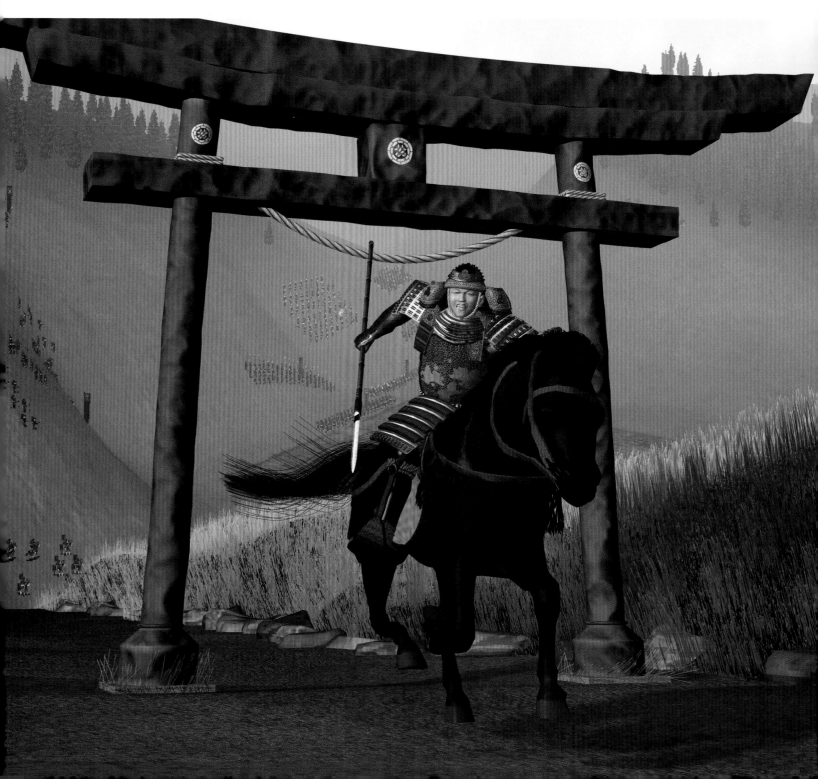

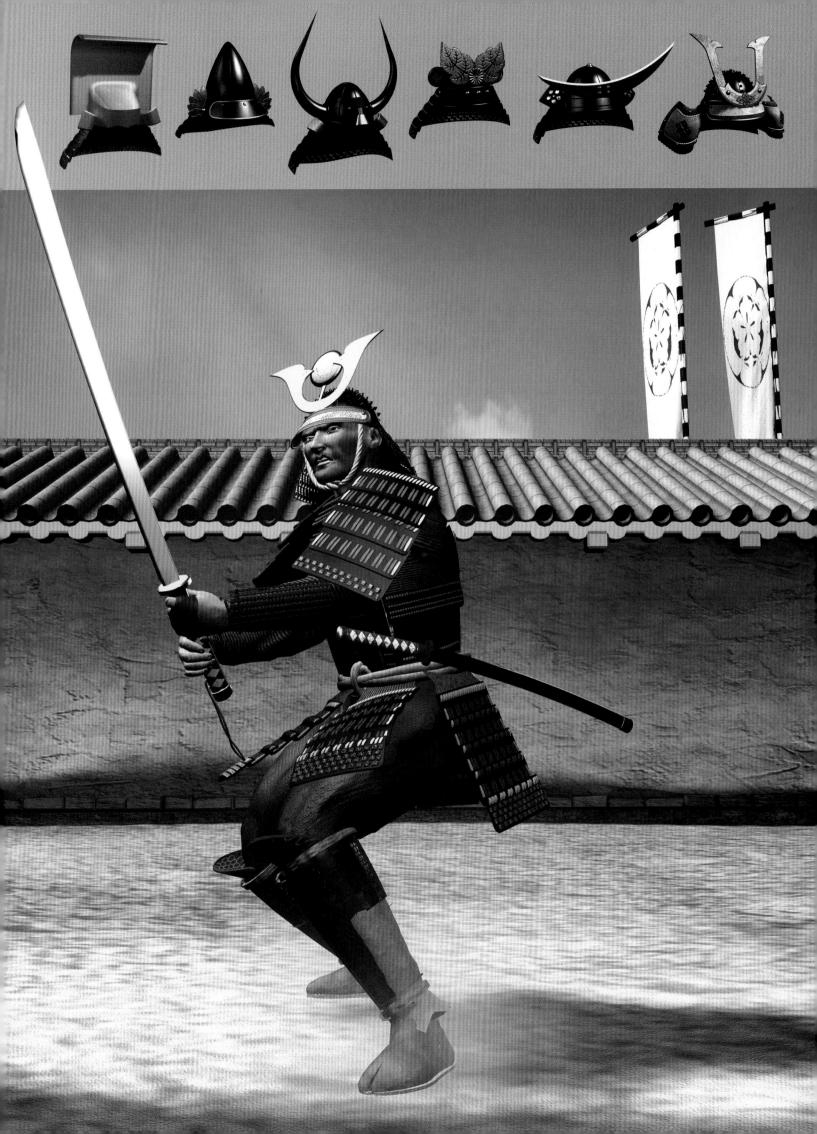

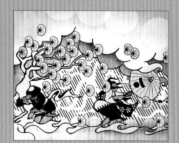

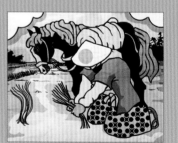

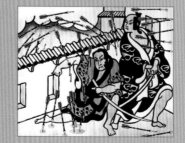
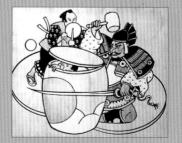

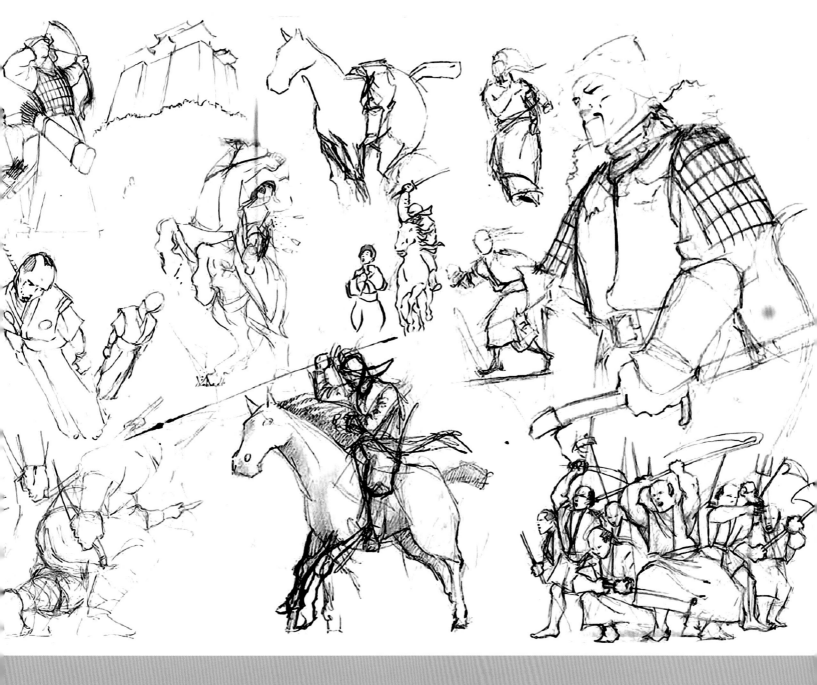

Twelve years separate the two *Shogun* games in Creative Assembly's series, and the difference in their production, and in their art, is astounding. Back in 2000, between eight and nine artists helped realise the game – by 2012, that number had increased tenfold. "It's the same across all triple-A games," says lead artist Kevin McDowell. "The level of fidelity obviously is many factors higher than it was. The tools that we use are far more complex – just as an example, the original *Shogun* was just sprites. The complexity is massively higher. We work with much bigger teams, and we're more flexible in the way that we work."

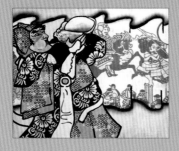
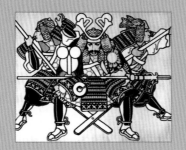
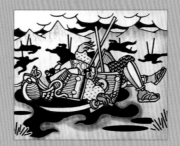
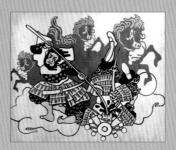

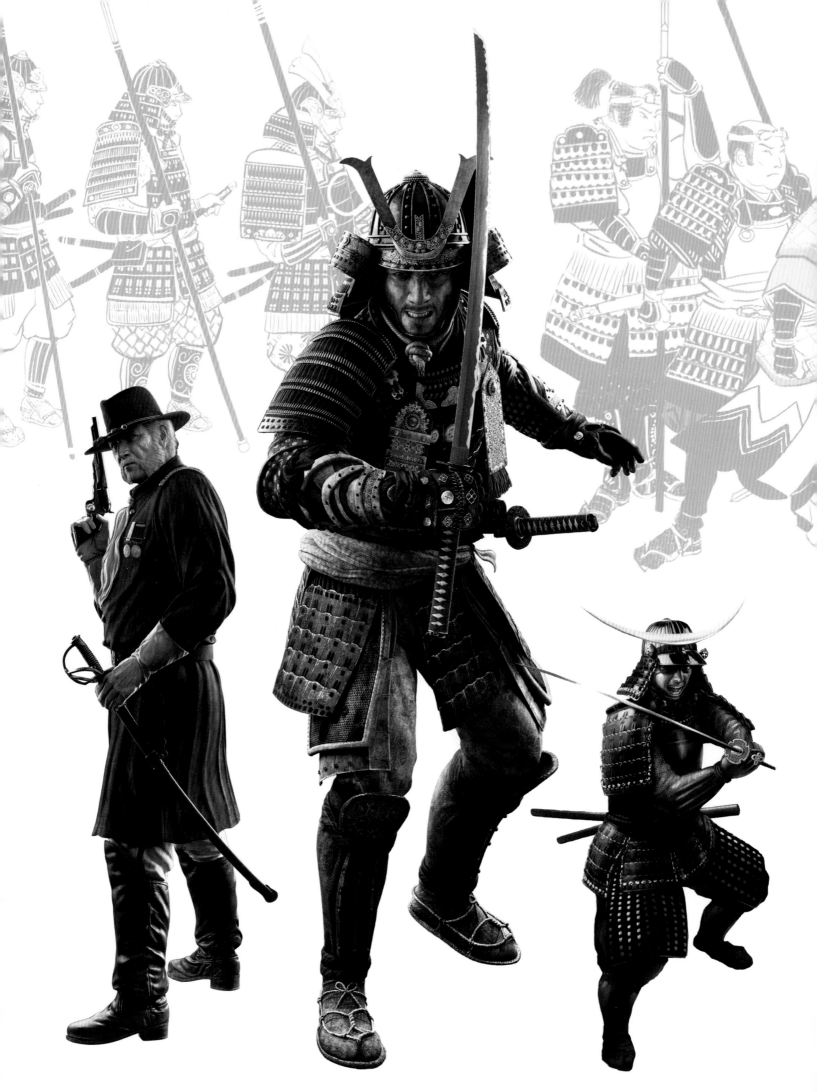

SHOGUN 2

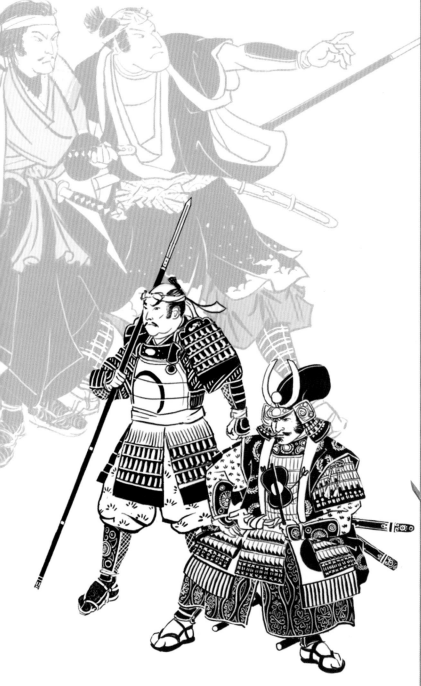

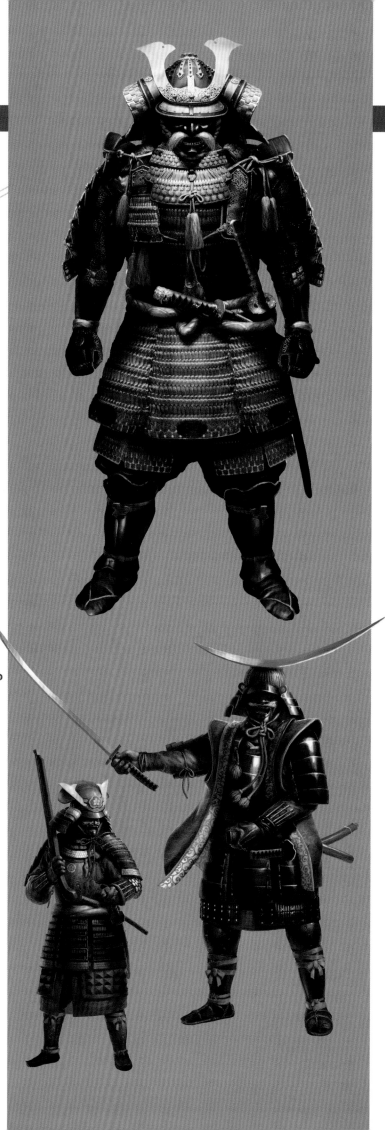

The *Total War* series utilises the broad canvas of history, and the subject matter at hand in *Shogun 2* presents some of the most stirring imagery in the series, from the pastoral plains of Japan to the strutting elegance of a samurai. "With it being the Sengoku jidai period, there's some amazing armour and weapons and helmets to draw from, all pretty much historically accurate," says artist Joss Adley. "Without trying too hard you've got these amazing historically accurate characters you can just drop in. It's a very interesting time period in that respect. It's all done for us, really."

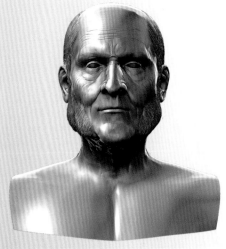
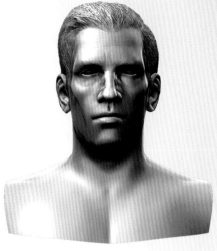

Recognisable Faces

While *Total War* takes its inspiration from history, it's often an idealised history that meets expectations of the players. So it is that characters such as Benkei, a Japanese *sōhei*, or warrior monk, whose antics have been carried on through folklore, came to feature in the Saints & Heroes battle pack for *Shogun 2*. "It's very much about appealing to the player's sense of what they feel is realistic," says designer James Russell, "Which is probably more Hollywood than they'd like to believe."

The design for Benkei himself was arrived at quickly. "It was trivial iterations with this – we tried different colours with his headscarf, and that was about it," says Kevin McDowell. "This is something that's critical to the *Total War* team's success – we try our damnedest to get it right the first time. We think about it, discuss it – we don't do iteration for iteration's sake."

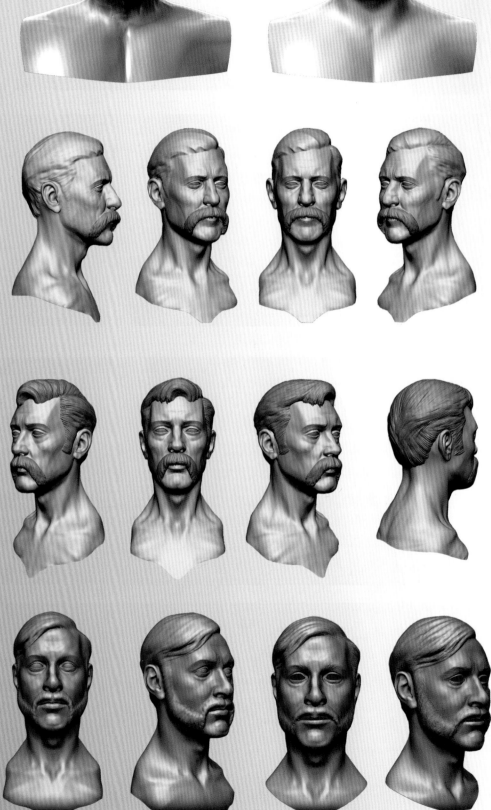

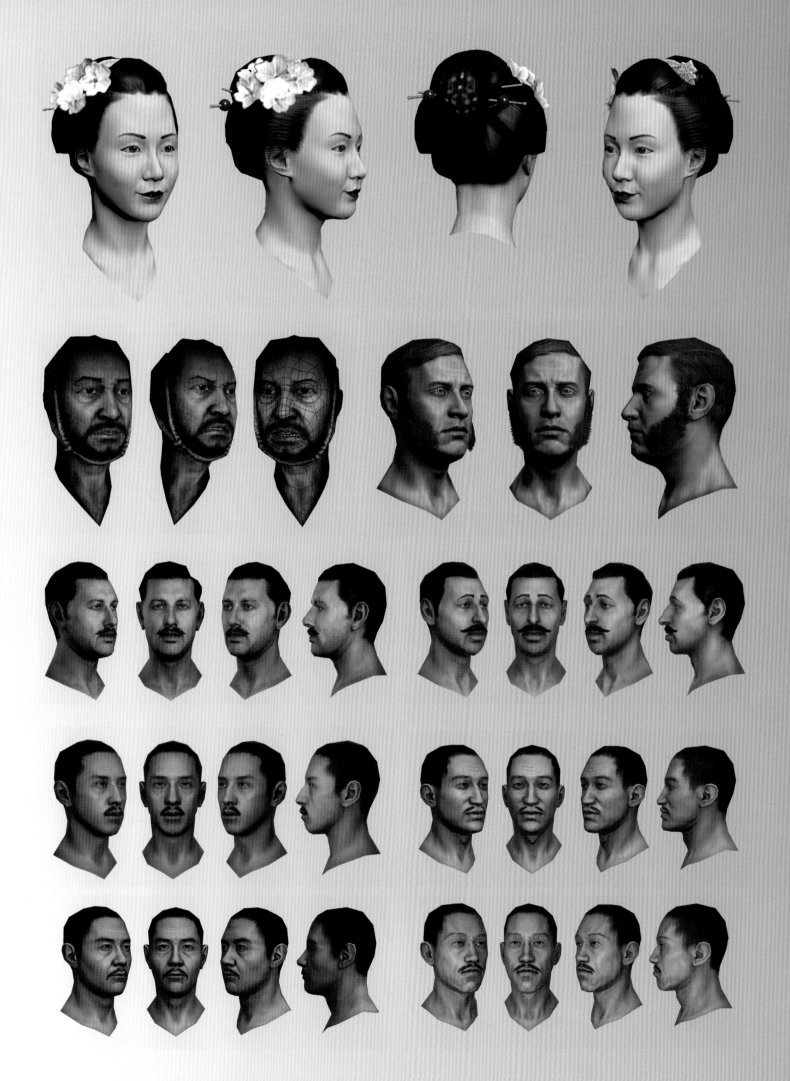

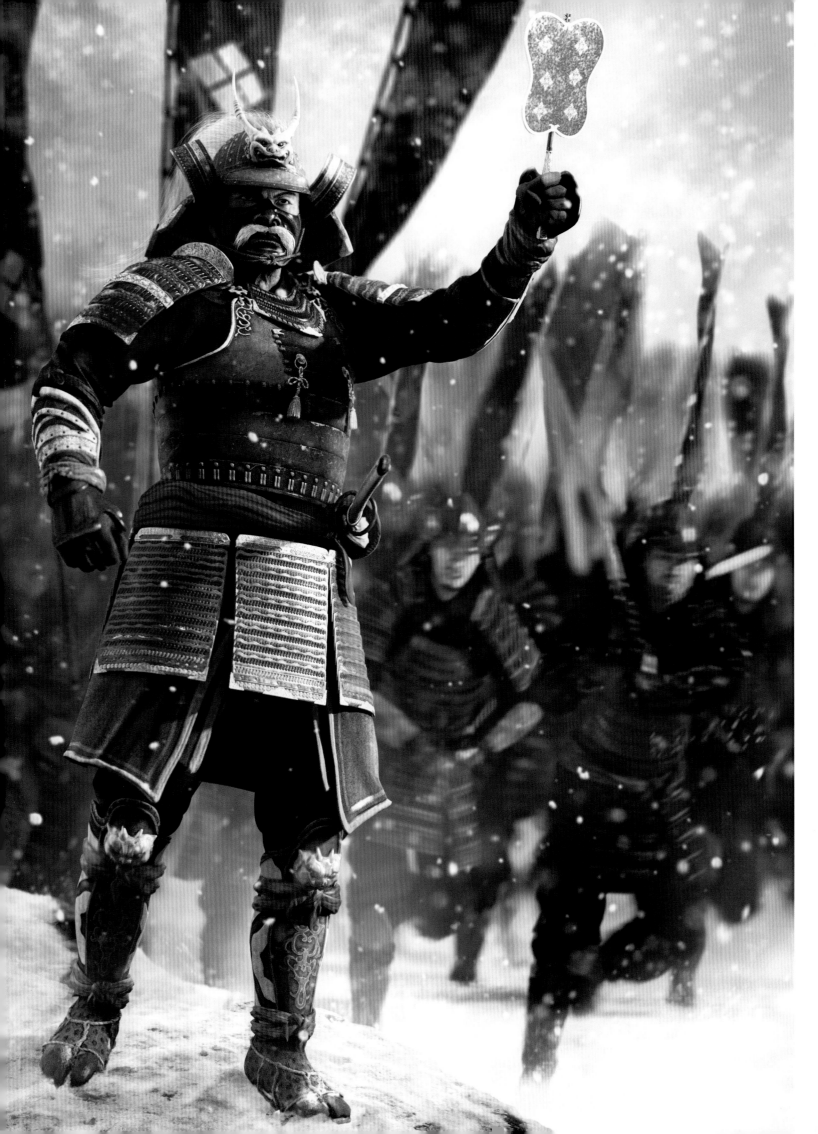

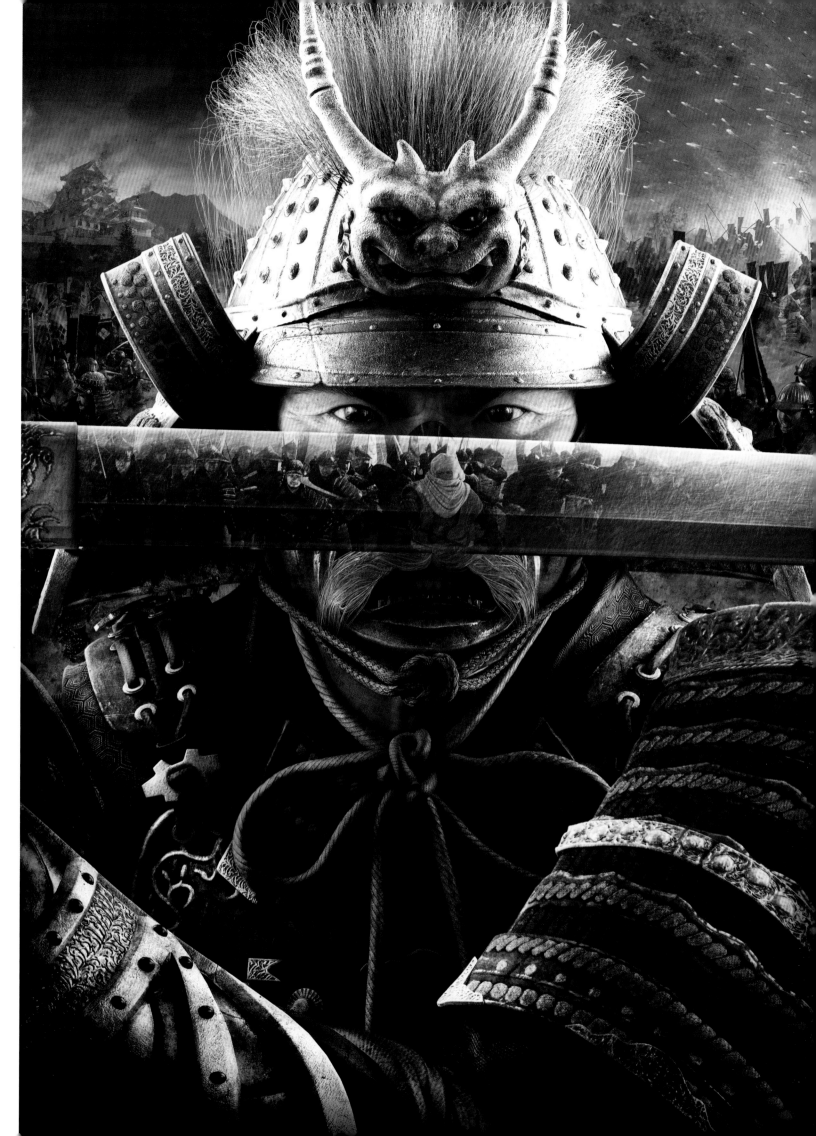

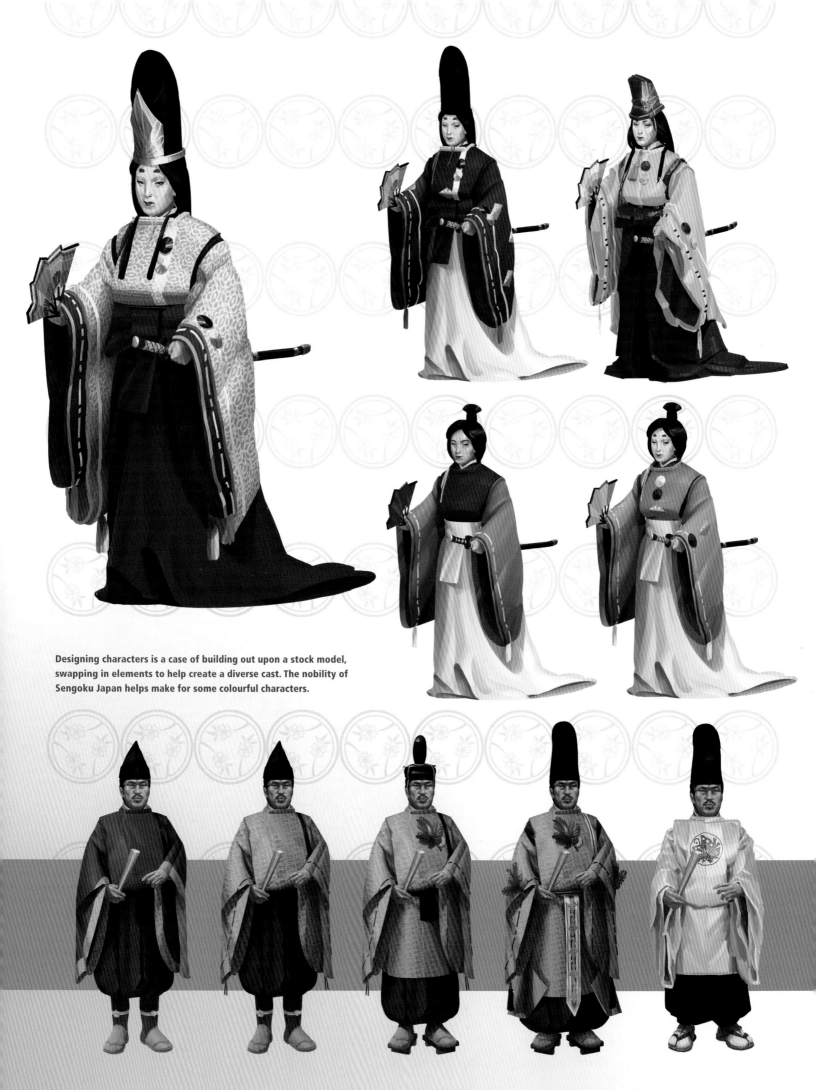

Designing characters is a case of building out upon a stock model, swapping in elements to help create a diverse cast. The nobility of Sengoku Japan helps make for some colourful characters.

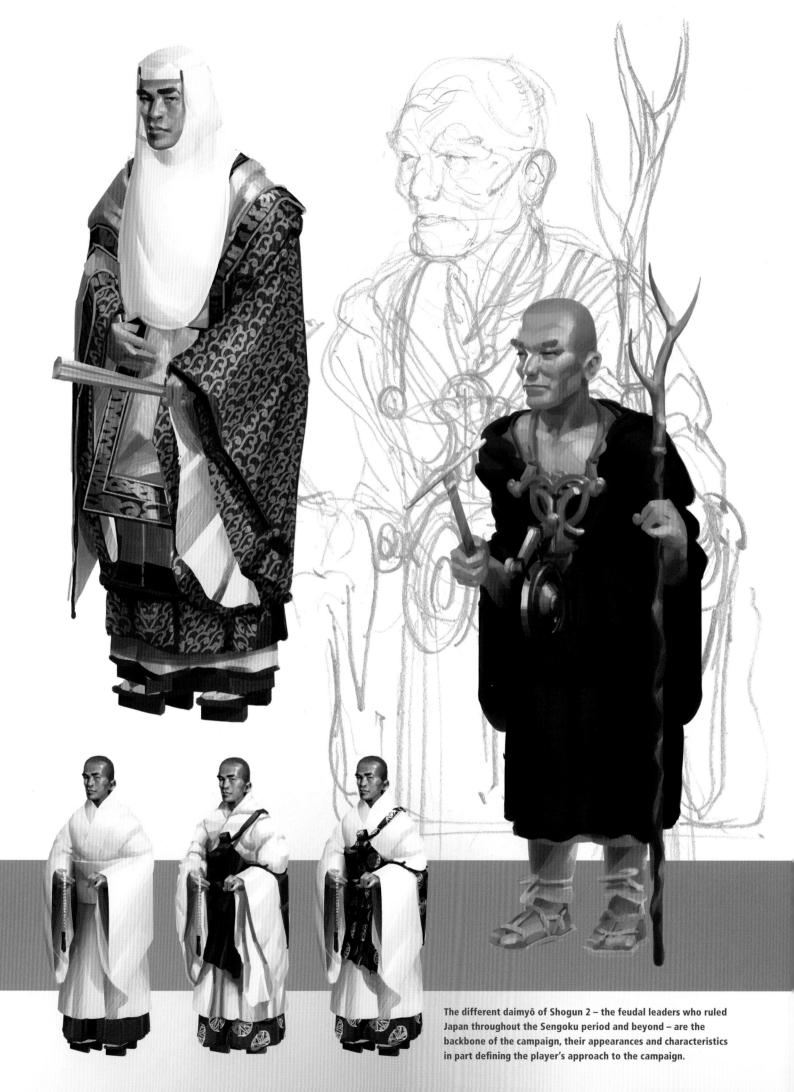

The different daimyō of Shogun 2 – the feudal leaders who ruled Japan throughout the Sengoku period and beyond – are the backbone of the campaign, their appearances and characteristics in part defining the player's approach to the campaign.

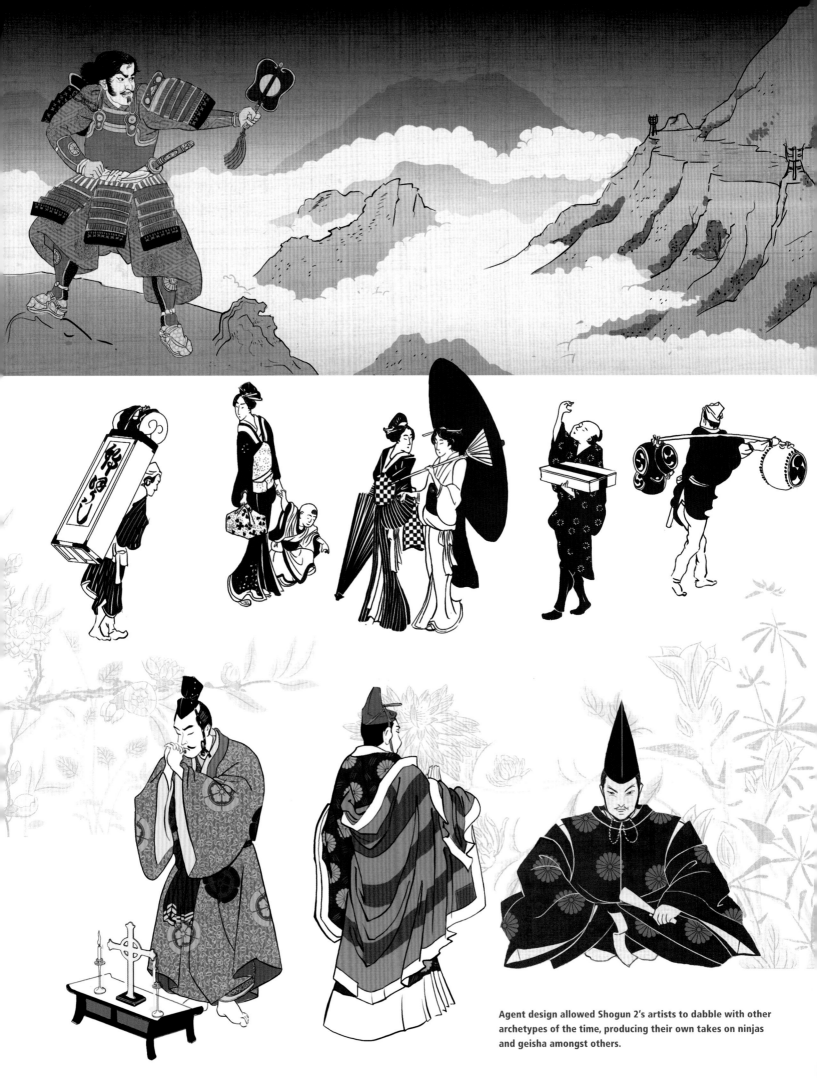

Agent design allowed Shogun 2's artists to dabble with other archetypes of the time, producing their own takes on ninjas and geisha amongst others.

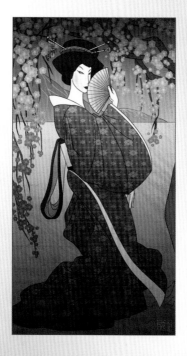
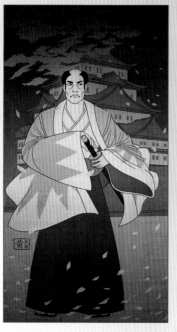

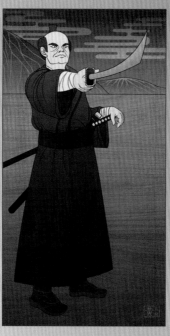
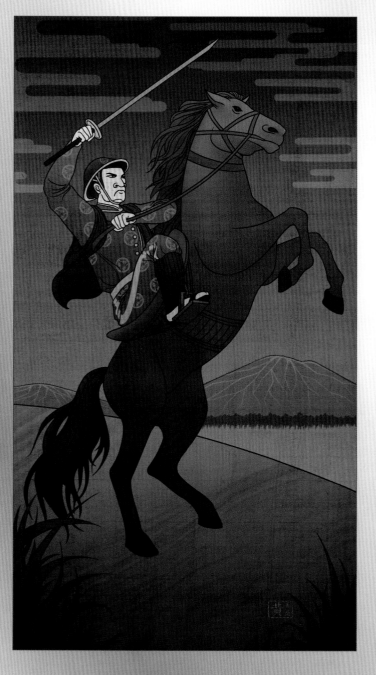
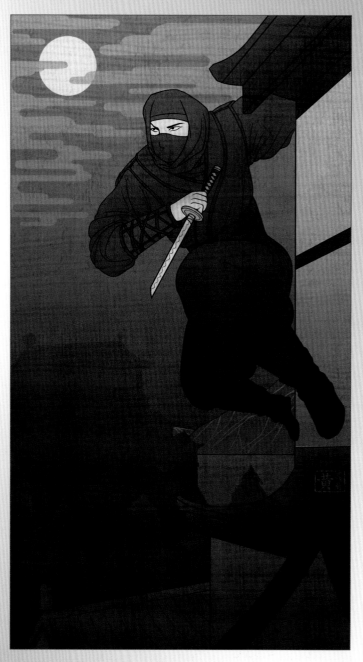

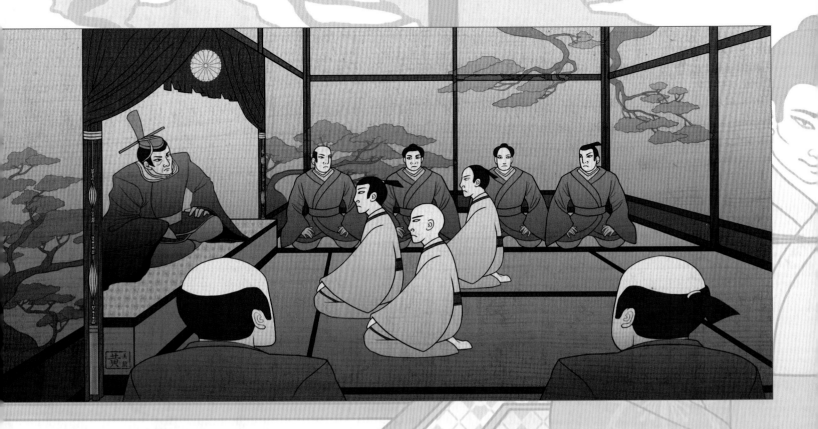

FALL OF THE SAMURAI

The art of expansion pack *Fall of the Samurai* is distinct from the standalone game. "It's a slightly later period, and we're almost getting to early photography," says artist Joss Adley. "It's keeping with art of that style – a strange mix of traditional Japan with a little of the modern elements thrown in as well."

Japanese woodblock art was an obvious inspiration for *Shogun 2*, although the reference points weren't always contemporary to the period depicted. "We bent the facts a little bit," says Kevin McDowell. "*Shogun 2* takes place in the medieval period of Japan, around 1600. But we were looking at woodblock prints from 1850-1860, stylistically. That was the best match for *Shogun 2* – they're very expressive, have a reasonably modern feel, and the familiarity is there. That's what we did for *Shogun 2*. In *Fall of The Samurai*, which takes place in the time period that we used for *Shogun 2*, we actually went further ahead for our visual reference. That takes place around 1850-1860 – but our visual reference was 1900-1915. We wanted to have them visually move on from where they were from *Shogun 2*."

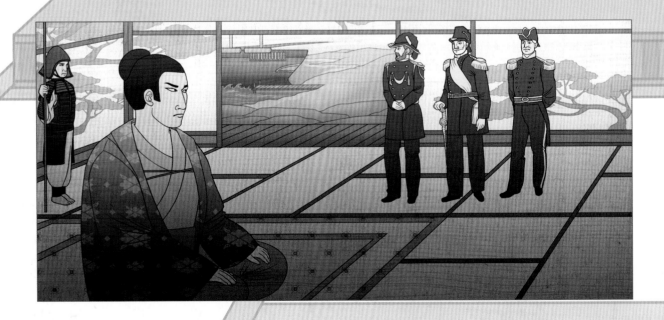

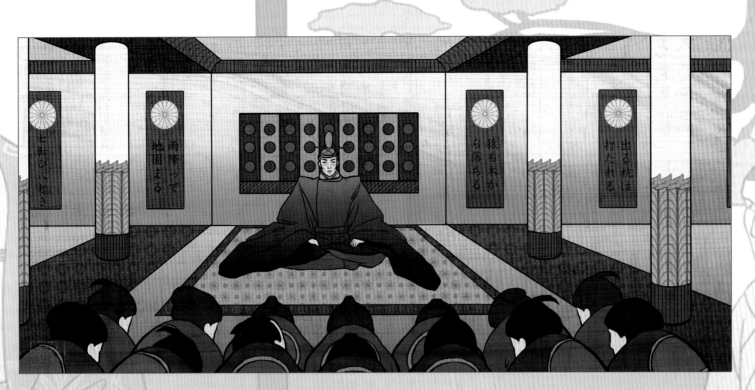

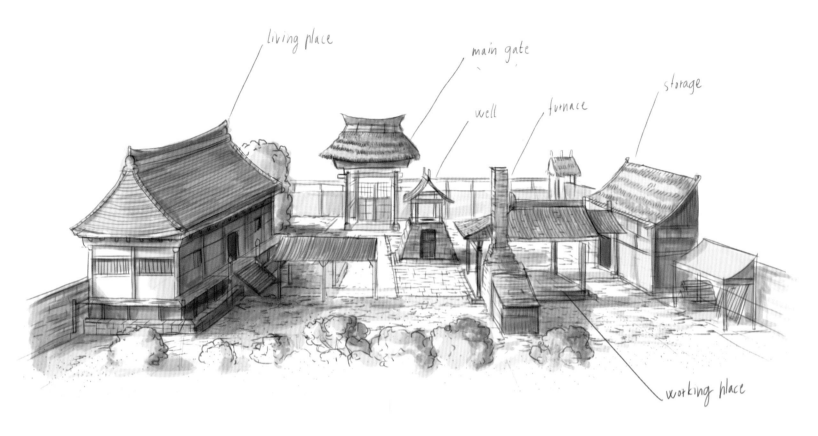

living place

main gate

well

furnace

storage

working place

BUILDINGS

"The architecture is a bit different to what you see with our approach to weapons," explains Kevin McDowell. "While they're trying to copy reality as closely as they can - while bearing in mind the technical and animation restraints - the architecture is much, much more about being inspired by the look and feel of the place and time that we're dealing with.

"We will almost never copy a building verbatim, for a number of reasons. The number one is that most buildings will have idiosyncrasies we don't want to have. We'll instance our buildings throughout the map, and if a building has a funny green chimney sticking out of it, your eye will be attracted to that, and you'll see it all over the place. You have to make these things fairly nondescript."

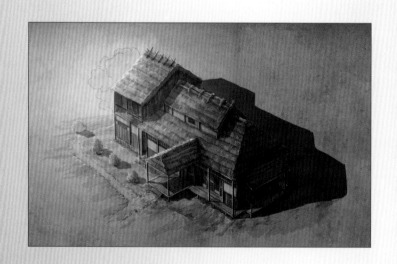

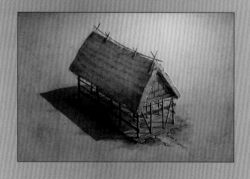

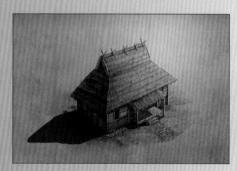

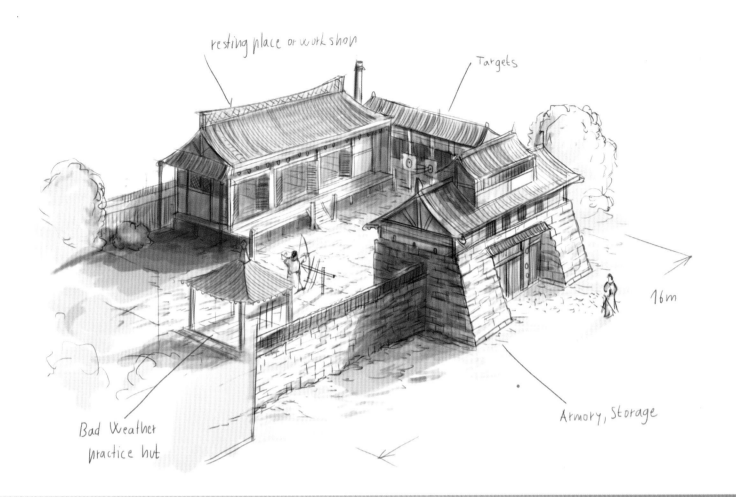

resting place or workshop

Targets

16m

Bad Weather practice hut

Armory, Storage

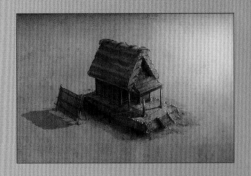

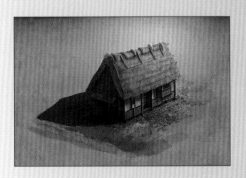

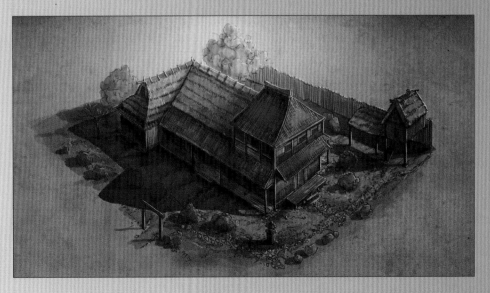

Outhouses and other buildings aren't just there to populate maps with more furniture – they often have ramifications for gameplay, a consideration to be made during the design stage.

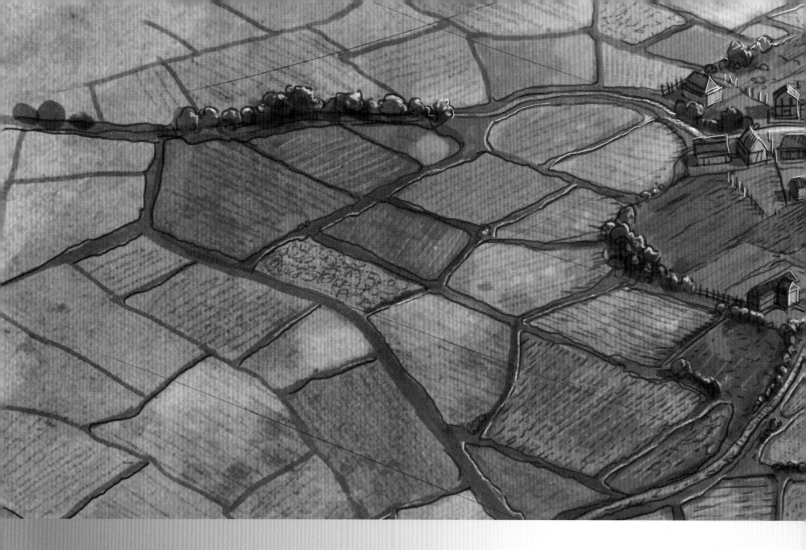

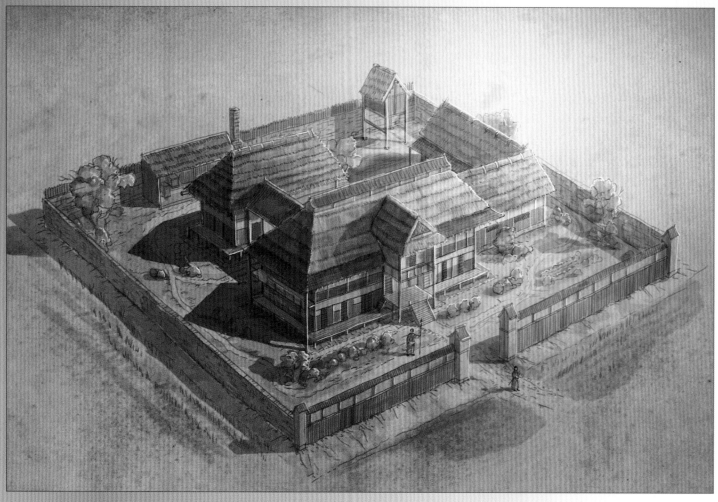

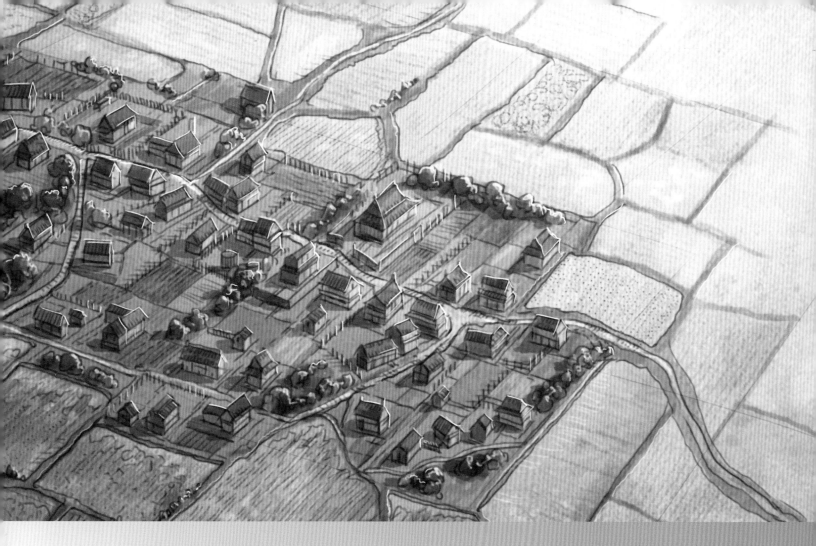

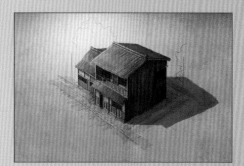

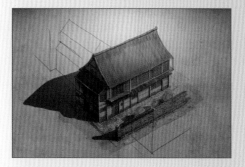

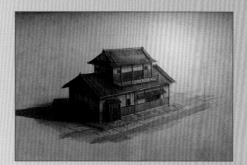

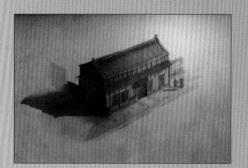

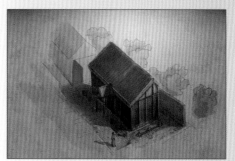

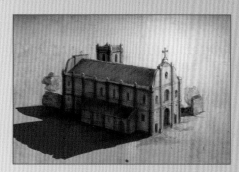

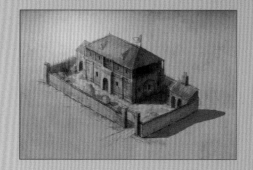

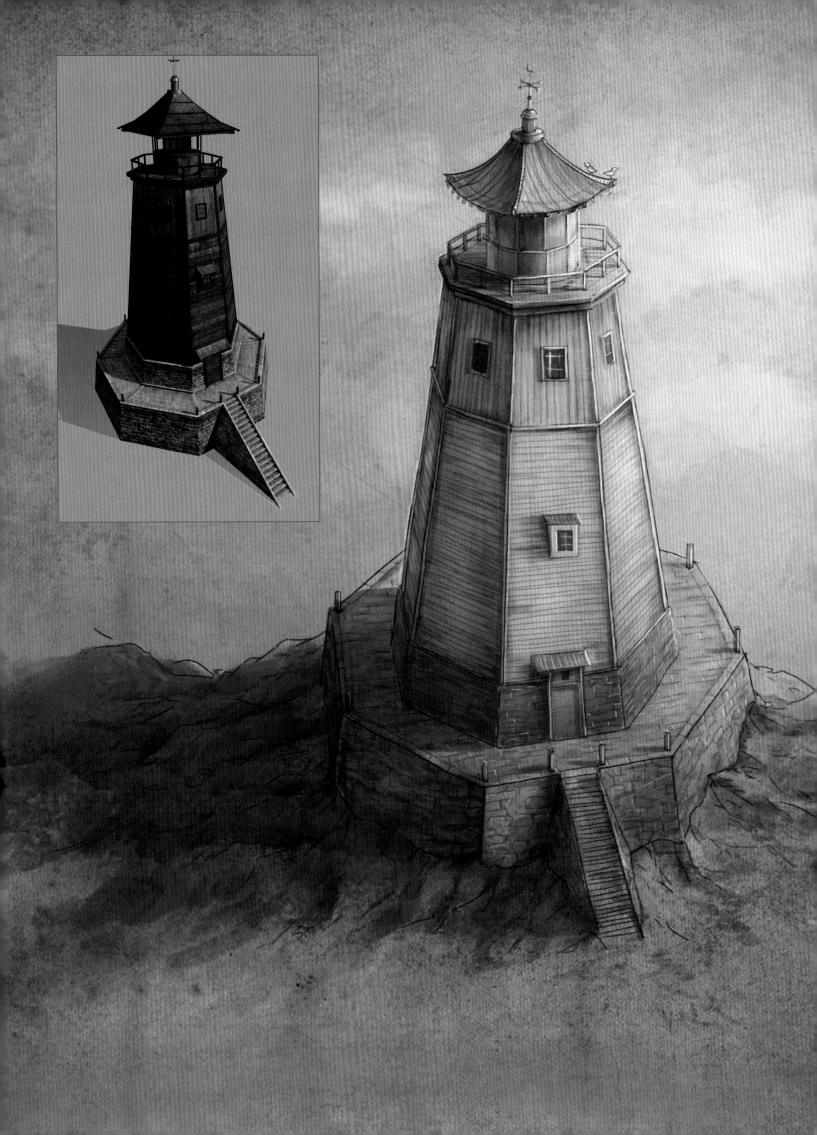

Just as there's an archetype associated with Japanese warriors of the Sengoku period, so too is there an archetype to the architecture of the time. The shiro of the time, fortified castles with elegant, swooping roofs, have become embedded in the public consciousness. "All of the architecture you see is designed by us. We design it ourselves based on the reference, and it's all about coming to grips with the reference, and designing something you think is going to be the most iconic example while avoiding some of those idiosyncrasies."

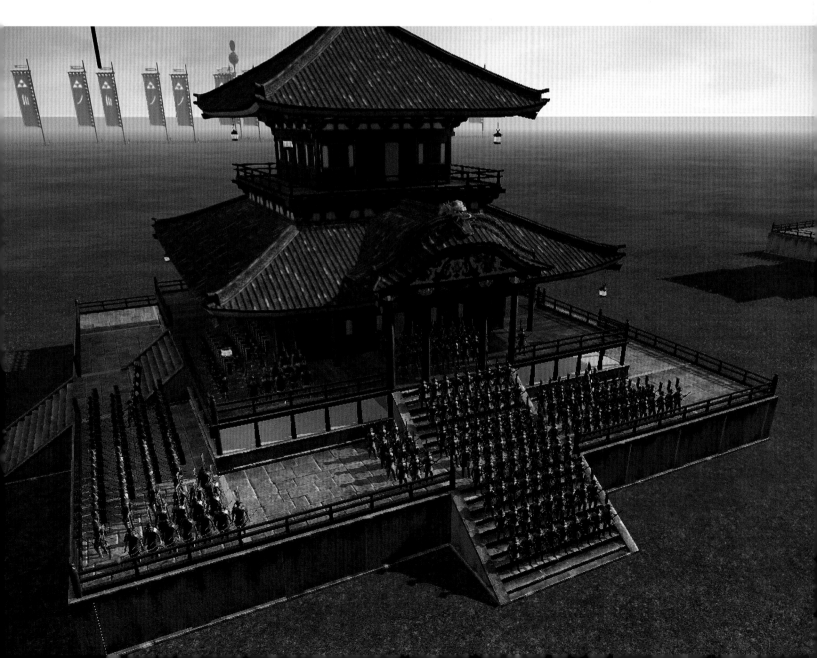

Released as a standalone a year after *Total War: Shogun 2*, *Fall of the Samurai* depicted the slow creep of Western powers into 19th century Japan, and the rapid modernisation that followed. The differing strategies of Japanese and American forces suggests that historical warfare isn't always as balanced as players like their games, but Creative Assembly's James Russell says it works in their favour. "The story of the struggle of civilisations, which is what we make a game about, is fundamentally balanced," he says. "Humans are intelligent. There will be some tactic that someone innovates – like cavalry or the use of horses - any civilization they come across will be defeated by this tactic, and they'll work out a counter – such as phalanxes, or heavily armoured spearmen. There's an arms race of tactical improvements that humans are forced to make in order to survive. It works well, and we don't really see a conflict – it just provides the tech trees that designers have to create."

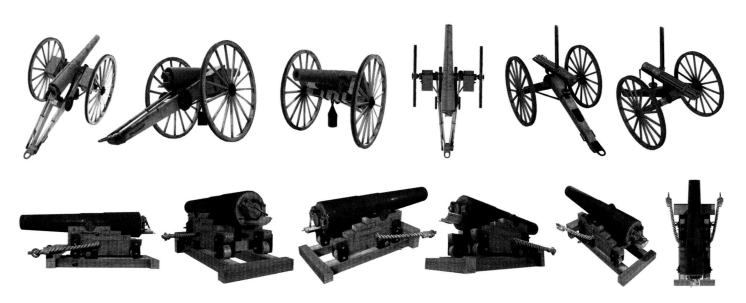

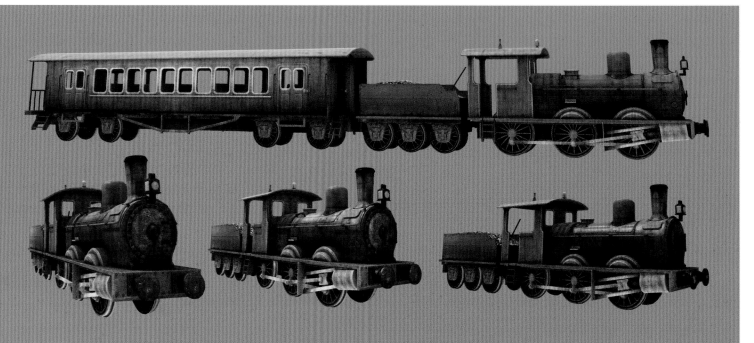

Fall of the Samurai is, at heart, about change. It's rapid, dramatic change too – the once picturesque fields that featured in *Shogun 2* coursed by steam-spewing trains, its battlefields where graceful fights between feuding Japanese troops torn apart by the vulgarity of Gatling gun fire. Beyond the scheming and the war, there's a look at the inrush of ideas as Japan found itself modernised at an alarming rate.

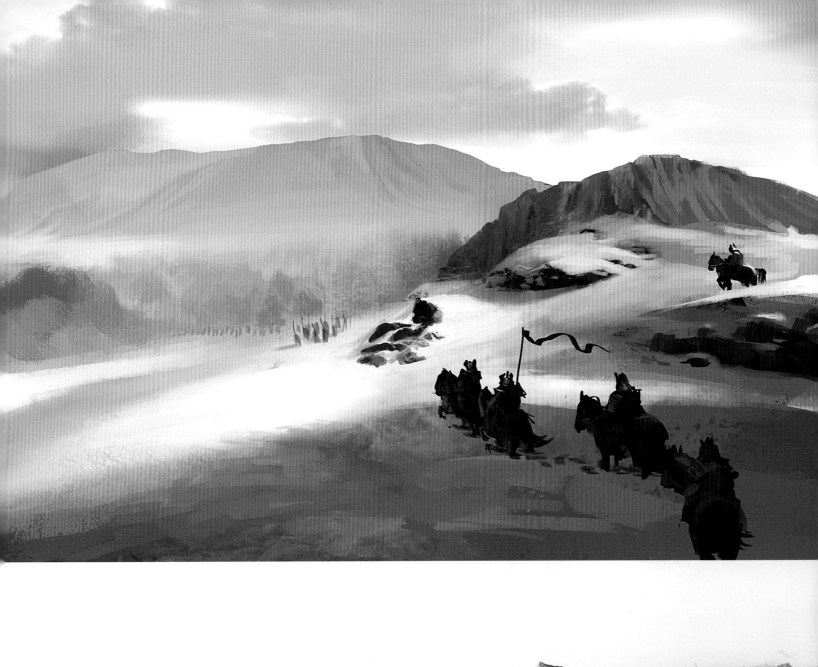
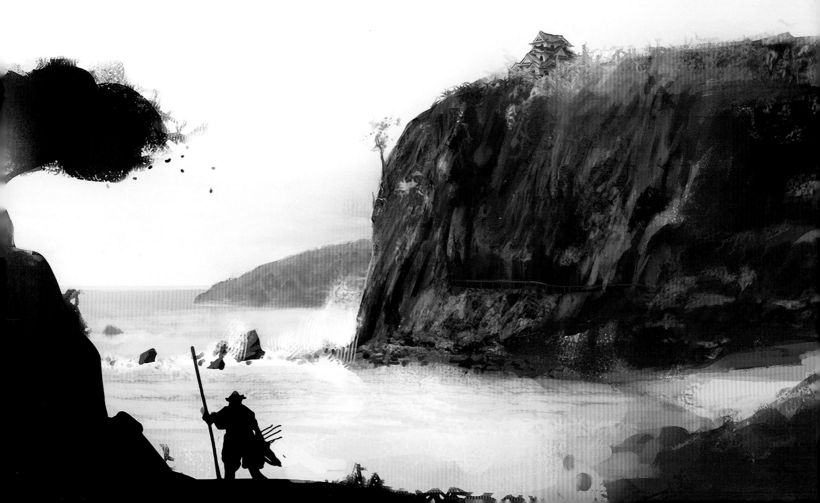

The naval battles that debuted in 2009's *Empire: Total War* returned for *Shogun 2*, flourished by the extravagance of Japanese fleets of the 16th century. Large Atakebune are joined by smaller Kobaya, the different ships unified by their elegance in design. The artists consulted original naval designs as the ships were created, resulting in authentic and majestic in-game models.

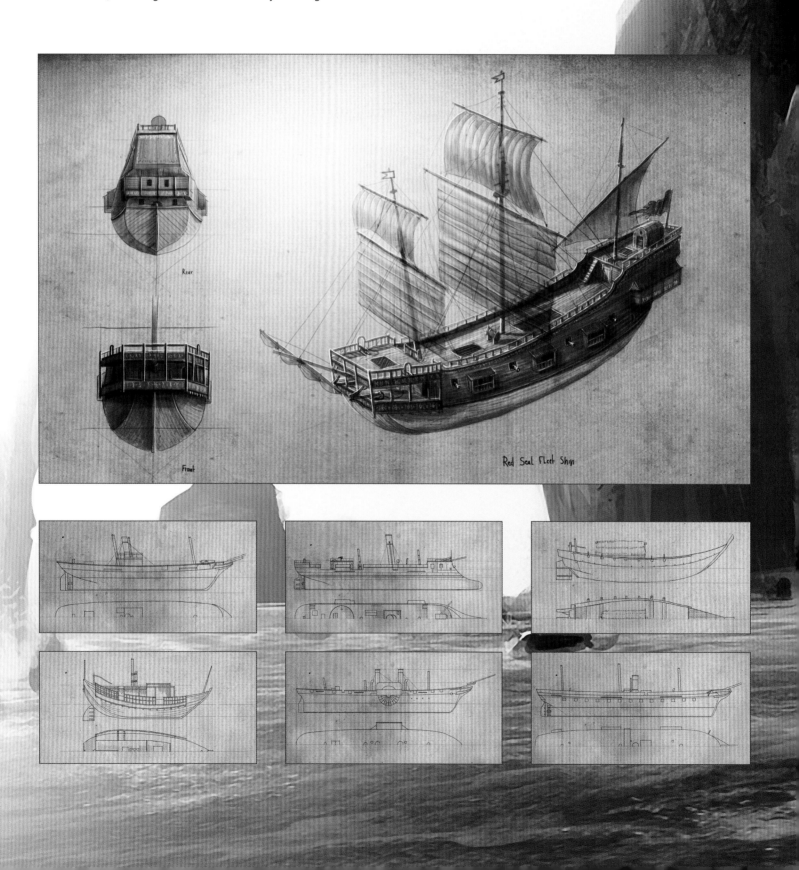

Red Seal Fleet Ship

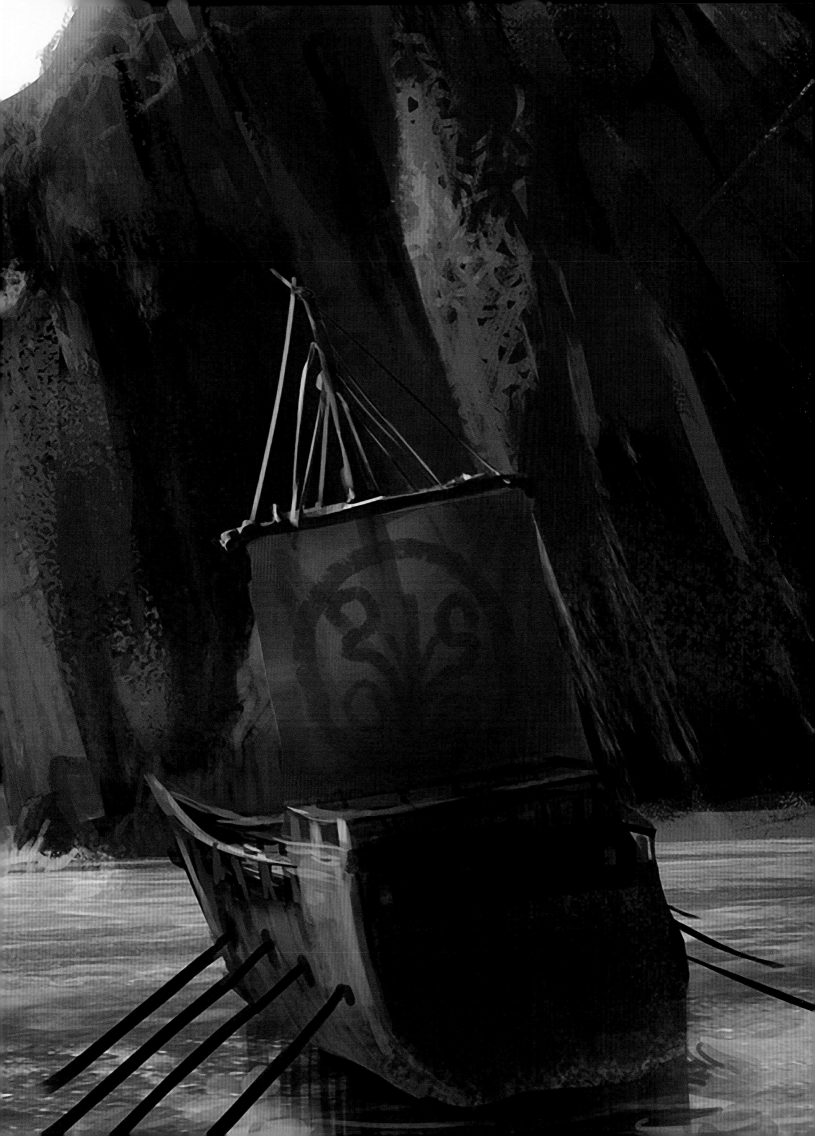

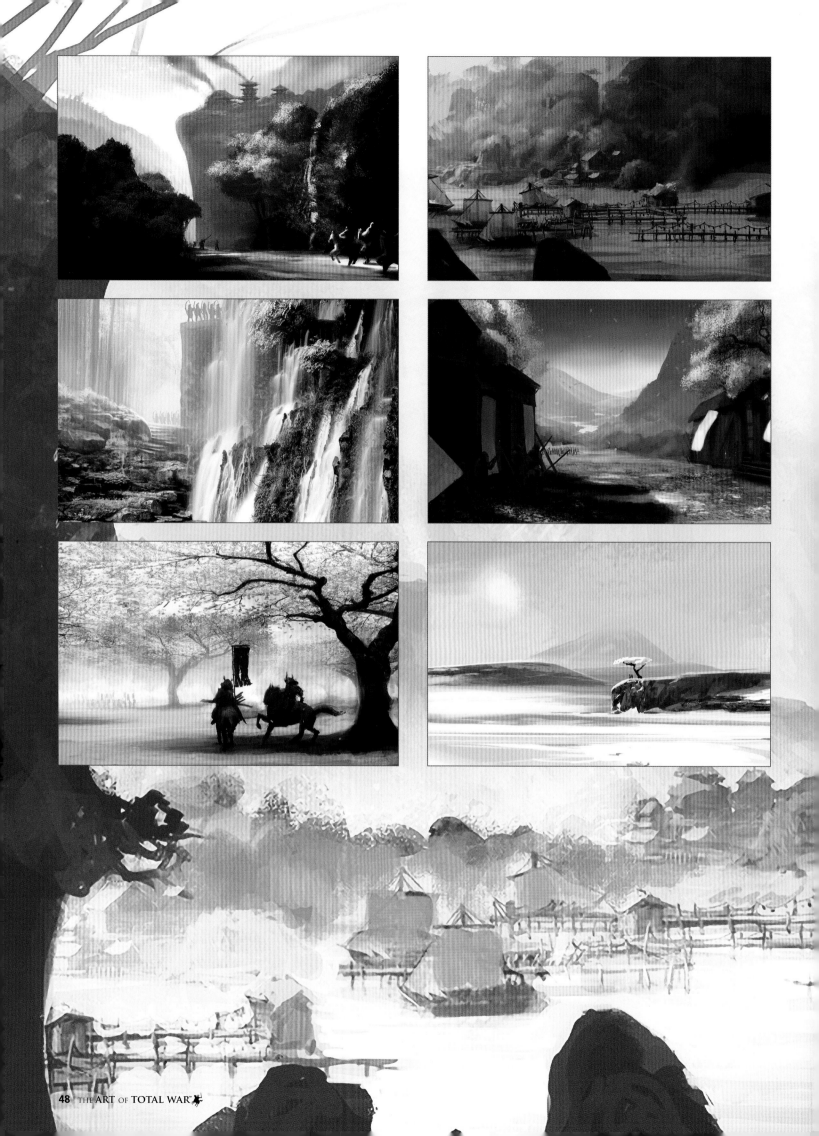

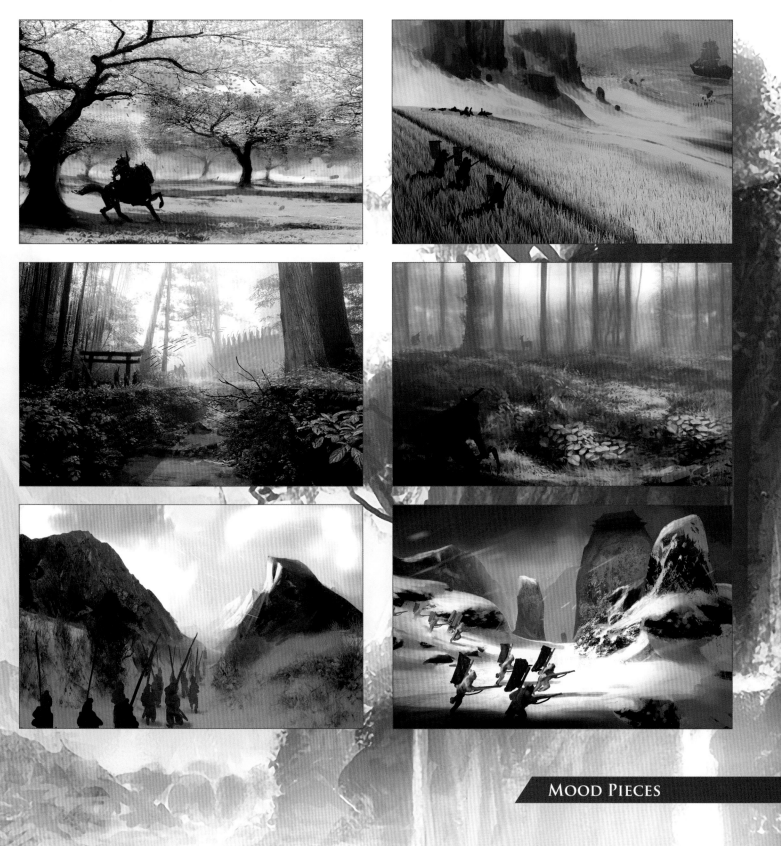

MOOD PIECES

Before a game like *Shogun 2* goes fully into production, artists create concepts and mood art that, while not necessarily depicting elements of the final game, define the spirit and tone of what's to come. *Shogun 2*'s own mood pieces draw upon more mystical, mythical visions of Sengoku period Japan, where cherry blossoms shield brave samurai warriors that look out upon verdant green fields. "This isn't specifically stuff we want to show in the game," explains Joss Adley. "It's about defining a look and feel, and getting people in the spirit of things, and just to get some ideas planted as to what direction we could go in. You'll see that some of these have things you might see in similar scenes in the game, and some won't – it's more to drive the project forward."

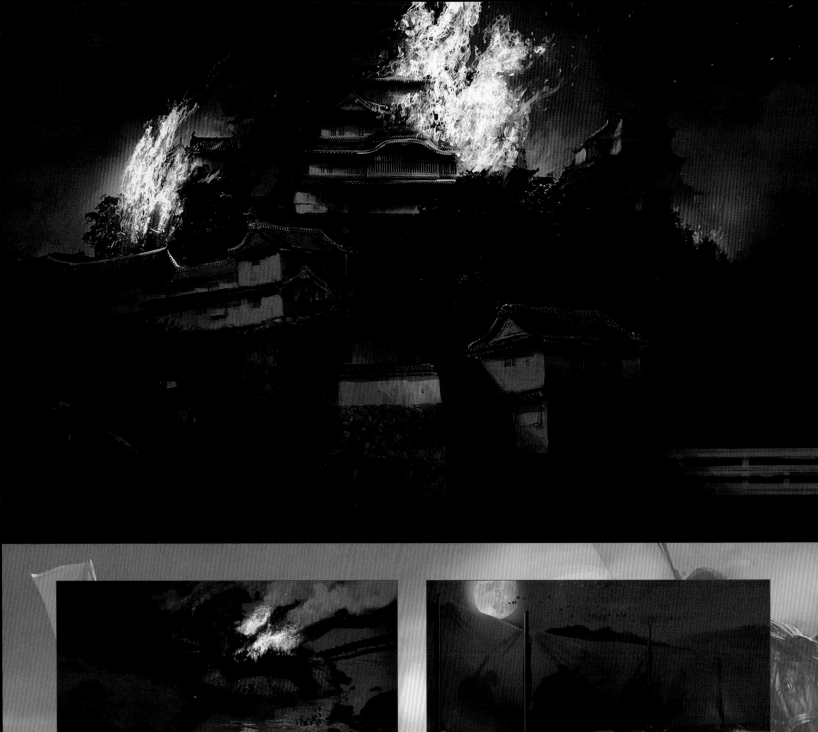
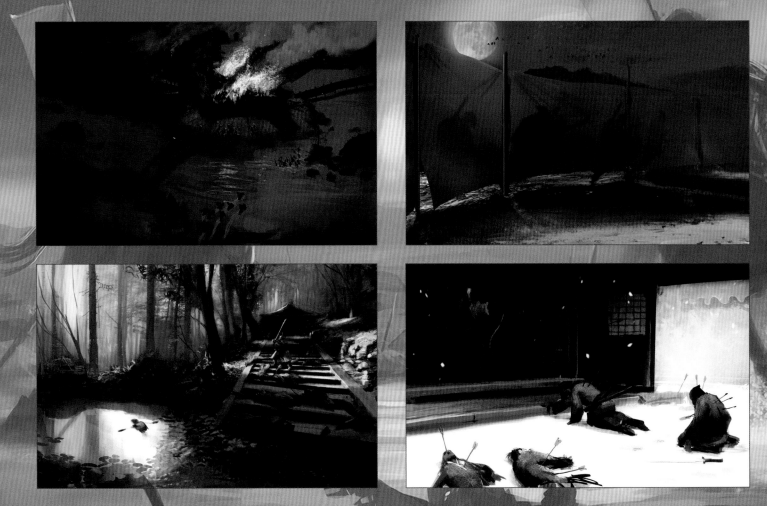

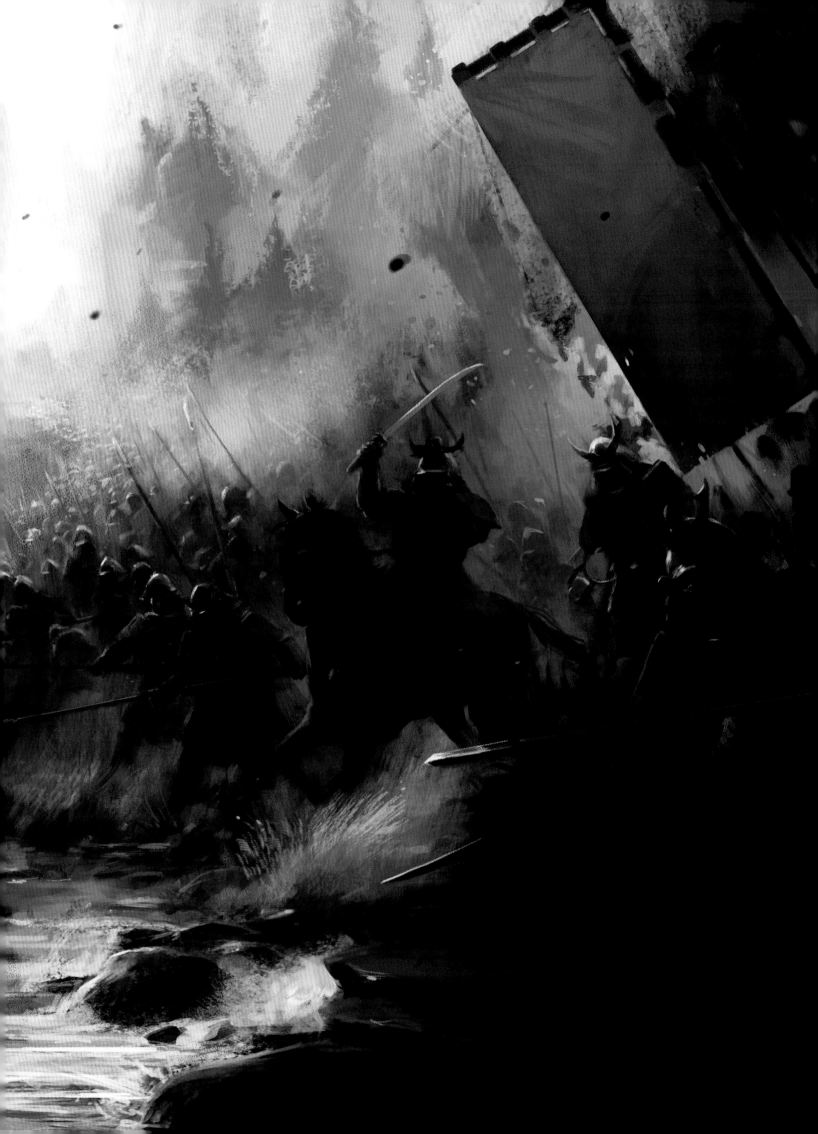

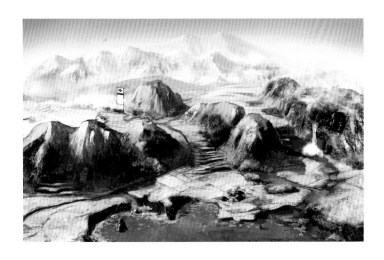

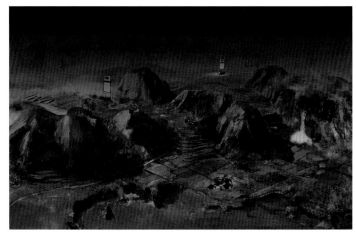

CAMPAIGN

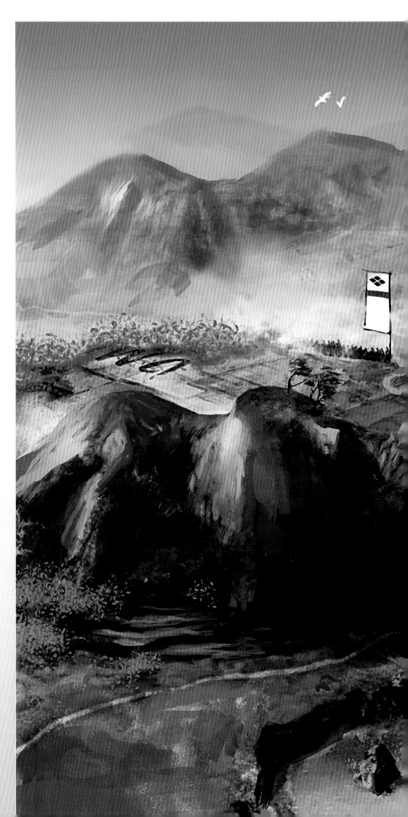

Total War's battlefields are where the spectacle is to be found, and where hundreds of units clash in skirmishes full of exquisite detail, but it's the campaign map where the scope lies. *Shogun 2*'s overview is imagined and designed with elegance. "From the start we wanted this miniature bonsai feel, where you're looking down at a living, breathing thing where the scale is smaller, but everything's still there," explains Joss Adley. "Another neat aspect that got added to the campaign later on was having the shrouded areas just as flat parchments – this living, breathing world was created out of a flat parchment map."

It's an area Creative Assembly sees potential for in the future. "With the campaign map, a big thing for us is to create something that is perhaps more alive than ever before," says James Russell. "We want it to be a thing of beauty that is living and breathing and animated. We keep pushing that, and we want to push it further."

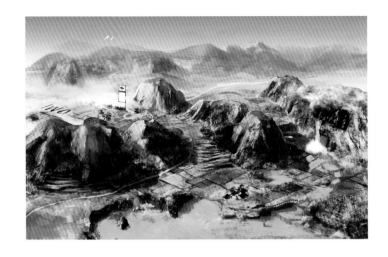
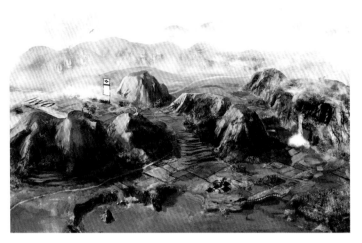
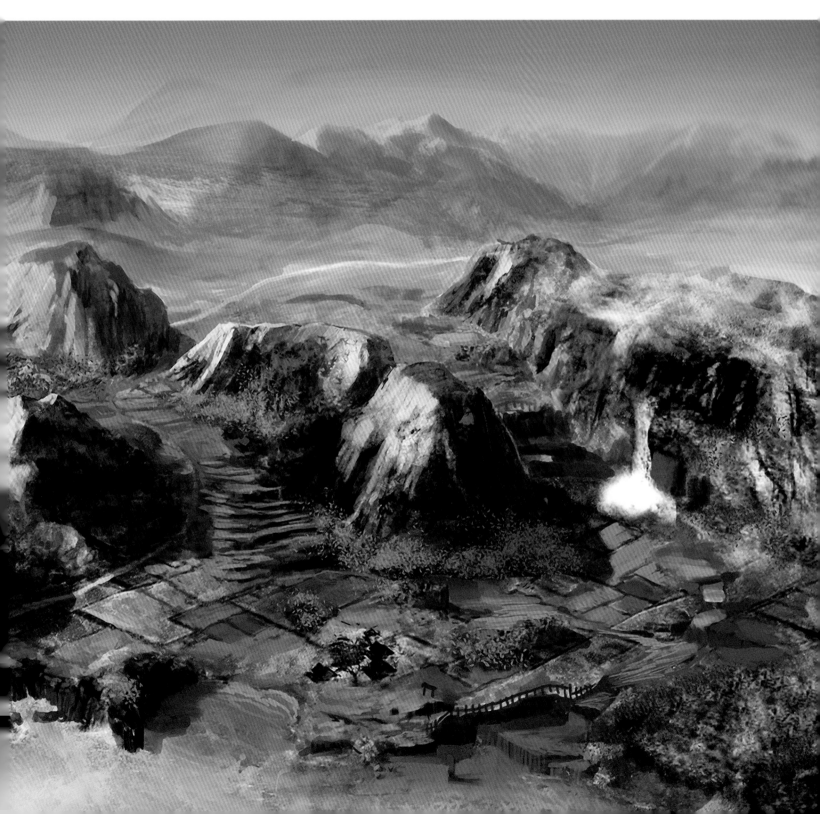

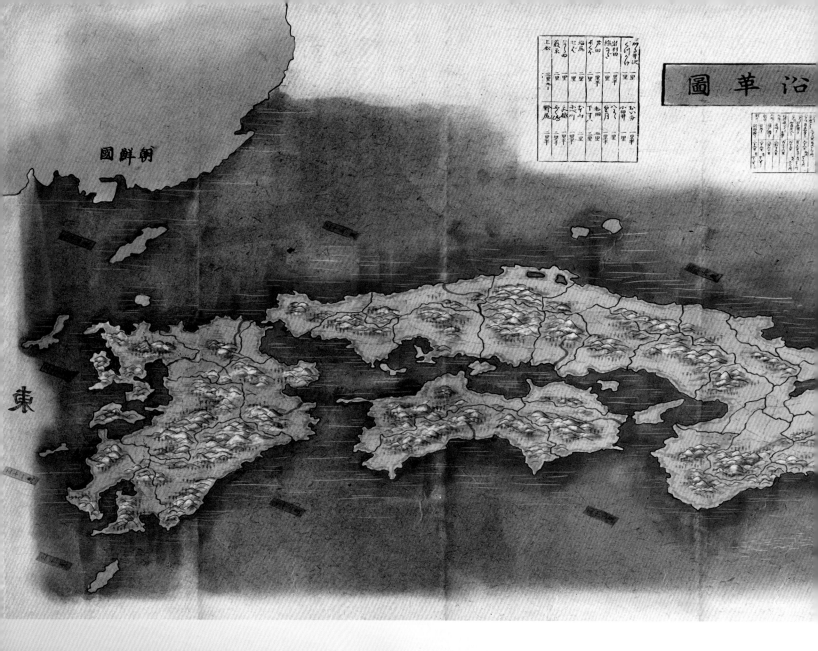

圖草沿

國鮮朝

東

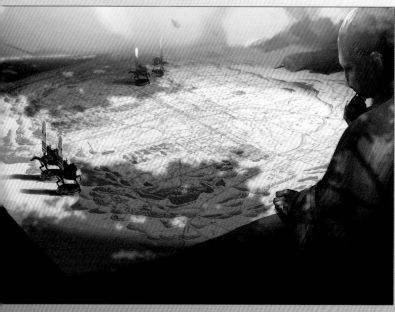

The invisible lines maps mark out across territories are so often points of contention, the imagined borders the starting points of so many conflicts. Elements of parchment maps find their way into *Shogun 2* via the campaign map and elsewhere throughout the game. "We look at period maps, and we look at details from them," says Kevin McDowell. "The most interesting map is perhaps the *Fall of the Samurai* map – because that map, I actually went and bought."

The map in question dated from 1848, an original that proved invaluable to the team as they went about their research. "We used that as the basis," says McDowell. "We scanned it, and conformed it to the shape of our map – there are always projections and other things that don't quite fit." While some of the errors of the old map were ironed out, and some of *Shogun 2*'s own inventions included, the end result was as close to an authentic 1850s example as you'd hope for.

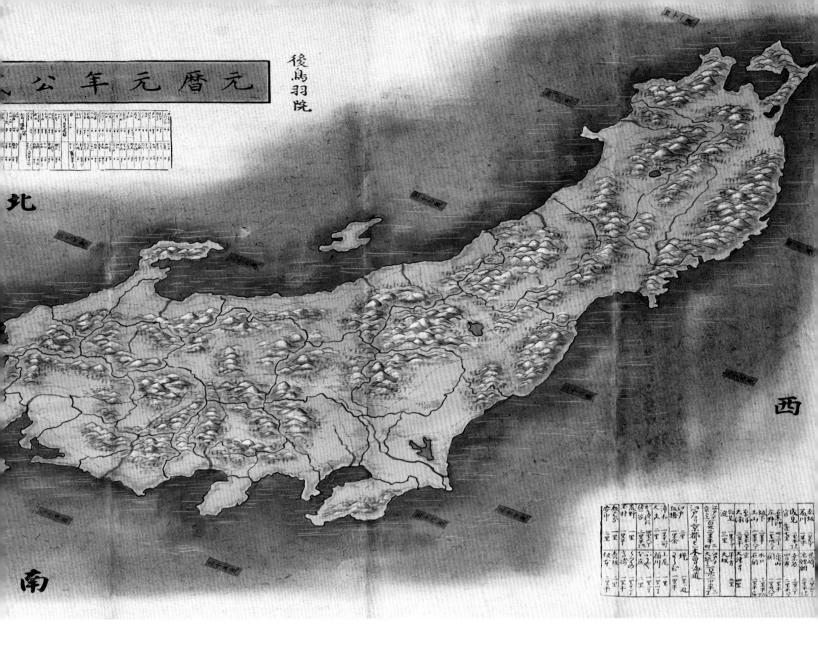

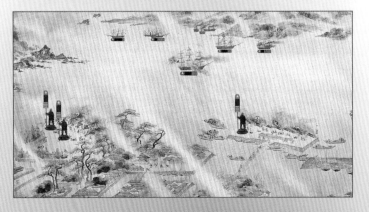

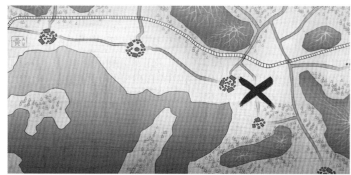
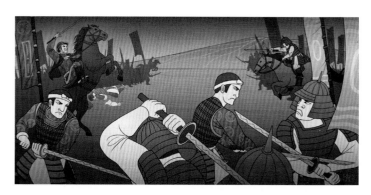

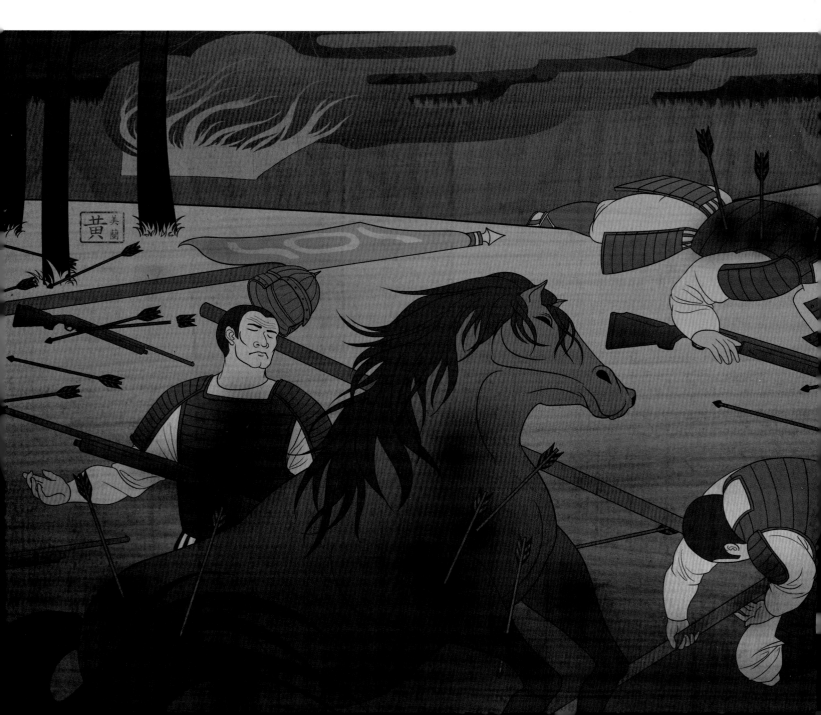

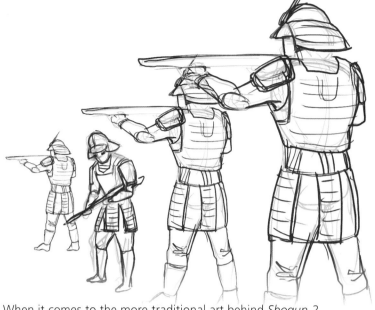

When it comes to the more traditional art behind *Shogun 2*, there were two reference points Kevin McDowell pointed all his artists towards. For the backgrounds the work of Katsutshika Hokusai, an artist most famous for his iconic 1832 painting *The Great Wave off Kanagawa*, was cited, while for the characters, Edo artist Utagawa Kuniyoshi was an inspiration.

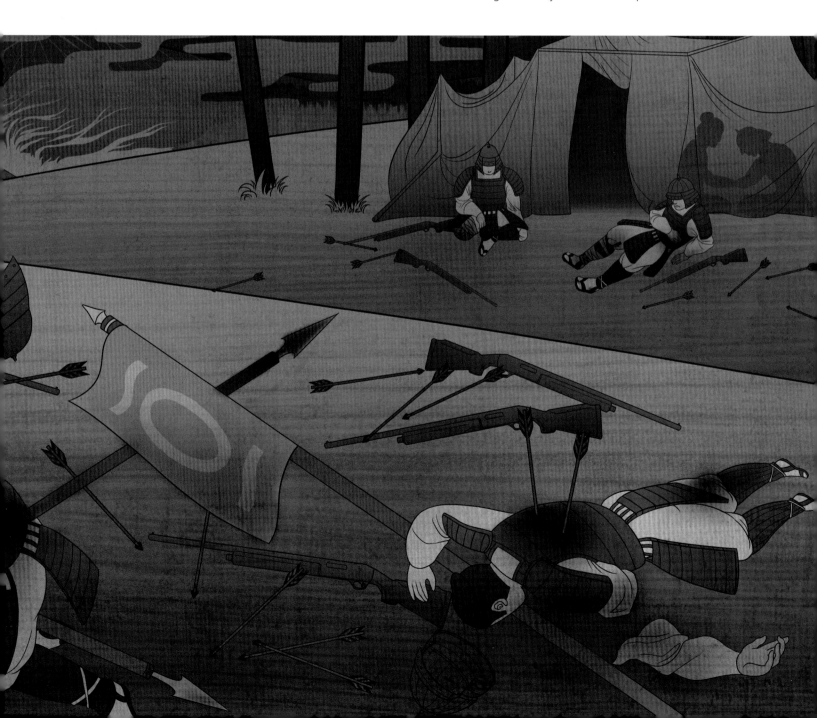

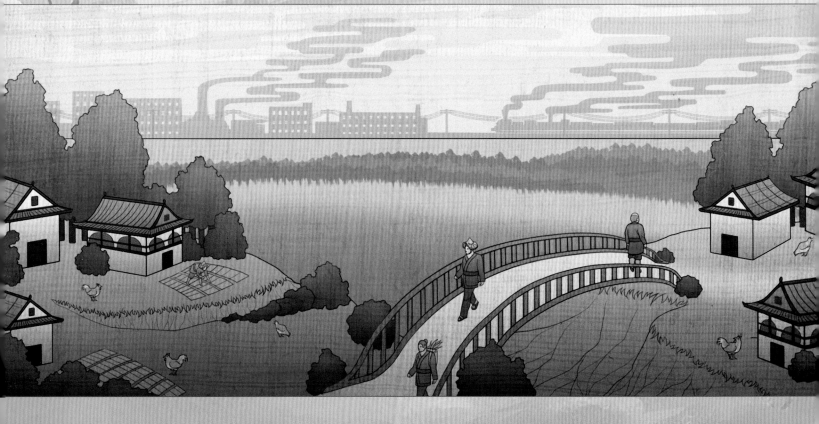

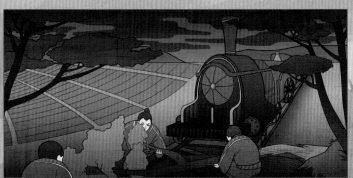

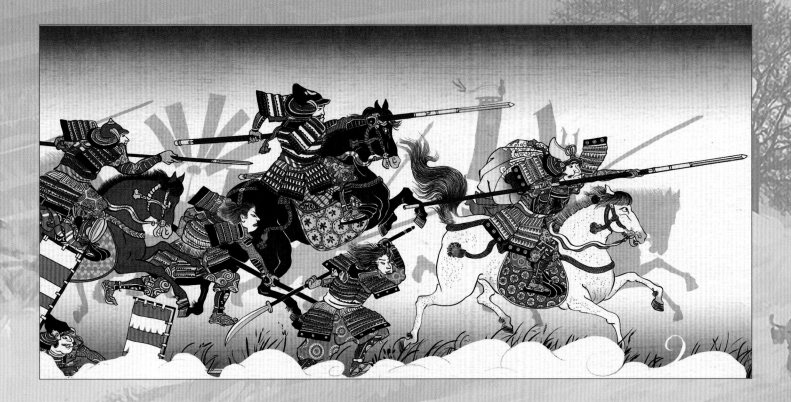

ILLUMINATING ART

The evocative art used to illustrate *Total War: Shogun 2*'s loading screens, to furnish its menus and to breathe life into campaign events belongs on a gallery wall, but sadly they never end up there. Many of the artists produce their work digitally, though sometimes they find themselves put to good use outside of the games. "We made some lamps out of some," says Kevin McDowell with a dry smile. "They are lovely lamps - I could see them selling quite well."

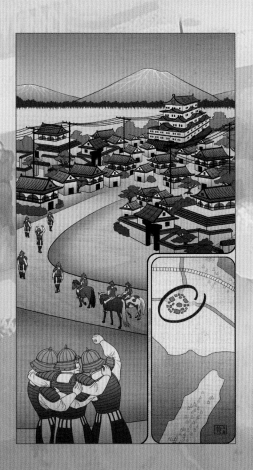

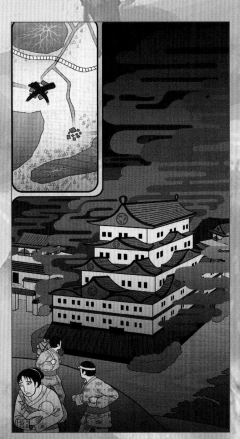

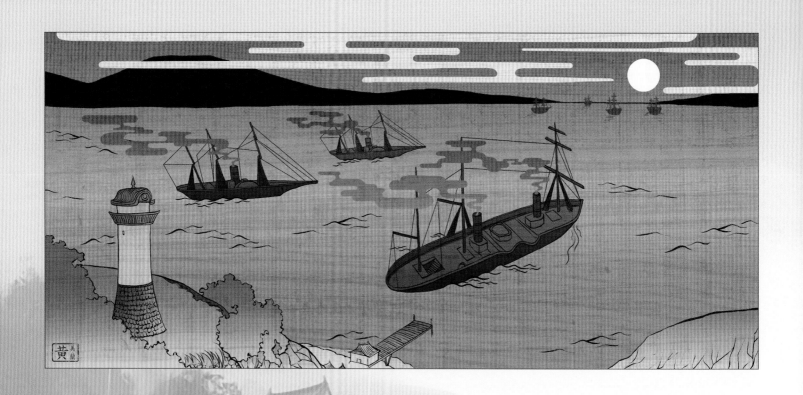

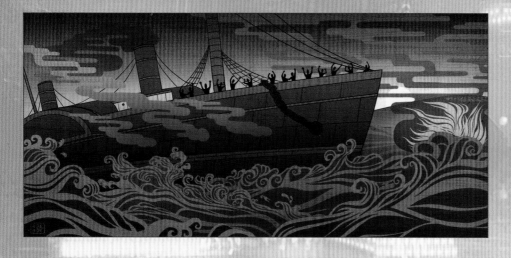

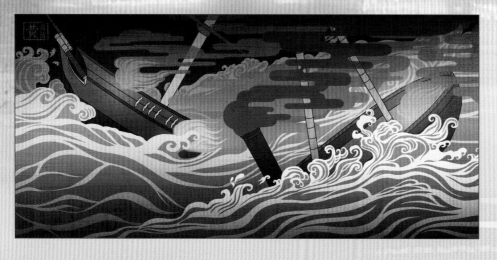

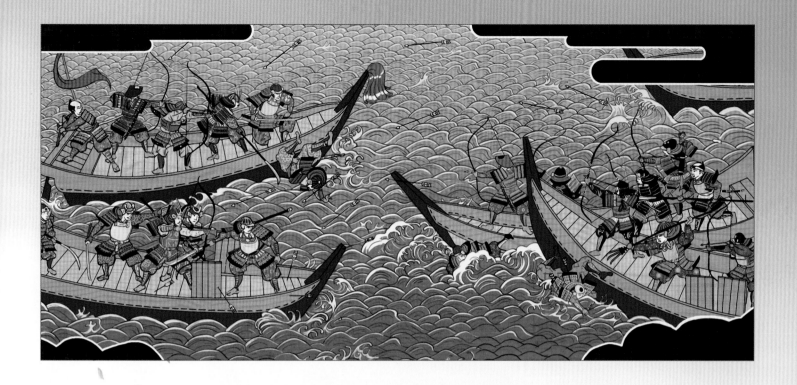

"There was a period of the Sino-Russian war between Japan and Russia, and the Japanese produced quite a few naval woodblock prints during that period," says Kevin McDowell. "We looked at a lot of that stuff, and it's really dramatic. Really dramatic."

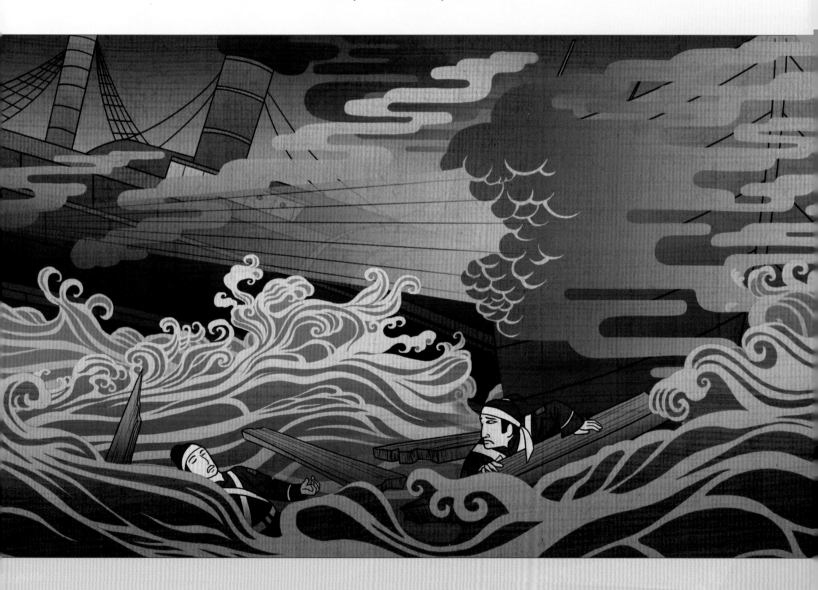

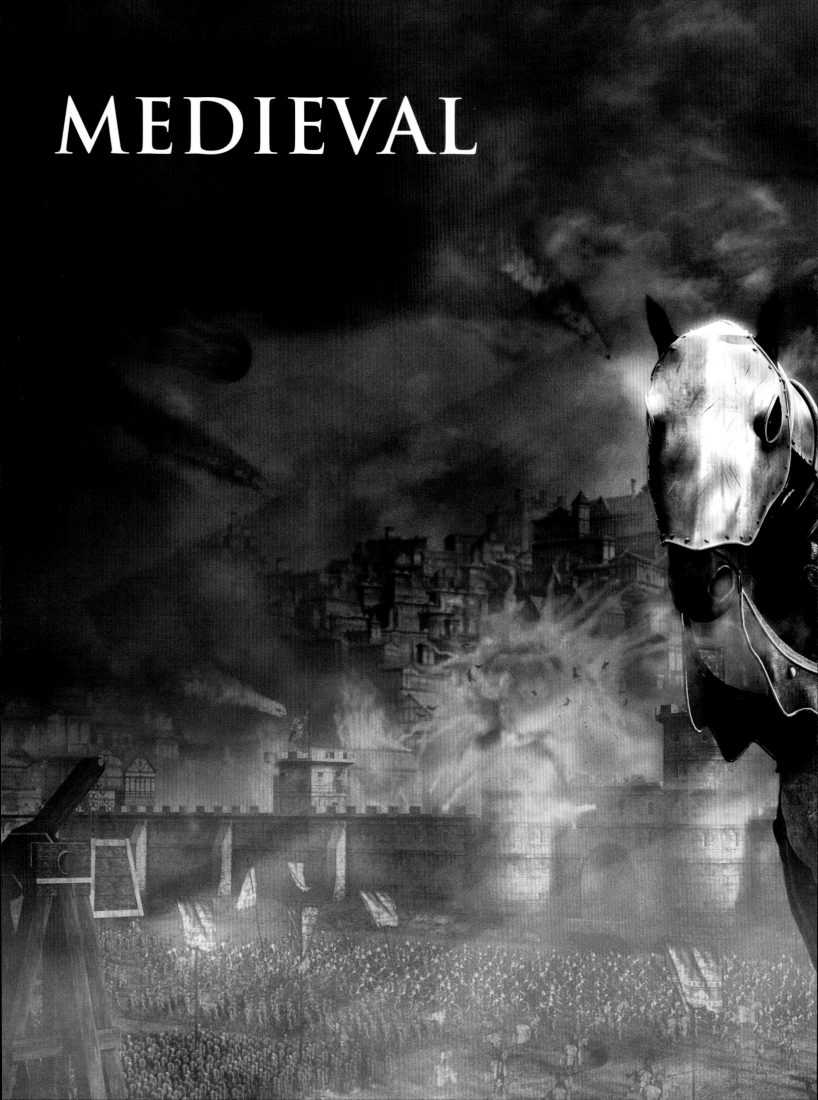

MEDIEVAL

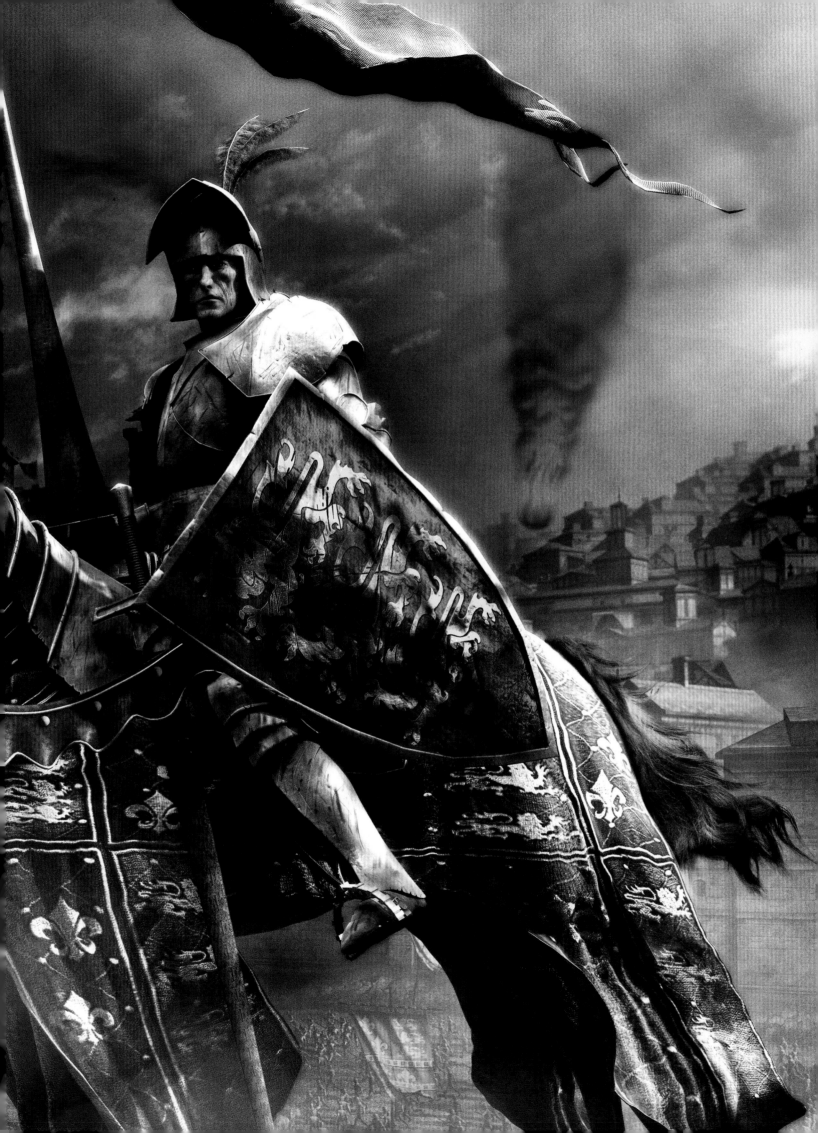

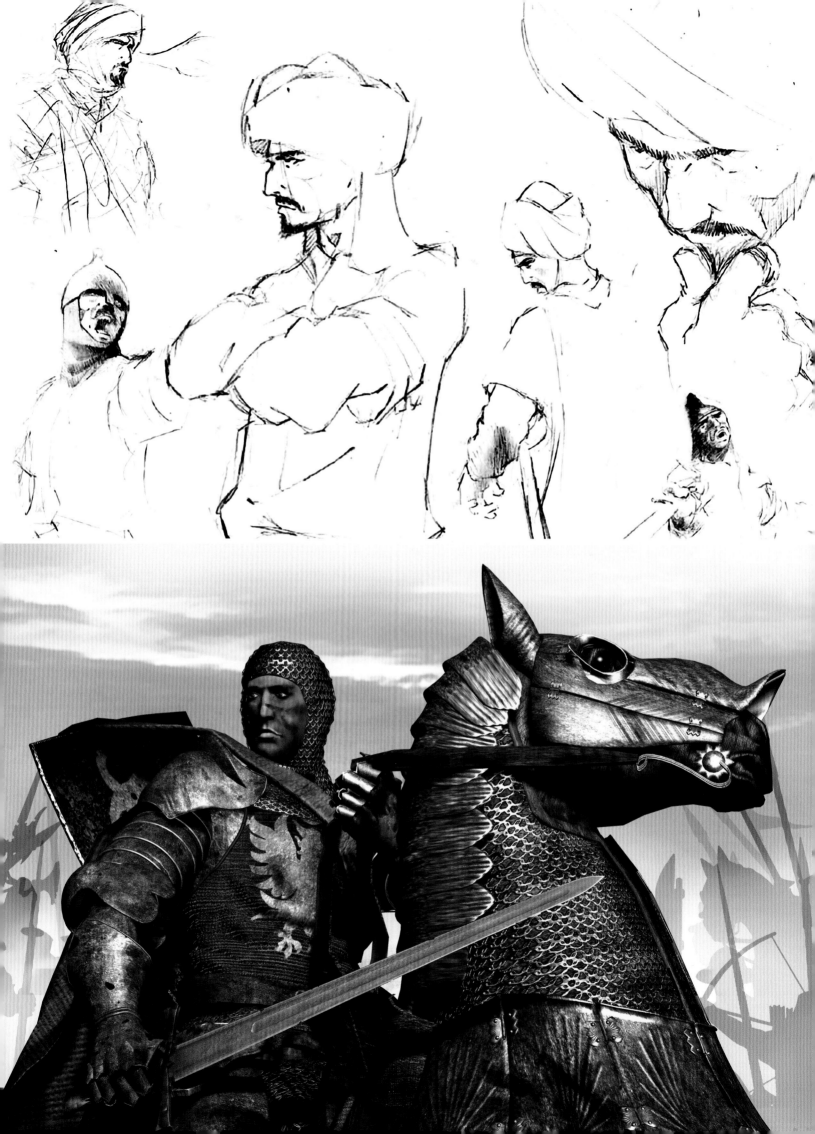

MEDIEVAL

INTO THE DARK AGES

Announced as *Crusader: Total War* in August 2001, The Creative Assembly's second strategy game shifted the focus to the west as it plundered the Middle Ages. The name was switched to *Medieval: Total War* before the final release in August 2002, and players were treated to more densely populated battles, more epic in their scope. The muddy fields that hosted the battles of the Hundred Years War and the Crusades featured domineering castles and grueling sieges, adding more wrinkles into The Creative Assembly's fast evolving formula.

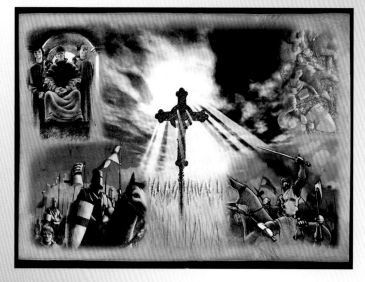

MEDIEVAL II

CHARACTERS

Medieval was The Creative Assembly's second installment in the *Total War* series, followed up some four years later by *Medieval 2: Total War*. Unlike many of the mainline games, however, development took place away from the main studio in the satellite company The Creative Assembly Australia, an outfit based in Queensland that has since closed its doors. Regardless, the period setting allowed for a deeper influence of religion within the game's systems, with Catholicism, Islam and Orthodox Christianity all taking hold across the campaign map. It also allowed for some notable cameos, such as Egyptian Sultan Saladin and Richard the Lionheart.

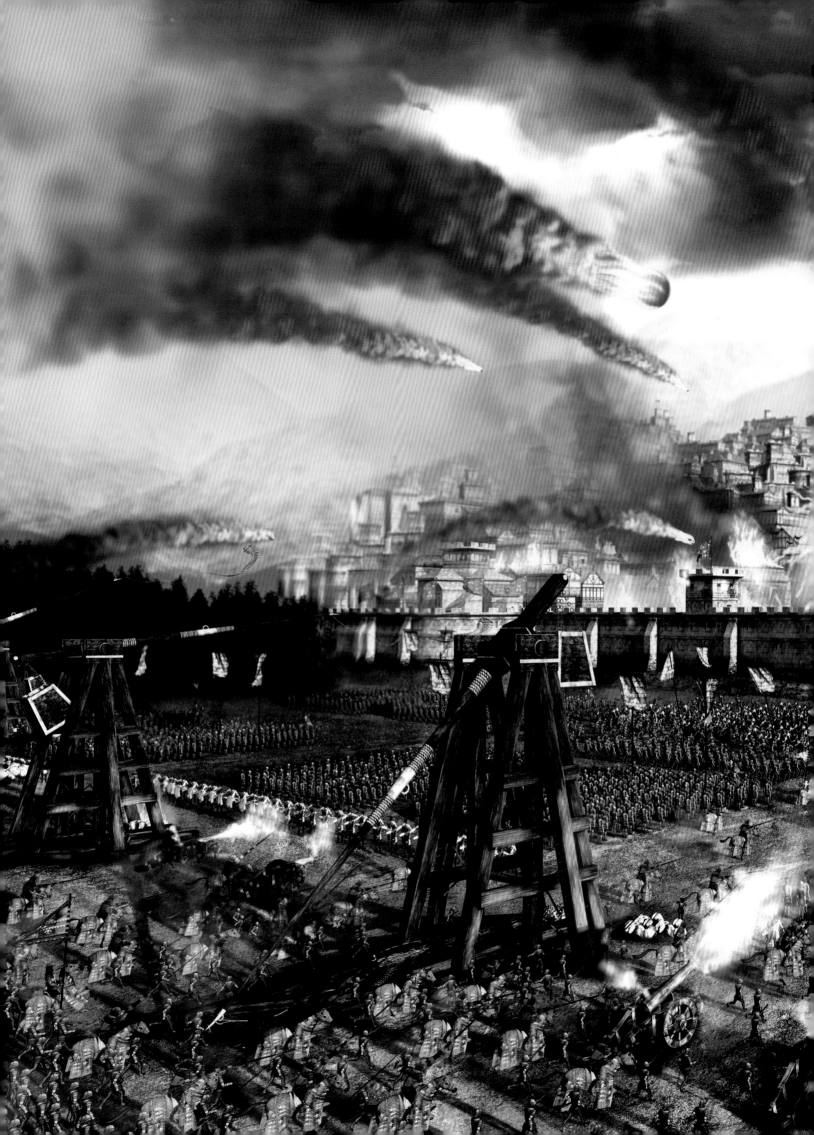

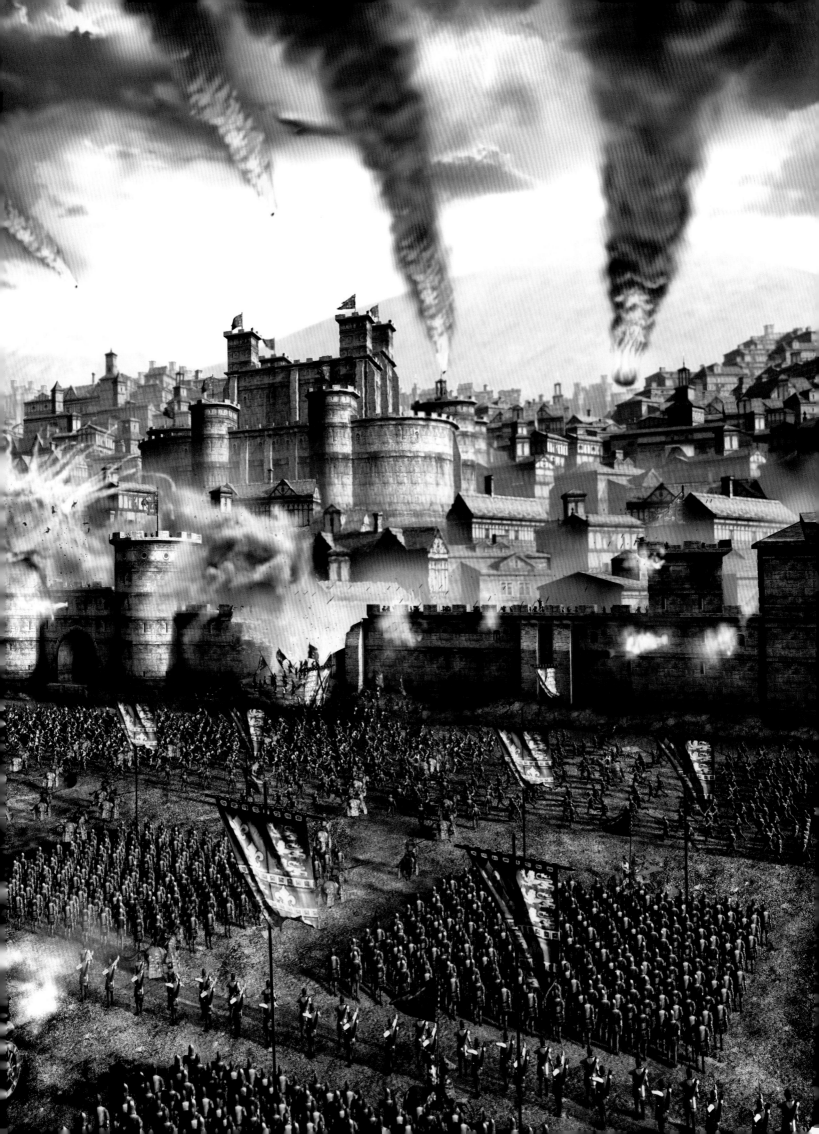

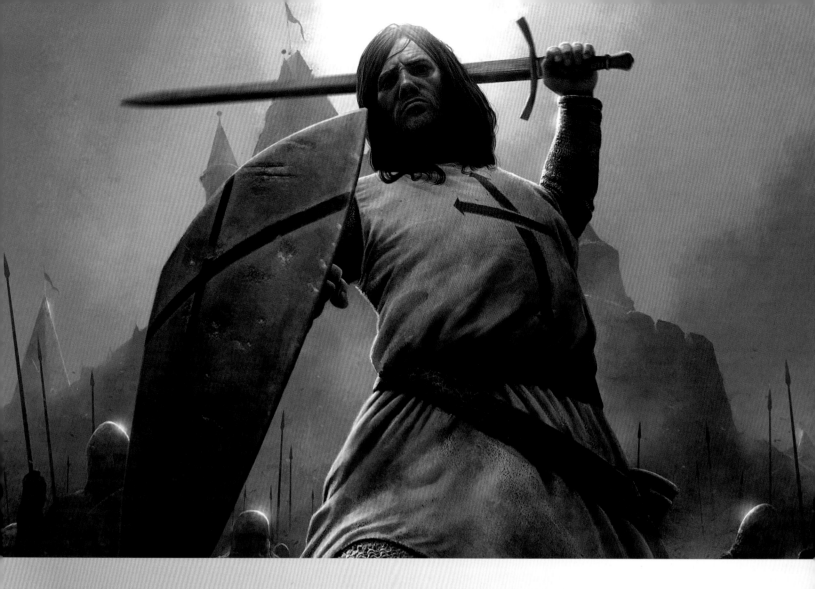

For *Medieval 2: Total War*'s expansion, the discovery of the Americas was folded into the game. It allowed for new factions to enter the fray, and for a new round of iconic art to draw from: Mayans, Aztecs and Apachean Tribes spanned the New World that was being conquered, and disputed, by kingdoms already established. The colonisation of Central America is covered in the campaign, as are the crusades and the campaign of the Teutonic Order.

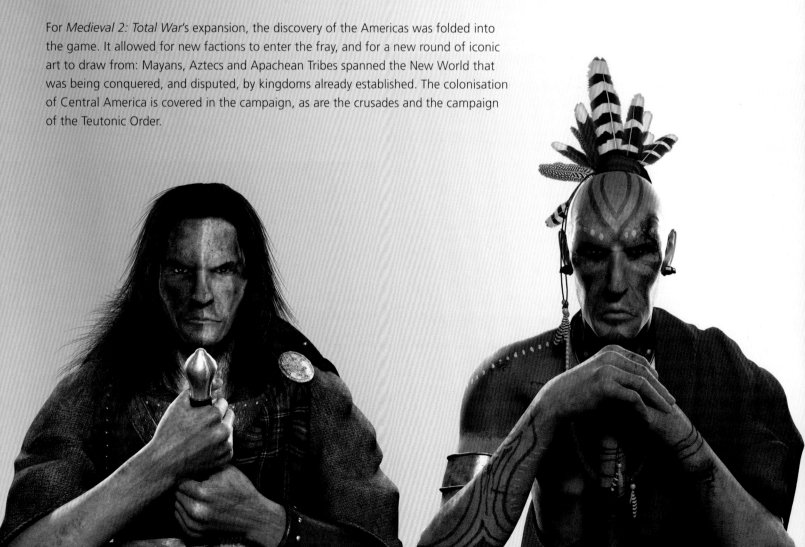

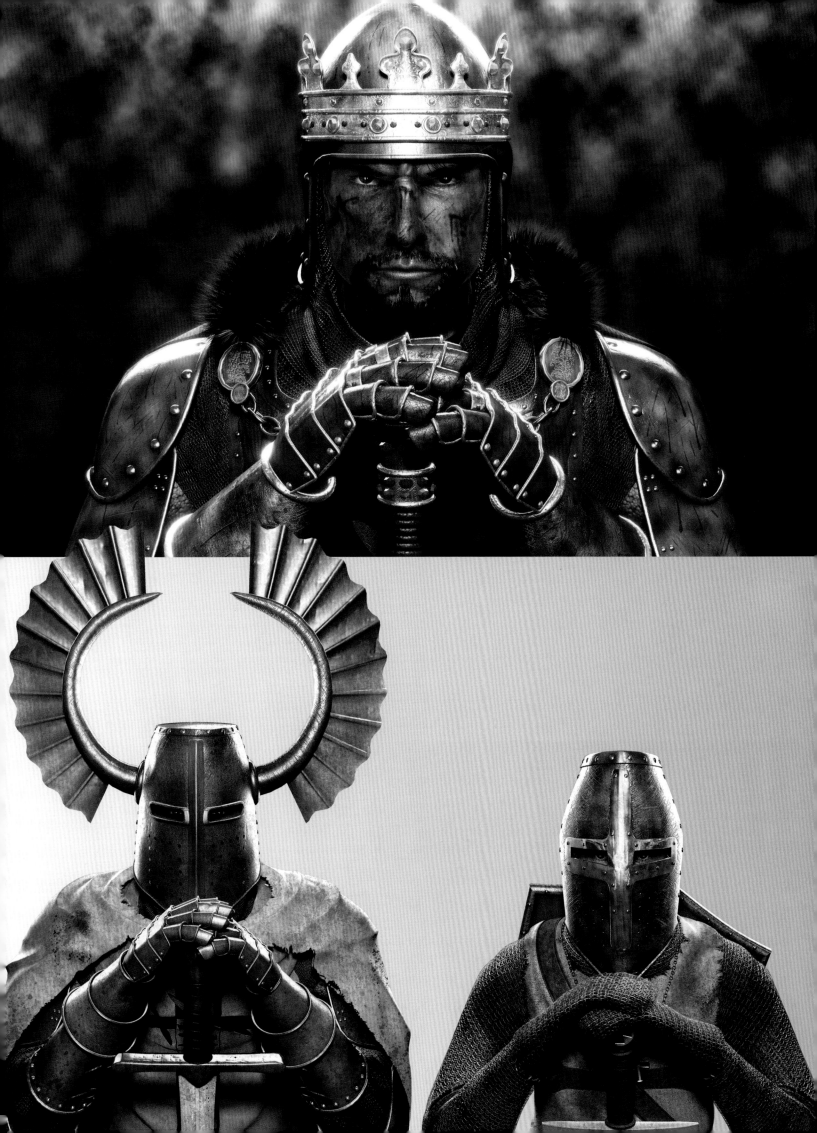

CRUSADER

A crusader's look is iconic, and in *Total War* it must also represent its abilities on the battlefield. "If there's a particular type of unit who's armoured in a particular way, we want to create that impression," says James Russell. "The unit designer works closely with the artists to make sure the right components get created, then they'll work together to assemble the parts and create the style they want. Each unit has a load of visual parameters, so it's not just about the visual style – it's about how fast it moves, the unit stats and all the animation types it does. We do research and have big arguments about whether spearmen should be overhand or underhand." Historical verity always wins out, though. "The look of the unit is mostly inspired by how a unit really looked. We don't necessarily make a powerful unit 10 feet tall."

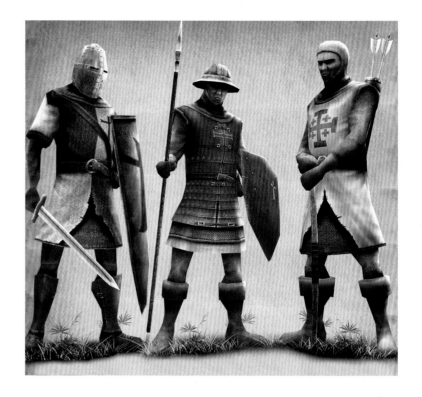

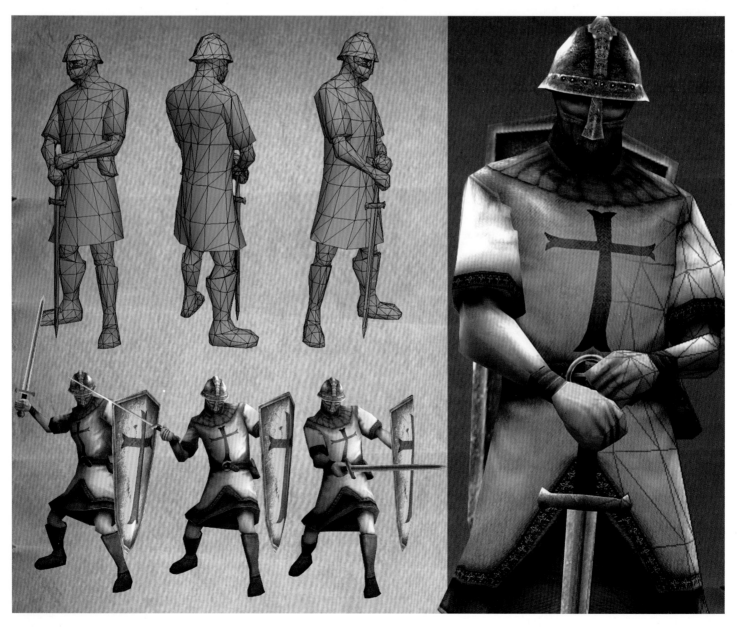

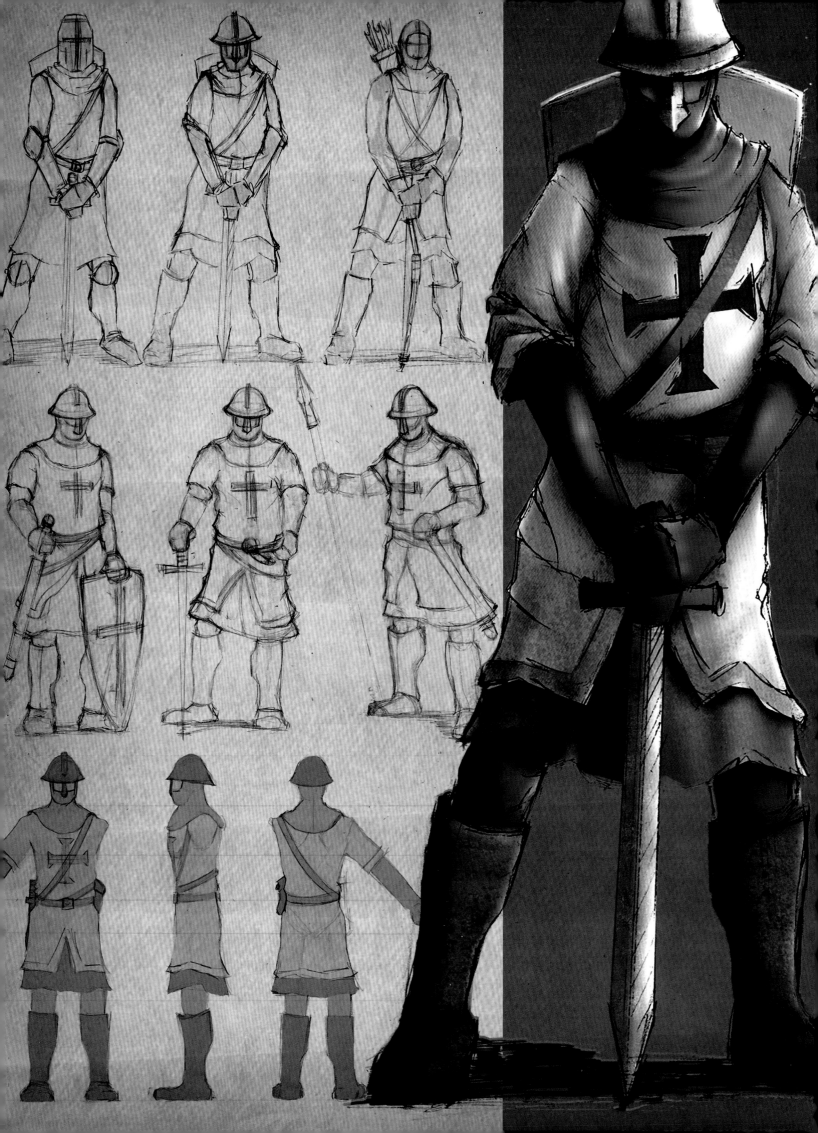

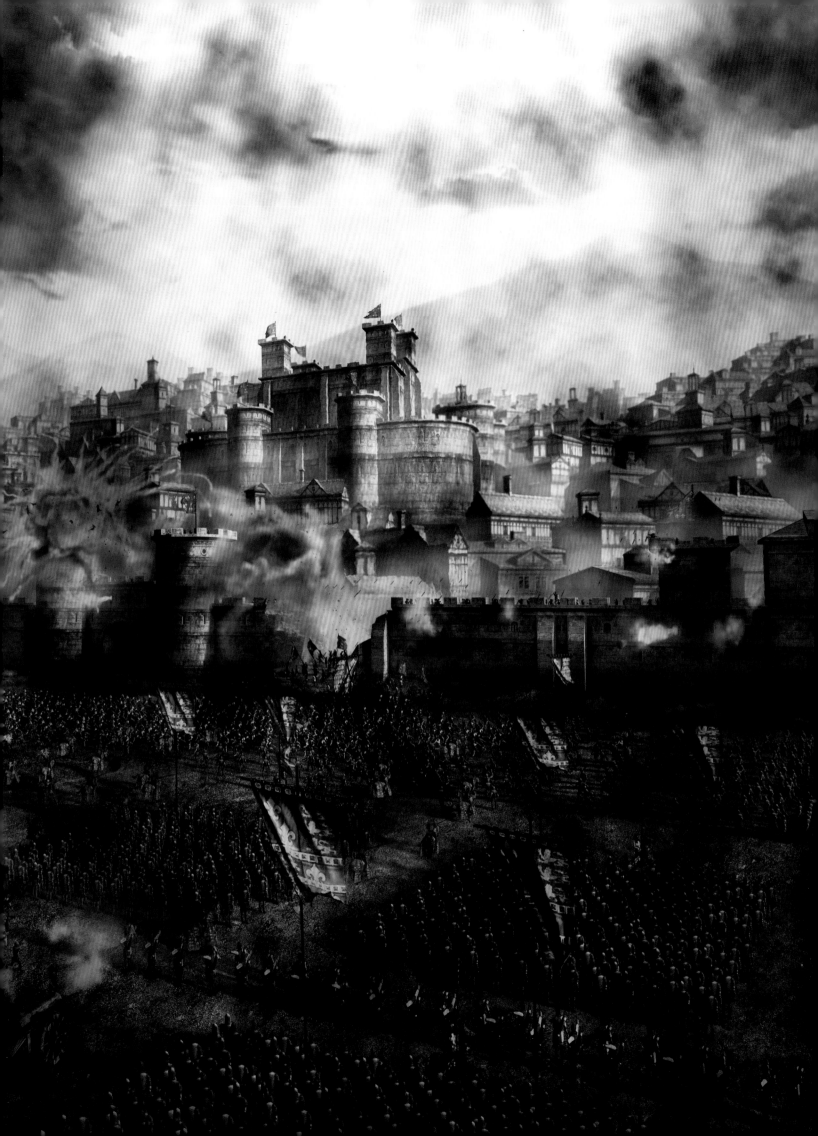

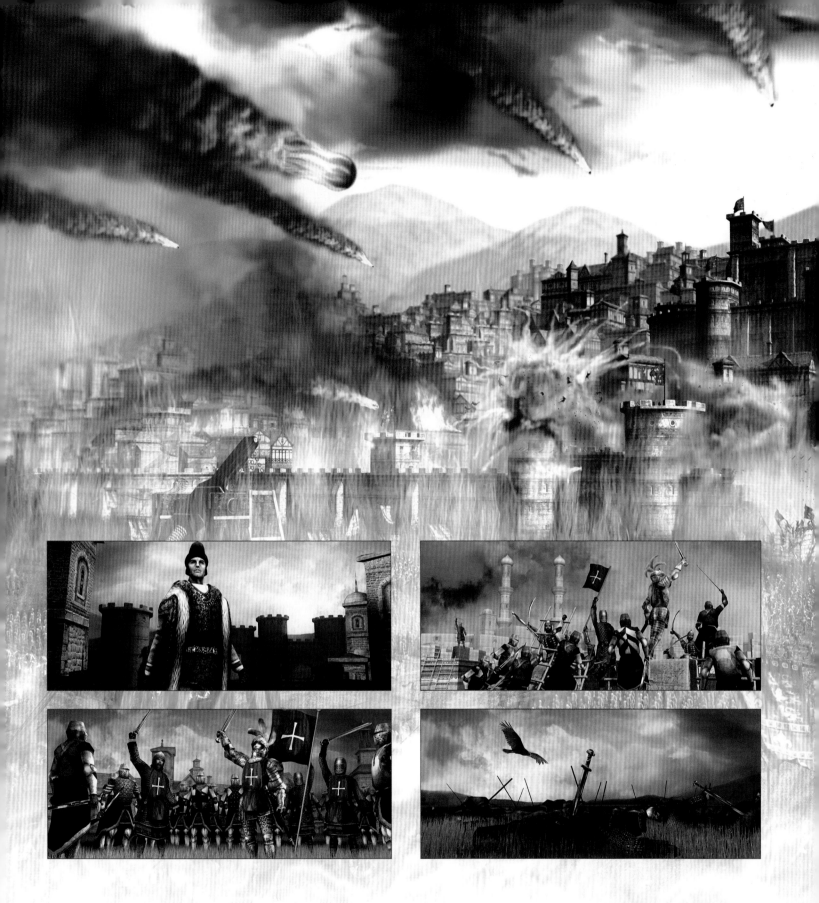

Artillery bombards a heavy fortification – and beneath the smoke and drama is a strong, clearly defined visual language that endeavours not to break the illusion. "Many real time strategy games will have a unit and he'll have health," says James Russell. "As he takes damage, the health will reduce. Historically, we've said there's no health – there's 100 guys, and you can see they're taking damage because half of them are dead. We're creating a vision of real battles, and trying to use real-world indications of how they're going."

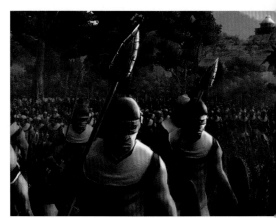

HOLY WAR

The new emphasis on religion allowed a new path to explore for more peaceful, less bloodthirsty players, though the opposing camp was more than catered for with the battles provided by *Medieval 2: Total War*. In keeping with the age, its concept art was moody and foreboding – the sun struggles to break through heavy cloud cover, the dark ages churning through battle beneath with a more enlightened time many years away.

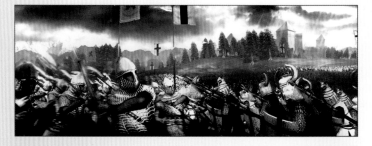

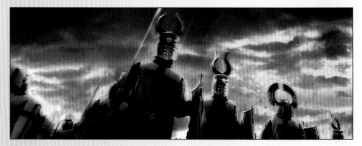

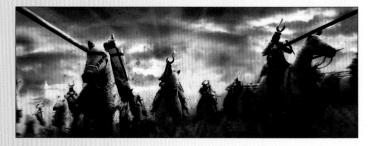

The clanging clashes of *Medieval 2: Total War* are the series at its most brutal – there's an art to the war being carried out here, but it's often obscured by the chaos and fury.

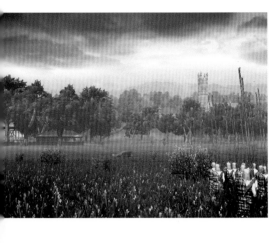
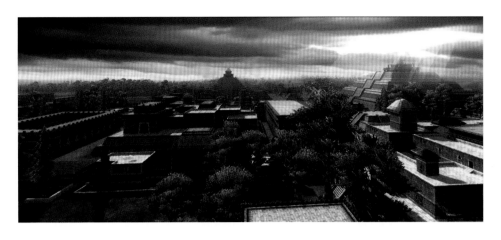

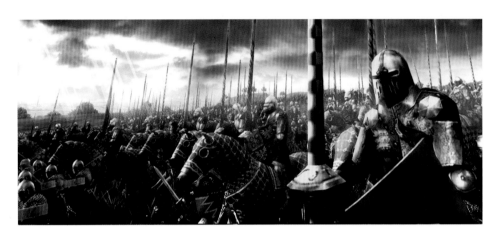
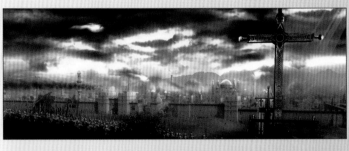
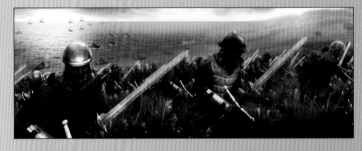
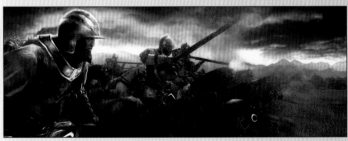
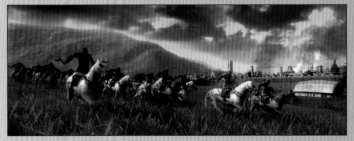
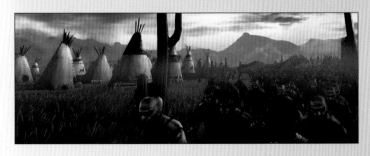
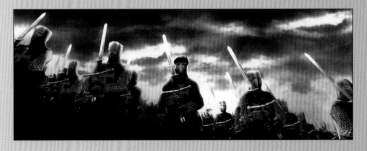

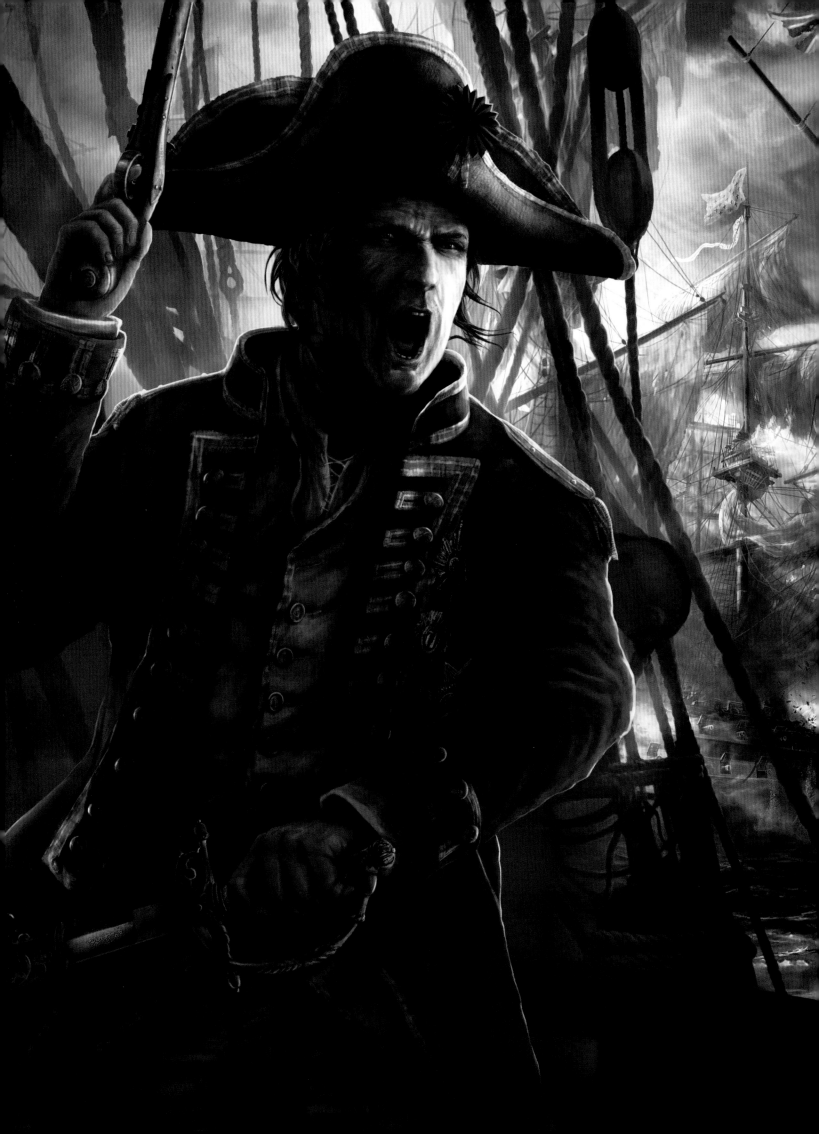

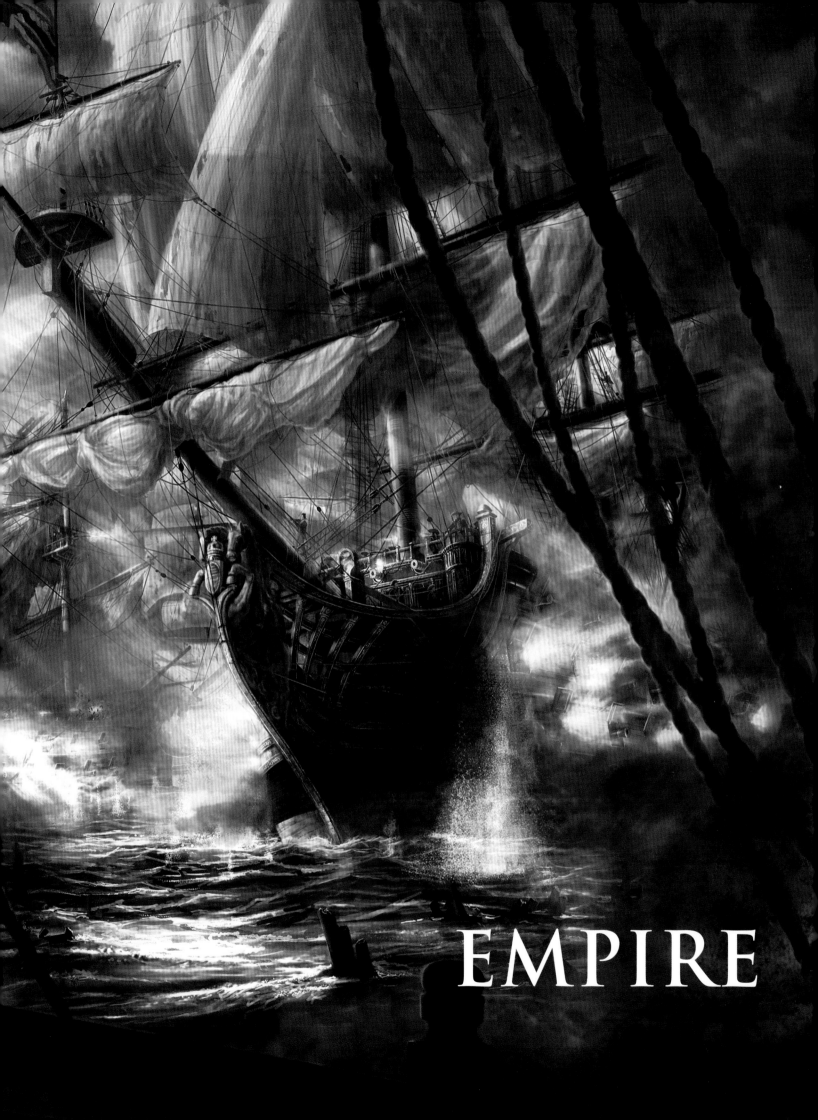

EMPIRE

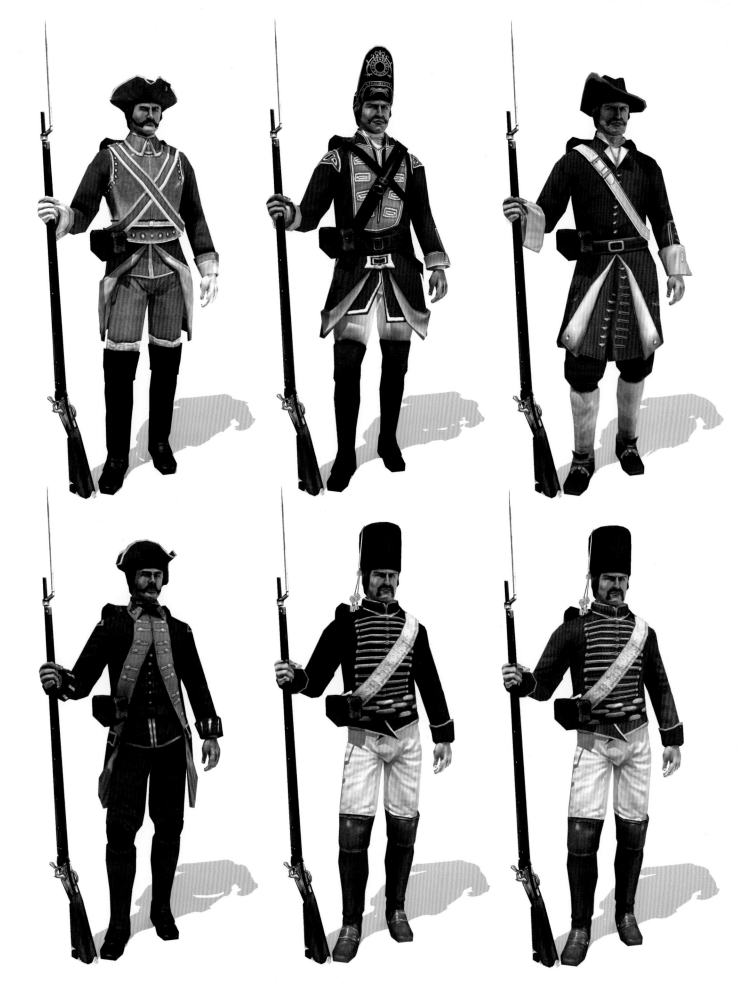

EMPIRE

Released in 2009, *Empire: Total War* marked one of the most significant evolutions in The Creative Assembly's series, an all-new graphics engine allowing for more spectacular battles, and a more evocative take on history.

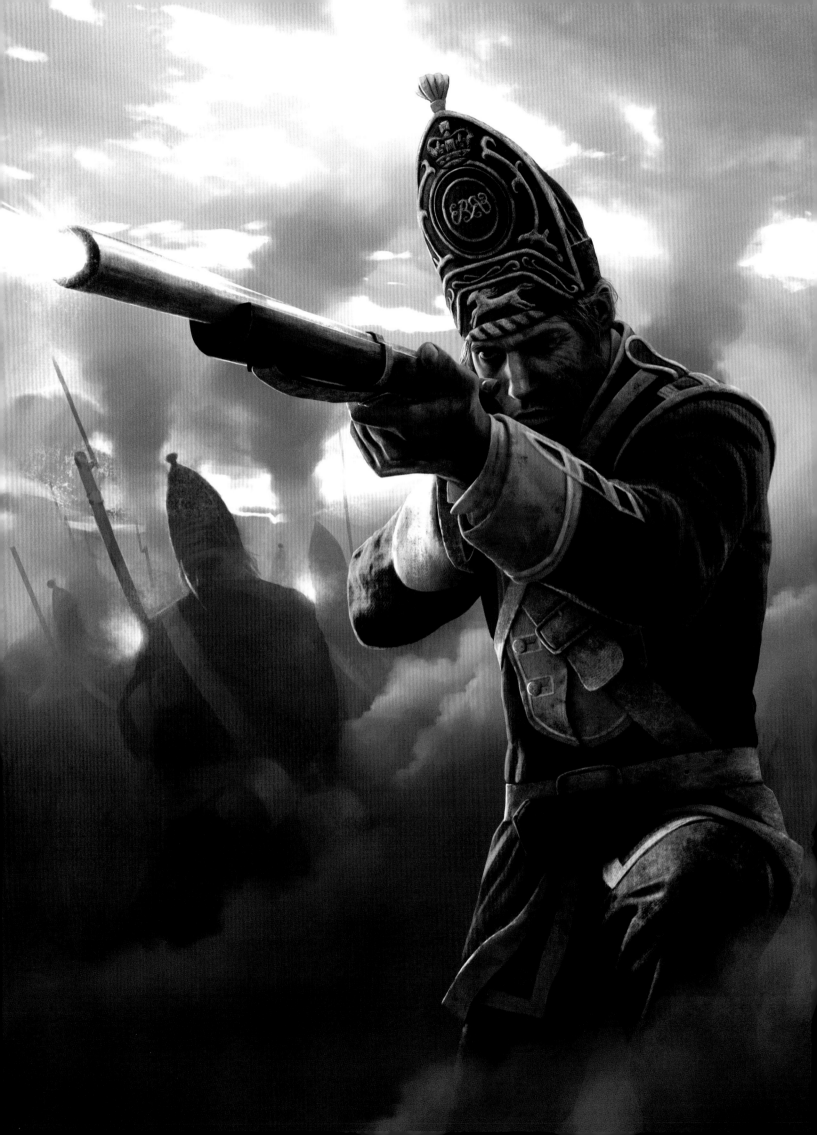

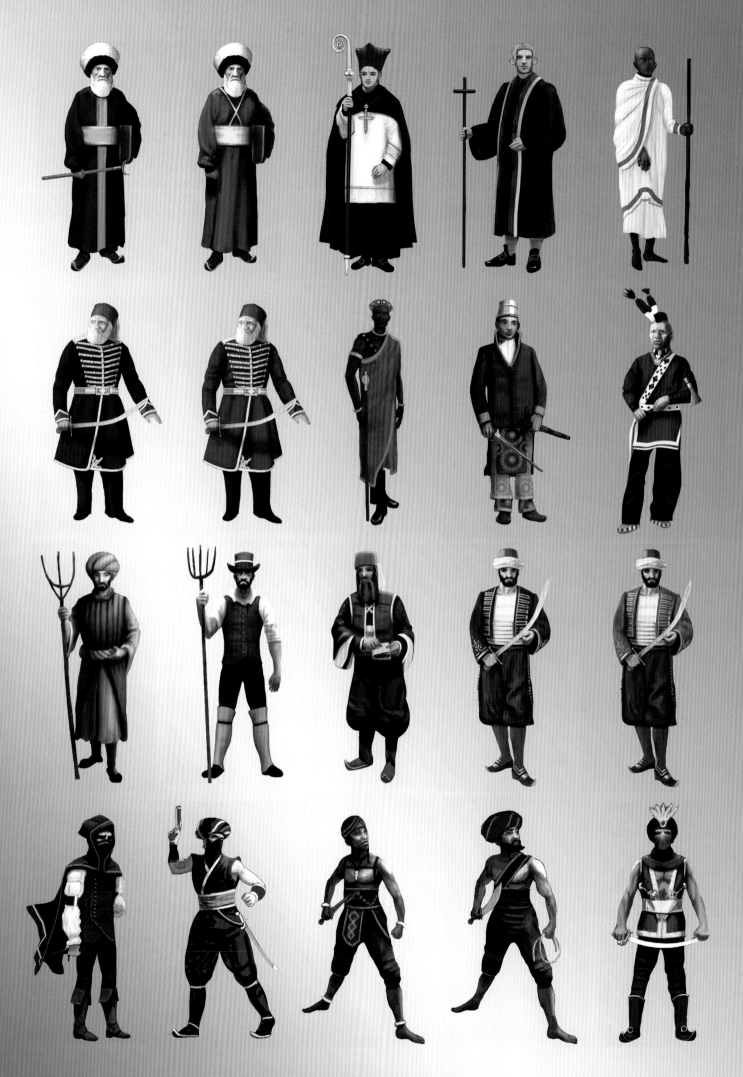

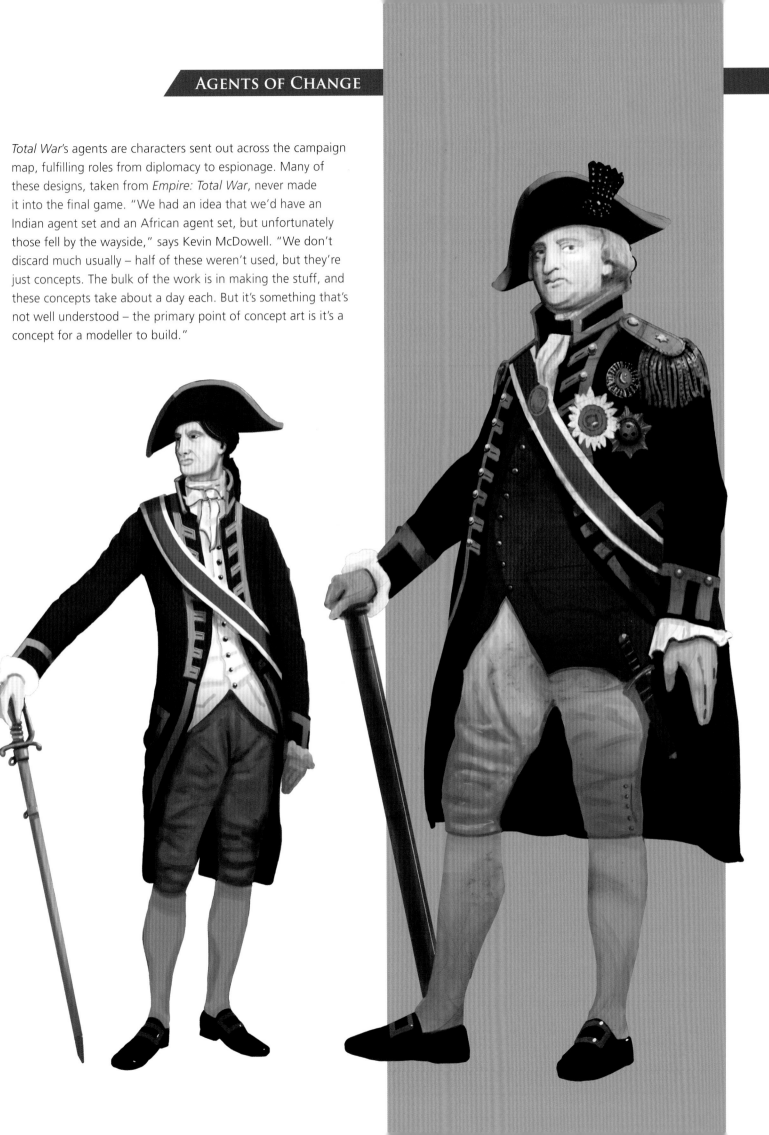

Total War's agents are characters sent out across the campaign map, fulfilling roles from diplomacy to espionage. Many of these designs, taken from *Empire: Total War*, never made it into the final game. "We had an idea that we'd have an Indian agent set and an African agent set, but unfortunately those fell by the wayside," says Kevin McDowell. "We don't discard much usually – half of these weren't used, but they're just concepts. The bulk of the work is in making the stuff, and these concepts take about a day each. But it's something that's not well understood – the primary point of concept art is it's a concept for a modeller to build."

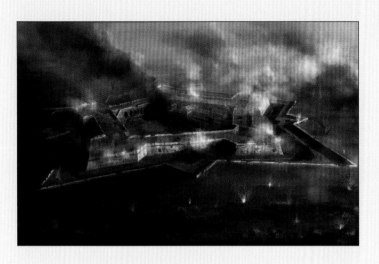

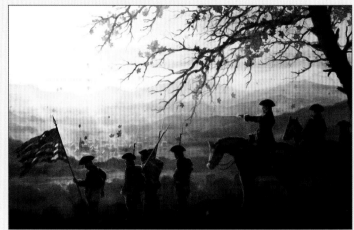

THE BEAUTY OF BATTLE

Empire: Total War's concept art brings a striking, painterly eye to the battlefields of the 18th century. "These are mood pieces, but then also we use them as loading screens," explains Kevin McDowell. "It's another way we like to double up our efforts. They can be used as a mood piece, and then used in the game – if it's a good piece of art."

External artist Rado Javor is responsible for the imagery, and his work has its own distinct feel. "Rado's art is quite soft," says McDowell. "It tends to have a big sun in the background, and this soft light."

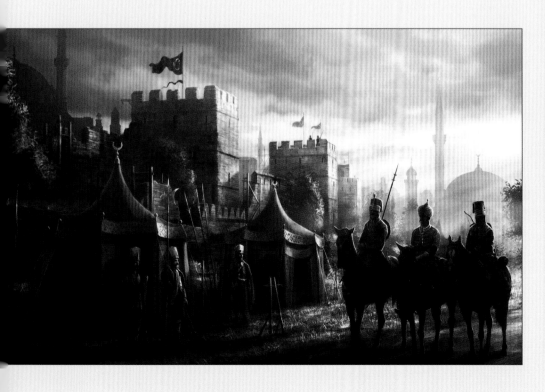

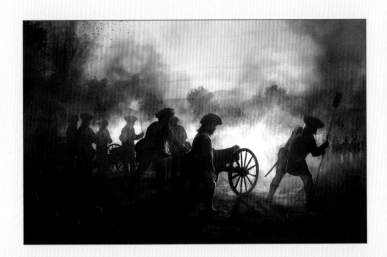

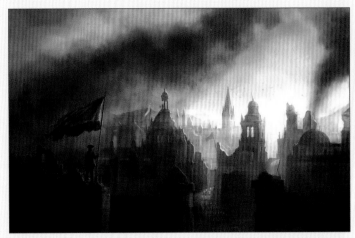

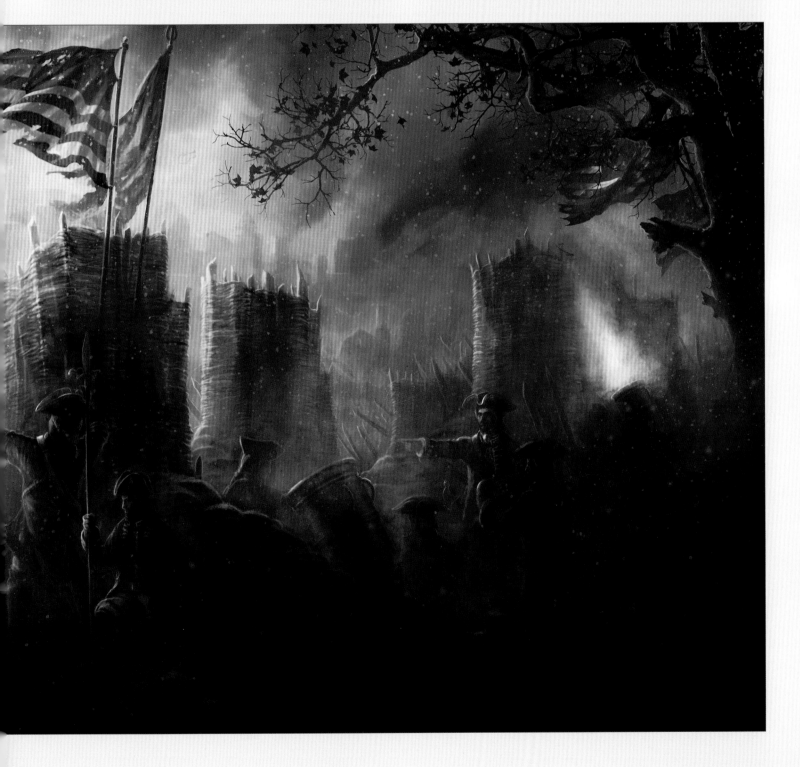

Six months after the release of *Empire: Total War* came its full-blooded expansion, *The Warpath Campaign*, which shifted the focus from Europe and the colonies to North and Central America and introduced Cherokee, Huron, Iroquois and Pueblo as factions. Early concept art features dark, foreboding skies that sit atop scenes of savagery and conflict beneath. "There's a bit of fire and brimstone going on," says Kevin McDowell. "Although these images are probably a bit darker and moodier than the overall tone of the game – they're probably a little bit further afield than they could have been. But that's okay - different artists have different interpretations."

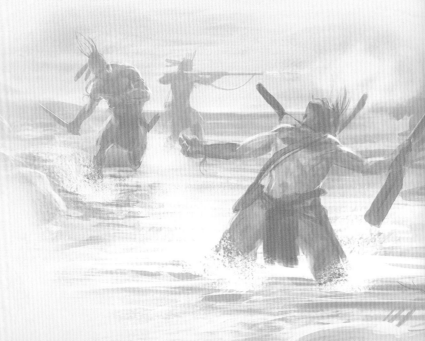

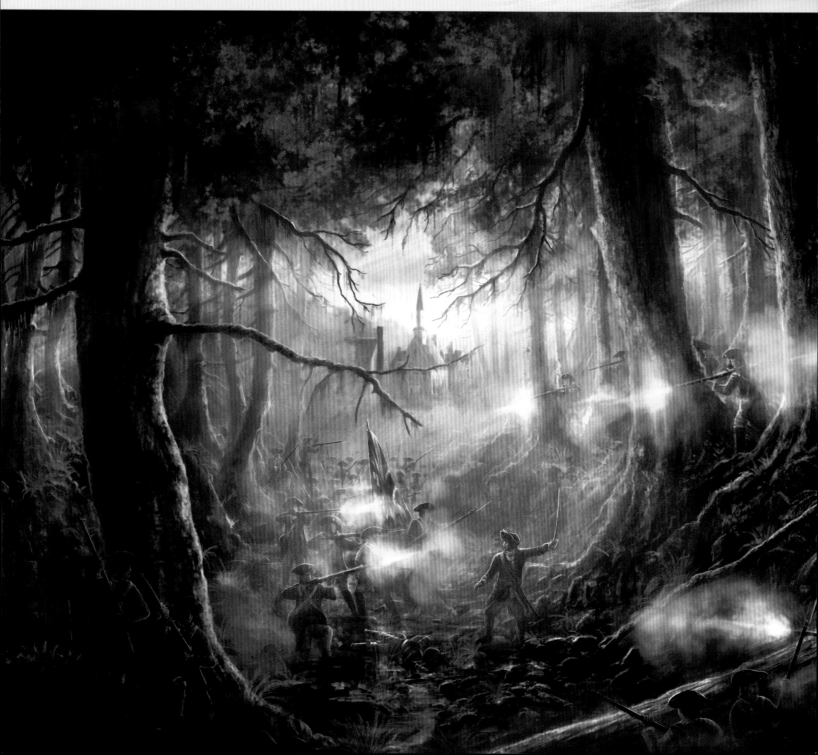

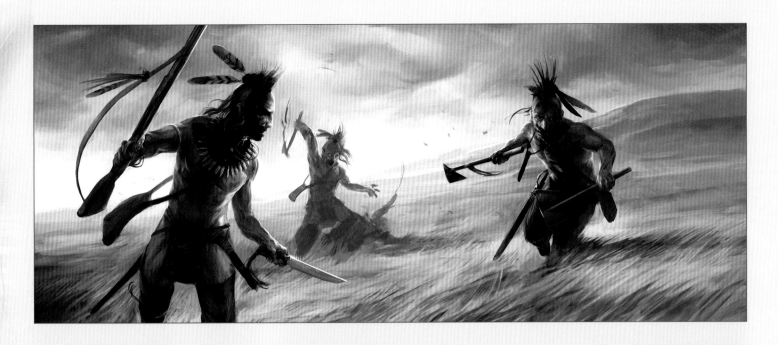

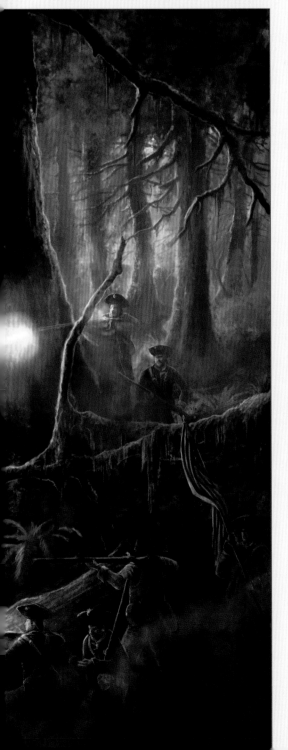

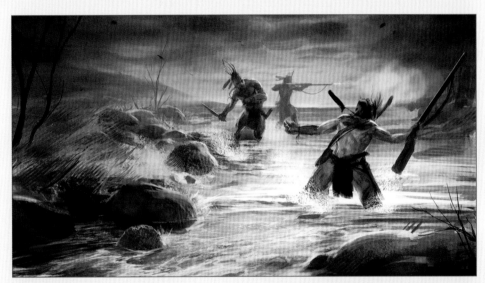

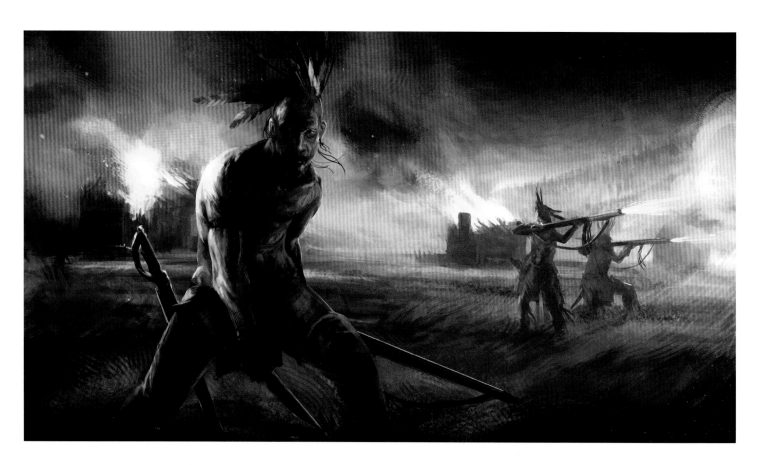

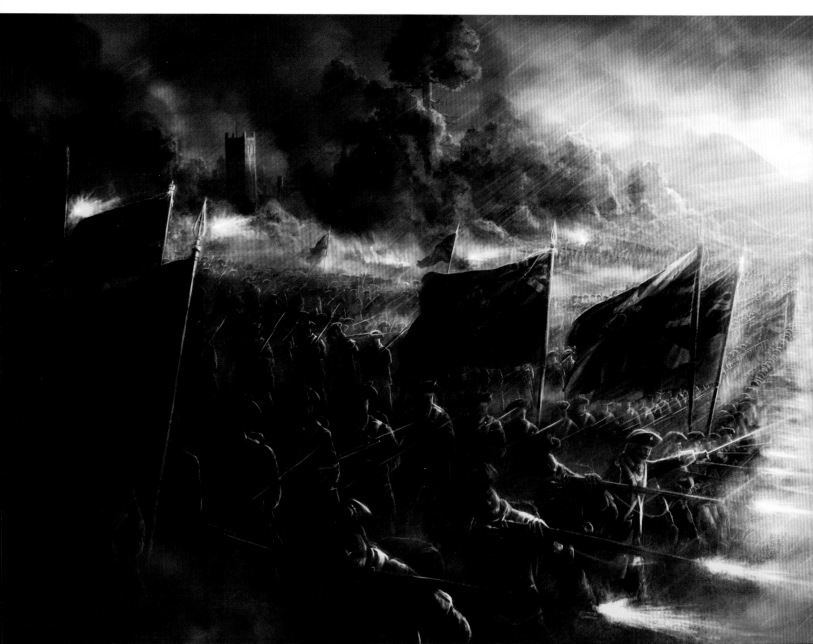

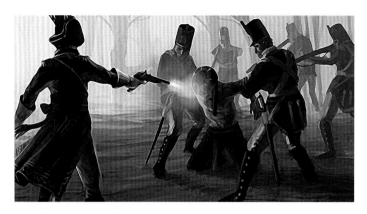

Empire: Total War marked the debut of an all-new game engine for The Creative Assembly, which presented its own problems for the artists. "We were in this limbo where we didn't have an engine to put our stuff into," says Kevin McDowell. "We were making stuff blind." Knowing the limits of what's technically possible is important to artists as they flesh out a vision, through concepts or otherwise. "As a professional games artist, you know what your polygon budget should be, and how your shaders should be set up. It's quite simplistic," says McDowell. "With Empire: Total War we didn't have issues on that side – it's more about how it's important to get the work on the game in order to know what we need to iterate on, what we need more of and what bits we're overcooking. From that point of view, we were blind for a couple of years."

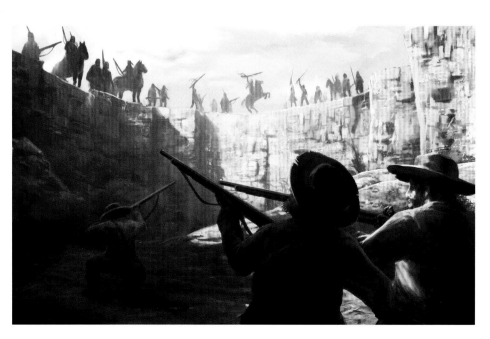

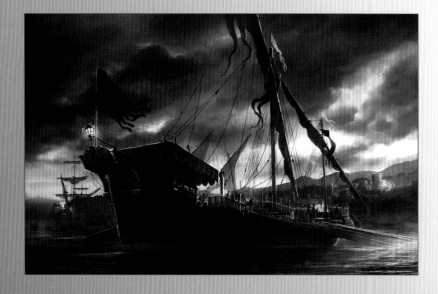

Rado Javor's concepts are never less than dramatic – such as a battle in Vigo bay between British and Spanish fleets that erupts into flames.

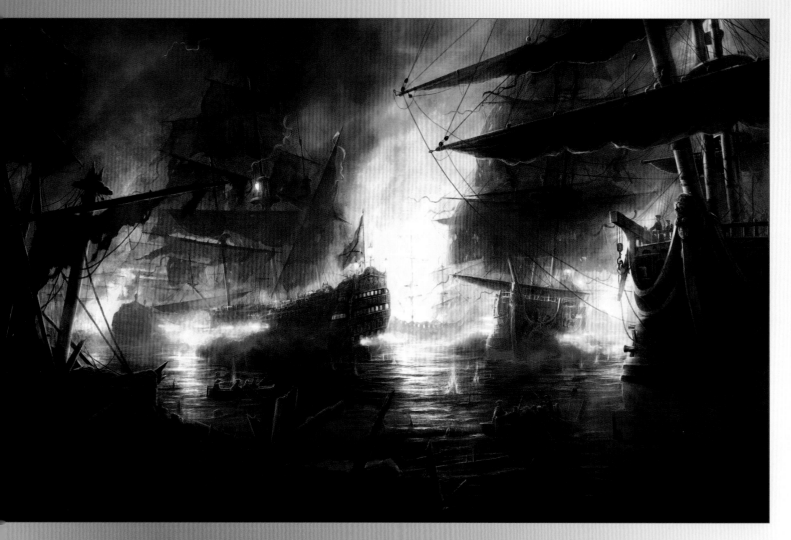

THE AGE OF SAILS

The story of colonial expansion and conflict in the 18th century is defined by naval warfare, contemporary perception of the era shaped by epic depictions of warring fleets. Naturally, it made sense for The Creative Assembly to introduce naval warfare for *Empire: Total War*, a feature that's been a mainstay of the series ever since. "You go back and you see how much we've moved on in terms of gameplay mechanics, and the look and feel and the level of immersion that you get in each environment," says designer James Russell. "Since Empire we've had naval battles, which is another huge thing – and the naval battles in Empire, in particular, are very spectacular."

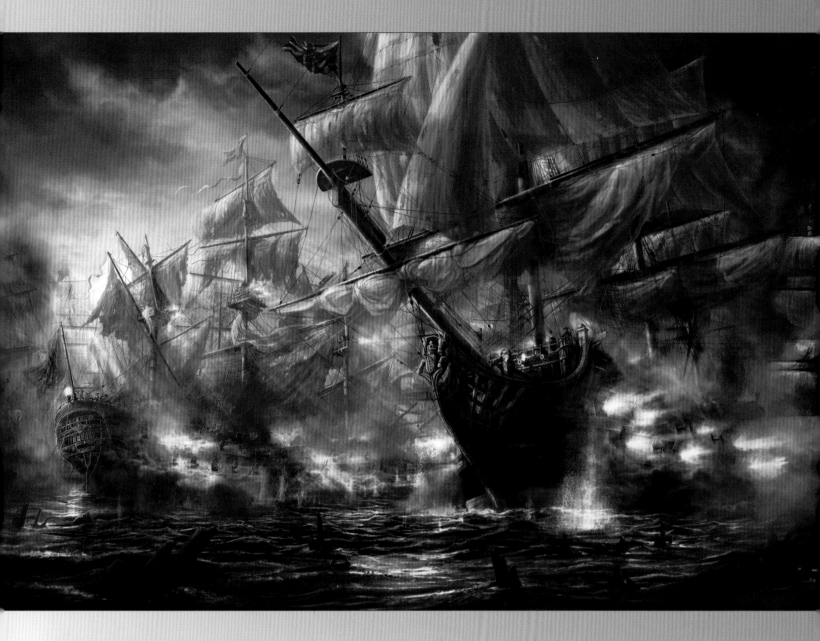

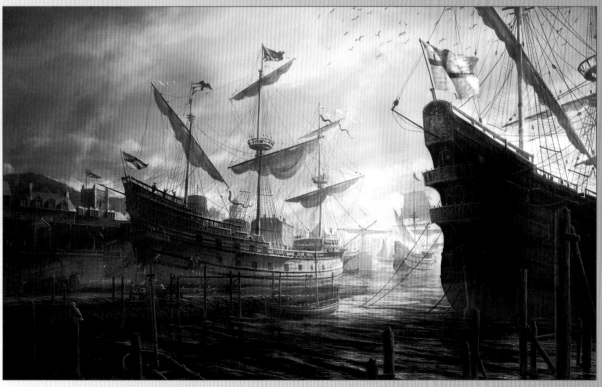

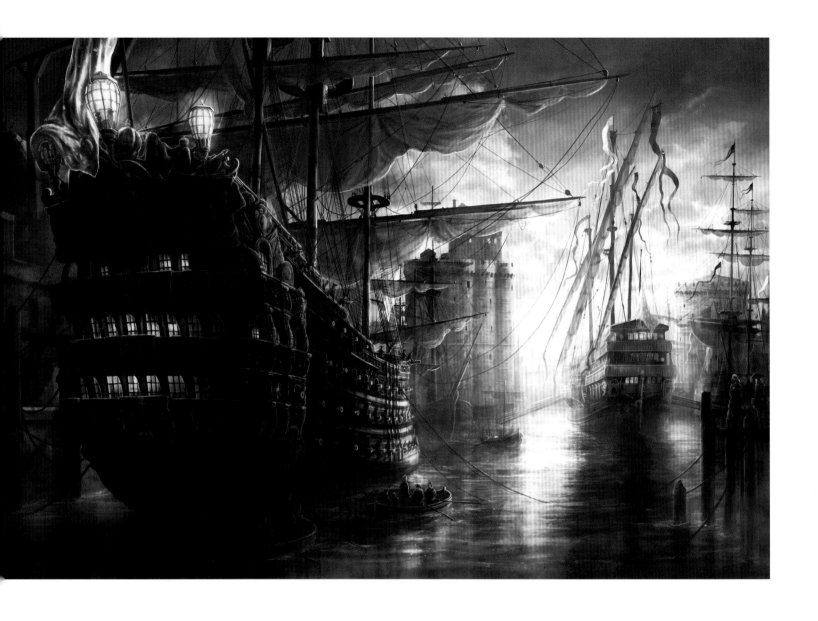

EVERY PICTURE TELLS A STORY

Littered throughout *Total War*'s campaigns are event pictures such as these, depicting anything from the expansion of one of your own cities to the arrival of a deadly plague. "They're quite small, and we blast through hundreds of them," says Kevin McDowell. "There are lots of things that happen in the game, and instead of displaying dry text we attach an image to it. It helps with the immersion, and with the imagination."

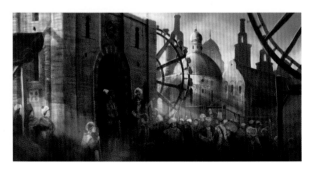

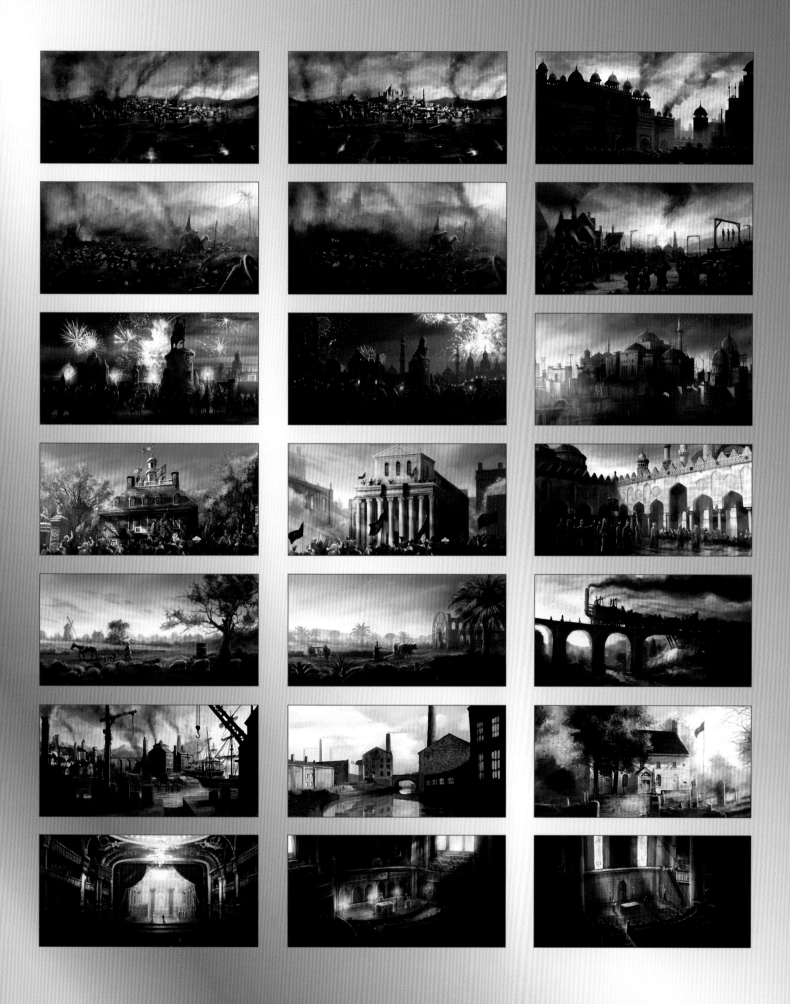

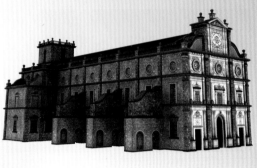
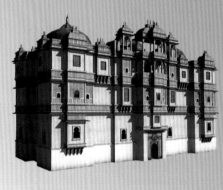
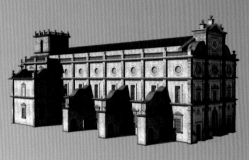

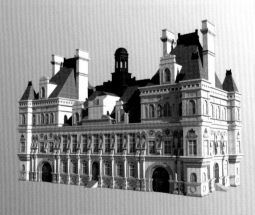
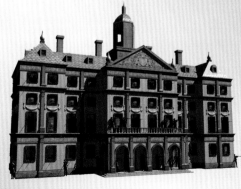

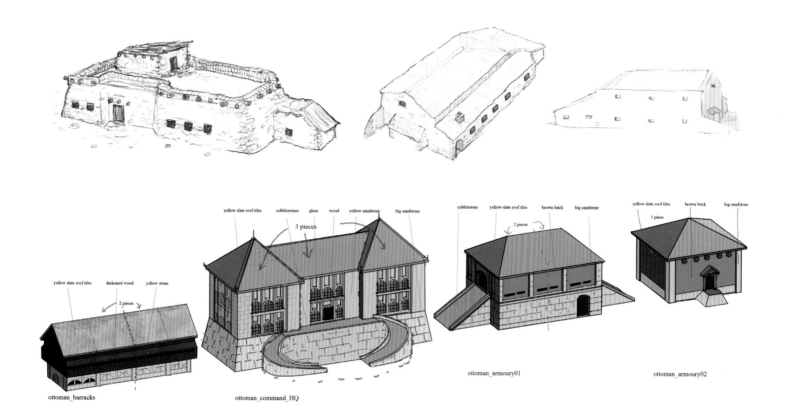

yellow slate roof tiles cobblestones glass wood yellow sandstone big sandstone

3 pieces

cobblestone yellow slate roof tiles brown brick big sandstone

2 pieces

yellow slate roof tiles brown brick big sandstone

1 piece

yellow slate roof tiles darkened wood yellow stone

2 pieces

ottoman_barracks

ottoman_command_HQ

ottoman_armoury01

ottoman_armoury02

Designing buildings for a game such as *Empire: Total War* requires consideration of both real-world concerns and the requirements of the game. "In Empire we had a number of buildings that were inhabitable, and a number of buildings that were not," says Kevin McDowell. "Any that aren't inhabitable, we'll use a real world reference for. Anything that is inhabitable, we'll have to design for gameplay. We still tend to go for a more realistic type of design – even though they're much more designed for gameplay." The references themselves are typically historical. "We find an appropriate looking church, and it's very much I'll have one of those please," says McDowell.

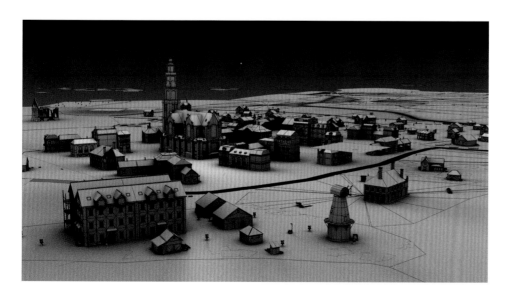

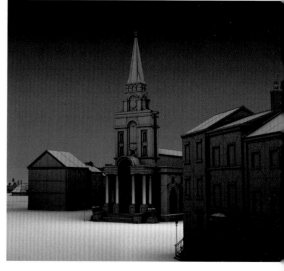

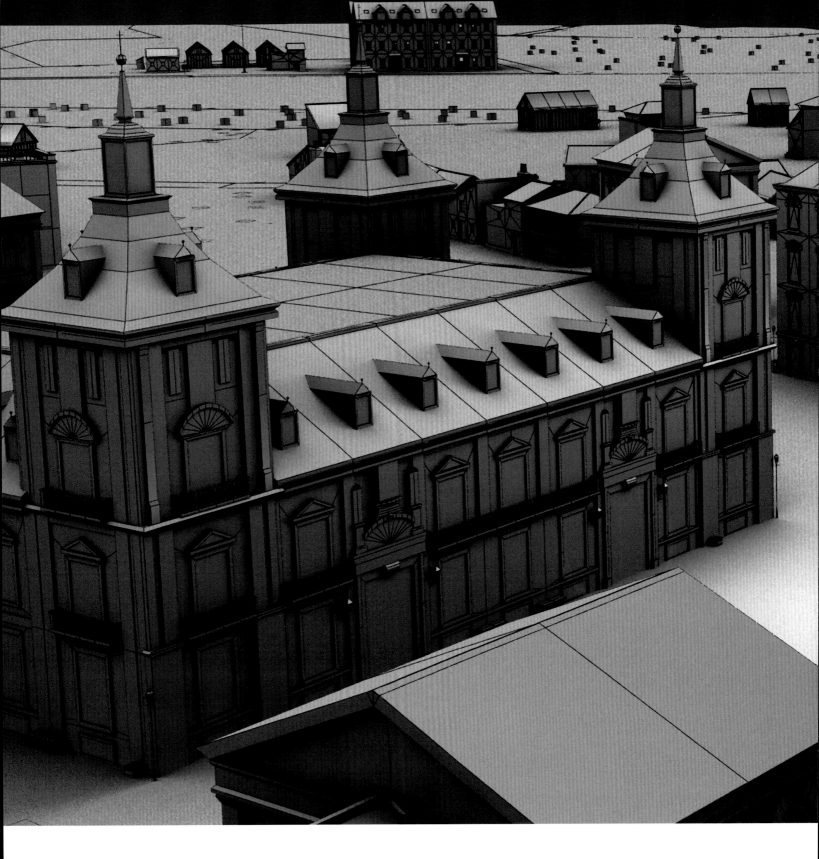

A virtual city stripped down to the bare essentials. Blockouts like this are crucial to the planning process, allowing artists and designers to visualise how a city will work.

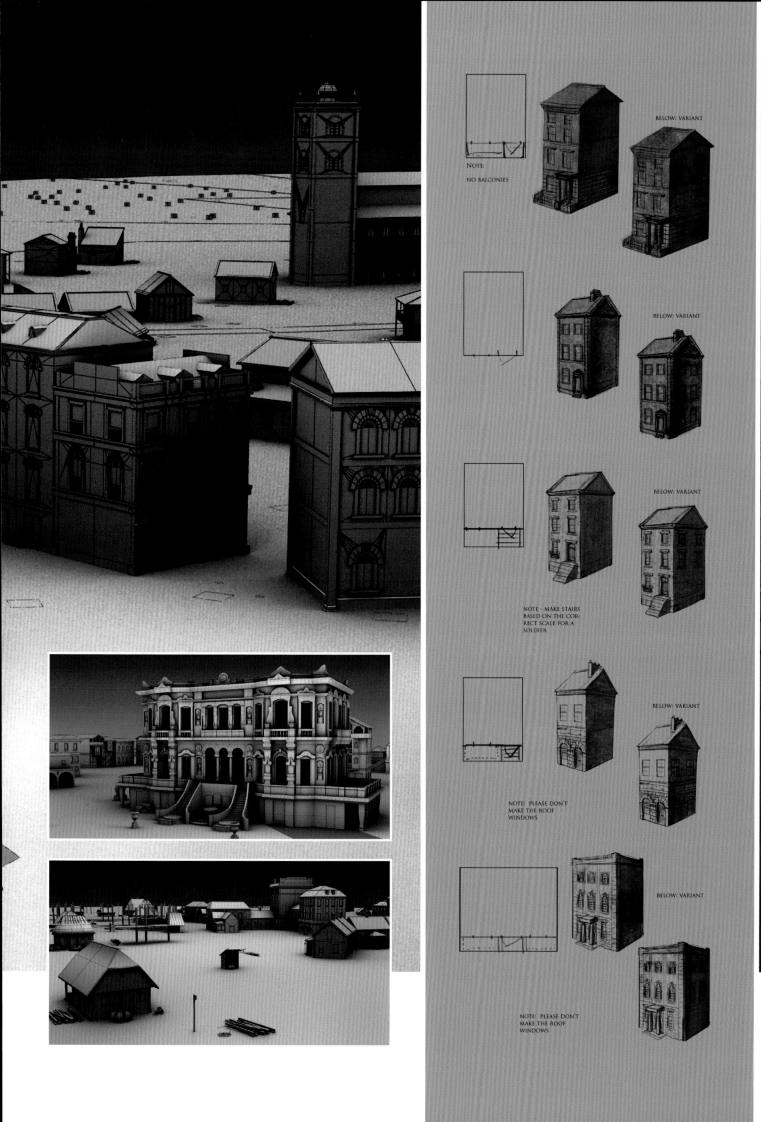

NOTE:

NO BALCONIES

BELOW: VARIANT

BELOW: VARIANT

BELOW: VARIANT

NOTE - MAKE STAIRS
BASED ON THE COR-
RECT SCALE FOR A
SOLDIER

BELOW: VARIANT

NOTE: PLEASE DON'T
MAKE THE ROOF
WINDOWS

BELOW: VARIANT

NOTE: PLEASE DON'T
MAKE THE ROOF
WINDOWS

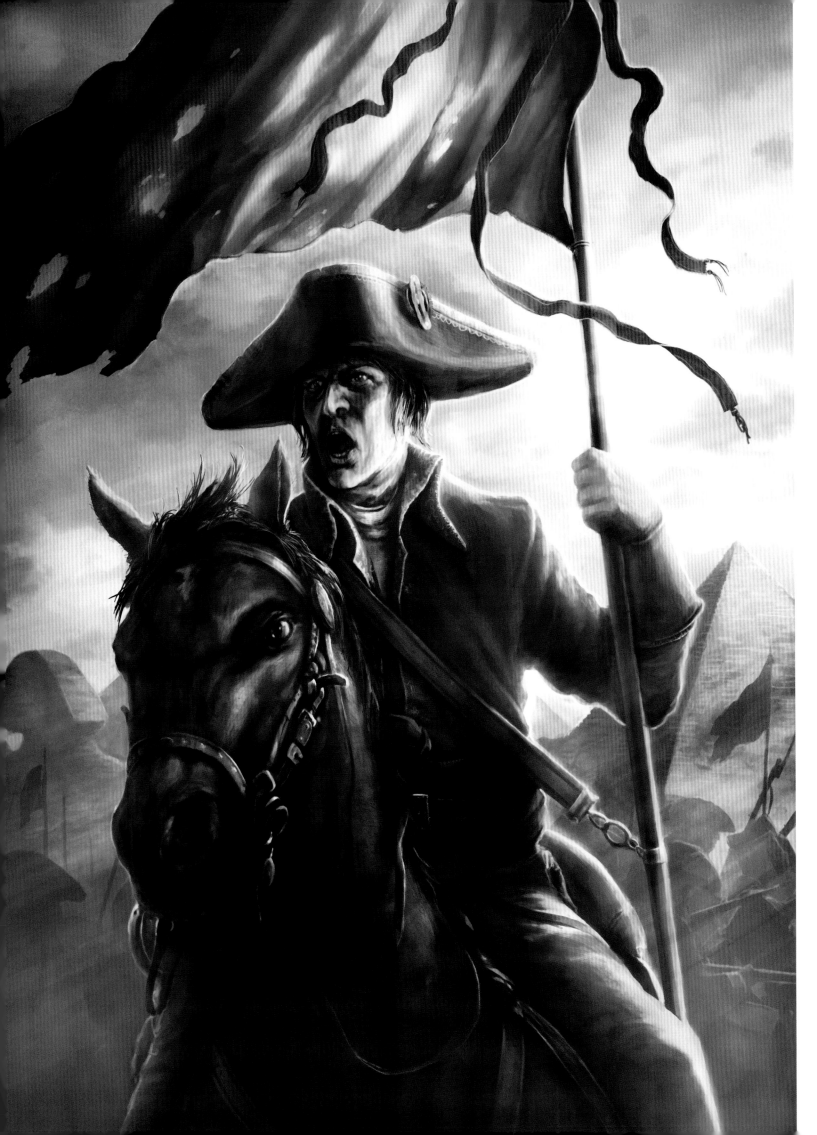

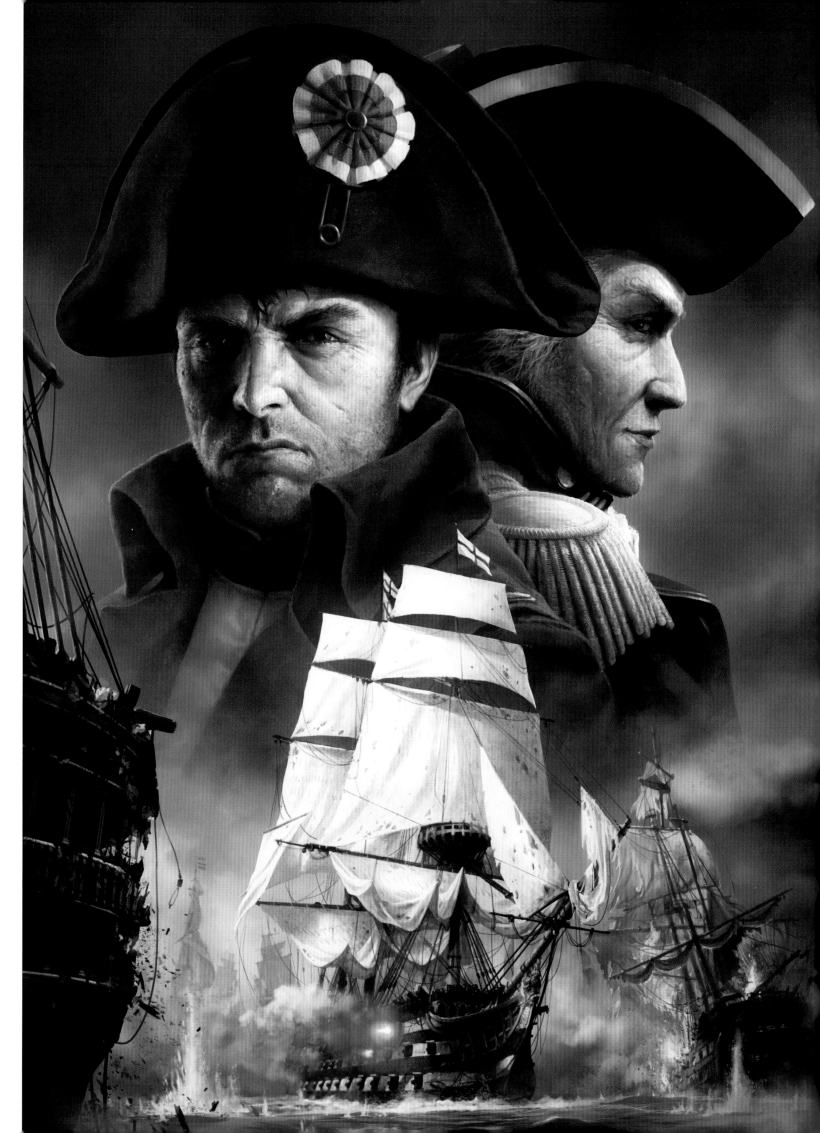

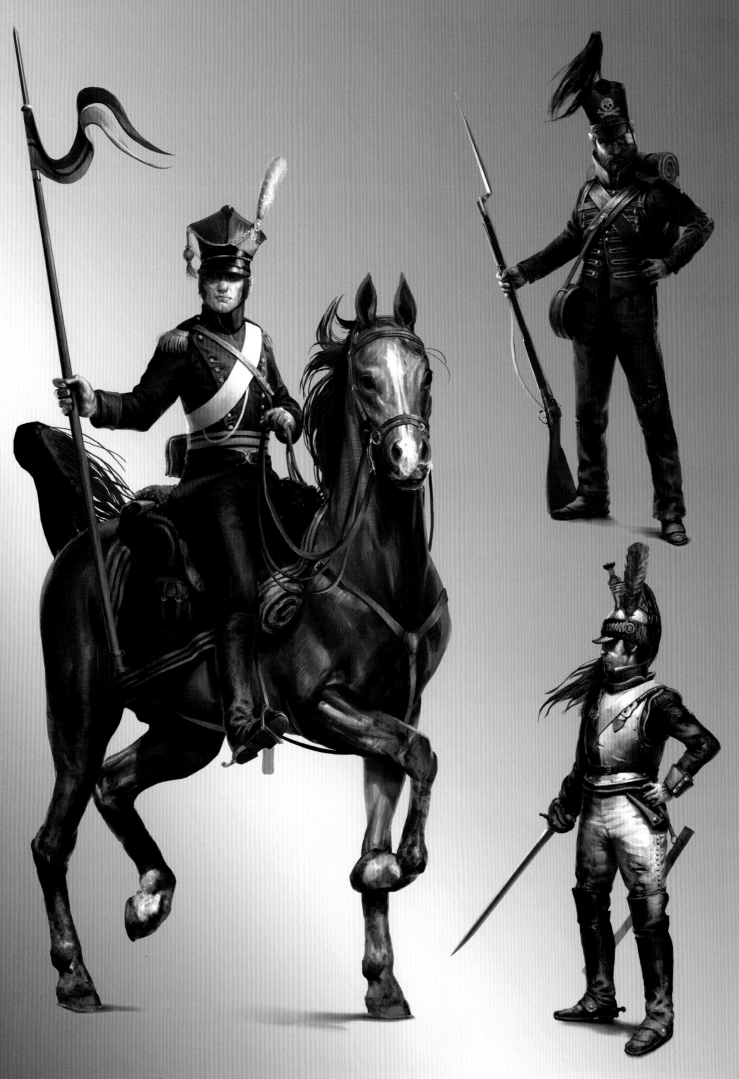

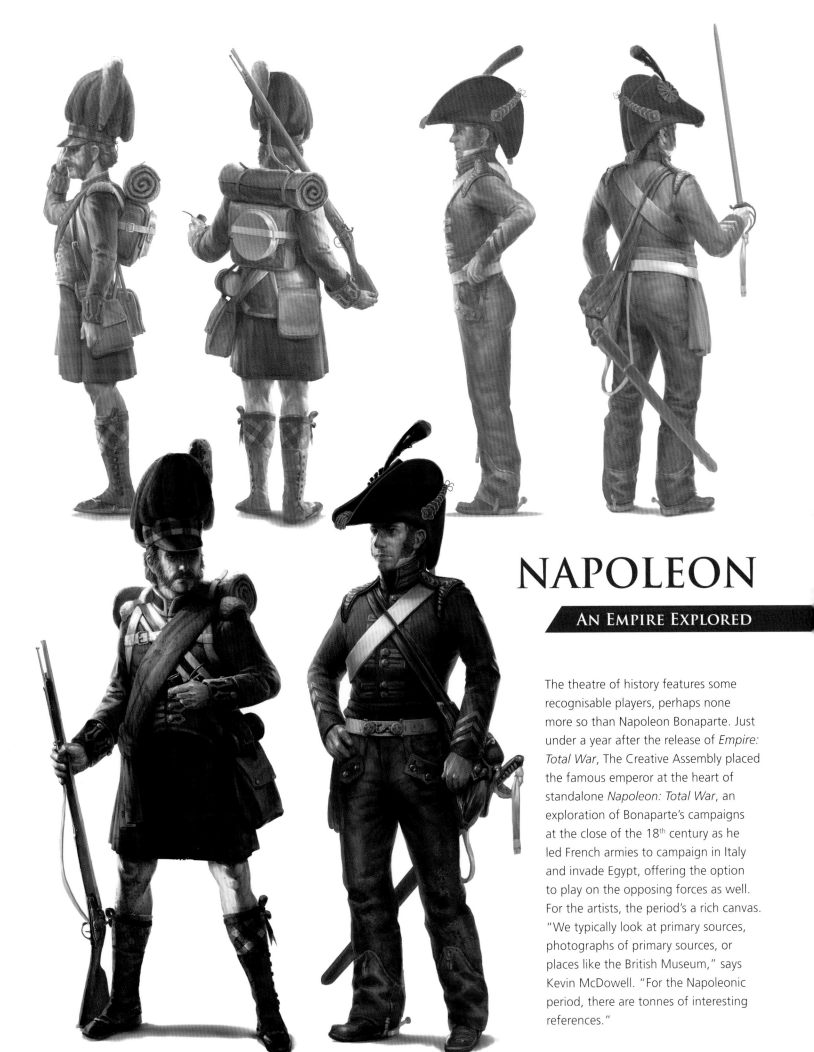

NAPOLEON

AN EMPIRE EXPLORED

The theatre of history features some recognisable players, perhaps none more so than Napoleon Bonaparte. Just under a year after the release of *Empire: Total War*, The Creative Assembly placed the famous emperor at the heart of standalone *Napoleon: Total War*, an exploration of Bonaparte's campaigns at the close of the 18th century as he led French armies to campaign in Italy and invade Egypt, offering the option to play on the opposing forces as well. For the artists, the period's a rich canvas. "We typically look at primary sources, photographs of primary sources, or places like the British Museum," says Kevin McDowell. "For the Napoleonic period, there are tonnes of interesting references."

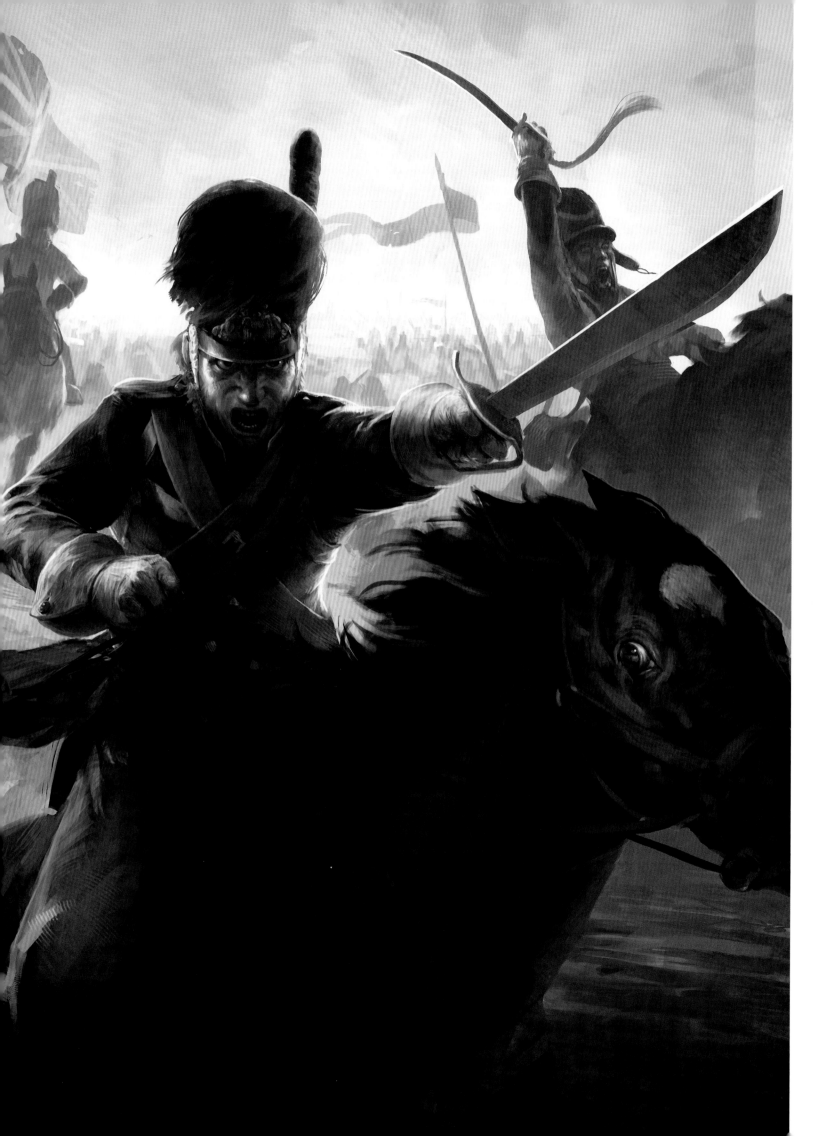

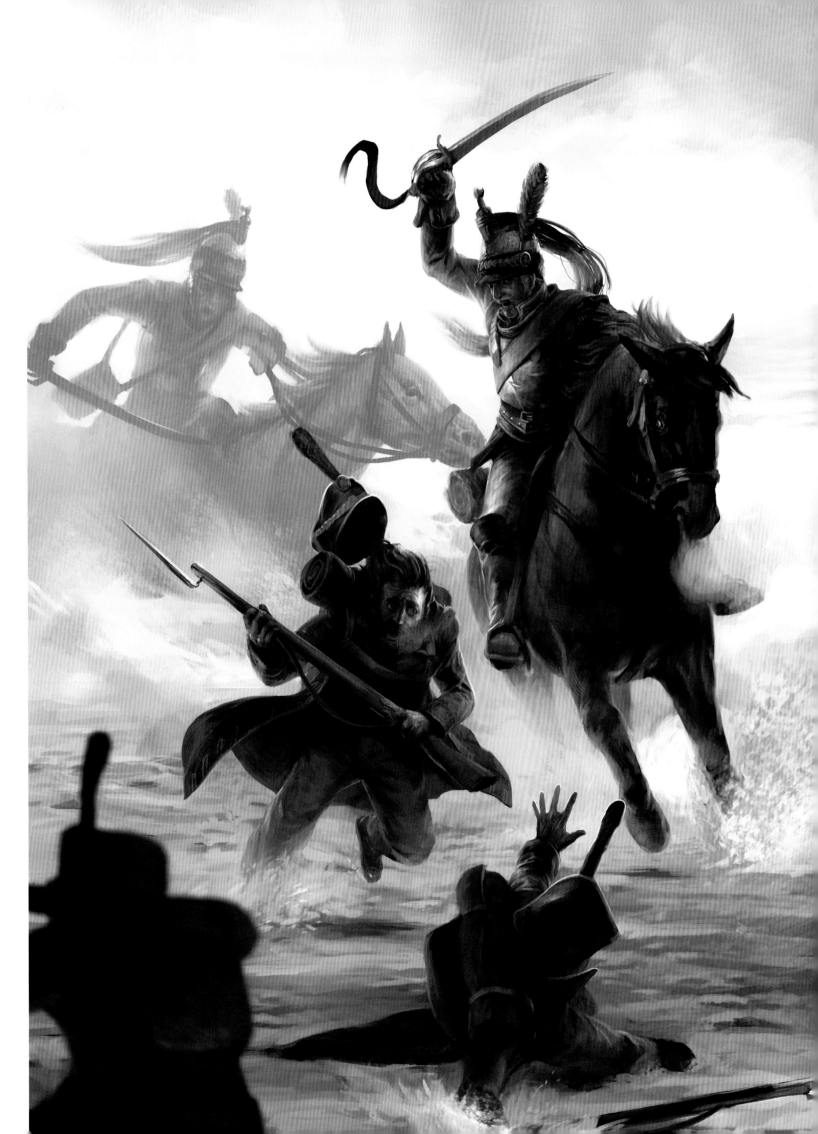

NAPOLEONIC IDEALS

Depictions of Napoleon have been diverse, from the full-blooded romanticism of Marlon Brando's turn in Désirée to the staunch heroism of Albert Dieudonné in Abel Gance's silent masterpiece. When coming up with their own depictions of an era, and of its people, The Creative Assembly lead towards an iconic ideal, one that can be readily grasped by the players and one that lives up to their expectations. So the battles themselves stay true to history, but are shot through with cinematic inspiration, where there's a focus on the spectacle that's all-important to keep player's attention. The alternative – ponderous battles played out over days – is perhaps too arduous for even the most dedicated player to contemplate.

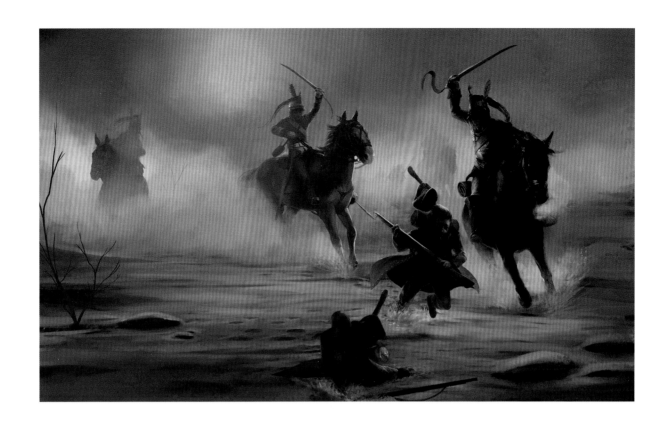

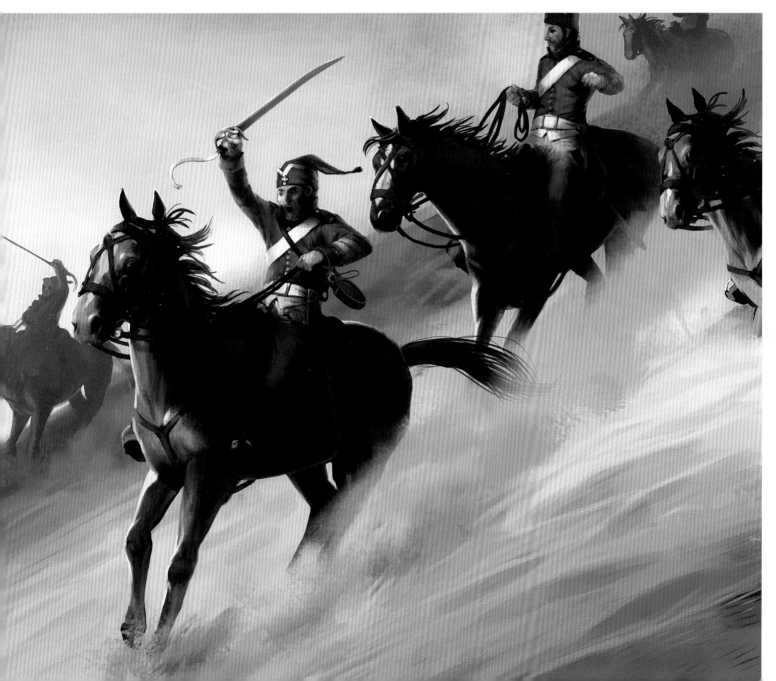

BATTLE PLANS

For *Empire: Total War*, The Creative Assembly struck up a deal with Greenwich's National Maritime Museum whereby it was able to access a vast archive of ship plans. "We licensed a whole bunch of their ship plans," says Kevin McDowell. "The designs aren't copyrighted – they're over 100 years old – but the museum owns the plans." The authenticity in the final designs suggest it was a deal well worth making.

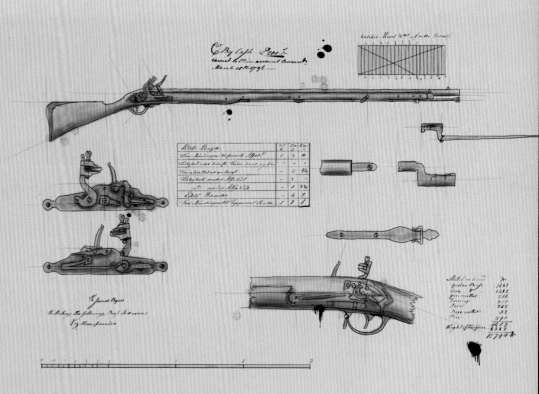

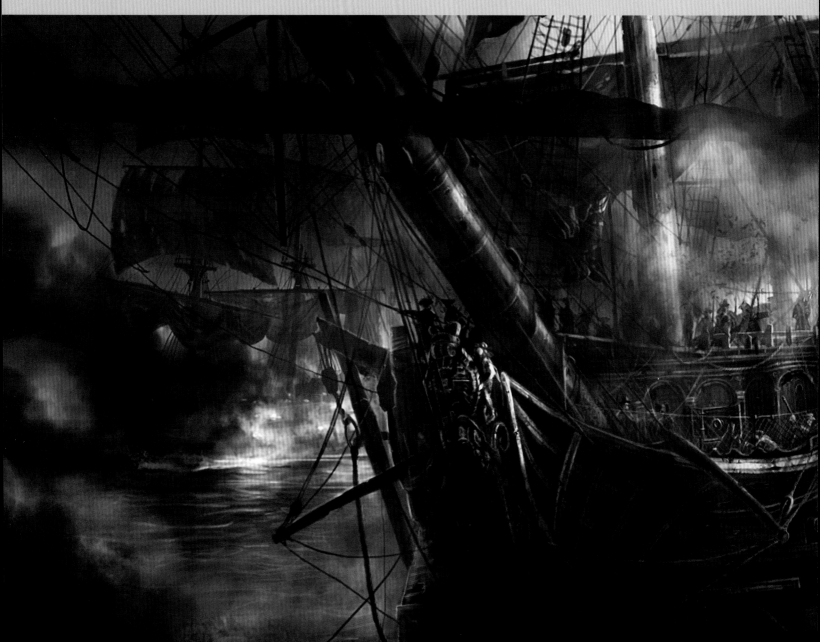

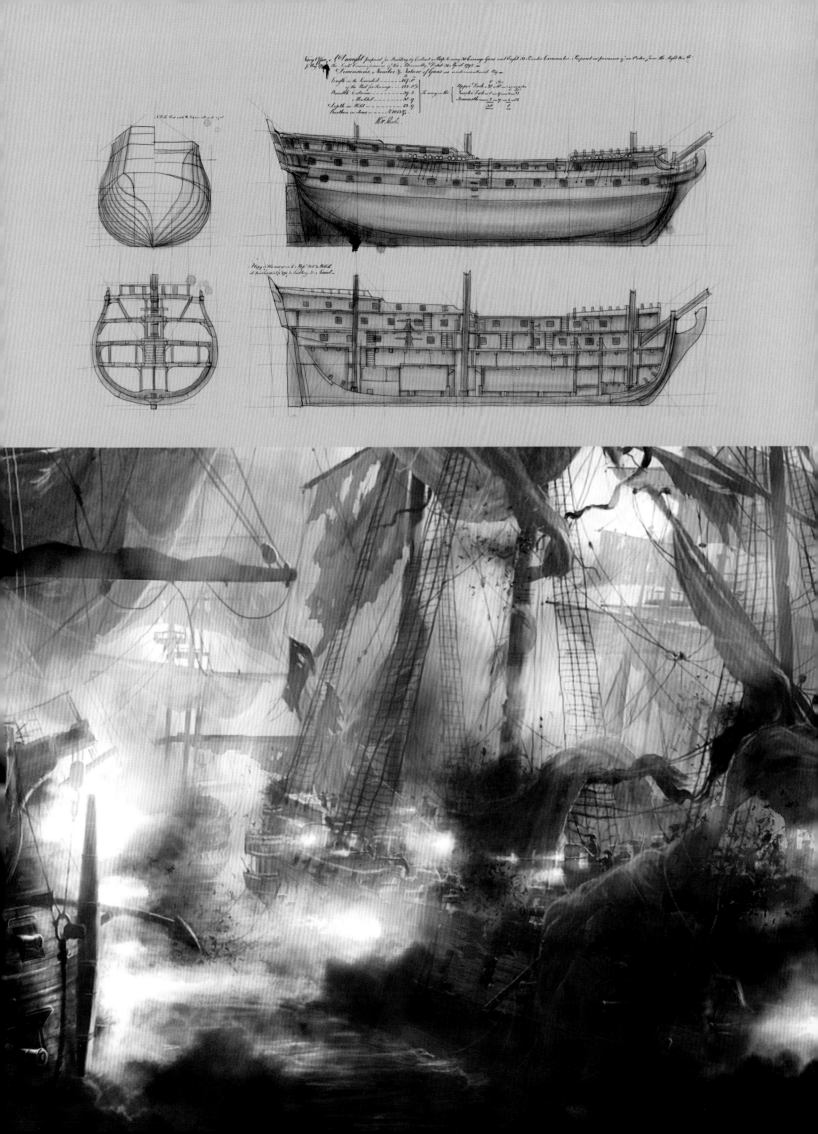

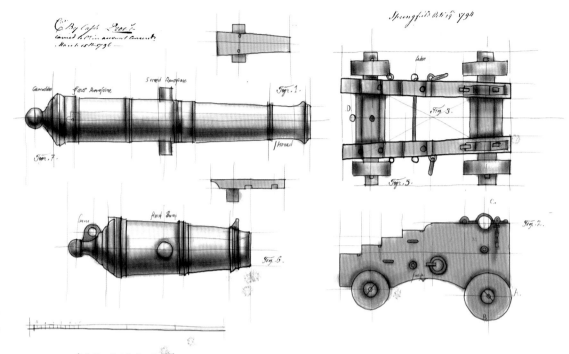

Weapon designs also benefited from the relationship with the National Maritime Museum, and the introduction of ballistics introduced a new look for the series, where battlefields became enshrouded in gunpowder smoke.

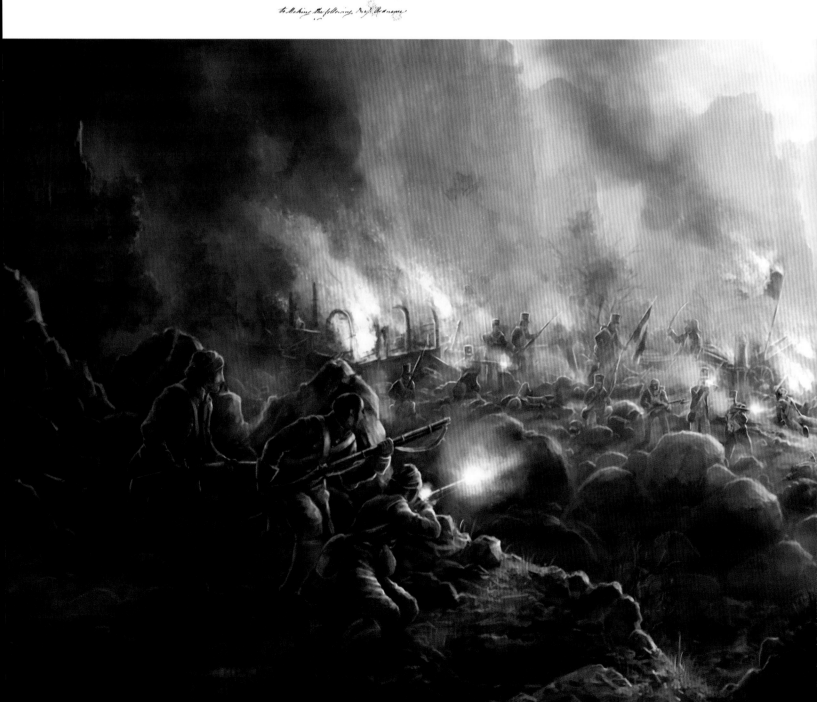

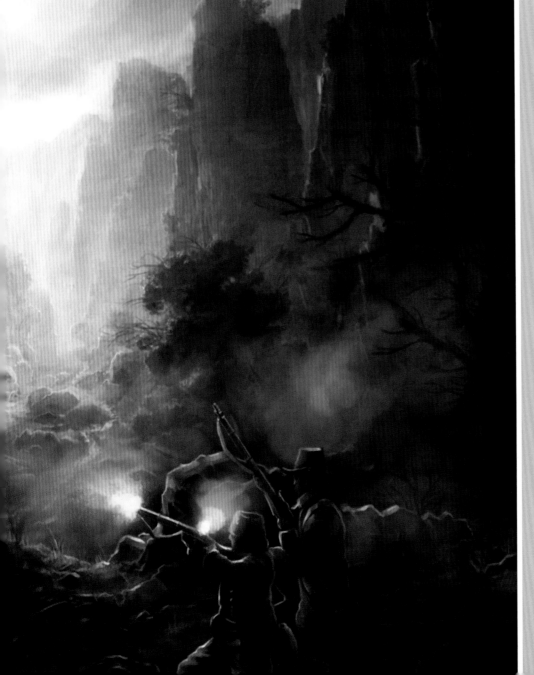

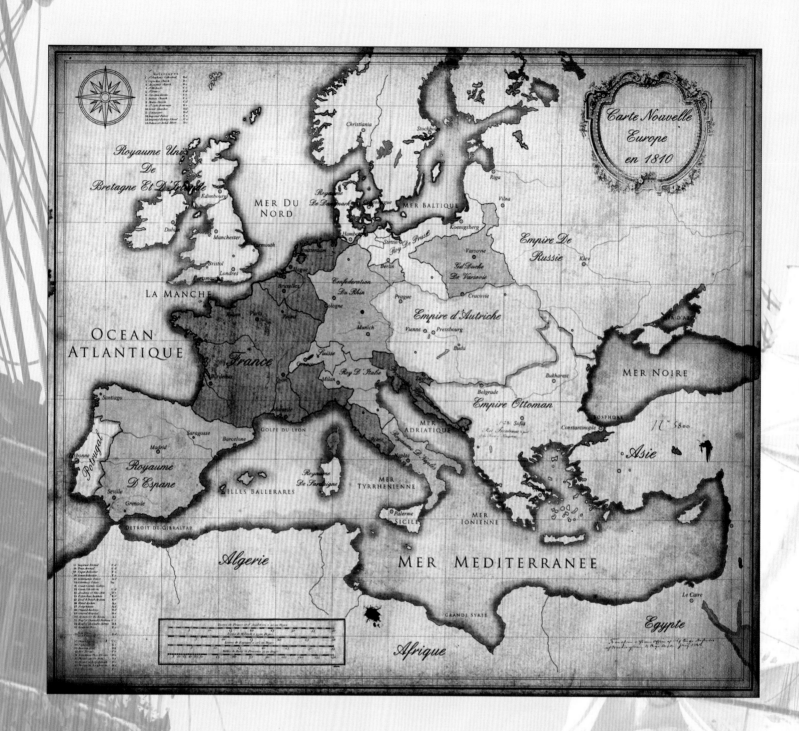

The following place names and labels appear on the map:

Carte Nouvelle Europe en 1810

Royaume Uni De Bretagne Et D'Irlande

MER DU NORD
Christiania
Stockholm
Riga
Vilna
Koenigsberg
MER BALTIQUE

Edimbourg
Dublin
Manchester
Yarmouth
Bristol
Londres
Portsmouth
LA MANCHE

Royaume De Danemark
Copenhague
Hambourg
Stettin
Berlin
De Prusse
Varsovie
Gd Duche De Varsovie
Crucovie
Prague

Empire De Russie
Kiev

OCEAN ATLANTIQUE

Amsterdam
Hague
Bruxelles
Cologne
Confederation Du Rhin
Munich
Empire d'Autriche
Vienne
Pressbourg
Buda

France
Rouen
Paris
Nantes
Suisse
Geneve
Bordeaux
Lyon
Milan
Roy D'Italie
Zagreb

Santiago
Saragosse
Barcelone
GOLFE DU LYON
Marseille
Belgrade
Bukharest
Empire Ottoman
Sofia
Constantinople

MER NOIRE
BOSPHORE
N° 5800
Asie

Lisbonne
Madrid
Royaume D'Espane
Seville
Grenade
DETROIT DE GIBRALTAR

ISLES BALLEARES
Royaume De Sardaigne
Rome
Naples
Royaume De Naples
MER ADRIATIQUE
MER TYRRHENIENNE
Palerme
SICILE
MER IONIENNE

Algerie
MER MEDITERRANEE
GRANDE SYRTE
Le Caire
Egypte

Afrique

MAPPING THE EMPIRE

Tracking down the parchment plans of the 18th century is one of the easier tasks presented to *Total War*'s artists; they're readily available, either from specialist shops or online. It's important they're authentic, of course, and take into consideration contemporary understandings – as well as misgivings – of global geography. *Empire: Total War*'s campaign map took an expansive look as far as colonial influence spread, while follow-up *Napoleon: Total War* honed in on the smaller, more focussed territory.

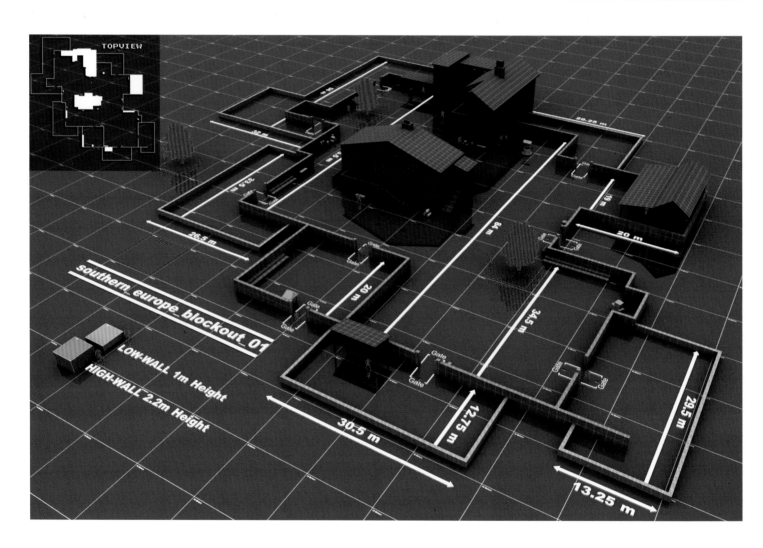

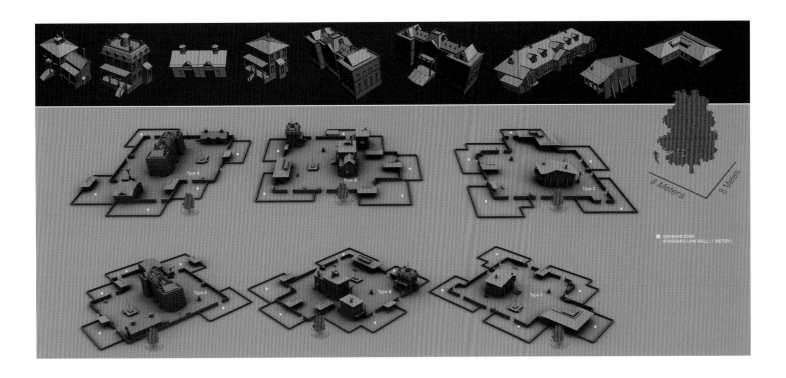

Artists at The Creative Assembly are often talented in multiple disciplines, an essential trait when mapping out areas such as this southern European town. Lead artist Kevin McDowell originally trained in architecture, while his team must all be versed to some degree in game design. "The artist will come up with ideas and bounce them off the designers – and vice versa," says McDowell. "Artists – especially environment artists – should have a design bent to them."

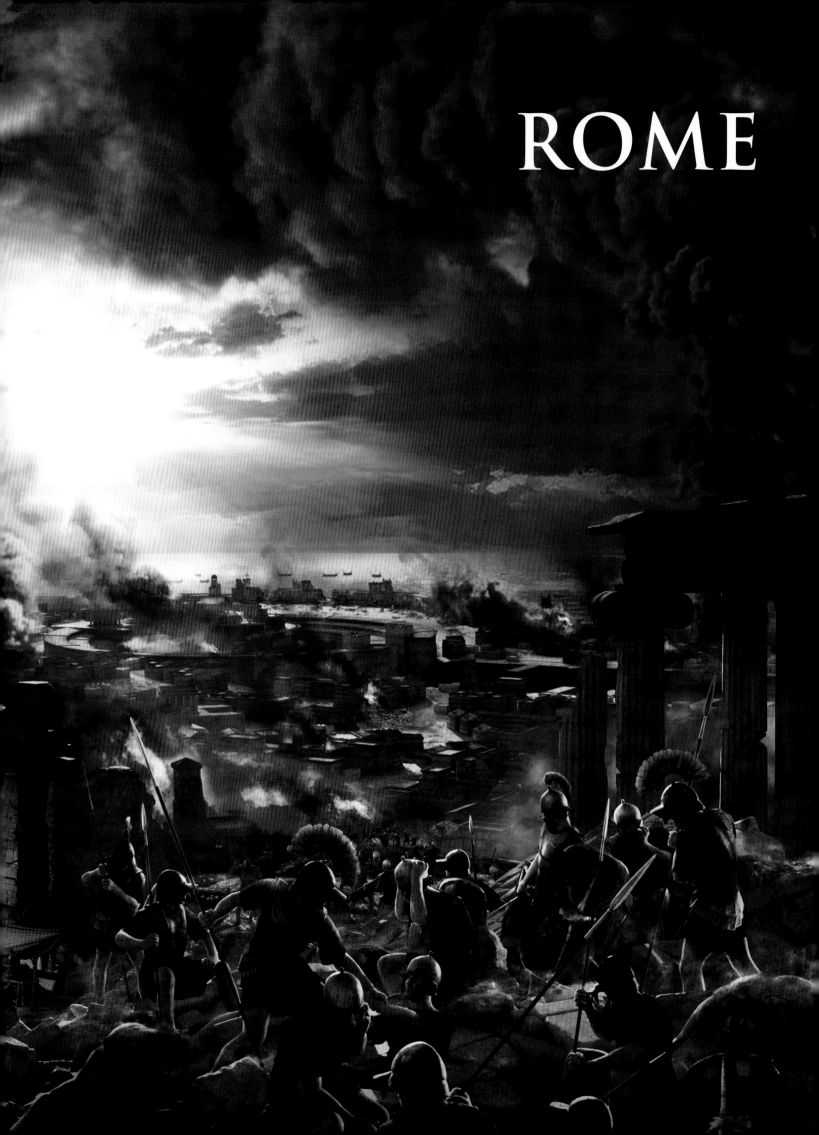

Different formations have different functions on the field, and they are – of course – historically accurate.

ROME

While forerunners *Medieval* and *Shogun* brought new dimensions to the strategy genre, it was 2004's *Rome: Total War* that was first considered a great – a classic who's class hasn't dimmed in the ten years since. With its focus on the rule of the Roman republic and Empire, there was a grandeur to the spectacle of the game's battles, and a fidelity that wouldn't go unnoticed in the wider world. It is *Rome: Total War* that would provide recreations for two television shows, the History Channel's *Decisive Battles* and BBC Two's *Time Commanders*.

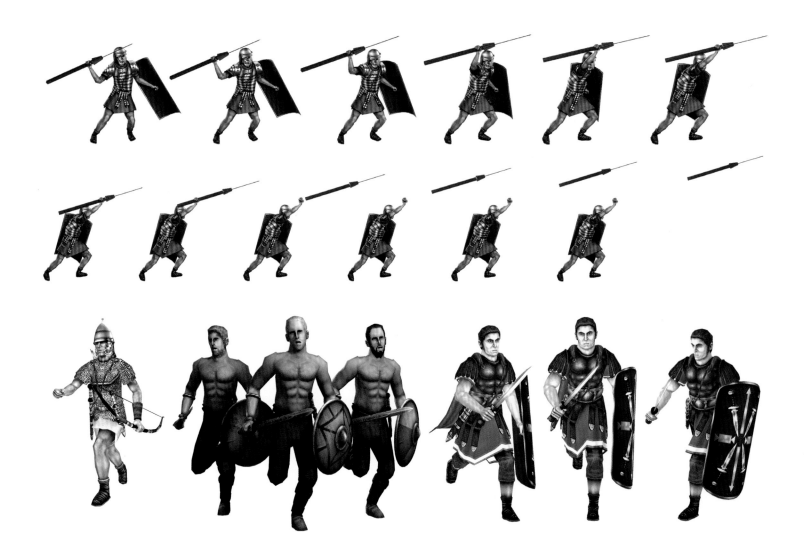

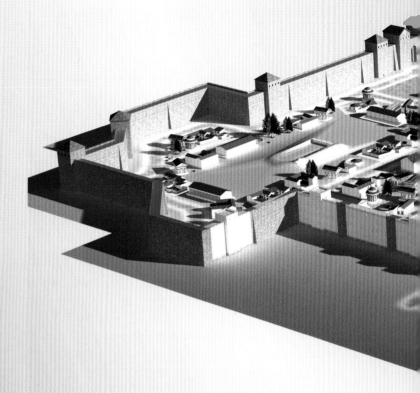

Rome: Total War was a technological achievement that still stands to this day, even if, some ten years on, the technology has evolved. There are now more polygons in a rock that gets thrown by a catapult than there was in a soldier from *Rome: Total War*," says designer James Russell of the 2014's sequel. "The visual fidelity has increased, and the game just looks that much better."

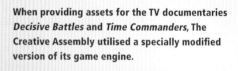

When providing assets for the TV documentaries *Decisive Battles* and *Time Commanders*, The Creative Assembly utilised a specially modified version of its game engine.

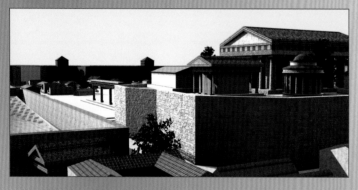

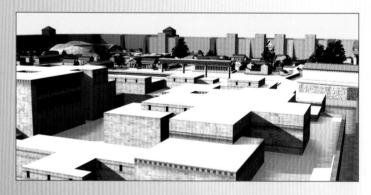

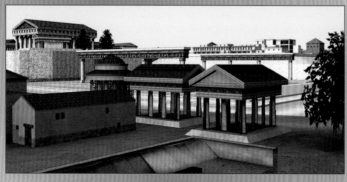

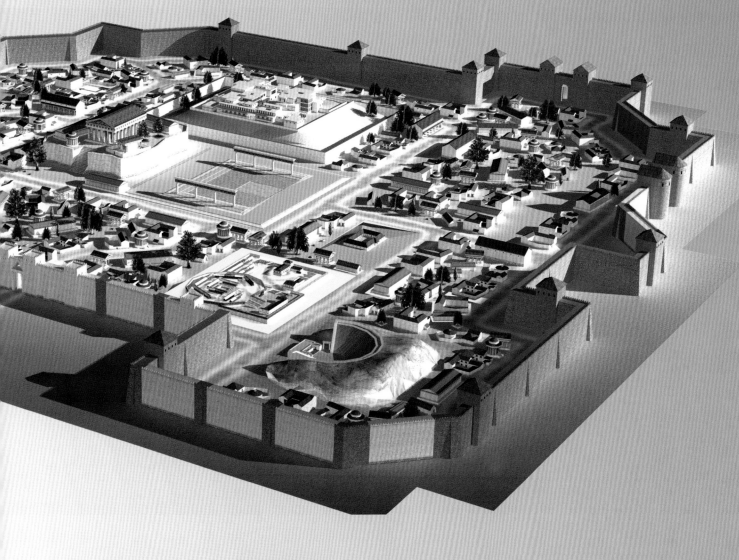

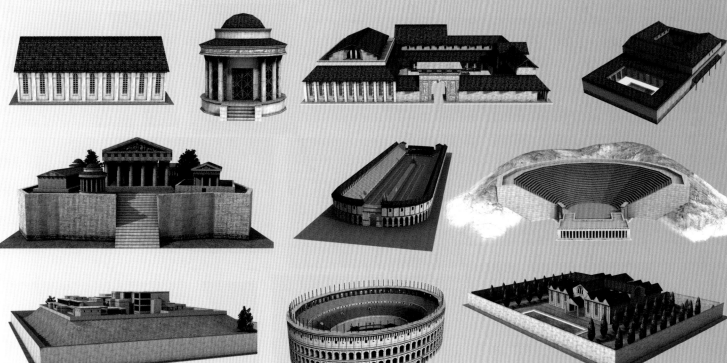

ROME II
AN EMPIRE REVISITED

The Creative Assembly isn't a stranger to revisiting eras it has explored before. Nine years passed between the *Rome* games, though in that time any ideas left on the table after the original have long since been subsumed. "I'm more focused on the games at hand," says Kevin McDowell. "Maybe people don't understand this, but every game that a studio works on, you only do this tiny bit of what you'd like to do. As an artist, you want to recreate the whole world, every shrub, every grain of sand. Obviously we can't do it, so we have to tone it down."

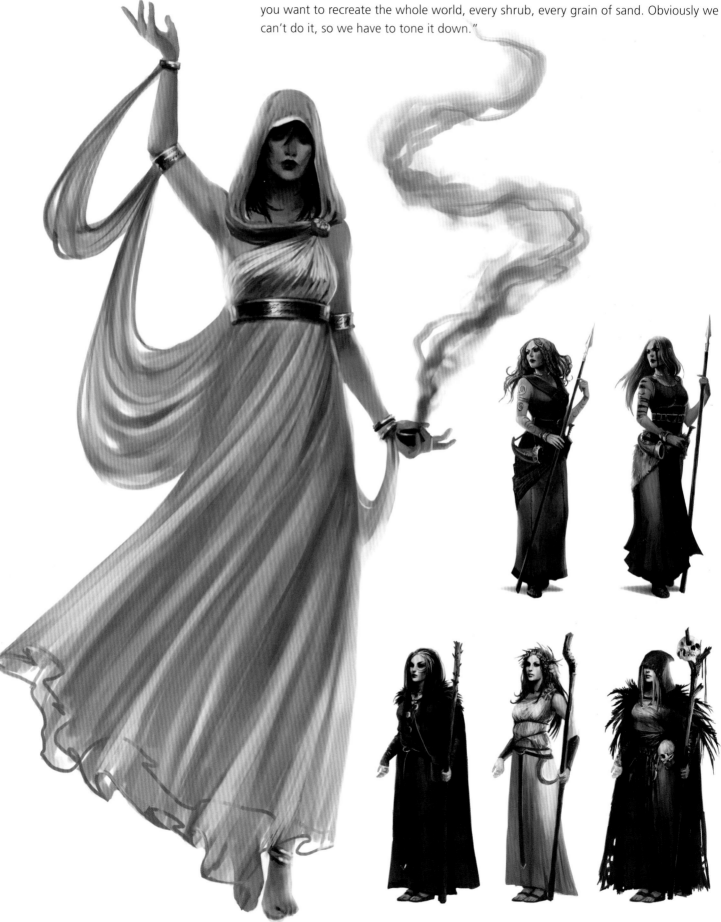

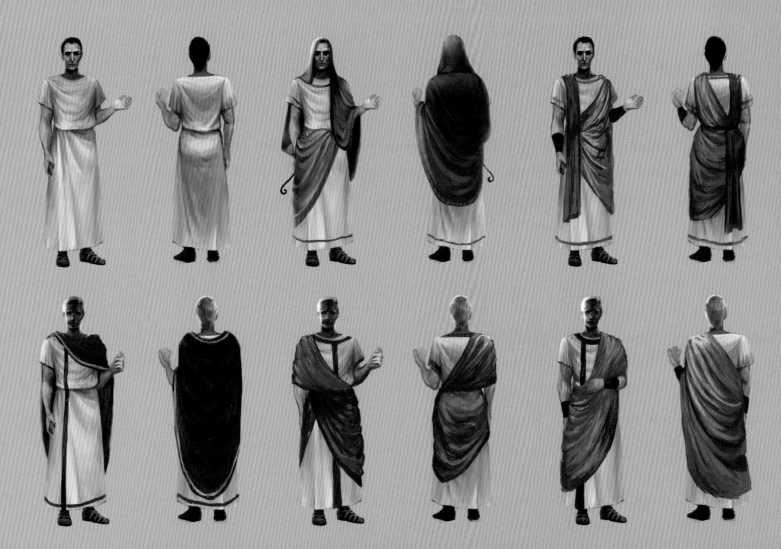

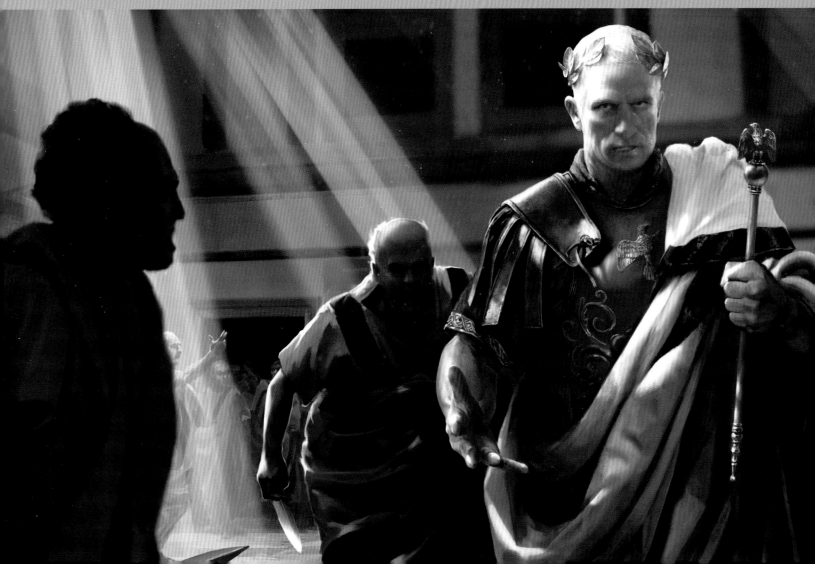

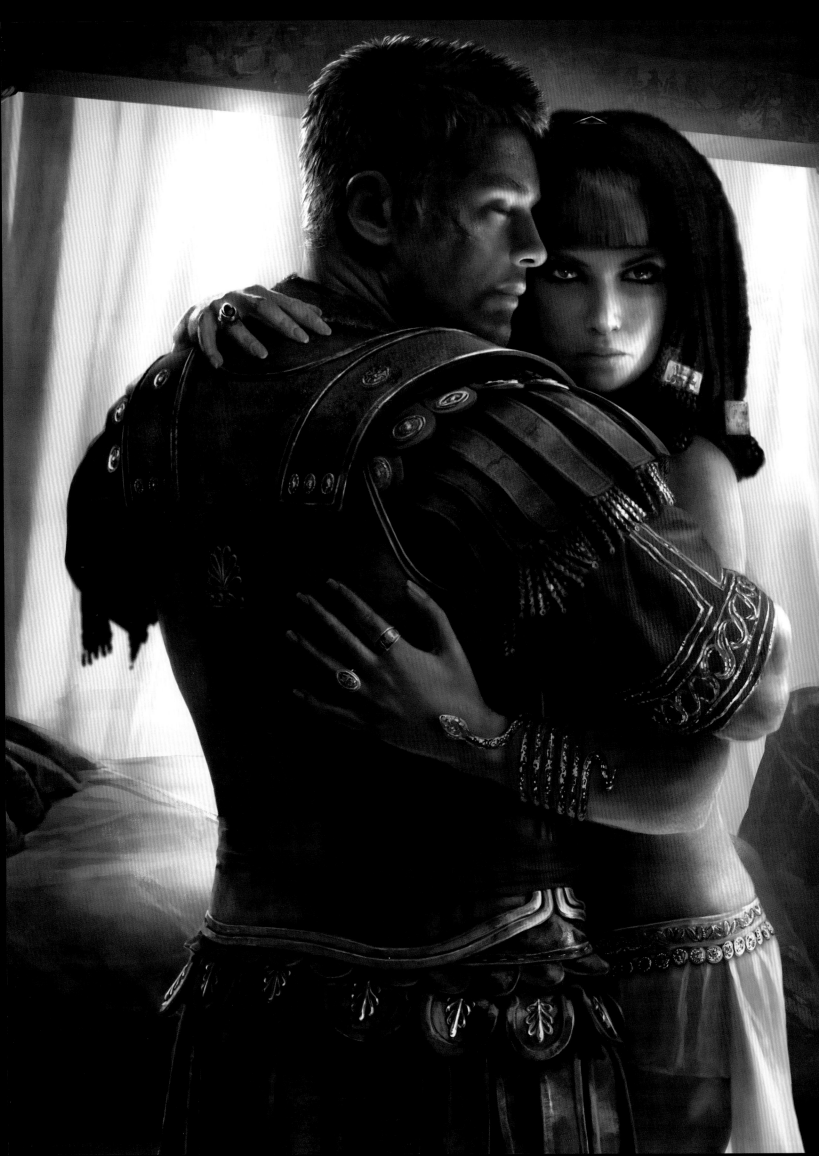

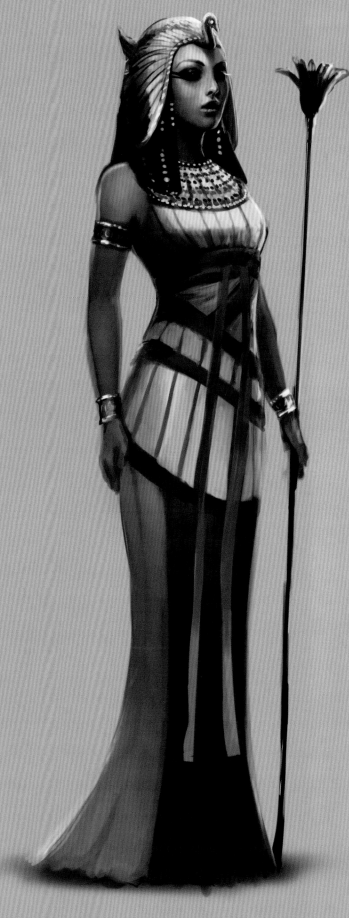

While the team strives to use primary sources for reference, it's understandable a little bit of Hollywood will seep into its designs – especially when dealing with iconic characters of the age.

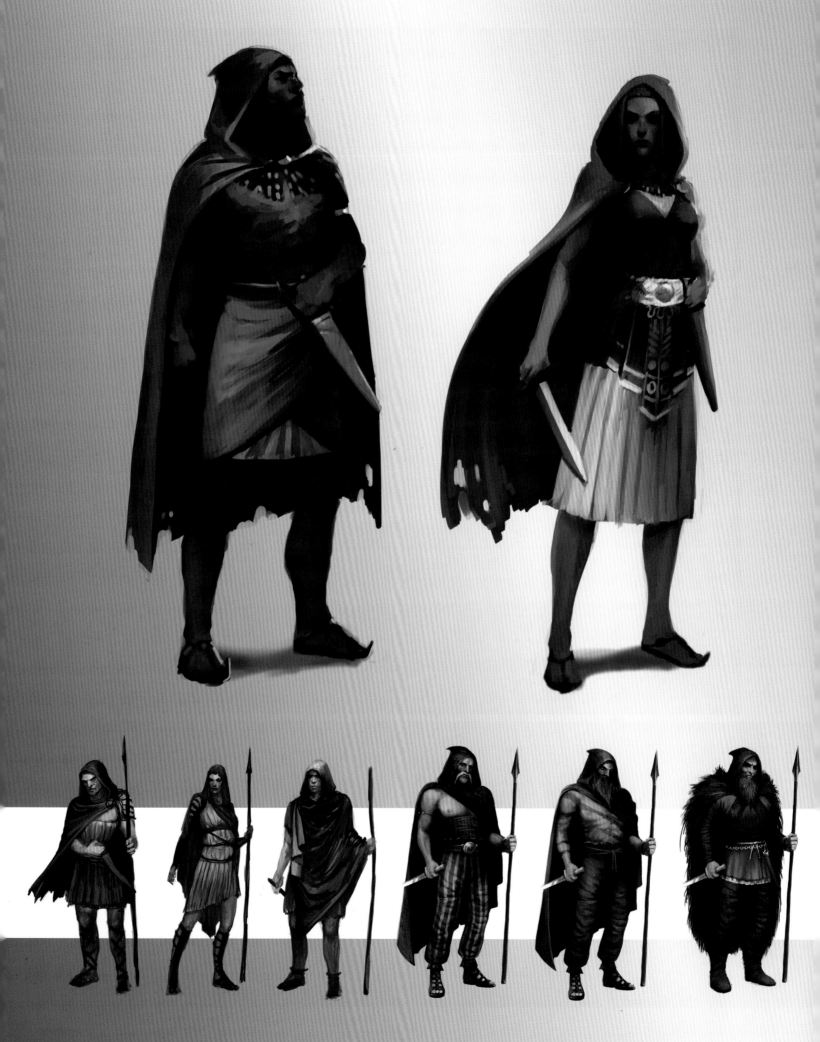

"The tone was a lot grittier in *Total War: Rome II*," says McDowell. "It was more historically accurate, much moodier and much more evocative of the period – you put the two side by side and the original looks quite cartoony by comparison."

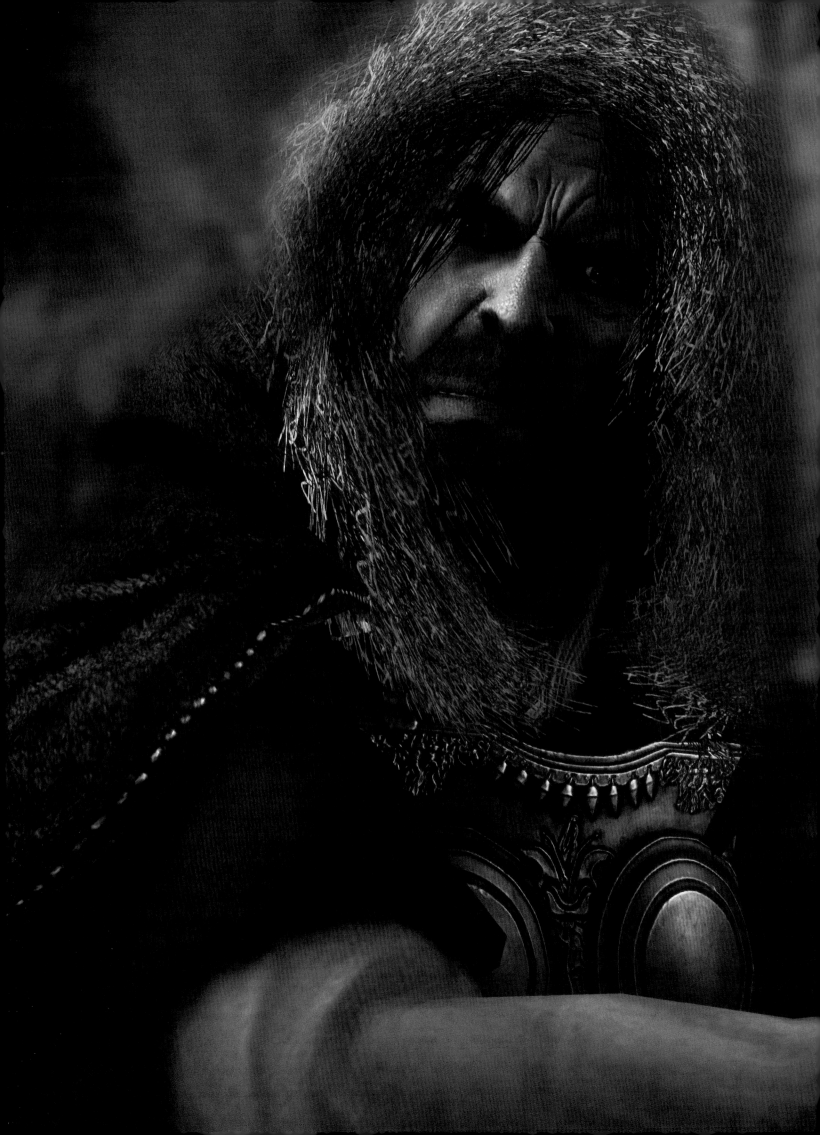

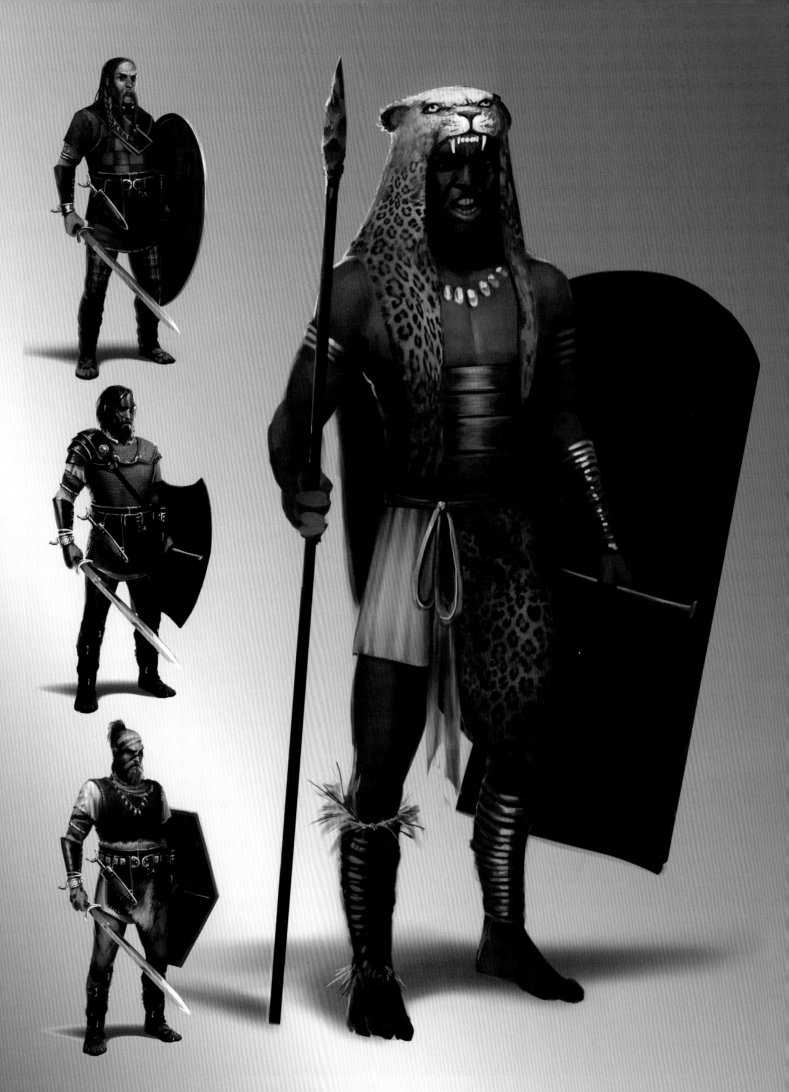

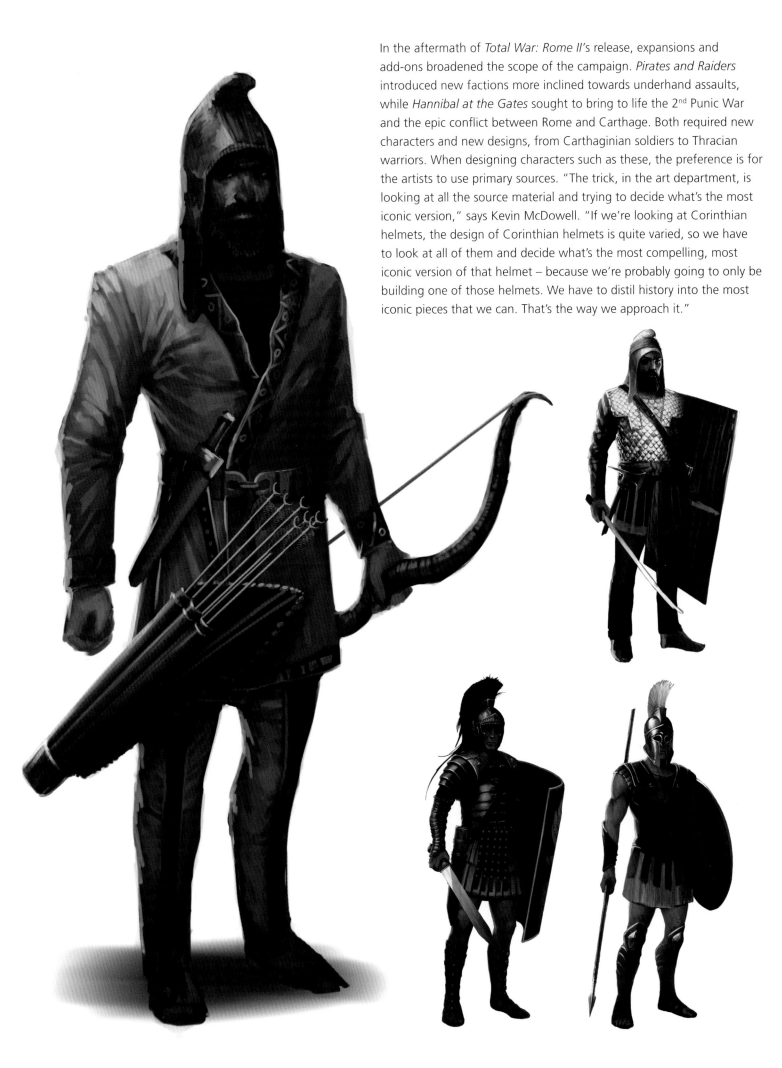

In the aftermath of *Total War: Rome II*'s release, expansions and add-ons broadened the scope of the campaign. *Pirates and Raiders* introduced new factions more inclined towards underhand assaults, while *Hannibal at the Gates* sought to bring to life the 2nd Punic War and the epic conflict between Rome and Carthage. Both required new characters and new designs, from Carthaginian soldiers to Thracian warriors. When designing characters such as these, the preference is for the artists to use primary sources. "The trick, in the art department, is looking at all the source material and trying to decide what's the most iconic version," says Kevin McDowell. "If we're looking at Corinthian helmets, the design of Corinthian helmets is quite varied, so we have to look at all of them and decide what's the most compelling, most iconic version of that helmet – because we're probably going to only be building one of those helmets. We have to distil history into the most iconic pieces that we can. That's the way we approach it."

As the technology has evolved, so too has the process of designing characters to populate *Total War*'s world. With each new game, and with each technological step forward, more detail is allowed. "The designers will come up with a list of units they want, and we'll then break that down into parts and the artist will model those part," says Kevin McDowell. "We've got a tool that we use to construct units out of parts, so designers can make custom units. It allows us to have a variety. A unit might have an option of three different helmets, two different trousers, five different heads."

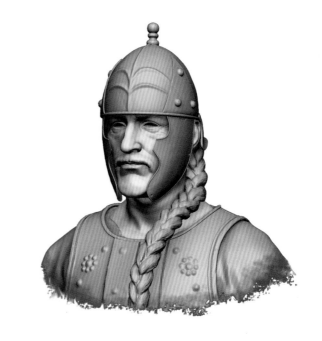

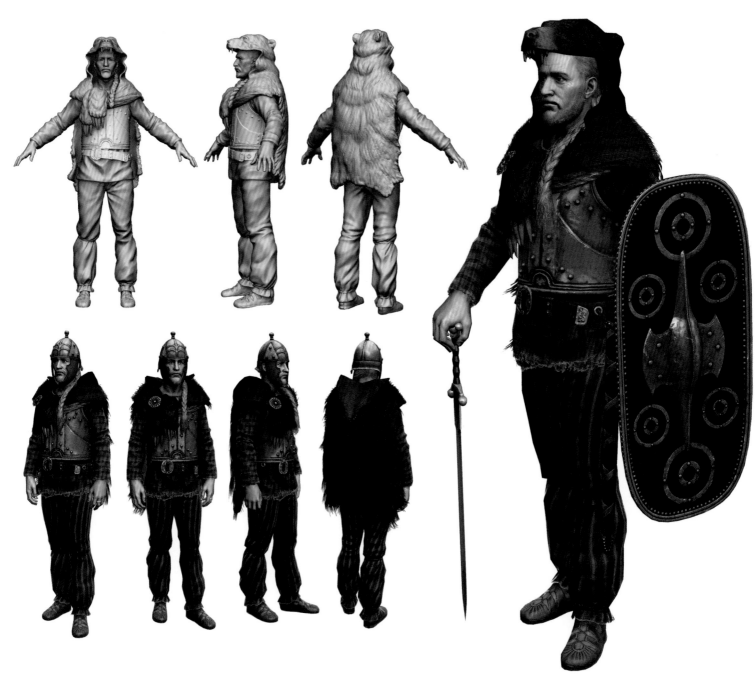

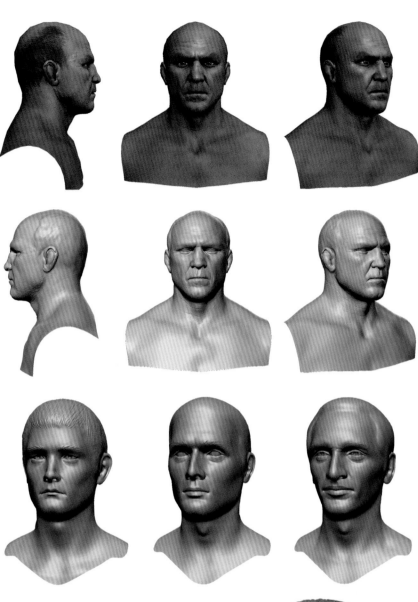

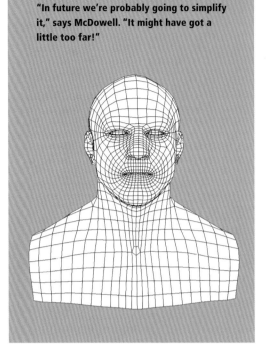

While the advances in technology have allowed for more variety, there is a limit. "In future we're probably going to simplify it," says McDowell. "It might have got a little too far!"

In the original *Rome* characters were simply clones – by the time of *Empire* they comprised of three parts, which had ballooned to some nine elements for the release of Rome II.

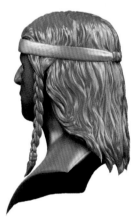
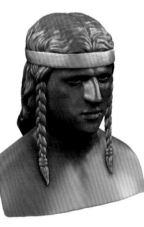

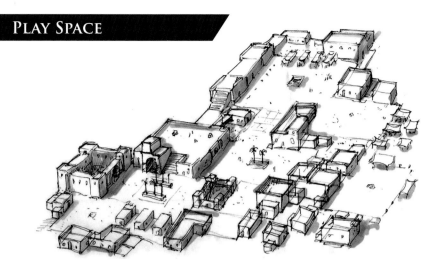

"When it comes to the architecture in the game, in some cases the gameplay will take precedence," explains Kevin McDowell of the city planning. "If you look at the design of our cities, the way the walls are constructed for sieges etc, the primary consideration is gameplay. The rest is skinning it to the right culture type." McDowell himself has some experience in how to build cities for more practical purposes, having originally trained as an architect. "I quit architecture because I wanted to build virtual worlds," he says, before noting the crossover between disciplines. "I know five or six architects, at least, who work in video games."

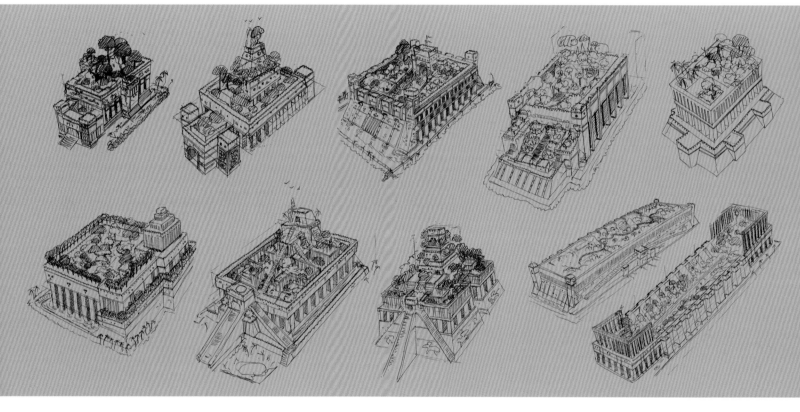

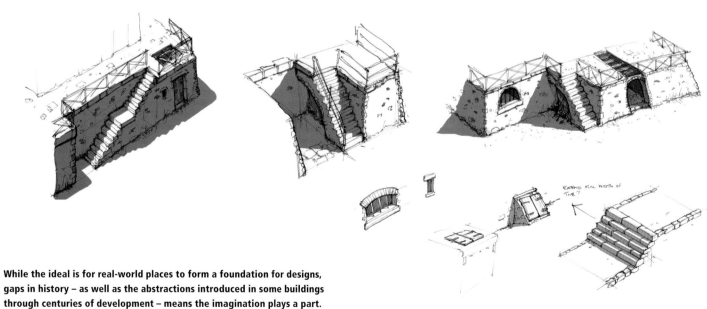

While the ideal is for real-world places to form a foundation for designs, gaps in history – as well as the abstractions introduced in some buildings through centuries of development – means the imagination plays a part.

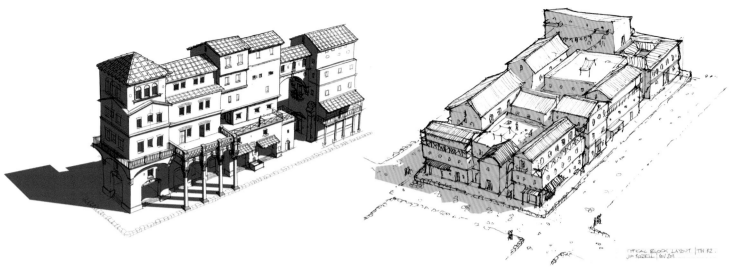

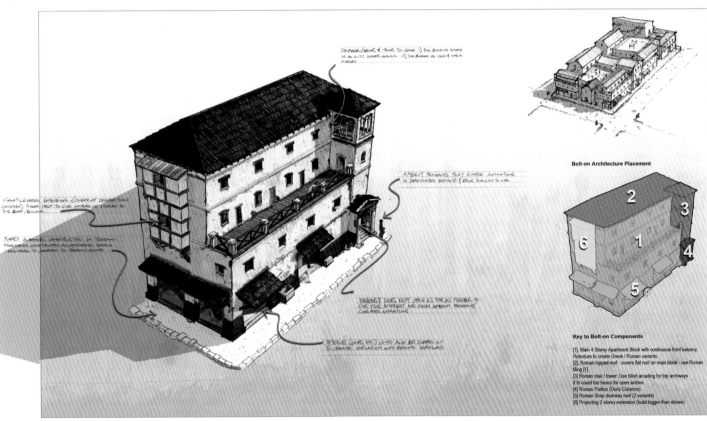

Bolt-on Architecture Placement

Key to Bolt-on Components

[1]. Main 4 Storey Apartment Block with continuous front balcony. Retexture to create Greek / Roman variants.
[2]. Roman hipped roof - covers flat roof on main block - use Roman tiling [1]
[3] Roman stair / tower. Use blind arcading for top archways if tri count too heavy for open arches.
[4] Roman Portico (Doric Columns)
[5] Roman Shop doorway roof (2 variants)
[6] Projecting 2 storey extension (build bigger than shown)

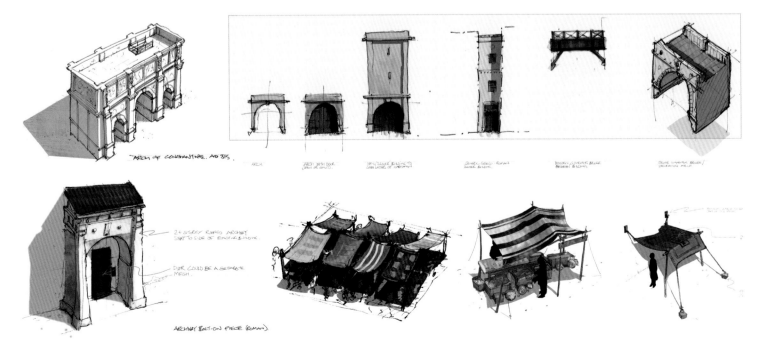

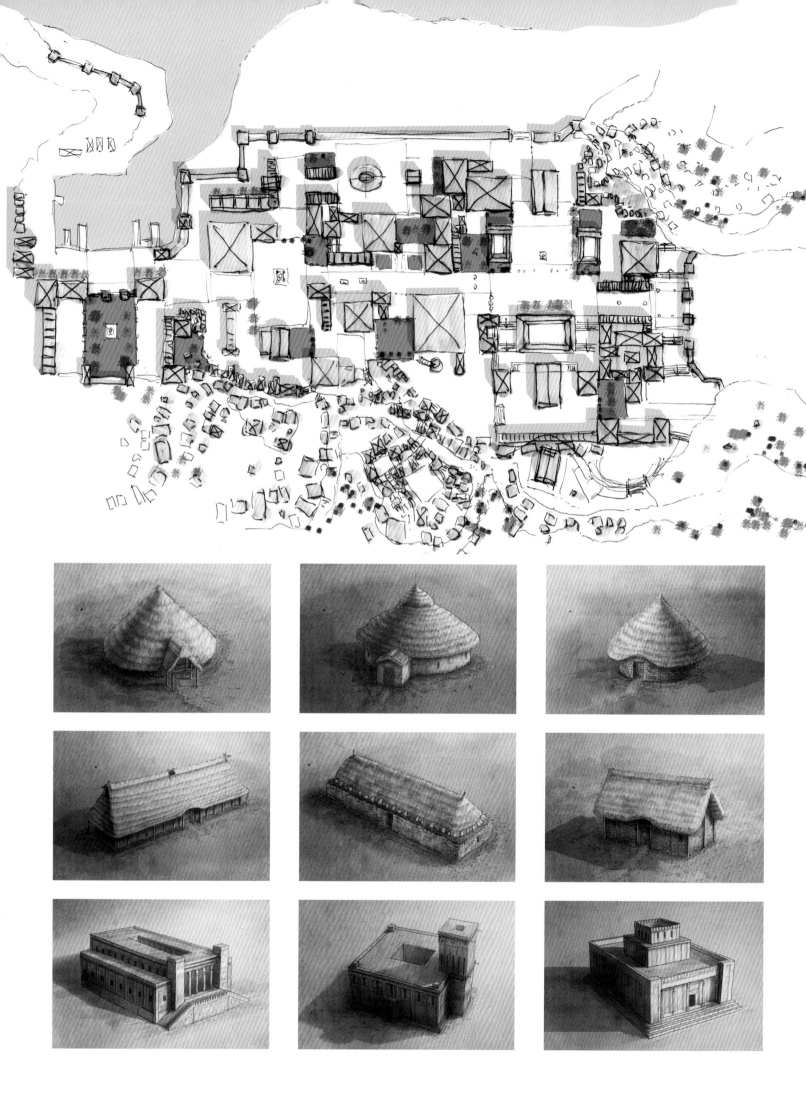

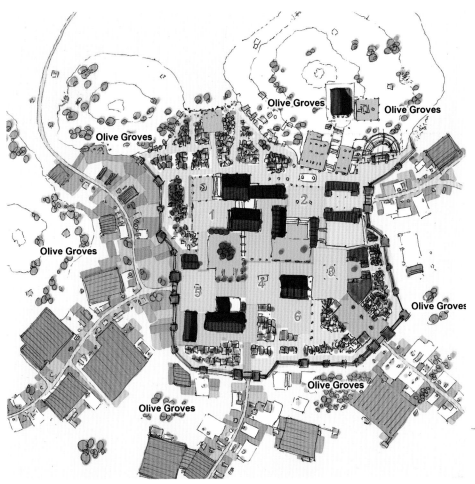

Olive Groves

Olive Groves

Olive Groves

Olive Groves

Olive Groves

Olive Groves

Olive Groves

Olive Groves

Different contexts require different approaches – whereas buildings that feature in battle are designed with gameplay in mind, those that are intended for the campaign map feature less detail, and are more for illustrative purposes.

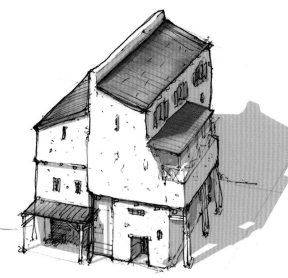

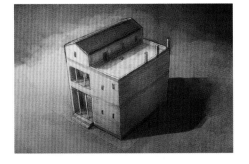

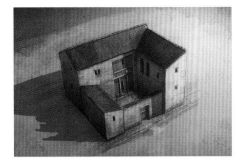

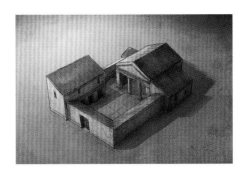

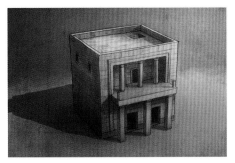

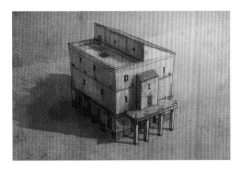

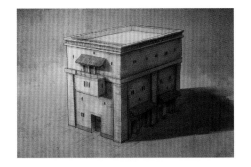

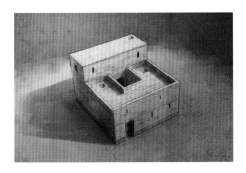

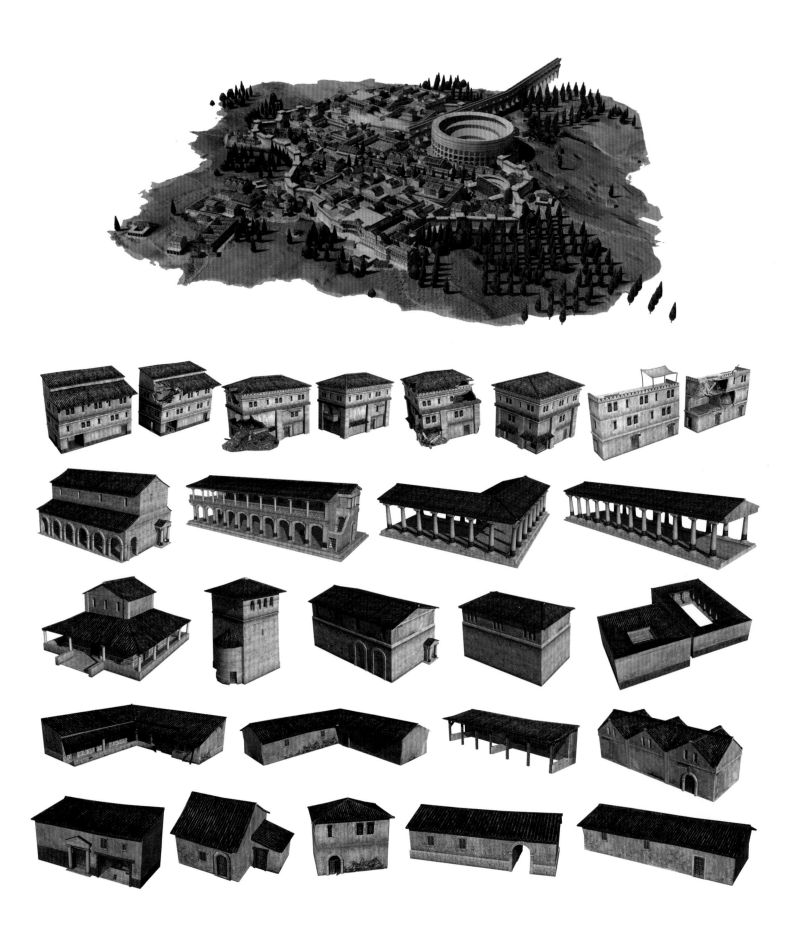

While historical maps give some idea of fallen cities such as Carthage, gaps remain to be fleshed out in order to create coherent spaces.

The military port of Carthage is an elegant construction, meticulously reconstructed by The Creative Assembly's artists and modellers. As a building it's impressive, its imposing shape once sitting in the now ruined Tunisian city. It would play a starring role in the Third Punic War's Battle of the Port of Carthage, its narrow entrance blockaded and allowing a slim victory for the Carthaginian forces.

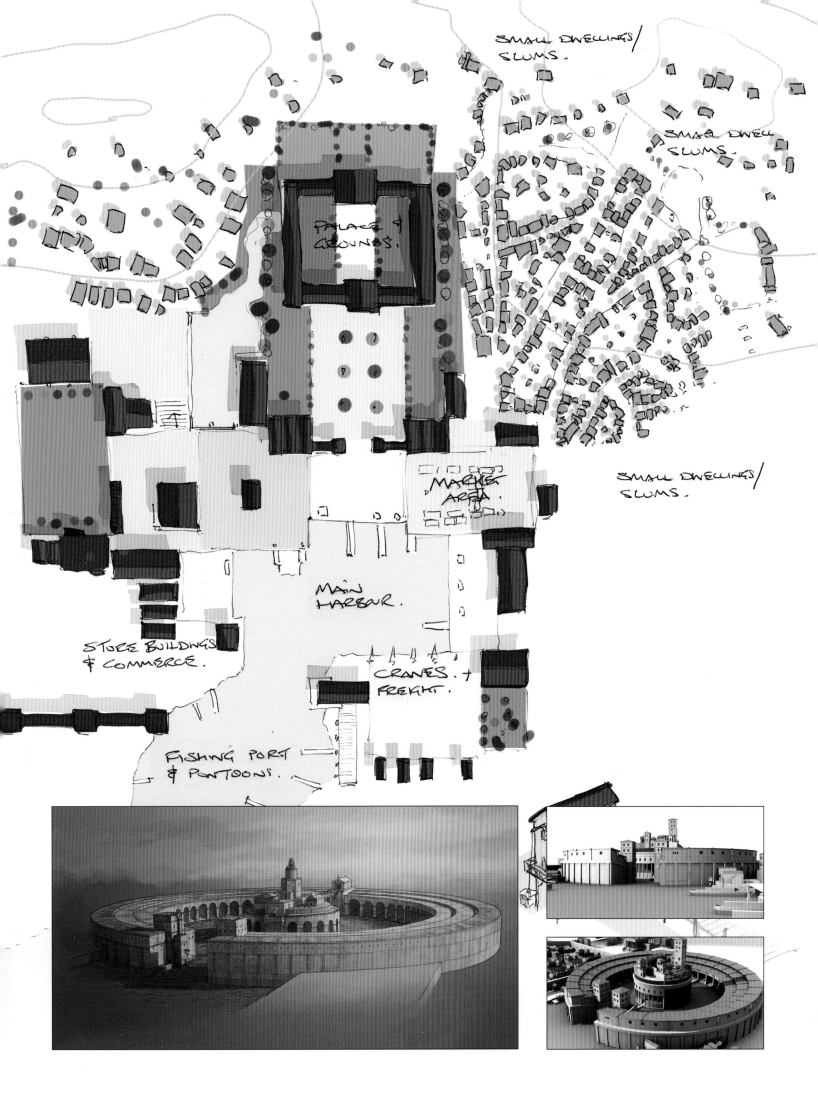

SMALL DWELLINGS/
SLUMS.

SMALL DWELL
SLUMS.

PALACE &
GROUNDS.

SMALL DWELLINGS/
SLUMS.

MARKET
AREA.

MAIN
HARBOUR.

STORE BUILDINGS
& COMMERCE.

CRANES +
FREIGHT.

FISHING PORT
& PONTOONS.

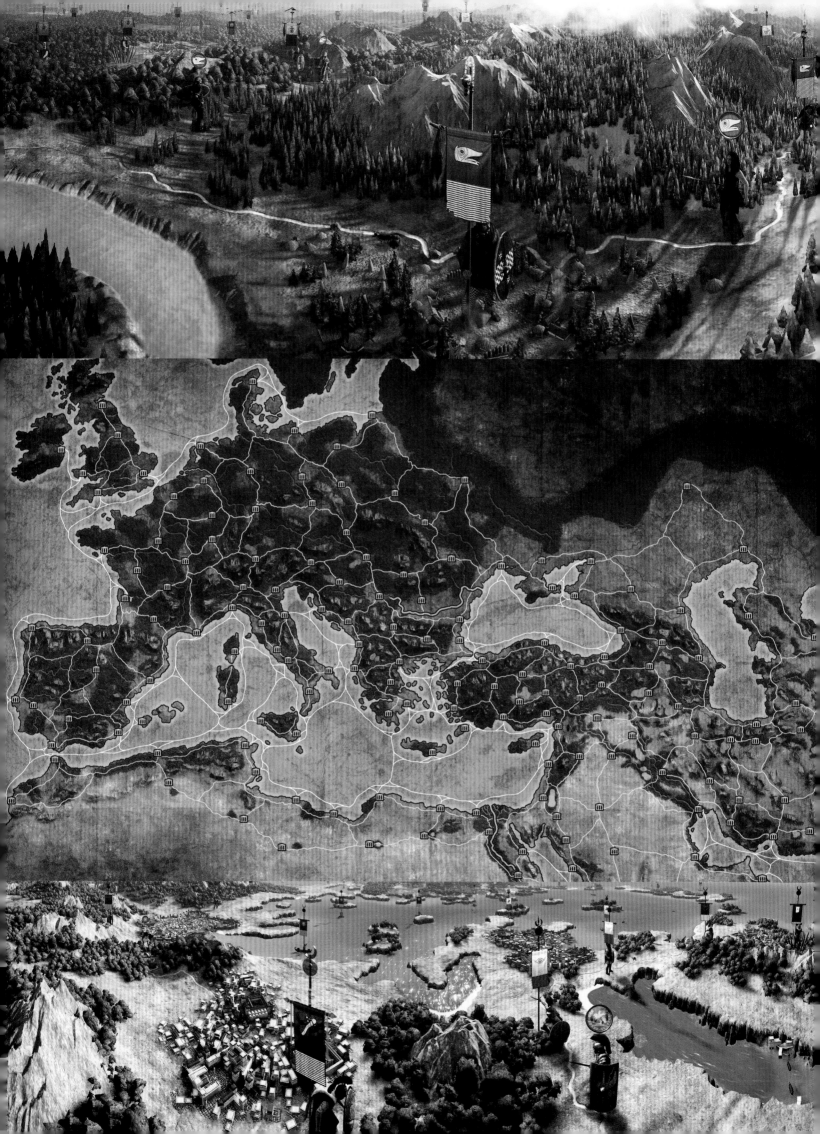

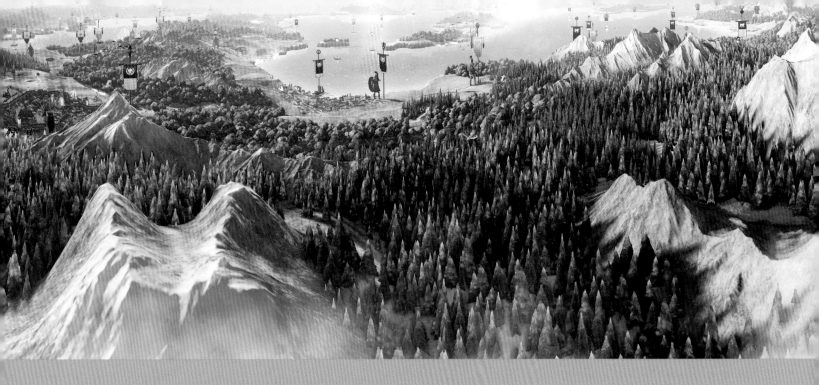

An increasing area of focus for The Creative Assembly is the campaign map itself. "In our original prototype, the campaign map was constructed as a wrapper to generate the battles," says James Russell. "We've now made the campaign game more elaborate. Obviously the battles have improved, as has the campaign map. Now it's designed to be a game in its own right. People love playing the campaigns – it's the structure of the game you're playing. The battles are an integral part of it, but the unique selling point of *Total War* is that combination." With each new instalment of *Total War*, that map becomes more complex – and by the time of *Total War: Rome II*, it's a dense, incredibly detailed depiction of the world you fight to control.

CAMPAIGN MAP

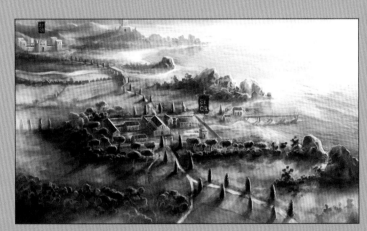

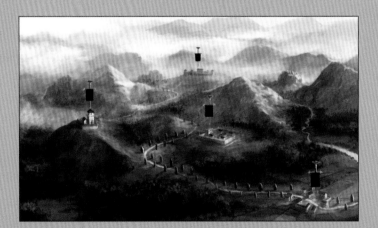

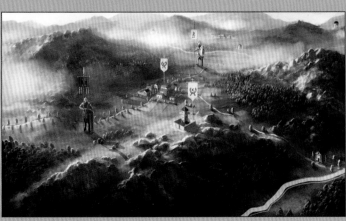

Total War has always excelled at grand spectacle, just as it's endeavoured for great detail. It's a challenge unique to a series that takes a broad view of history while allowing players to get up close with the battlefields it has been fought upon. "What's special about the battles is this spectrum of scale that you've got," says designer James Russell. "You zoom out and you've got thousands of soldiers, and it looks epic. You zoom right in and they have to look great close up when you're seeing a one-on-one melee. We have a very sophisticated level of detail system that means we can deal with that, but the artists also have to create something with great fidelity close-up but also understand that a lot of the time players are going to be looking at ants."

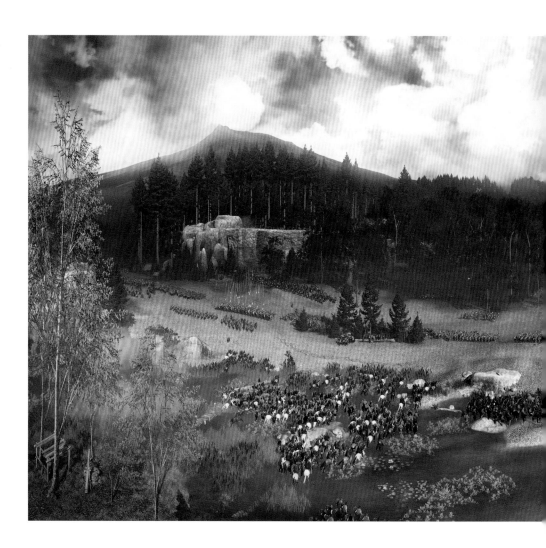

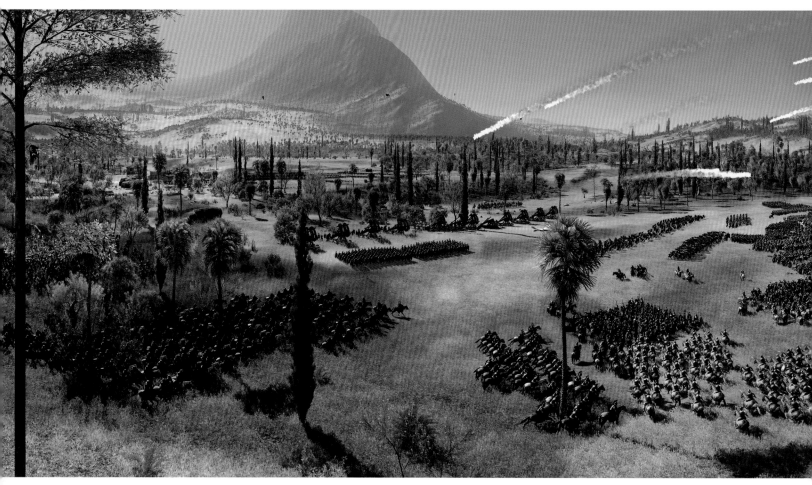

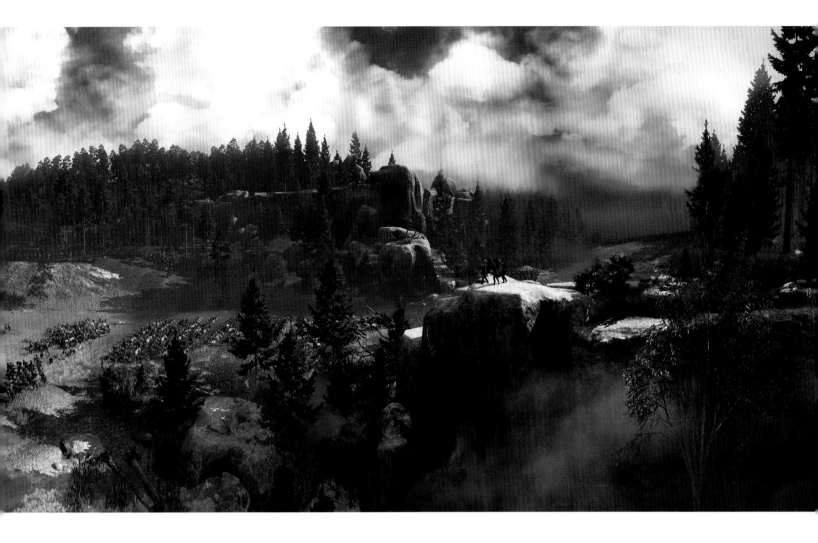

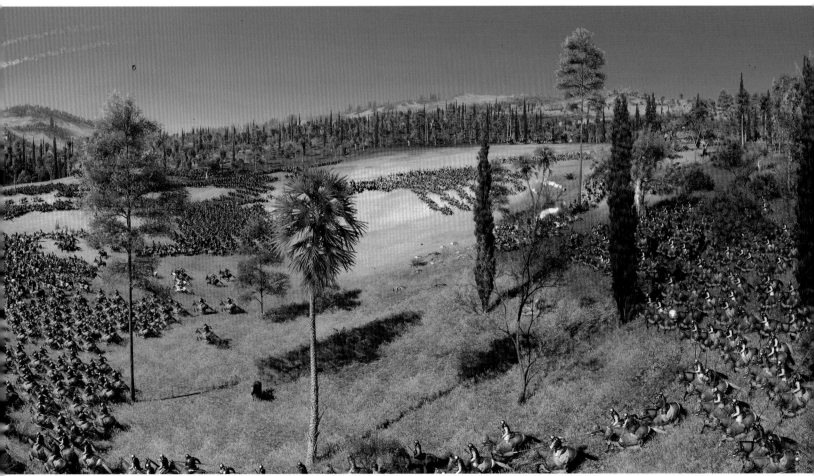

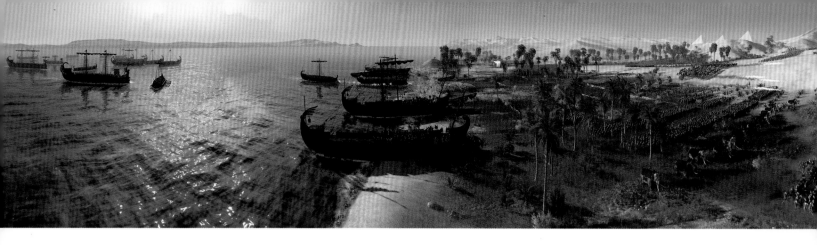

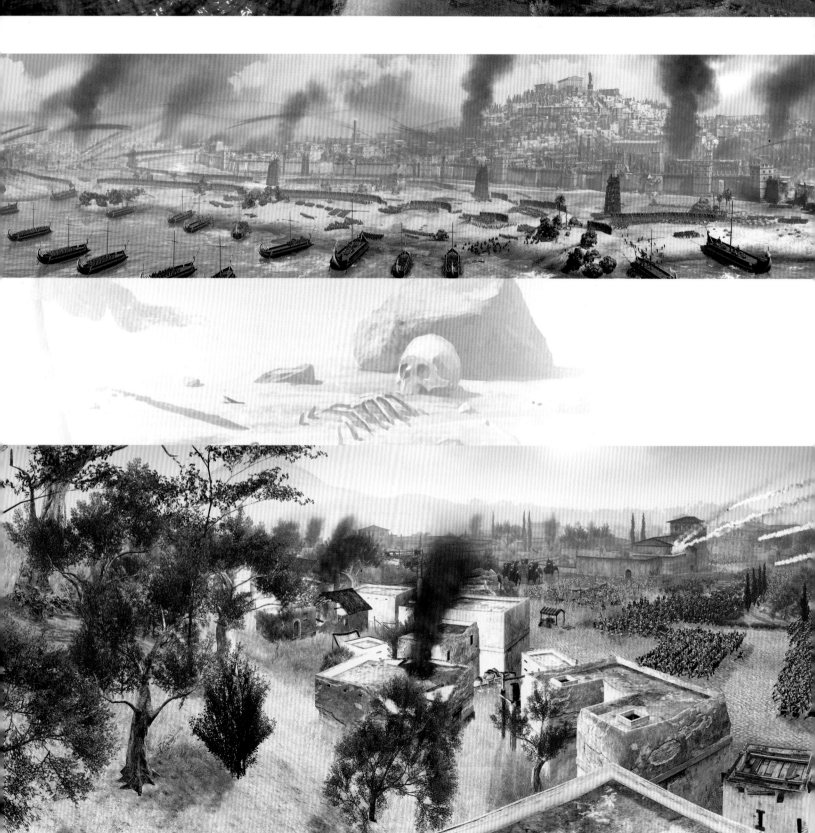

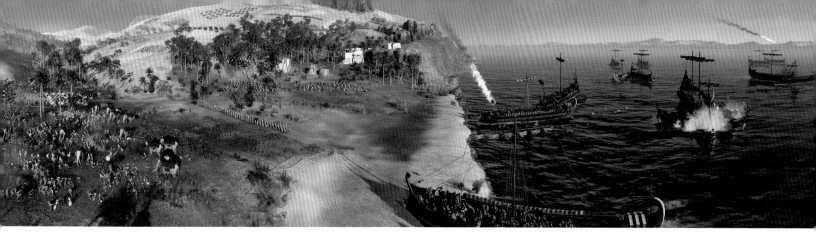

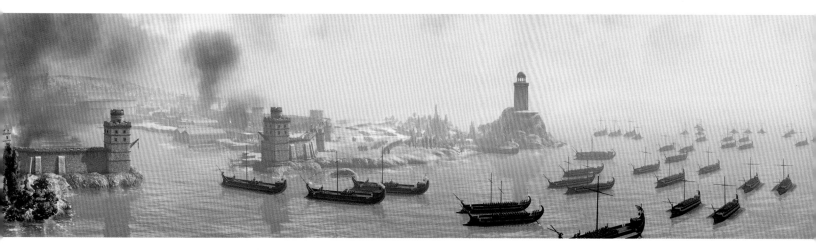

Panoramic screens taken from *Total War: Rome II* show just how beautiful its battles can be when caught in action. "We do have a very cinematic philosophy," says James Russell. "In the battles, our intention is that they look very cinematic. Every game developer will say that, of course, but what that means for us is we do sometimes make compromises – we don't make game-lead delineations where we say this area is grass, this area is a forest with all its modifiers. We have those modifiers, but we're not having barriers – it's all visually-led."

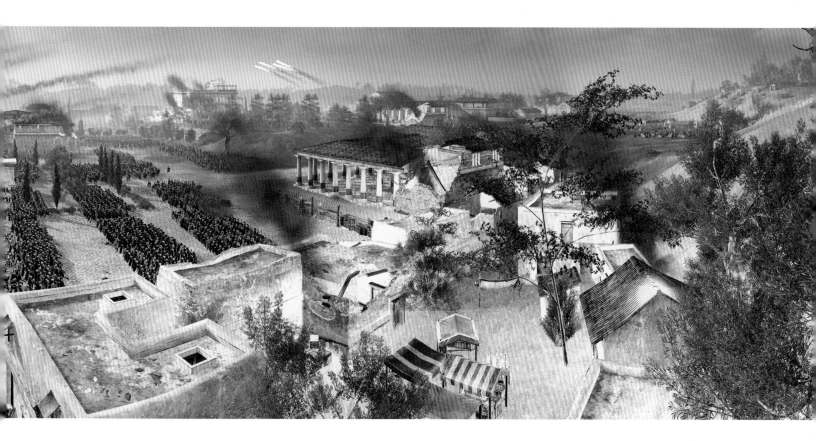

The painterly art of Rado Javor does more than bring a soft, moody light to historical scenes such as the Battle of the Port of Carthage - the artist's own passions help some of the reconstruction, too. Javor has a passion for ships that's proven indispensable. "Rado designs a lot of the ships, especially for an ancient period like Roman times," says Kevin McDowell. "There's virtually nothing in terms of primary sources, or even secondary sources when it comes to these. You have to fill in the gaps – and Rado's very good at that due to his knowledge in ship design."

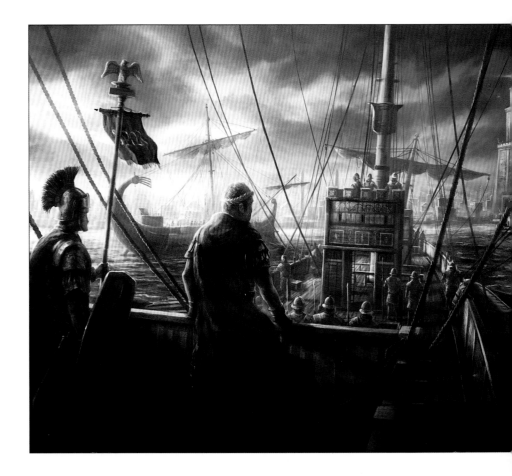

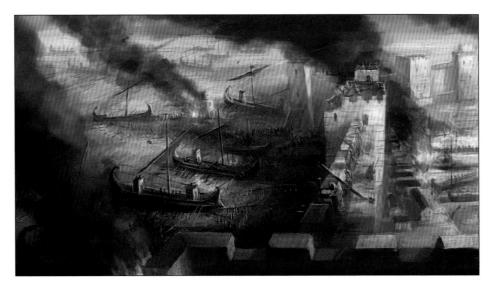

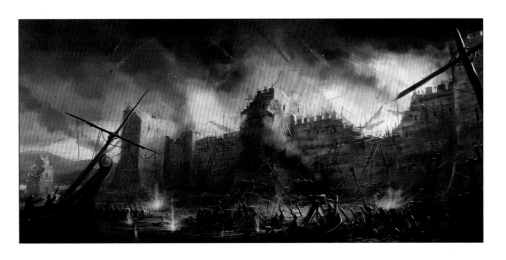

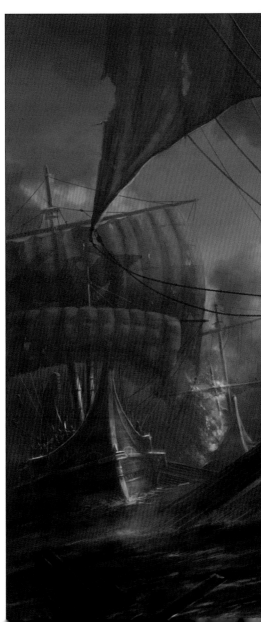

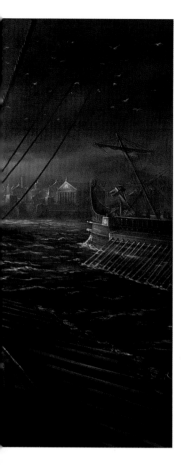

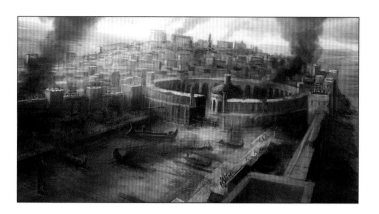

"The idea of realism in a game has to be taken with a pinch of salt," says James Russell of the conflict that runs through the *Total War* series. "This is a line I often use: if battles were truly realistic, they'd last 24 hours, and there'd be breaks every few hours for people collecting their dead and eating. You'd have two-day battles.

"It's not about saying we want to be like Hollywood – when you're creating an entertainment product, there has to be shortcuts, and we happen to have similar shortcuts to what Hollywood would use. Hollywood focuses on the spectacular elements, and we want to do the same thing, which is focus on the spectacular. We don't want to spend six months on a siege – we leave that on a campaign map – we want to focus on the bombarding, when the walls come down, and the assault."

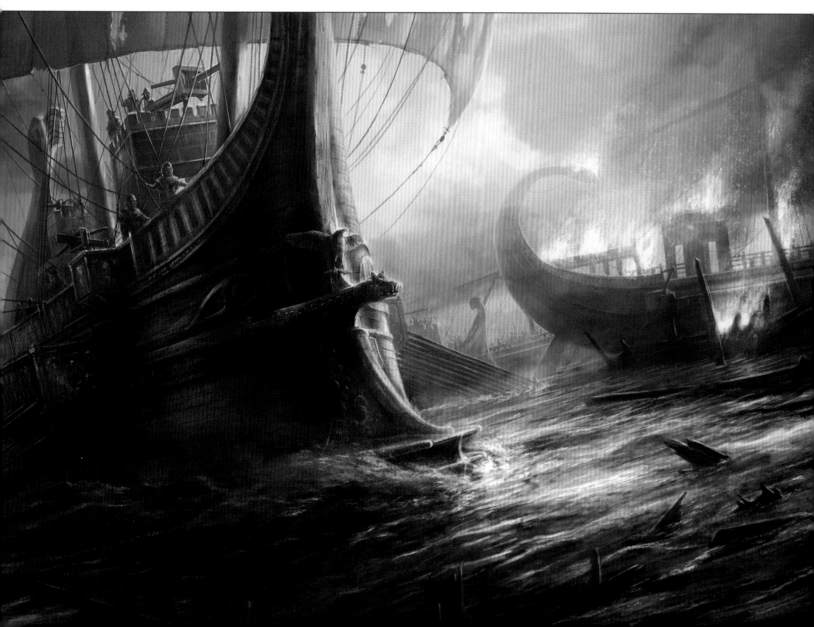

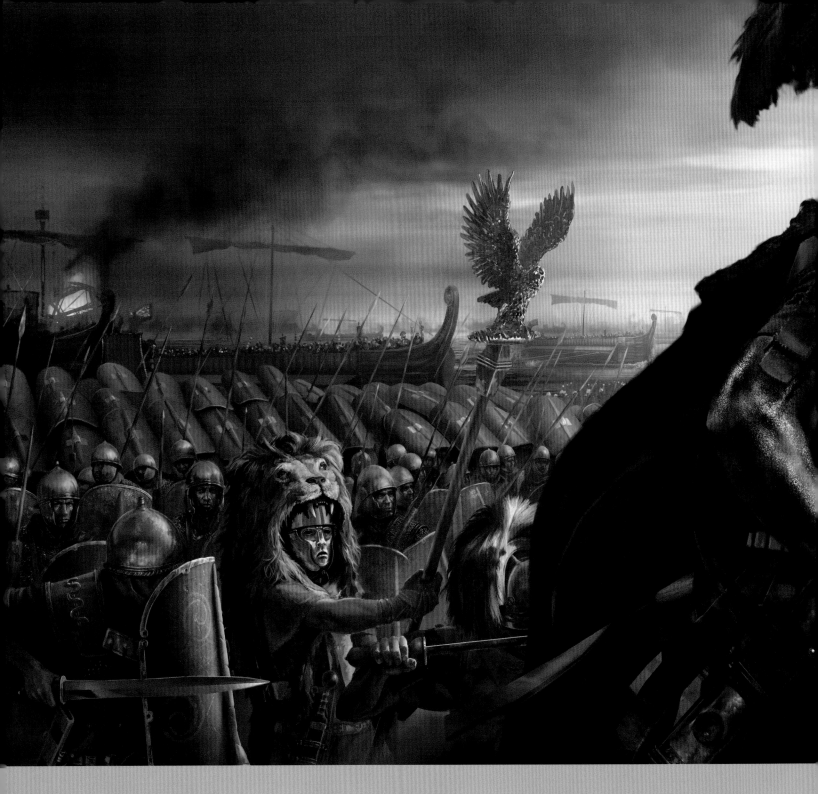

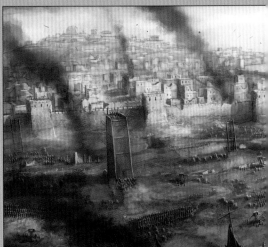

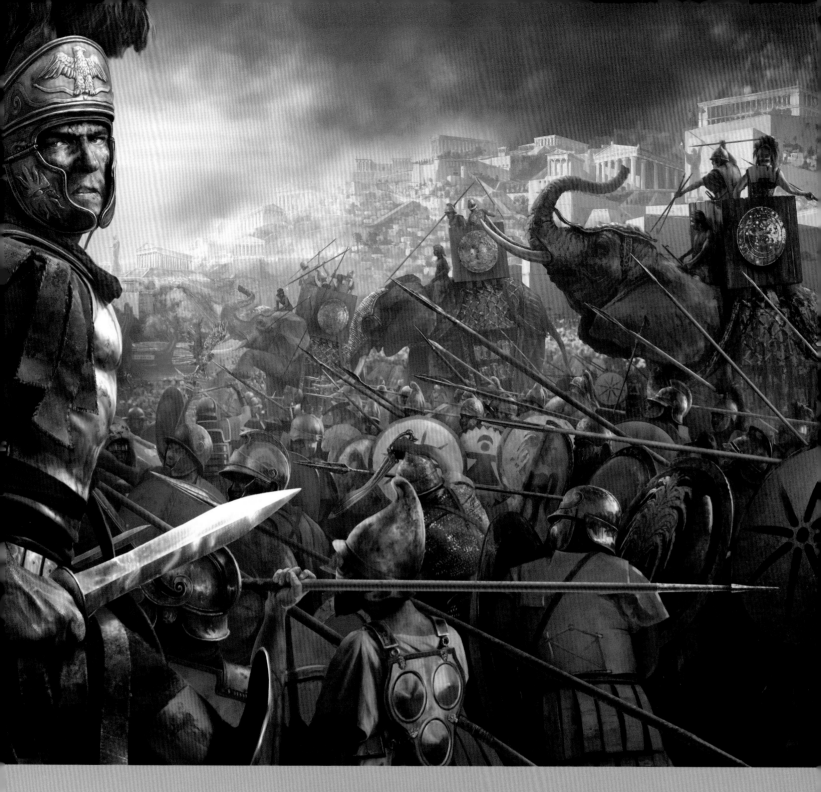

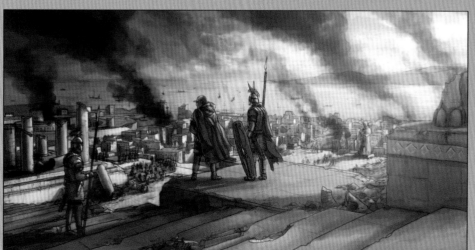

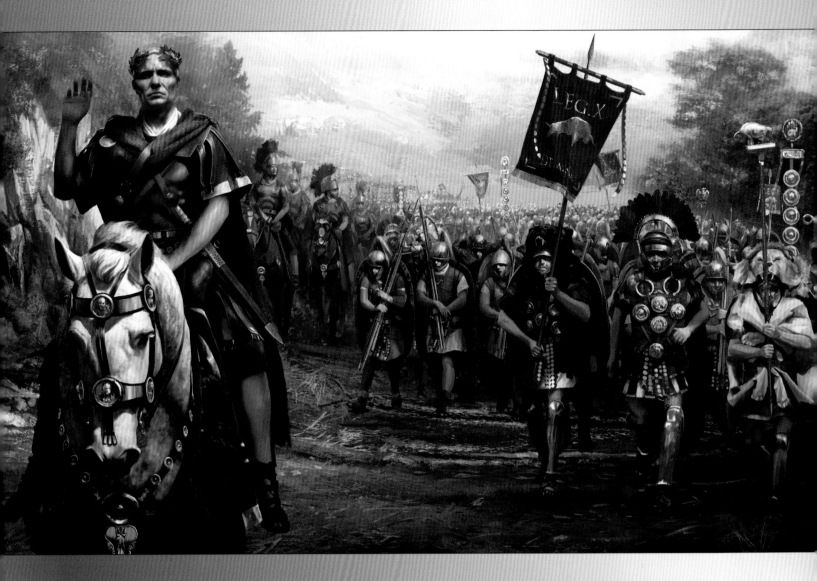

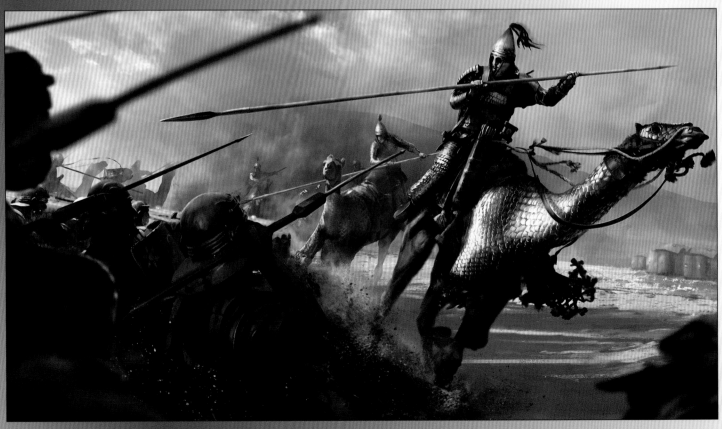

Battlegrounds can be confusing, though it's the job of designers to make sense of them for the player. "We want the user interface to be perhaps a little bit more minimal than many games," says James Russell. "You don't get dozens of icons – you have them over the units, but we try to make them as embedded in the world as possible."

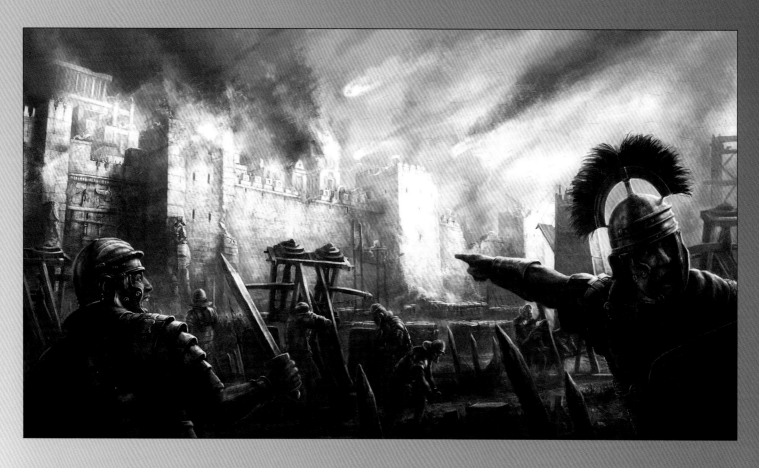

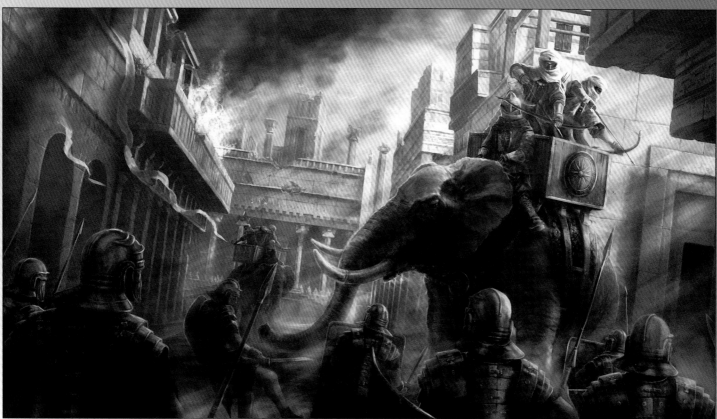

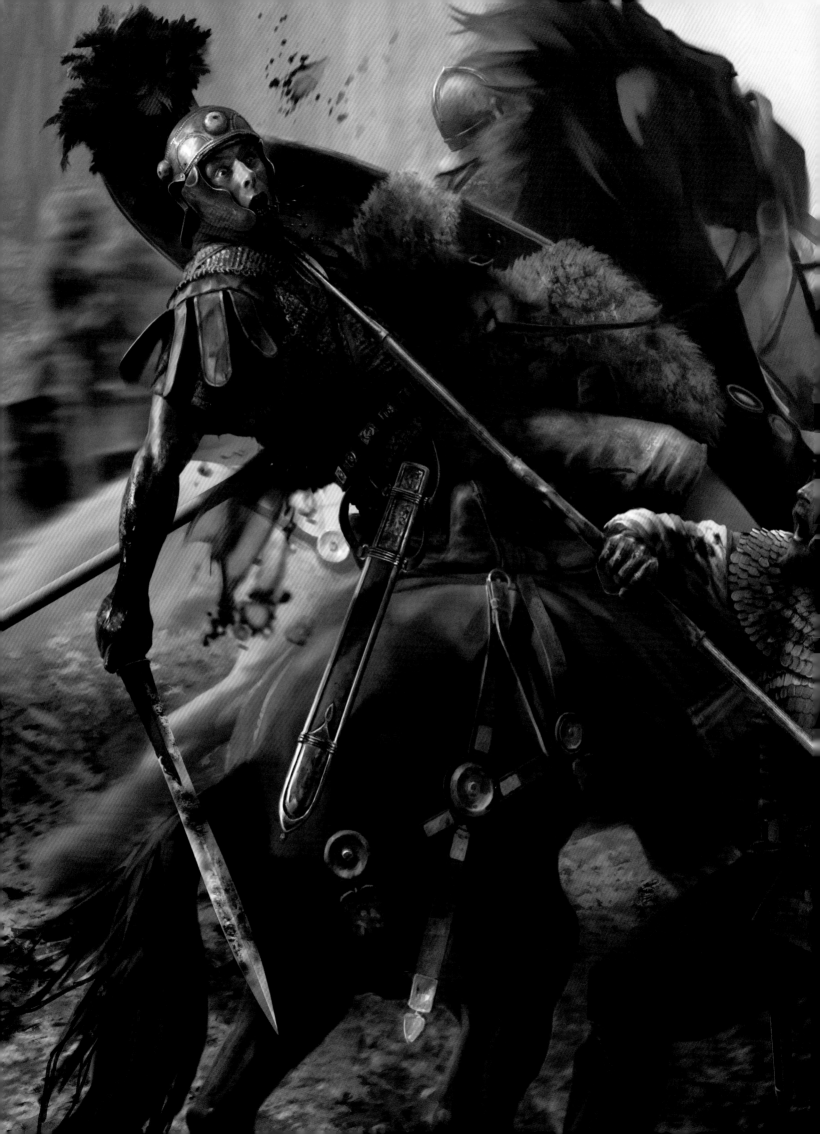

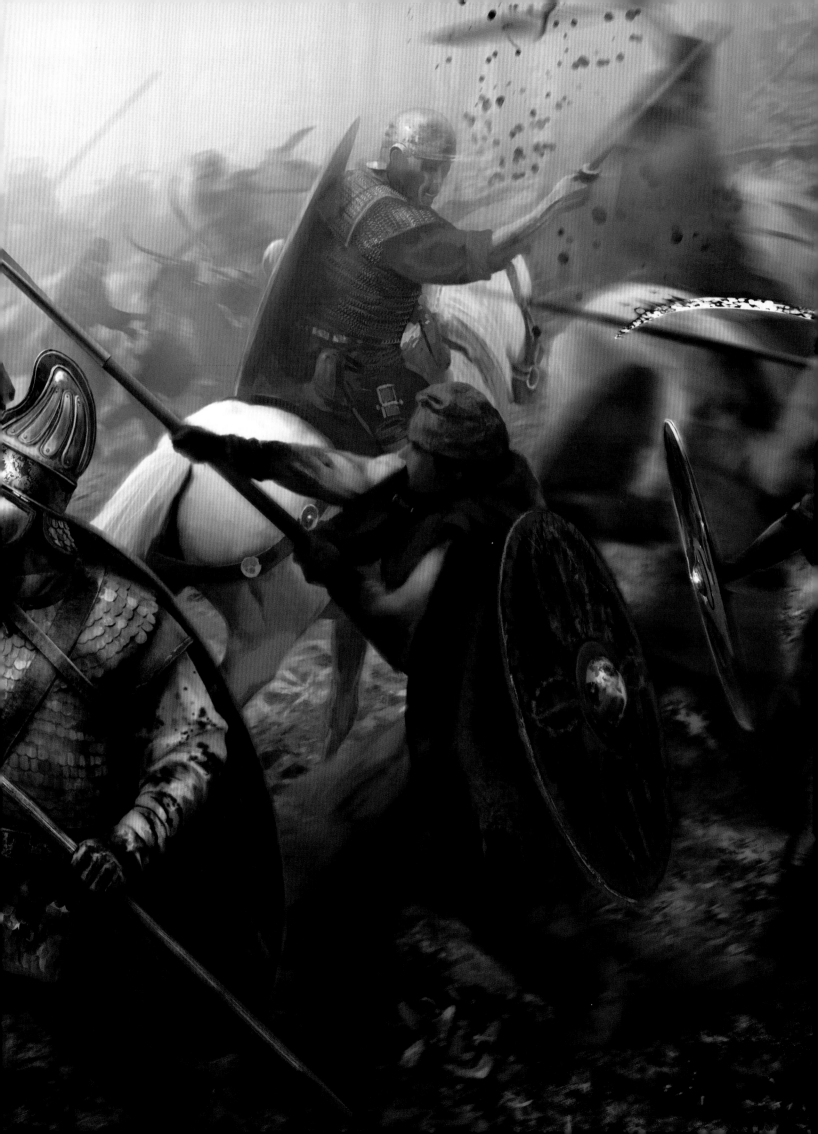

"Death and disease stalk the streets of *Total War: Rome II*'s cities.
"It's gritty, dark and a bit more brutal – which is the opposite of
Rome: Total War," says Kevin McDowell. "You know, war's not fun."

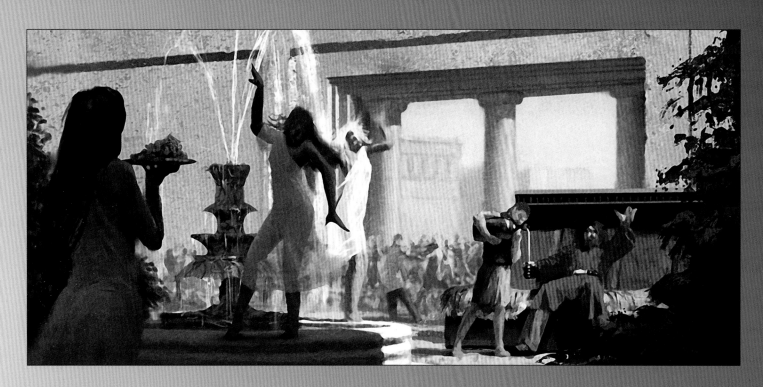

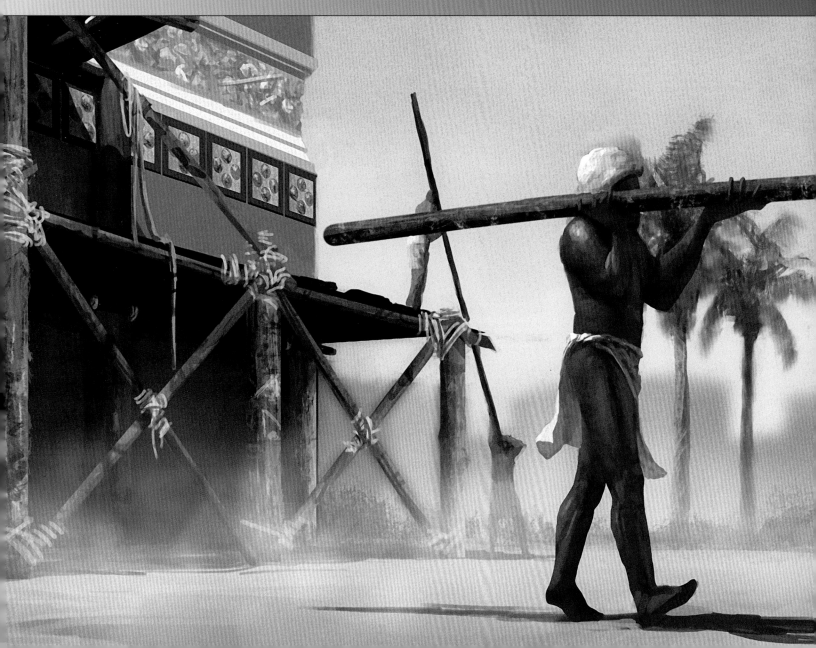

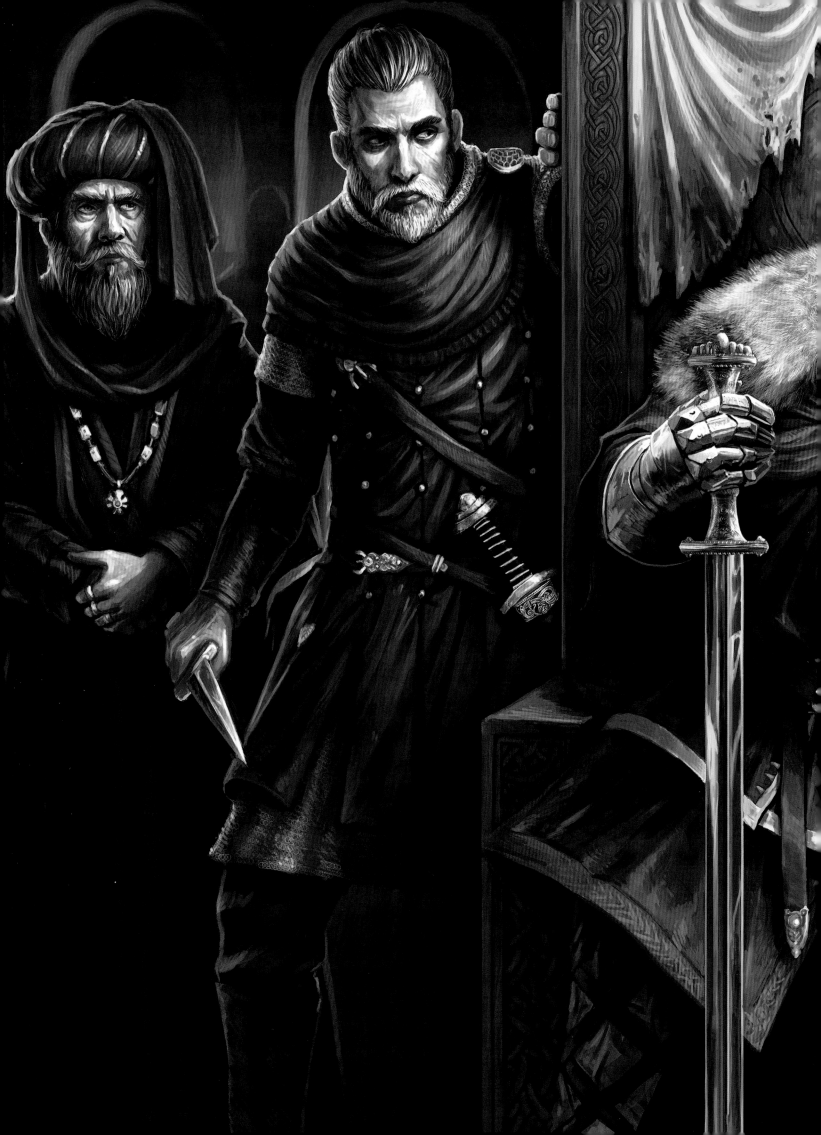

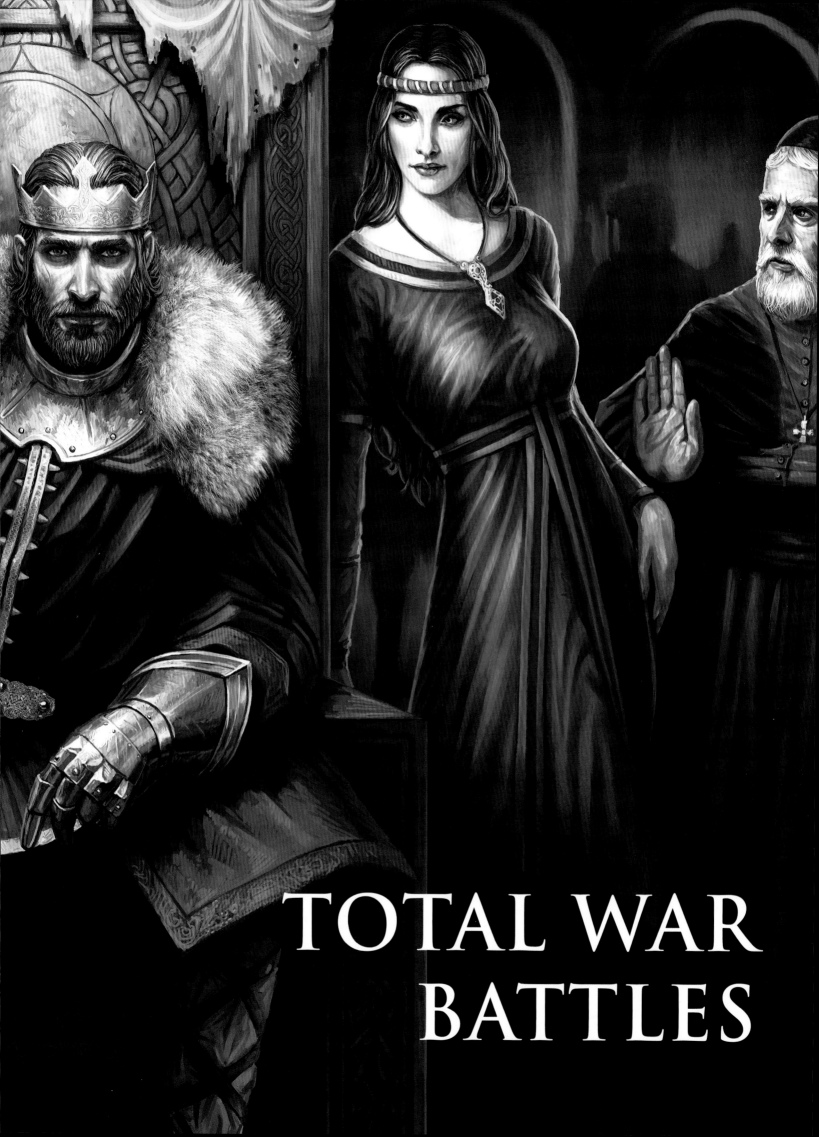

TOTAL WAR
BATTLES

KINGDOM
A New Realm Awaits

While the *Total War* series has never been short of fans, the rise of new platforms such as mobile and tablet enabled The Creative Assembly to embrace the new, emerging audiences with *Battles*. "The idea was to distil the core elements of *Total War*," says *Battles'* head Renaud Charpentier of how his team went about creating a mobile experience that was faithful to the tenets of the series. "A video game's DNA is in its core elements, and the rest is execution. You can change the execution when you change the platform, but you can also keep the DNA the same." Following the success of *Total War Battles: Shogun*, the team is now working on *Kingdoms*, a sequel set across 10th century England.

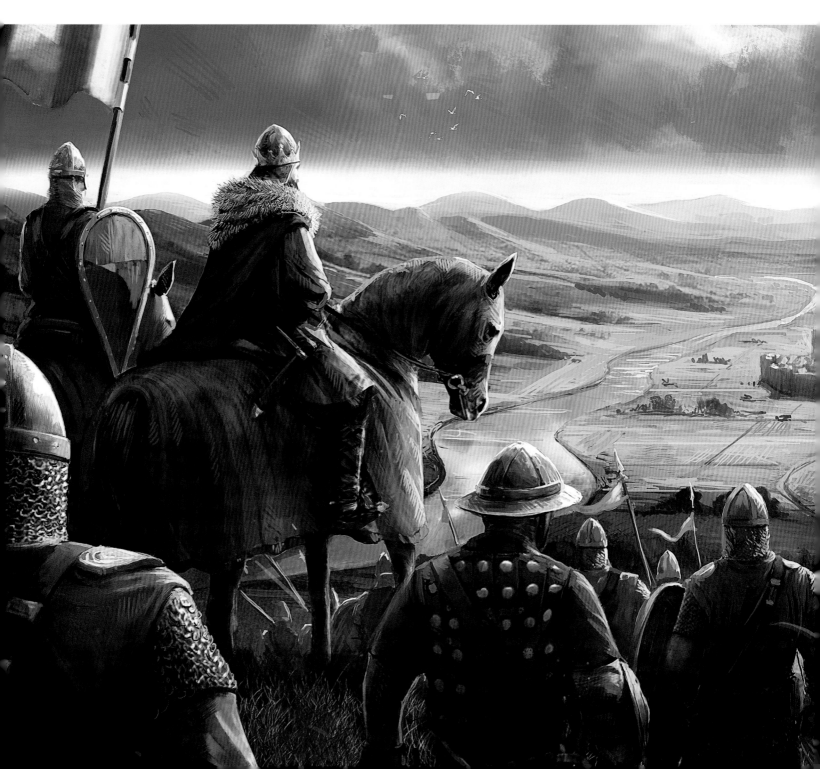

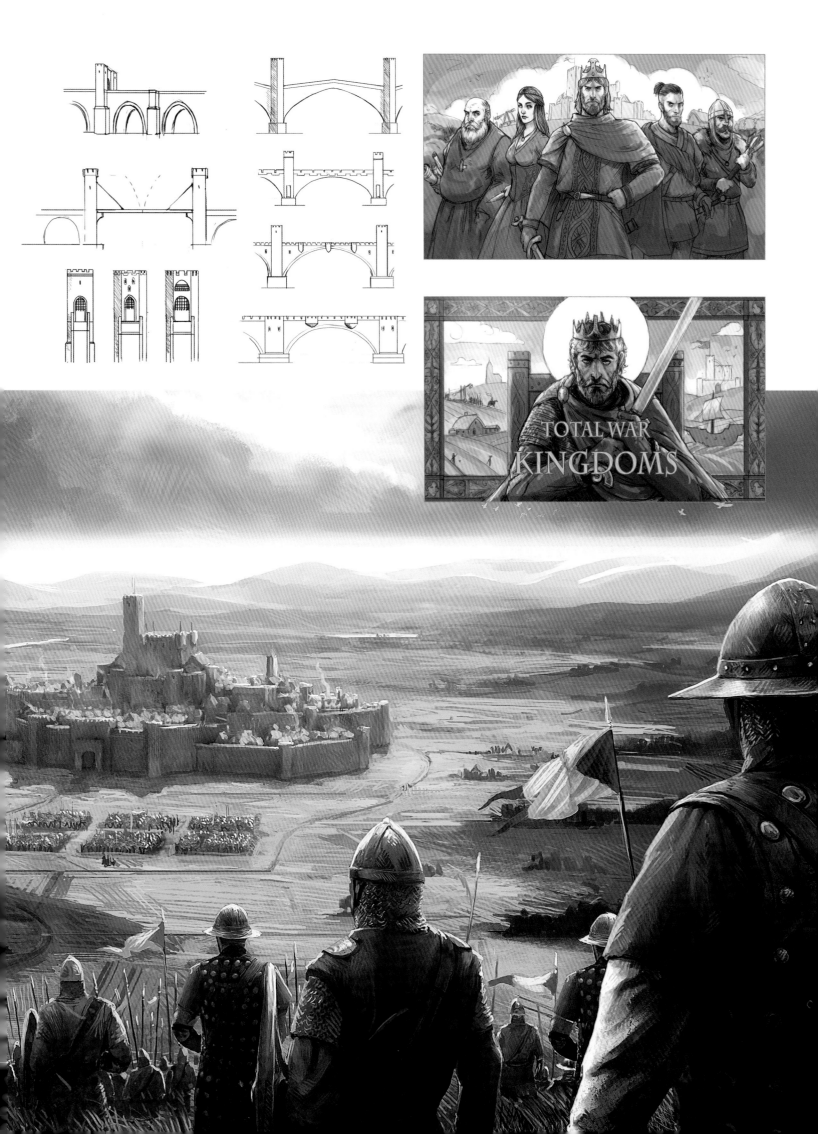

TOTAL WAR
KINGDOMS

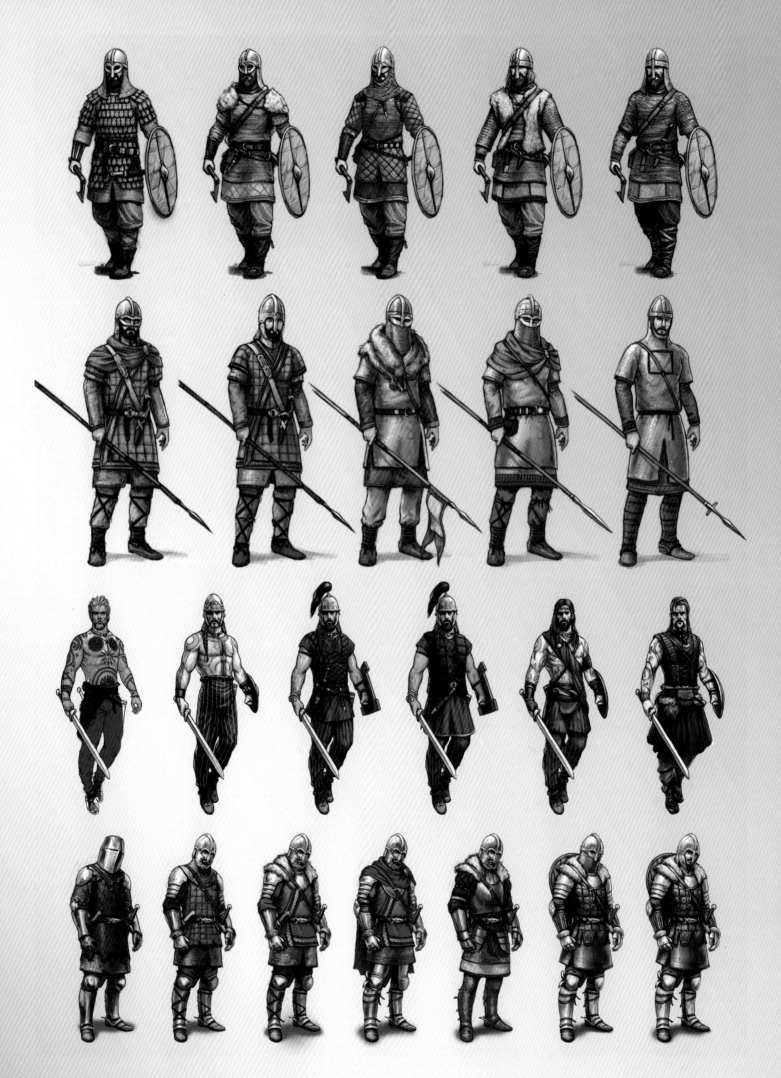

Total War Battles: Kingdoms continues the stylised look introduced by *Shogun*. "With the device we have now, we could go for a completely realistic look," says Renaud Charpentier. "However, it wouldn't work gameplay wise. You'd get these murky medieval world where everything looks like a hut." The team is still bound by a desire for historical accuracy, but the dearth of documentation of the time allows for some flexibility. Take the armour design. "We know that plate mail arrived around that time, and some invaders started to have plated mail elements - but we don't know for sure historically how that all mixed."

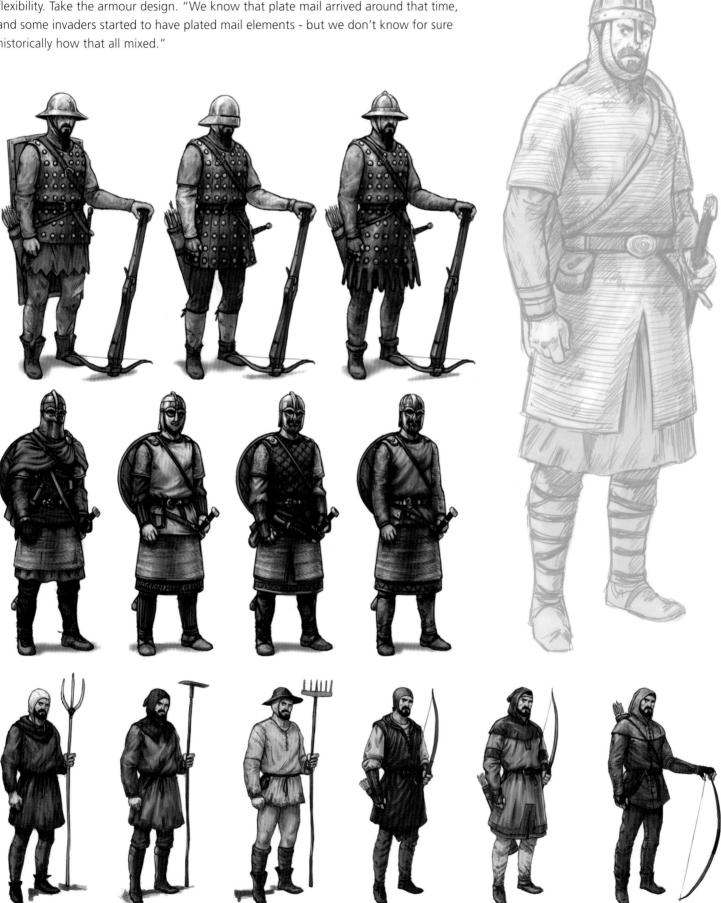

Total War Battles: Kingdoms starts players off in 914AD, their ultimate goal to become the first king of England. The art-style is reminiscent of the mainline series, but with subtle differences. "The *Total War* DNA, is if you look at it it's nothing cartoon-like," says Renaud Charpentier. "Battles is an extension of that brand, and it remains consistent, so we decided not to do that. Instead, we went stylised – and the two are completely different. You can aim for realism, or super-deformed artwork – and we clearly couldn't go there. It would no longer be true to the DNA of the series."

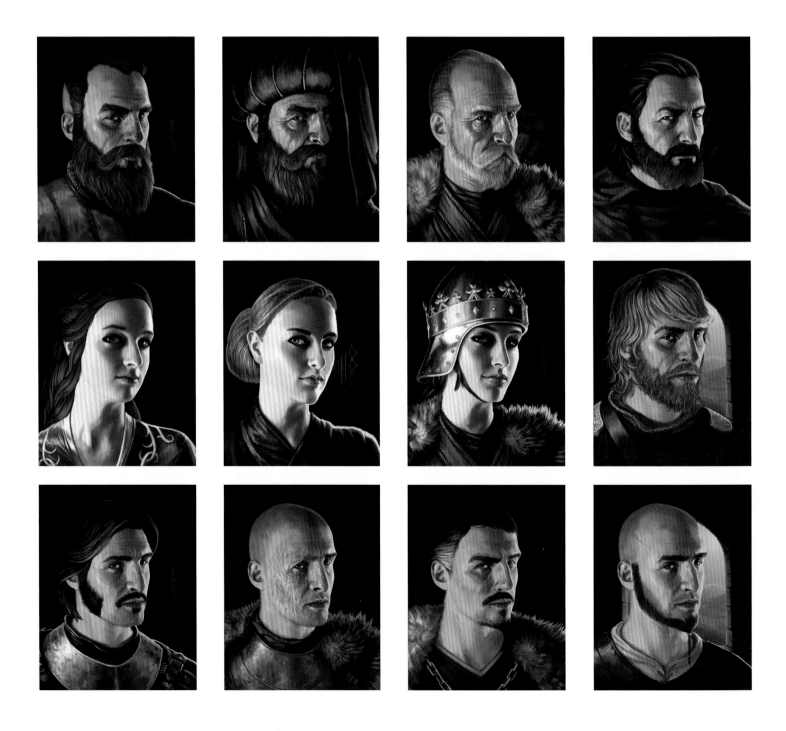

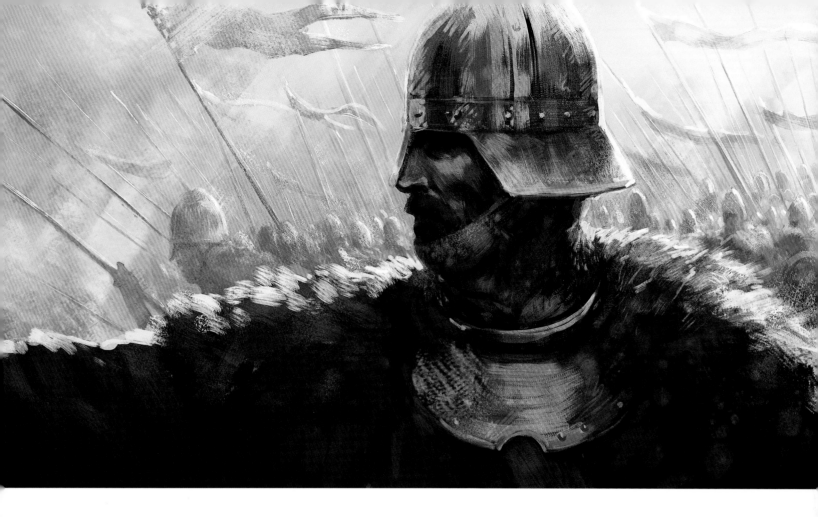

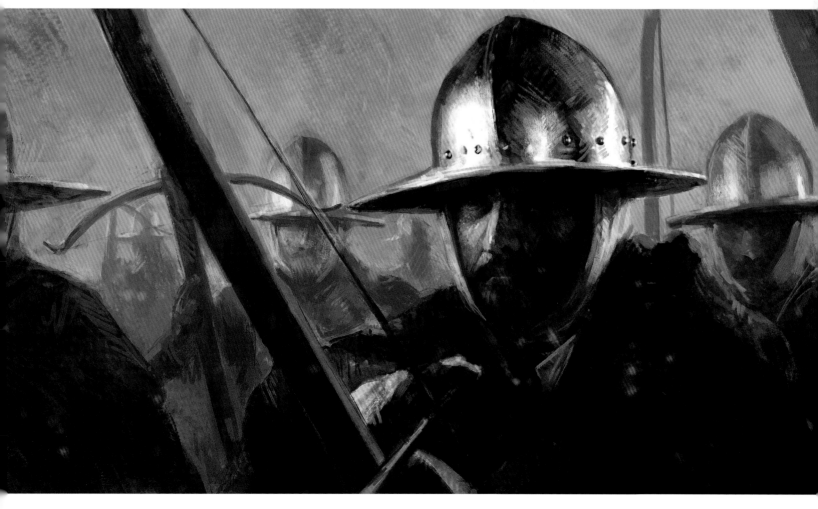

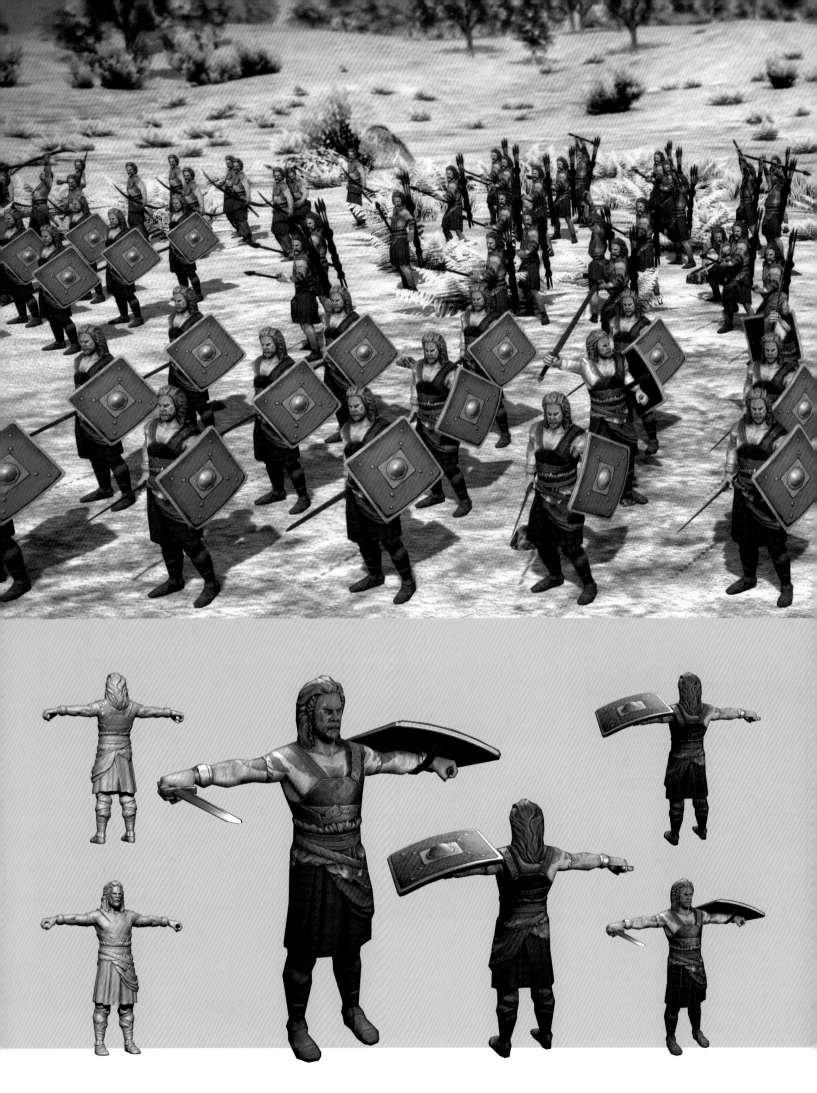

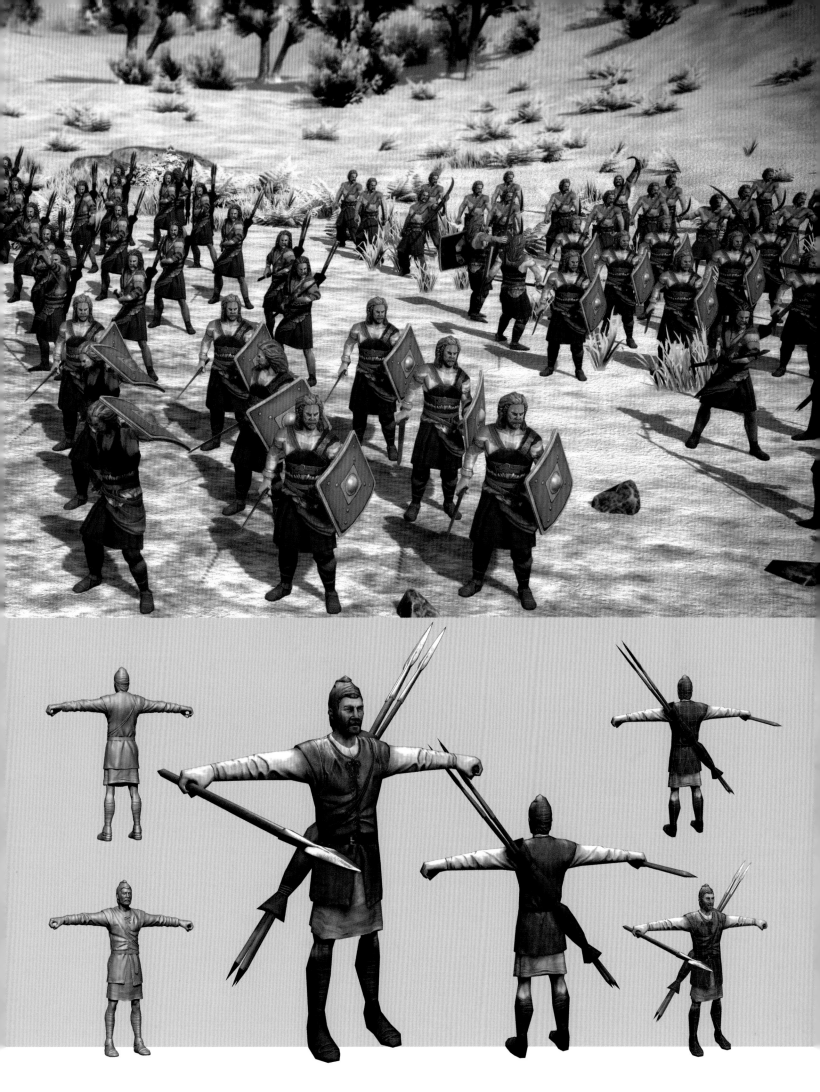

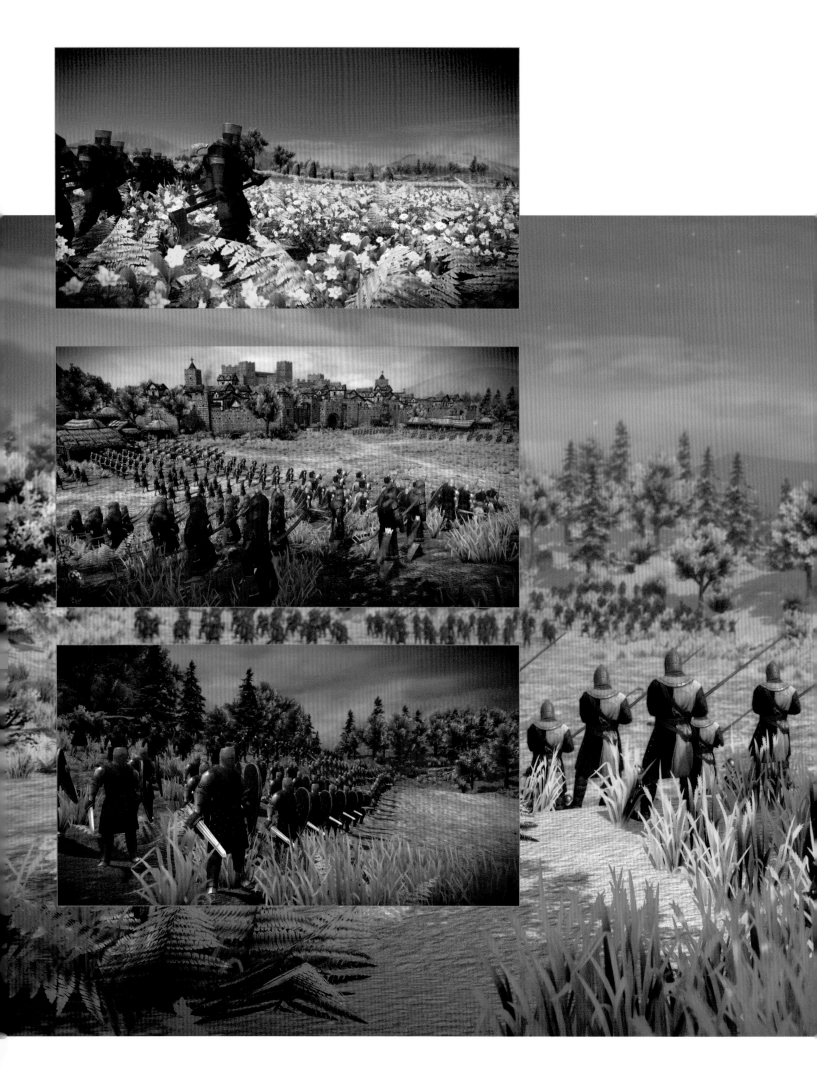

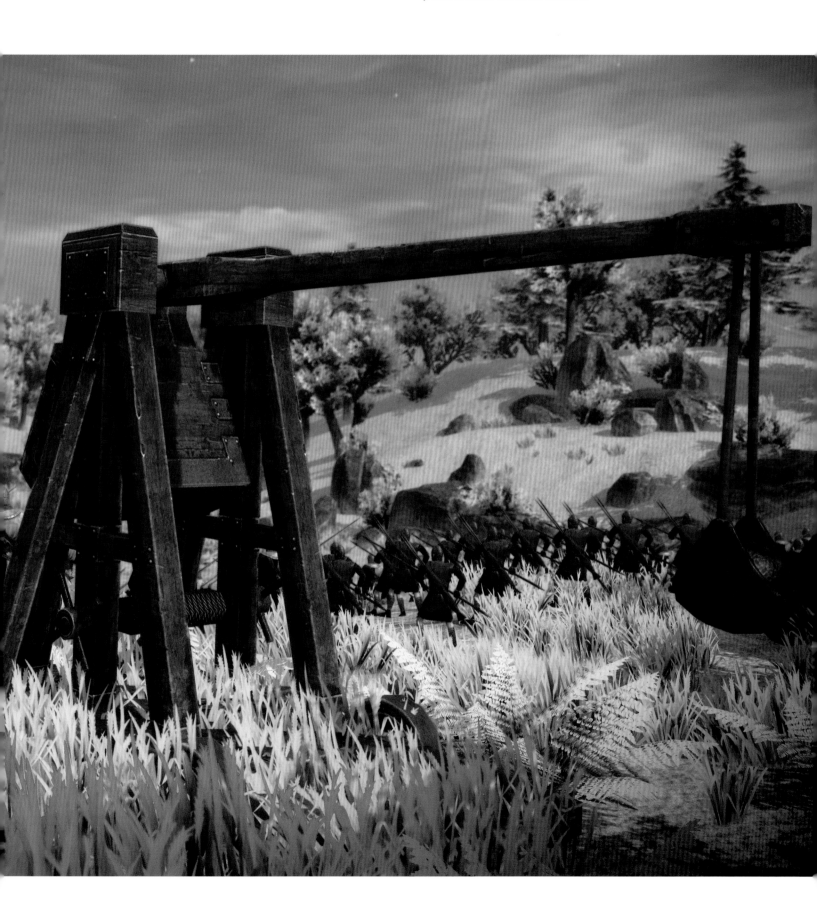

The scene looks every bit like a battle typical of the *Total War* series – but the colours are more pronounced, the units more readable.

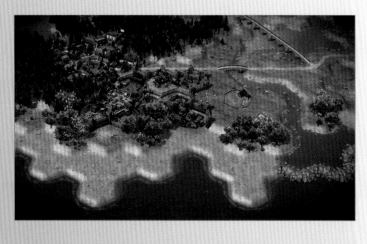

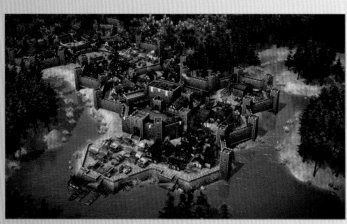
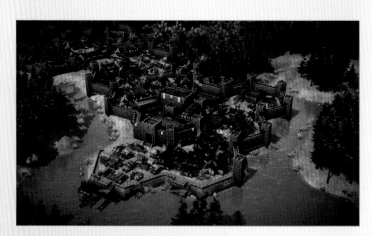

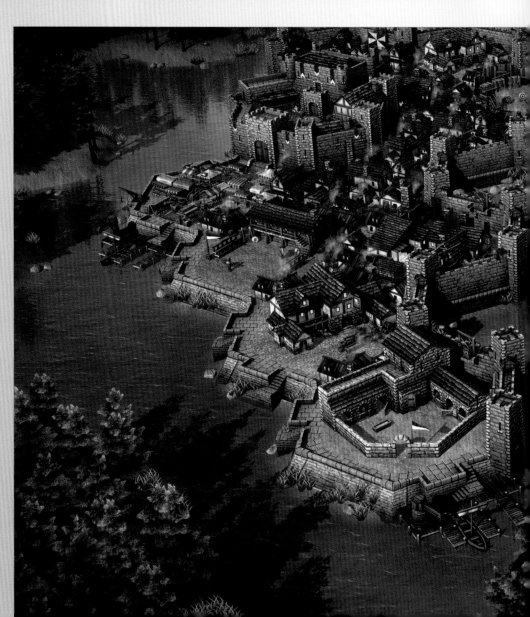

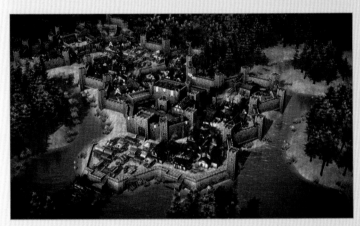

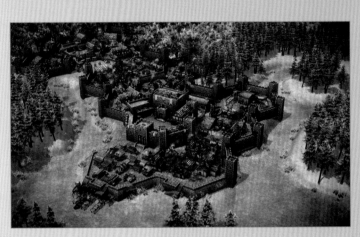

The *Battles* team is comparatively small within The Creative Assembly, created with the express aim to broaden *Total War*'s audience and working with the Unity engine to get their results. With that small size comes flexibility, though. "For *Shogun* and *Kingdoms*, we've done a lot of prototyping," says Renaud Charpentier. – we've a small team and an engine that already exists, so we have less inertia than a bigger team. We get to try lots of different solutions to see what works."

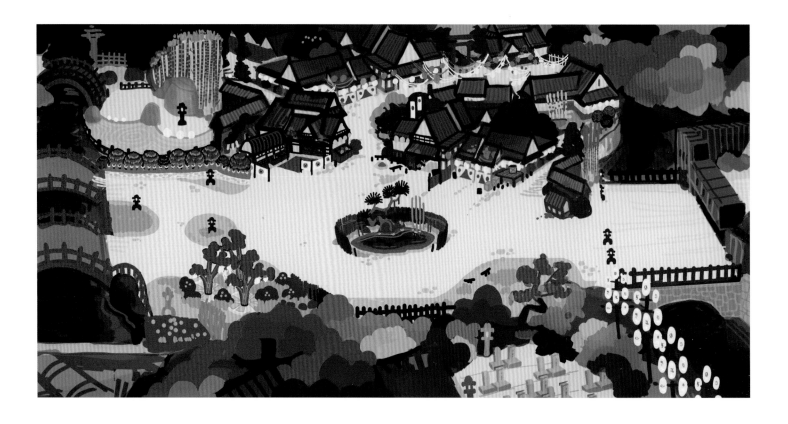

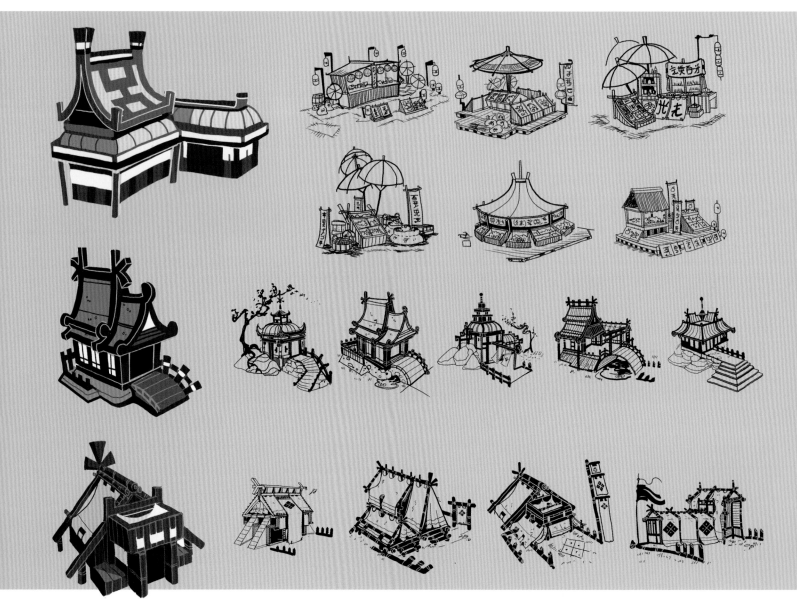

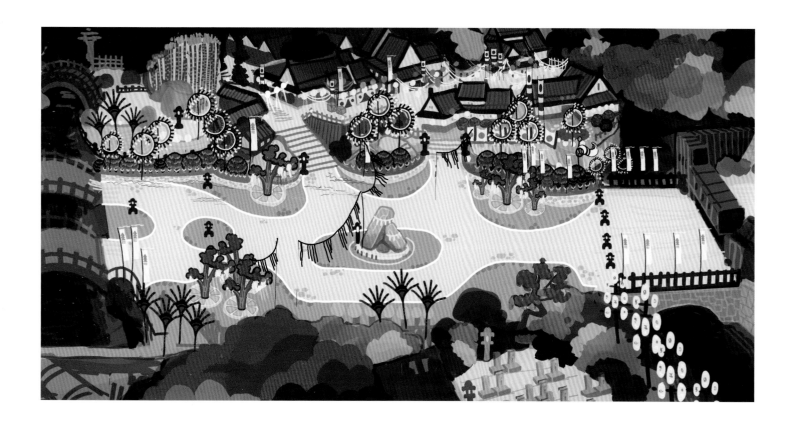

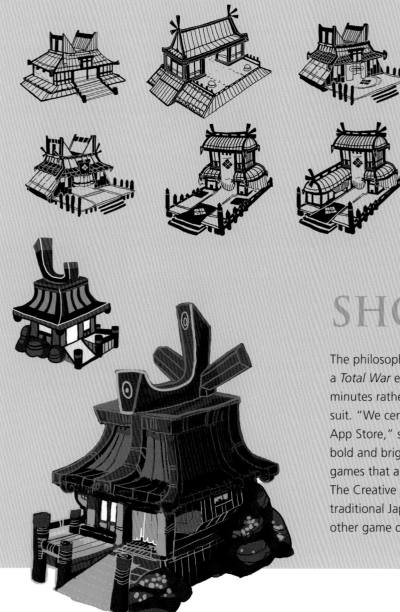

SHOGUN

Edo Blossoms

The philosophy of the *Battles* games, as introduced by Shogun, was a *Total War* experience where the play session could be counted in minutes rather than hours, as such, the art-style had to switch to suit. "We certainly looked around at a lot of other games on the App Store," says artist Jacques Wingrove. "All those games are very bold and bright, and that's what attracts people – these bold, bright games that are fun to dip into for a couple of minutes at a time." The Creative Assembly accentuated the colours of the era, using traditional Japanese art for an aesthetic as bold and vibrant as any other game on the App Store.

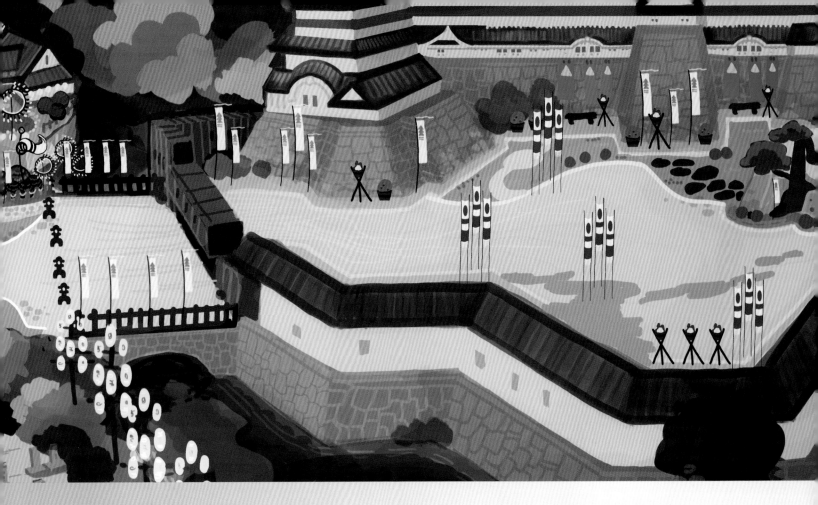

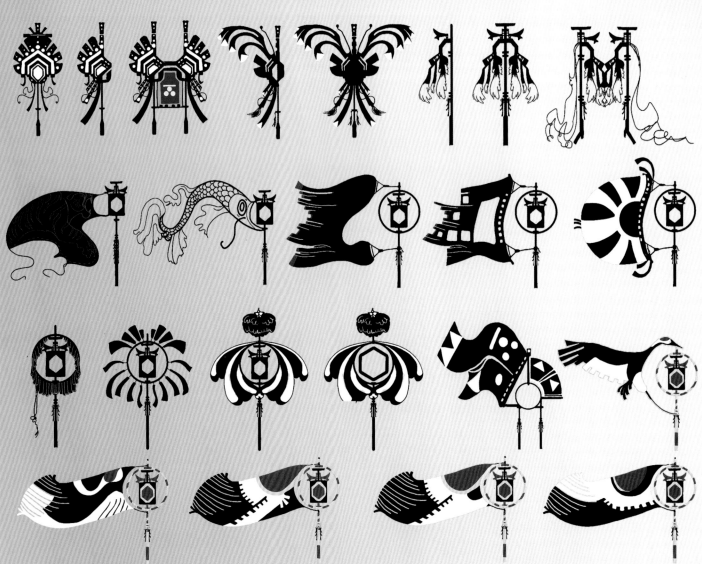

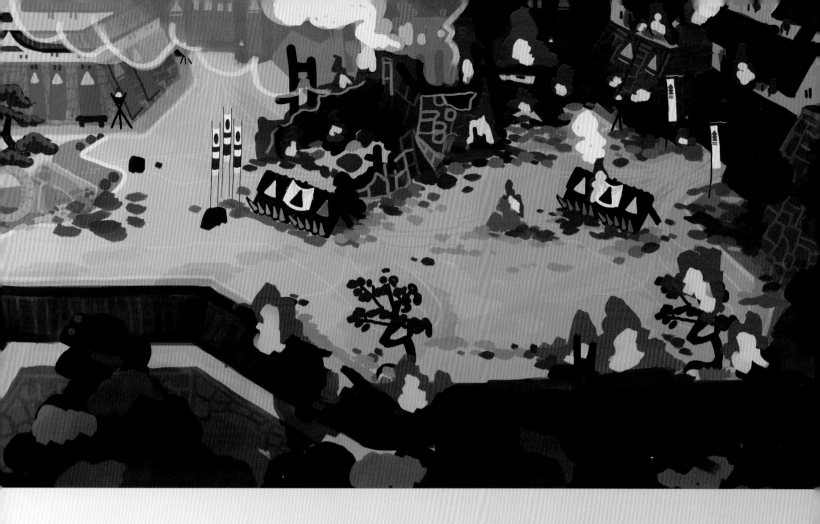

Battles' aesthetic is partly to allow it to compete with the more colourful competition on mobile, and partly for more practical reasons. "We tried to make it very bold and bright and easy to read," says Jacques Wingrove. "That's why the characters are colour-coordinated. When you scale down to a small screen it has to be clear – if you just scaled down *Total War* it'd be muddy and hard to read. And if you tried to scale it down, and scale down that aesthetic, you'd draw comparisons that would affect it negatively. It was another reason to go for the bold aesthetic."

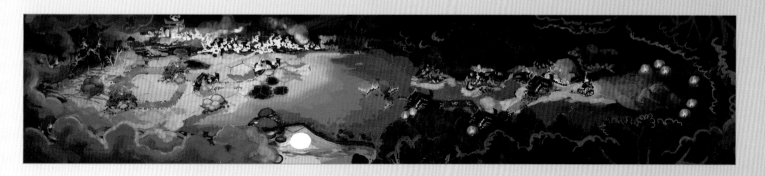

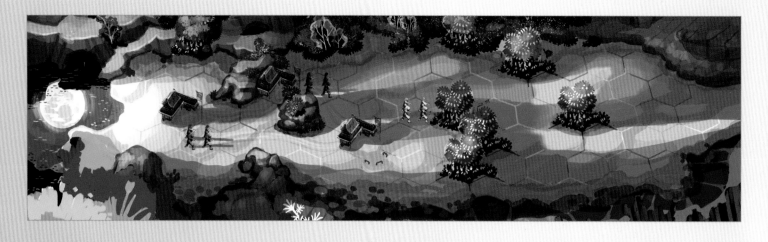

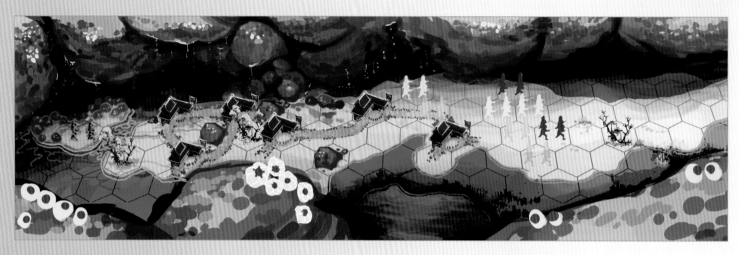

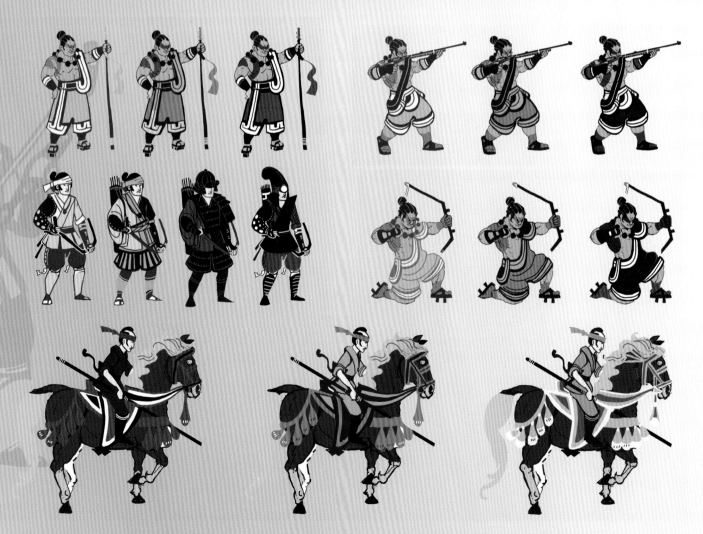

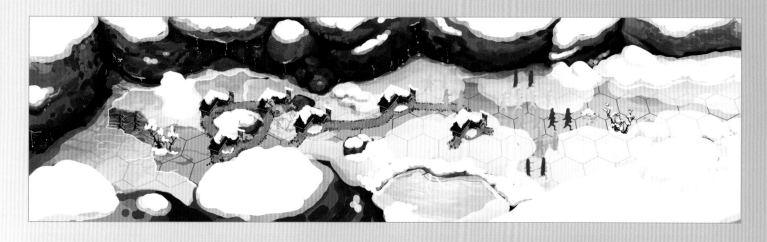

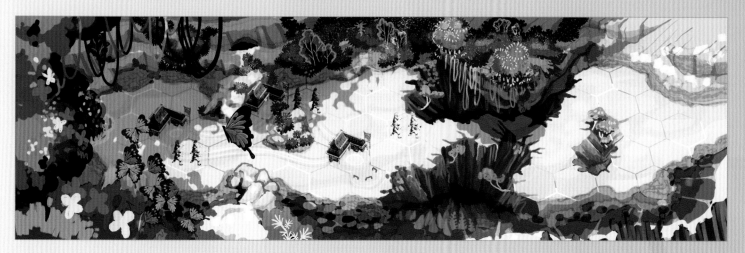

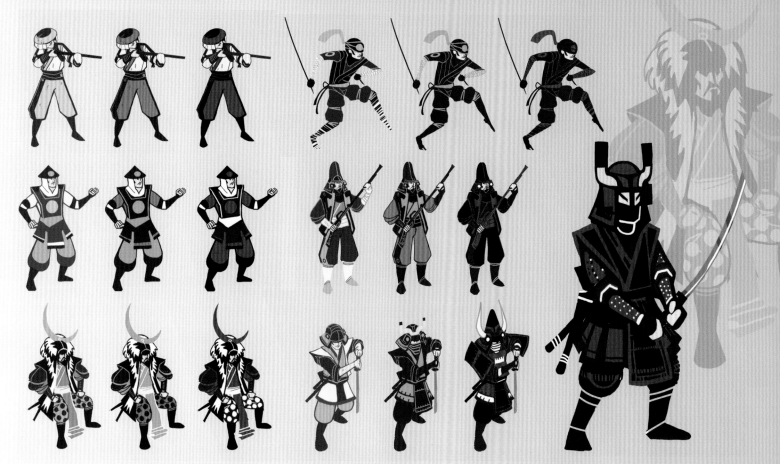

Character design also benefited from the colourful aesthetic. "One of the challenges we had was differentiating armies," says Renaud Charpentier. "We tried lots of different solutions, and the best one the artists arrived at was to use two completely different sets of colour codes. There's a red hot army and a colder green blue army on the other side – so you can always tell who is who."

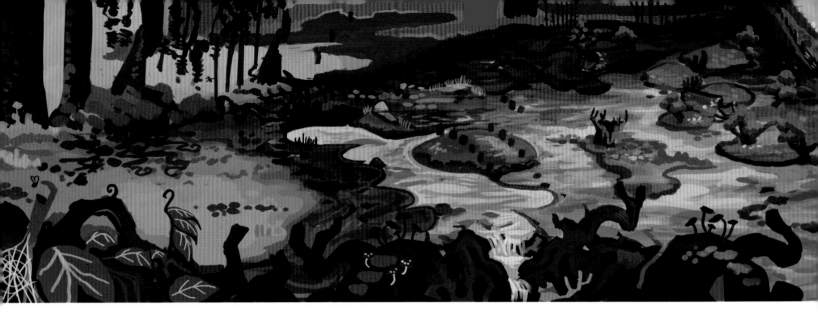

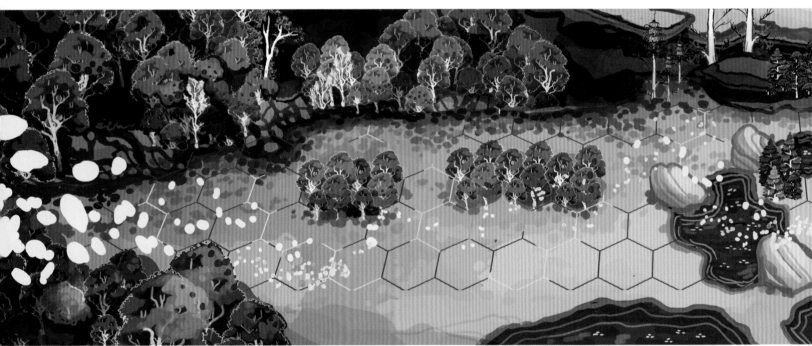

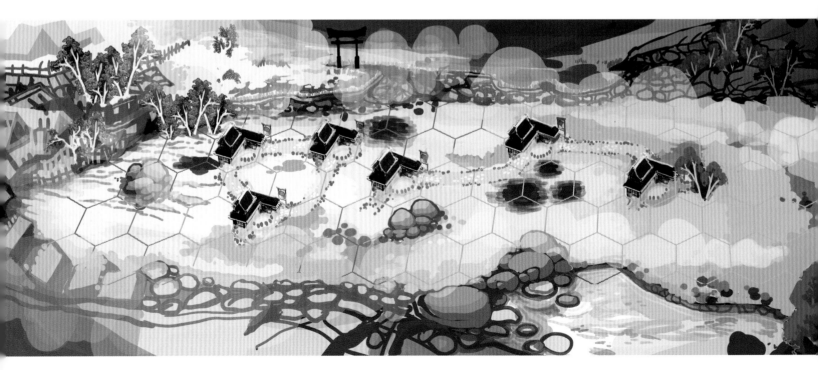

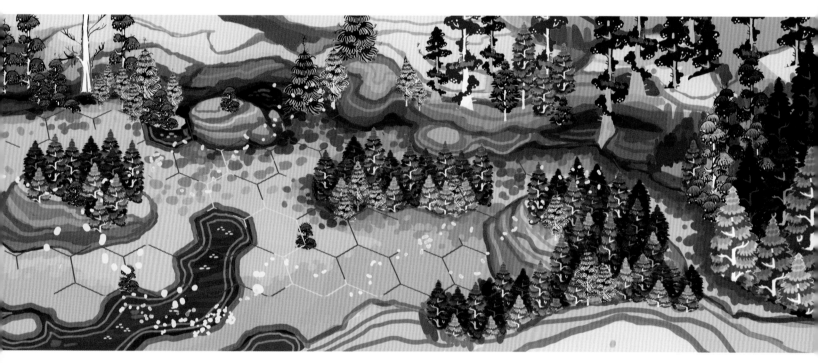

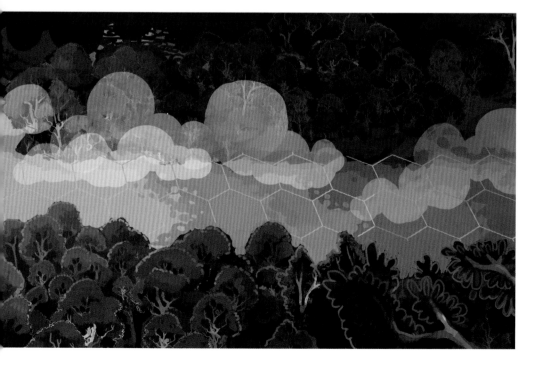

As with its mainline counterpart, *Total War Battles: Shogun* draws upon art contemporary to the period it depicts – as well as later, iconic depictions of the era, too. Woodblock art informs the characters, while the lavish backgrounds with their strong, accentuated lines and exaggerated colour draw upon the artwork lavished on six-fold screens in Japan of the Momoyama period. It's a tactile art which found a fitting home on the touchscreens of smart phones and tablets the game graced.

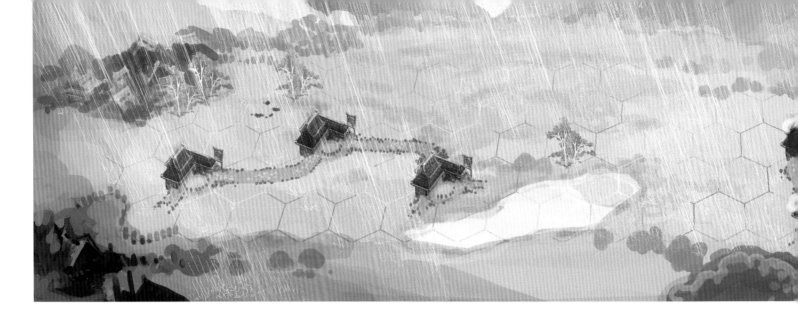

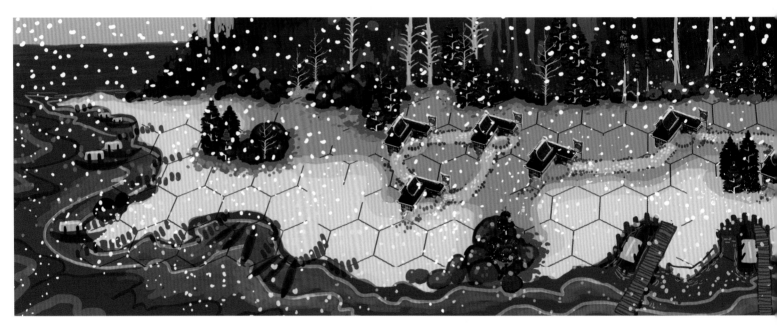

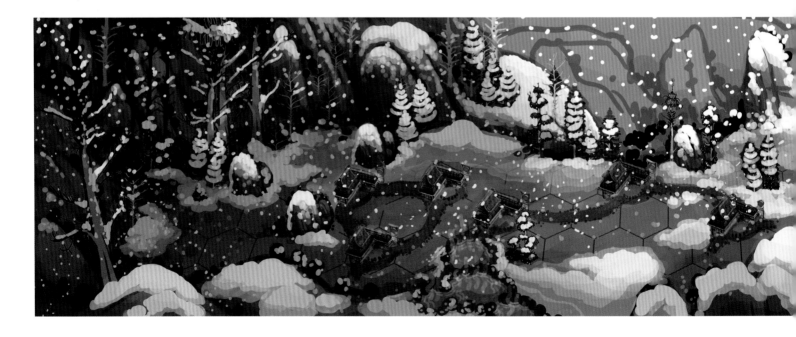

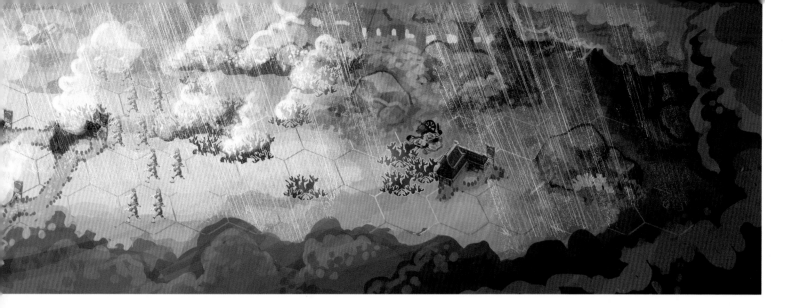

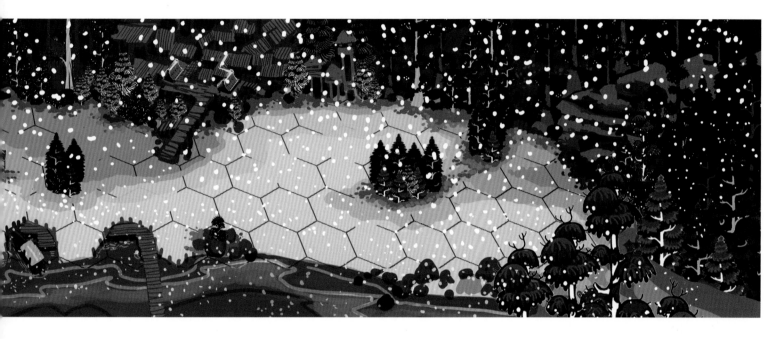

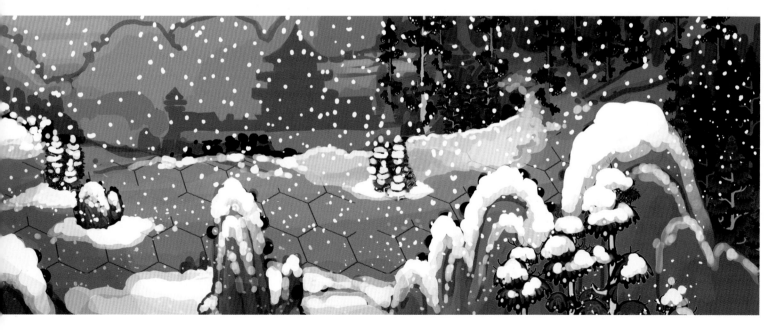

Extravagant art obscures the hex-based grid at the foundation of *Total War Battles: Shogun*'s battlefield – the panoramas look like snapshots of the most exquisite boardgame.

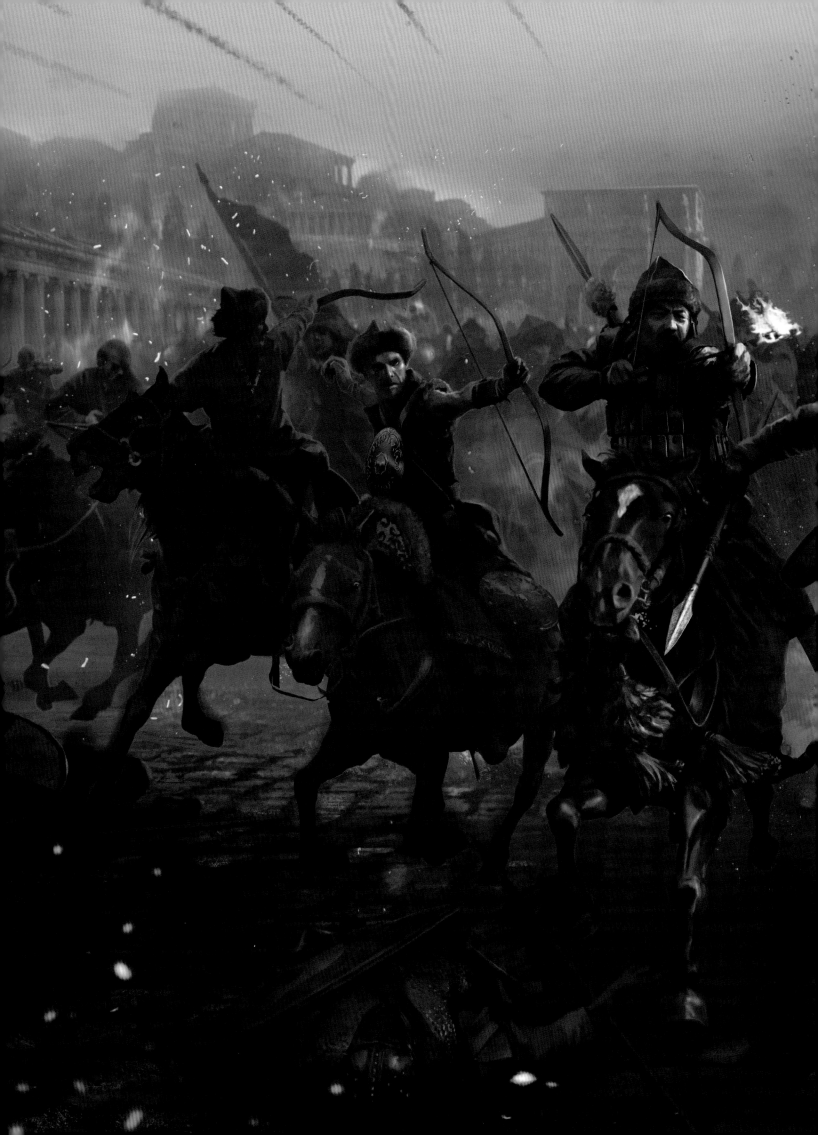

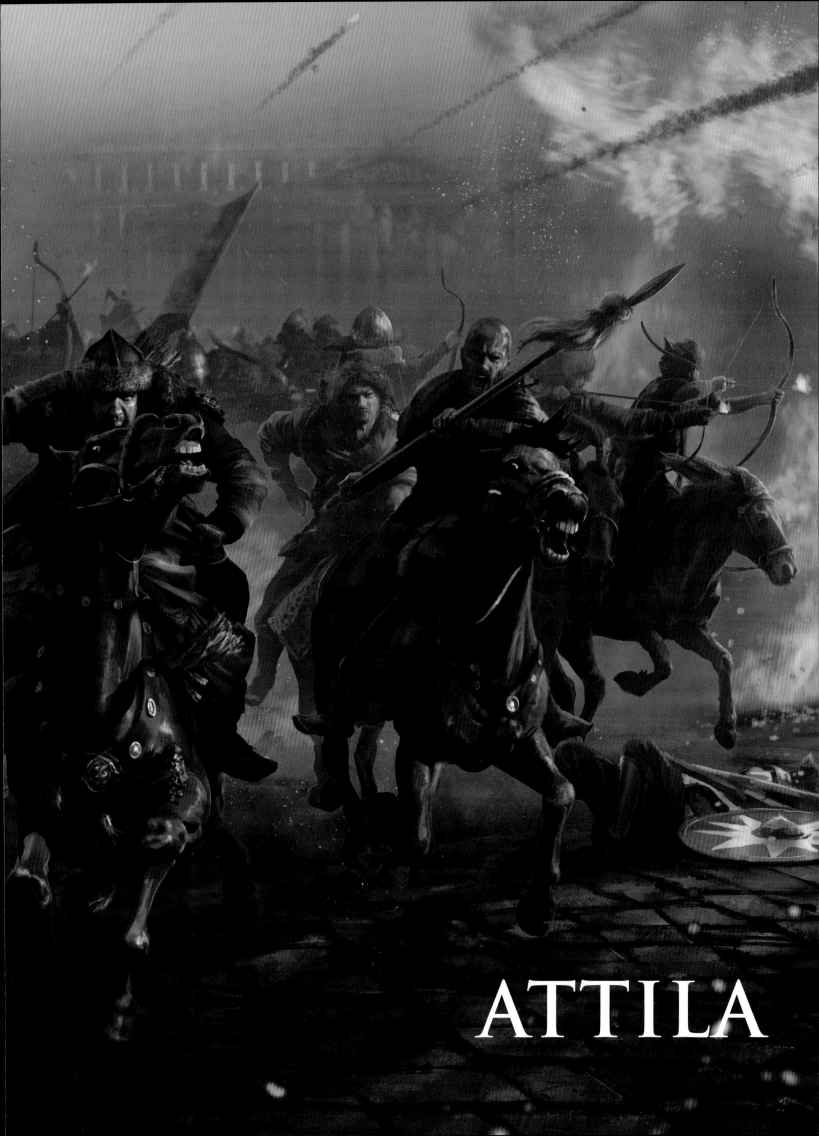

ATTILA

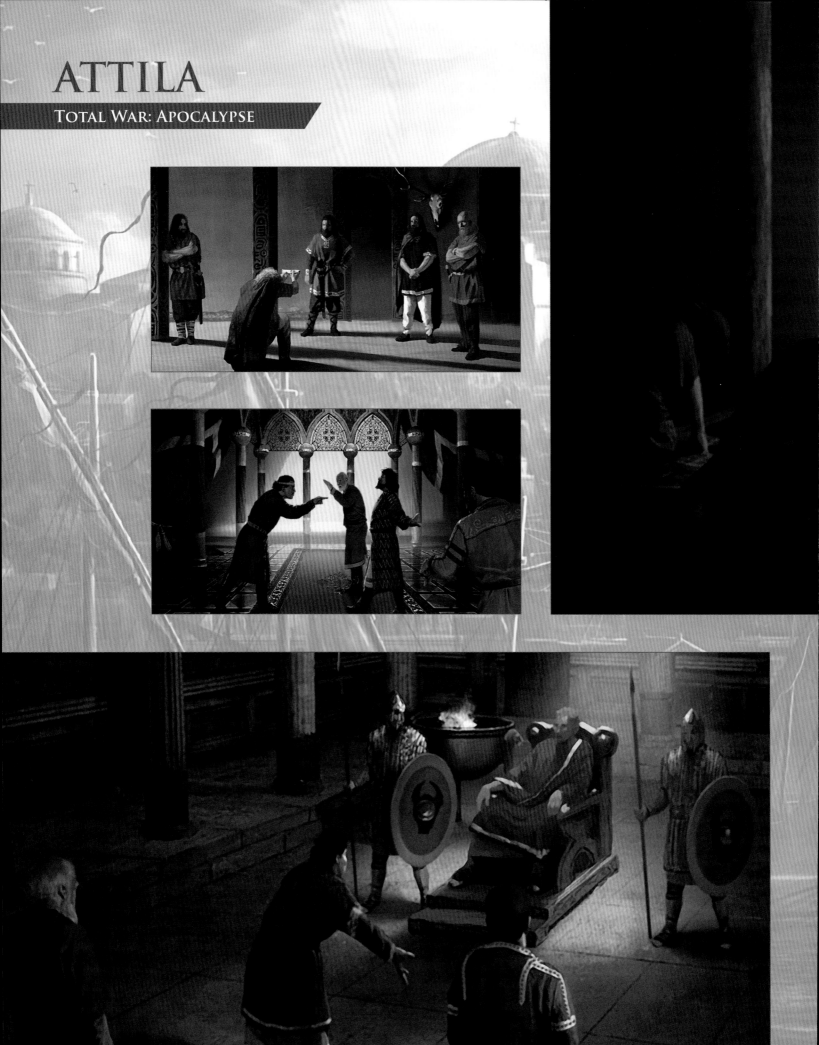

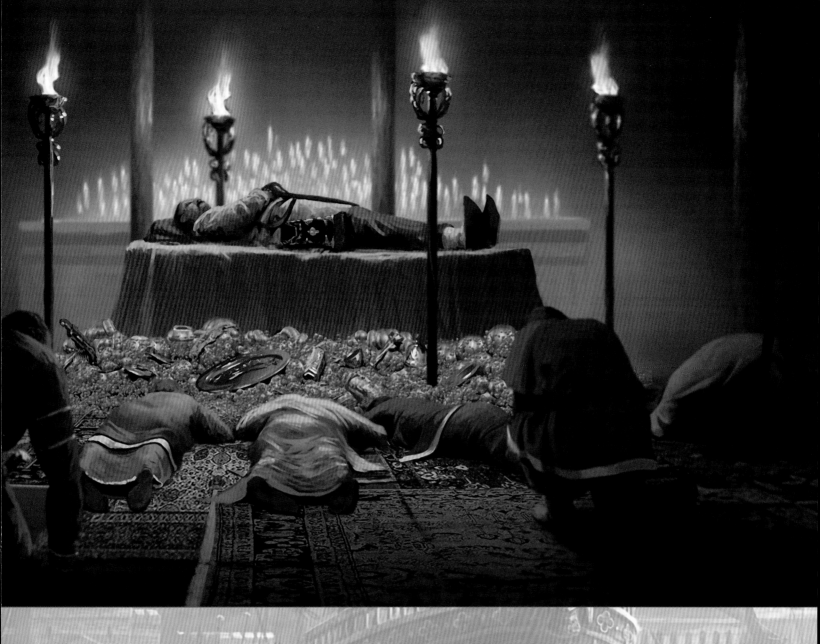

Total War: Rome II brought a darker tone to the depiction of the Roman Republic and Empire that The Creative Assembly has previously explored in 2004, so it makes sense that its expansion would go darker still. "It's the dark ages," explains lead artist Pawel Wojs. "The idea is, basically, it's the fall of the Roman Empire. Attila is coming, he's the scourge of God, it's the end of the world with the four horsemen of the apocalypse. That's the theme of everything. And with that are darkness, destruction, hordes raiding in the night. I guess the kind of ethos, the catch-all is end of days Total War. Apocalypse: Total War. Which ties in well with the dark ages!"

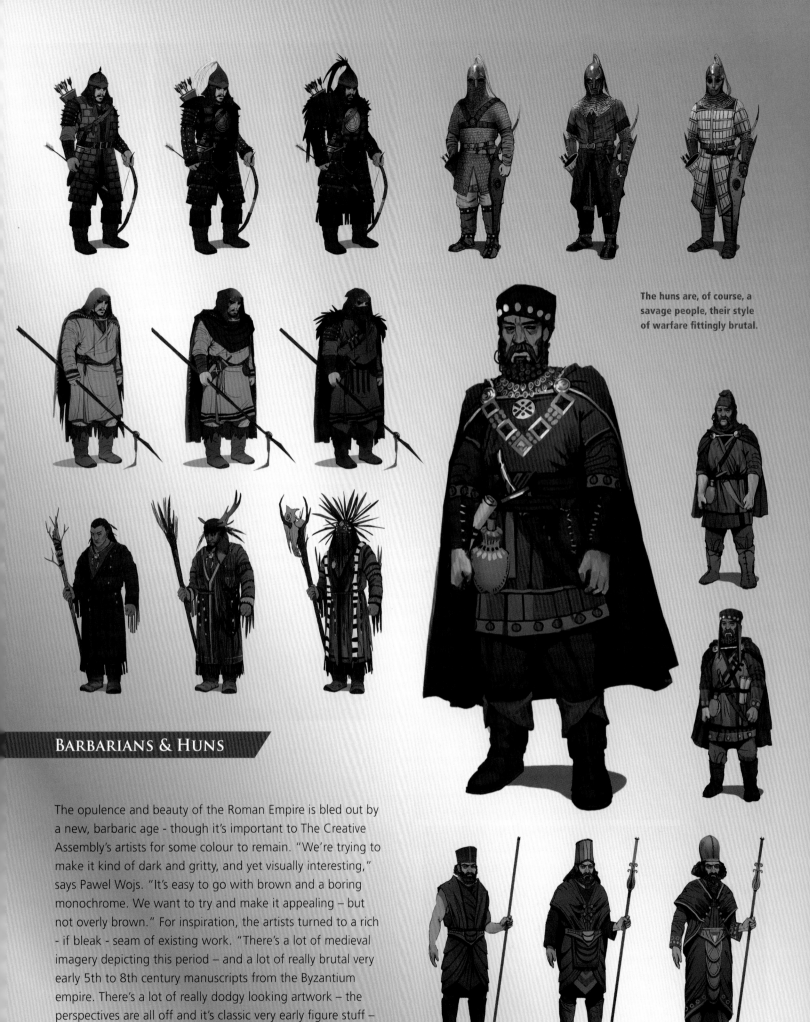

The huns are, of course, a savage people, their style of warfare fittingly brutal.

BARBARIANS & HUNS

The opulence and beauty of the Roman Empire is bled out by a new, barbaric age - though it's important to The Creative Assembly's artists for some colour to remain. "We're trying to make it kind of dark and gritty, and yet visually interesting," says Pawel Wojs. "It's easy to go with brown and a boring monochrome. We want to try and make it appealing – but not overly brown." For inspiration, the artists turned to a rich - if bleak - seam of existing work. "There's a lot of medieval imagery depicting this period – and a lot of really brutal very early 5th to 8th century manuscripts from the Byzantium empire. There's a lot of really dodgy looking artwork – the perspectives are all off and it's classic very early figure stuff – but there's a lot of really dark stuff."

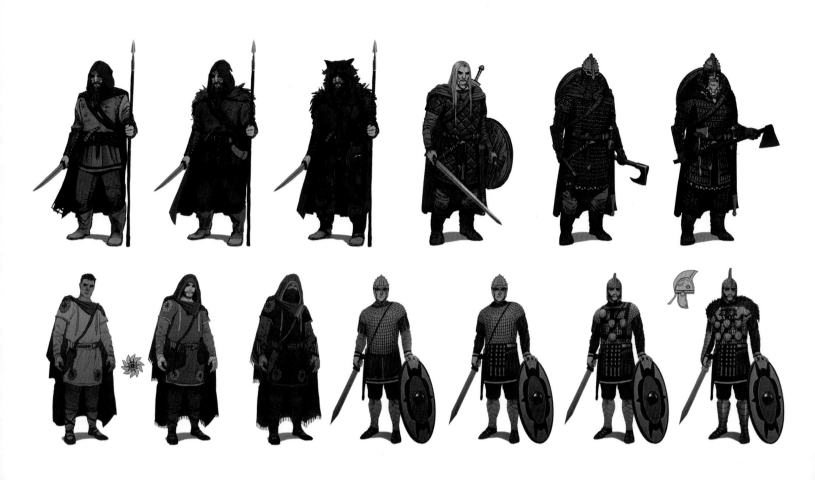

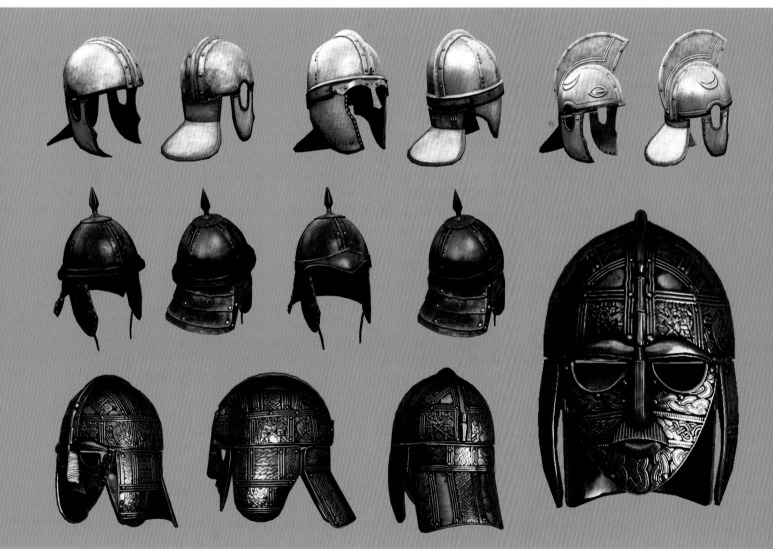

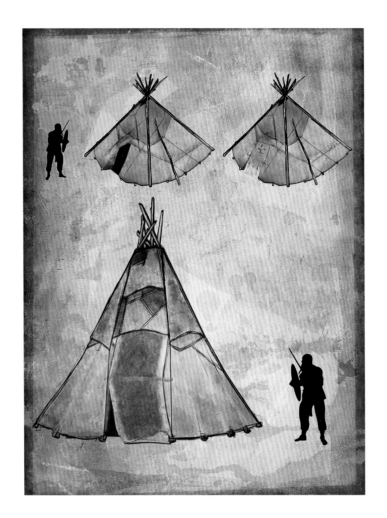

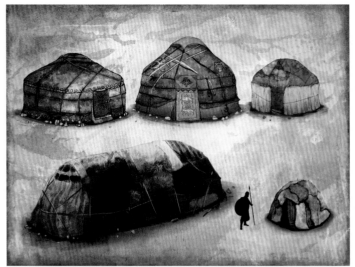

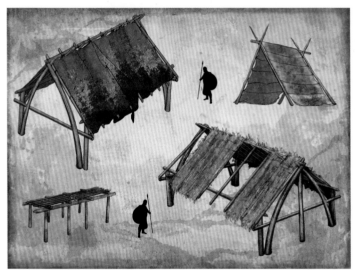

THE SCOURGE OF GOD

Accompanying the arrival of Attila, the scourge of God, was a climate change that fed into the apocalyptic atmosphere of the time. "At the same time as Attila's raids you have all these migrating hordes, migrating from the north because of famine," says Pawel Wojs. "They're seeking fertile lands further south, running away from Attila at the same time and trying to settle in these more fertile lands because of the climate change." This nomadic existence feeds into the designs of habitats in Attila, as well as defining the visual tone of the expansion. "One of our most striking early references was a snow-covered landscape with fire burning," says Wojs. "It's a classic image, really – a barbarian village covered in snow that's burning to the ground, illuminating the white around it."

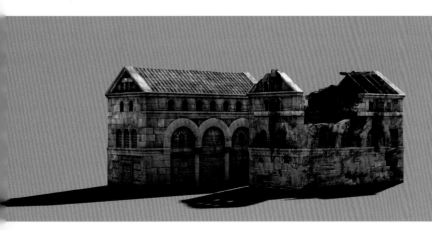

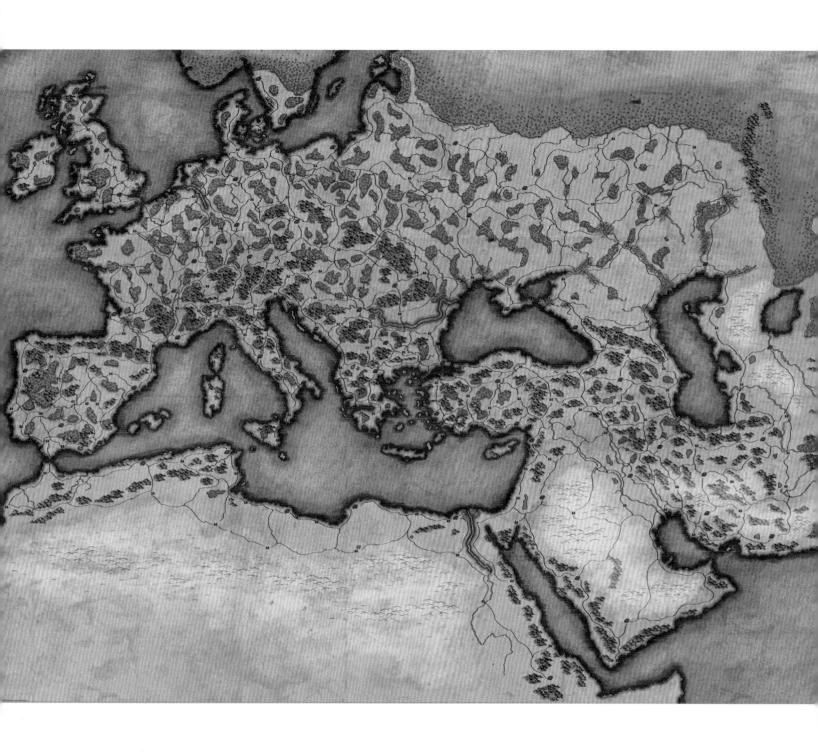

The Attila expansion harks back to
Barbarian Invasion, the follow-up to
2004's original *Rome: Total War*.

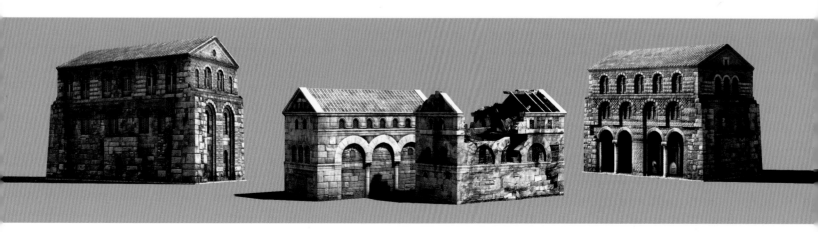

A vision of the apocalypse as informed by the Bible is at the backbone of Attila, with The Book of Revelation's seven seals opened one by one throughout the campaign. "We're building the visuals around that fact," says Pawel Wojs. "At the beginning it's sunny and there are mild winters and warm summers. With each opening of the seal the climate will change, and there will be a shift. A winter that takes a couple of turns at the start of the game, after a climate change it'll be several turns. The winters will be longer, there'll be colder, there'll be darker. The springs at the beginning will be flowery – at the end they'll be cold, they'll be muddy."

Some of the sheen from *Total War: Rome II* has gone, replaced by a murkier tone.

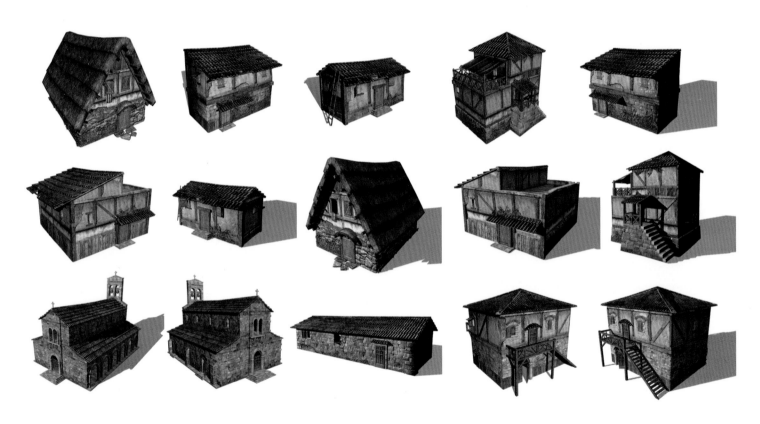

More contemporary art was referenced for the biblical apocalypse that underscores Attila's aesthetic – such as 19th century painter John Martin.

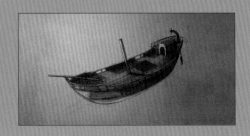
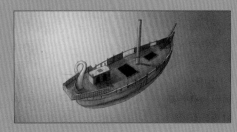
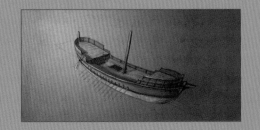

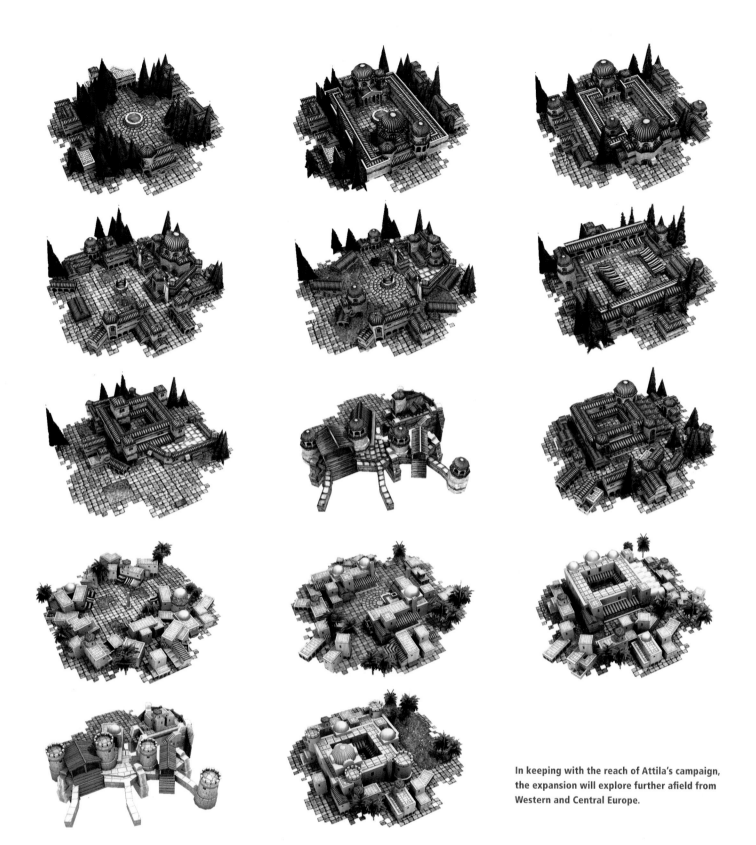

In keeping with the reach of Attila's campaign, the expansion will explore further afield from Western and Central Europe.

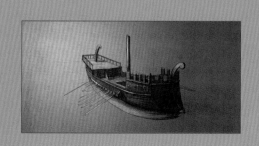

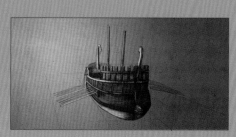

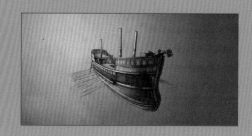

FUTURE OF TOTAL WAR: ARENA

Total War: Arena is perhaps The Creative Assembly's boldest new enterprise, a free-to-play multiplayer game that looks to broaden the series' appeal to a more competitive space. "It still feels like a Total War game, but it's faster paced," says lead artist Robert Farrell. It still has a lot of tactics, and there's lots to learn. It's all about strategy, tactics and how you use your units – and how you counter attacks and can surprise your enemy. We bring all of those into every Total War game that we make. We're bringing all those values across in Arena, but we're trying to add a few of our own ones as well, and speed it up a little bit as well." It's a more stylised take on the Total War aesthetic – where the Romans are anti-heroes everyone loves to hate, Barbarians are brutish savages and the Greeks stand out like Hollywood idols.

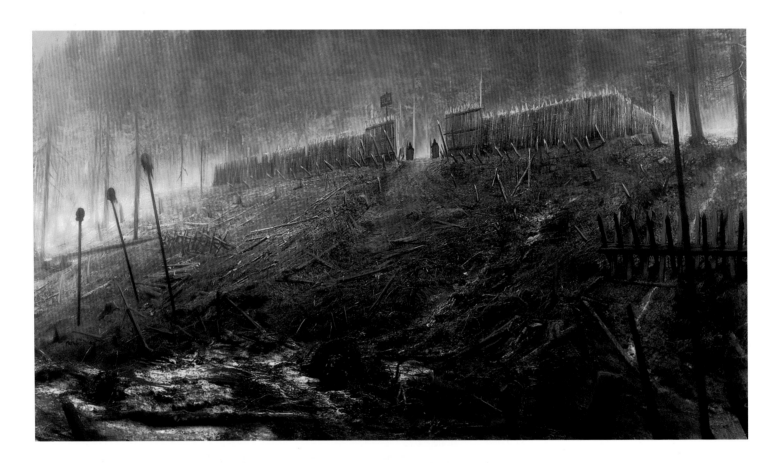

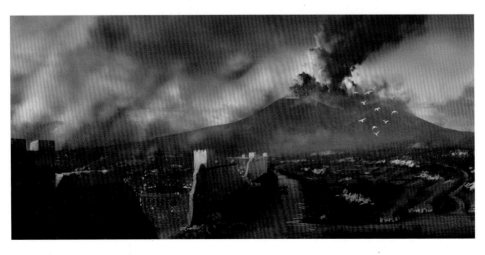

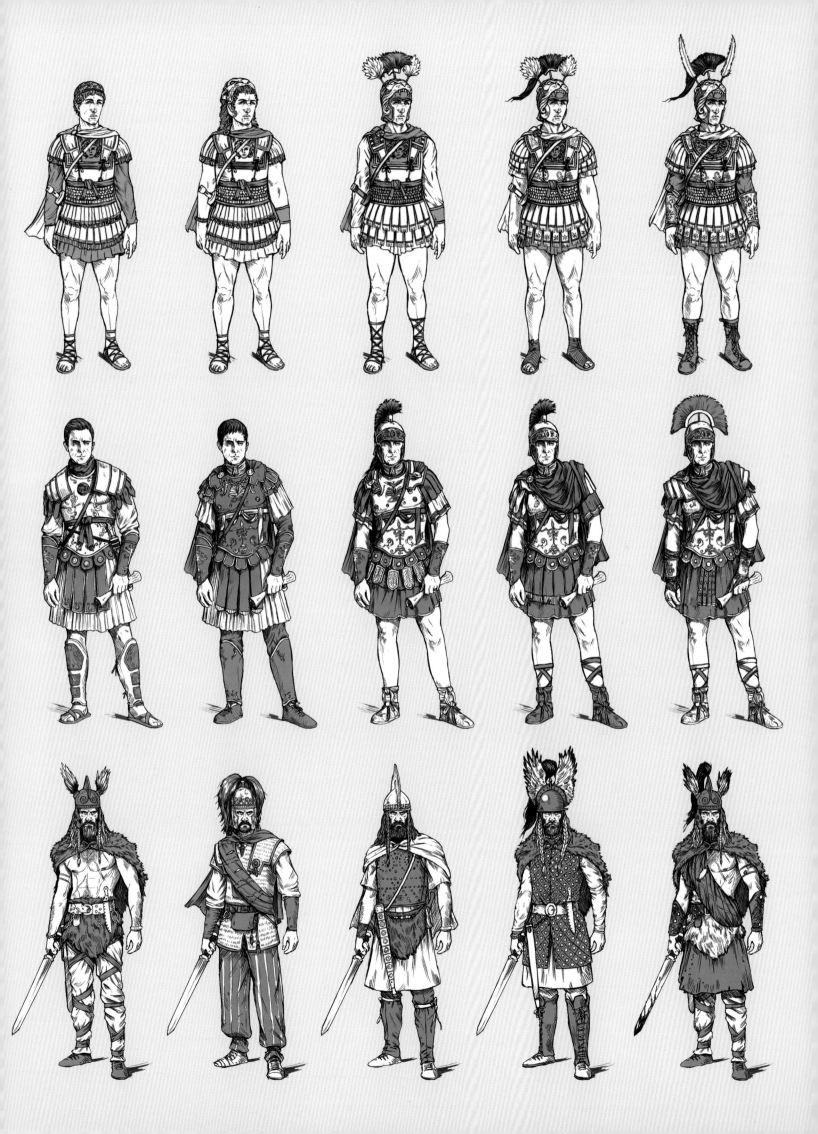

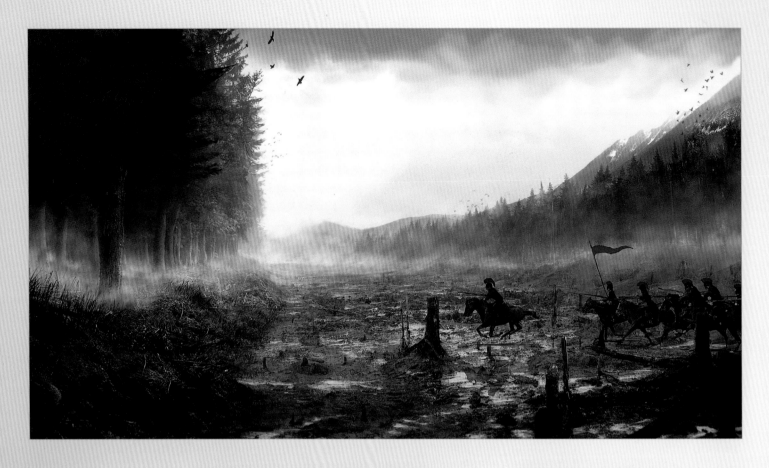

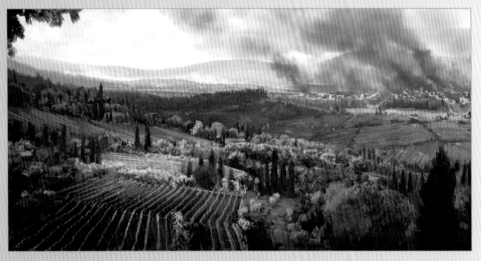

The battlegrounds in *Total War: Arena* are drawn upon iconic locales, and the whole game displays a tougher edge. "We wanted this metallic feel, this feel of forging, in Arena," says Farrell. "A lot of the stuff is very metallic, and very sharp. It's all about the war. You come back out, you go back in and you want to fight again, you want to keep going. The commanders are a strong focus, but so are the weapons. We want everything to feel sharp – like it could hurt you. It's a very aggressive feel, and a much more adult-themed game to other free-to-plays that are out there."

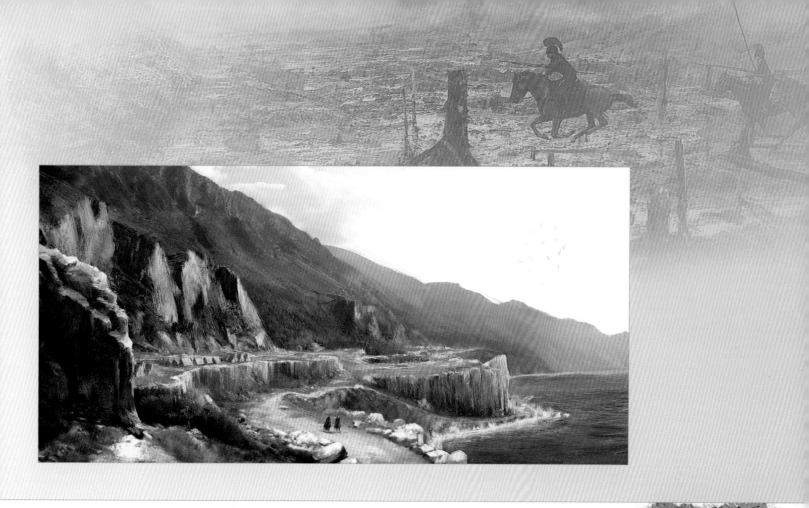
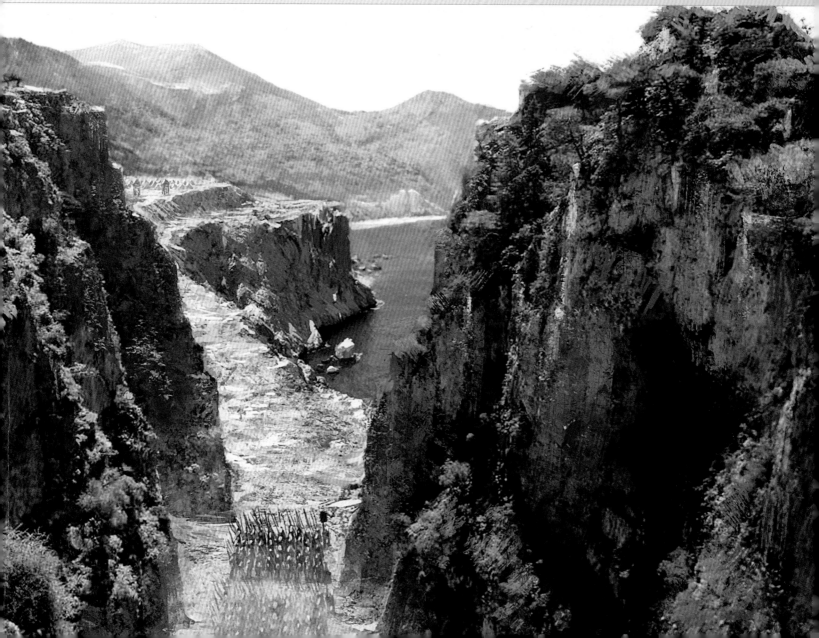

ACKNOWLEDGMENTS

The Art of Total War would be nothing without those artists who bring this vision of history to our screens; though these are not just artists in the conventional sense. In order to realise our games it takes modellers and animators to pose characters, graphics programmers to render lighting, cinematic technicians to set-up virtual cameras, and writers and designers to determine content, amongst many other disciplines. *The Art of Total War* is the product of a massive assemblage of creatives (naturally), we thank them all for everything over the years.

A. P. Taglione
Aaron Novelle
Aaron Symes
Aaron Travis
Abdul Oshodi
Abdule Oshodi
Adam Bryant
Adam Cooper
Adam Fielding
Adam Hartsfield
Adam Hussein
Adam Rowley
Adam Tortolano
Adrian Daly
Adriana Pucciano
Aidan Howe
Akane Hiraoka
Akmal Saleh
Al Bickham
Al Hope
Alan Ansell
Alan Blair
Alan De Plater
Alan Springer
Albert Roig
Alberto Toglia
Alessandro Ricci
Aletta Lawson
Alex de Rosée
Alex Epstein
Alex Moon
Alex Norton
Alex Teymour-Housego
Alex Wright-Manning
Alex Young
Alfonso Vallés
Alicia Marson
Alisdair Jarrold
Alison Warfield
Alistair Hope
Alistair Martin
Alistair Parker
Allan Suleman
Allen McKay
Amanda Cuthbert
Amir Hafeez
Ana Gomes
Anaick Lynch
Anders Lindström
Andre Baud
Andrea Contino
Andrew Bedford
Andrew Buchanan
Andrew Hall
Andrew Hartley
Andrew Oakl
Andrew Smith
Andrew Sparks
Andrew Young
Andriy Doroshchuk
Andrzej Lubas
Andy Bray
Andy Emery
Andy Serwatuk
Andy Smith
Andy Walsh
Angel Diaz
Angela Kase
Angela Somerville

Angela van Dyck
Angelo Cola
Anna Siganporia
Anna Wollin
Anne Marie Butland
Anne Miller
Anthony Barbagallo
Anthony Korotko
Anthony Mir
Anthony Moran
Anthony Simcock
Anton Lock
Antony Zwierchaczewski
Arian Barvarz
Arnoud Tempelaere
Artem Kulakov
Ashley Alymann
Ashley Parker
Aso Sherabayni
Attila Mohacsi
Audrey Meehan
Ayal Moreno
Baj Singh
Barbara Steel
Barry Scott
Barry Syder
Barry Tingle
Becky Eade
Ben Adams
Ben Deane
Ben Gray
Ben Greet
Ben Howell
Ben Hymers
Ben Lane
Ben Munson
Ben Potts
Ben Smith
Ben Wood
Bernard Sizey
Bernd Reinartz
Bernd Vollbrecht
Bernie Leon
Bianca Rudareanu
Bill Petro
Bjorn Hurri
Bob McPherson
Boris De Mourzitch
Boris Sosna
Brendan Rogers
Brendon Wright
Bret Blount
Brian Bowles
Brian Sawyer
Brian Spayth
Bruno Lucia
Bryan Davies
Bryan Fevrier
Bryan Rogers
Cain McCormack
Cameron Baldie
Camilla Grevstadt
Carl Allen
Carlo Mangani
Carlos Nogueras
Carmelo Hurtado
Caroline Dartnell
Caroline Kennison
Carolyn London

Catherine Woolley
Cathy Campos
Caty Campos
Ceri Owen-Jones
Chad Schnittjer
Chad Siedhoff
Charles Collingwood
Charles Paw
Charles Scibetta
Charles Wheeler
Charlie Dell
Charlotte Burrows
Cheryl Prince
Cheryl Prince (SIDE)
Chester Lee
Chip Blundell
Chloe Lochbaum
Chris Bien
Chris Budd
Chris Dale
Chris Fairbank
Chris Gambold
Chris Gascoyne
Chris Gray
Chris Harvey
Chris Johnson
Chris Jones
Chris Knight
Chris LeRoux
Chris Morphew
Chris Mowry
Chris Olson
Chris Reed
Chris Skrzypek
Chris Wagener
Chris Waller
Chris Webster
Chris Wolff
Christiaan Jones
Christian Aguas
Christian Carriere
Christian Paskota
Christian Skogen
Christine Kong
Christopher B. Hewish
Christopher Gray
Christopher Keim
Christopher Reed
Chu Hoang
Ciarán Daly
Claire Long
Clan Towashima
Clara Chua
Clare Parkes
Claude Conkrite
Claude Kronkite
Clifford Anderson
Clint Gibson
Clinton LittleJohn
Colin Perman
Constantine
 Hantzopoulos
Constantine Yacoumis
Corey Levin
Craig Allsop
Craig Kirby
Craig Laycock
Csaba Toth
Csaba Tóth

Dai Tabuchi
Daisy O'Sullivan
Dait Abuchi
Dale Richardson
Daleep Chhabria
Daley Chaston
Damien Garvey
Damien Paon
Dan Carreker
Dan Cole
Dan Coles
Dan Gallardo
Dan Glastonbury
Dan Golding
Dan Goldstein
Dan Ko
Dan Laviers
Dan Lehtonen
Dan Parkes
Dan Toose
Dan Triggs
Daniel Carrington
Daniel Coonan
Daniel Driscoll
Daniel McCarthy
Daniel Montoya
Daniel York
Danny Sweeney
Dario Rivas
Darío Rivas Brasero
Darius Sadeghian
Darren Williams
Darryl Jenkins
Dave Baker
Dave Caron
Dave Cobb
Dave Grove
Dave Knudson
Dave Koerner
Dave Nolan
David Baker
David Choe
David Cobb
David De Keyser
David Foster
David Hawkes
David Kay
David Menkin
David Payne
David Petry
David Philipp
David Robb
David Wood
David
 Zwierzchaczewski
Daviid Levin
Dean Powell
Debby Field
Debra Michaels
Deni Skeens
Denise Walsh
Denny Chiu
Denzil O'Neill
Derek Proud
Dhafer L'Abidine
Diane De Domecy
Dion Lay
Dirk Campbell
Dmytro Dudnikov

Dominic Mee
Dominick Ziccarelli
Dominik Johnson
Dominique Starr
Don Williamson
Donna Hicks
Doug Rothman
Doug Todd
Douglas Pennant
Douglas Purser
Dr. Stephen Turnbull
Drew Koupal
Duncan Gillies
Dusty Welch
Dylan Coughlan
Eain Bankins
Ed Ainsley
Ede Clarke
Eduard Itxart
Eduardo Sanchez
Edward Hampton
Edward Hardwicke
Eiji Kusuhara
Elena Matusova
Elesa Bussey
Ellie Koorlander-Lester
Elliot Jackson
Elliot Maren
Elliott Chin
Elliott Lock
Emiliano Miranda
Emilio Gallardo
Emily Sheafe
Emma Cole
Emma Powell
Emma Smith
Emmanuel Bonami
Emmanuel Livi
Eric Madsen
Eric Zimmerman
Errol O'Neill
Ester Reeve
Joss Adley
Eva Jobse
Ewan Stone
Faesal Saeed
Farrokh Hessamian
Federico Sauro
Felix Whitechapel
Florian Ziegler
Framboise Gommendy
Francesco Orlando
Francis Jimenez
Frank Scully
Frank So
Frankie Kang
Fred Tatascoire
Frederik De Caster
Gábor Béressy
Gabor Soos
Gabriele Coen
Gabriele De
 Rossi (Sample)
Gabrielle Coen
Gareth Hailes
Gareth Ramsay
Gary Bolduc
Gary Cox
Gary Dunn

Gary Knight
Gary McGougan
Gautier Ormancey
Gavin Kennedy
Geoff Lees
George Baladinos
George Fidler
George Kapiniaris
Georgina MacKenzie
Gianluca Iacono
Gil Jaysmith
Gilles Ketting
Giuseppe Rizzo
Glen Gathard
Glenn Sharp
Graeme Davies
Graham Axford
Graham Hilgendorf
Graham McTavish
Graham Schroeter
Great Britain Kendo
 Squad
Greg Alston
Greg Baldwin
Greg Smith
Greg Zheng
Gregory Smith
Grigoriy Podgorny
Guillaume Lairan
Guillermo Reinlein
Gunnar Cauthery
Guy Cunis
Guy Davidson
Guy Davies
Guy Schalom
Gwenifer Raymond
Hany Gohary
Harry Inaba
Harte Logan
Haruka Kuroda
Haskel Daniel
Haydar Koyel
Haydn Payne
Hayk Galstyan
Heather Clarke
Heather Lucchetti
Helen Camilleri
Hemi Yerosham
Henry Hankin
Henry Ryan
Herculess Bekker
Herman Witkam
Hernan Castillo Brian
Hester Wilcox
Hiroe Takei
Hitoshi Okuno
Hok Shun Poon
Howard Rayner
Hugh Tanton
Iain Hill
Iain McManus
Iain Quick
Ian Cleworth
Ian Livingstone
Ian MacInnes
Ian Roxburgh
Ilja Köster
Ingimar Hólm
 Gudmundsson

iotr Andruszkiewicz
Irene Chua
Irina Rohvarger
Ivan Gusev
J. Guy Davidson
J. Kevin Connolly
Jack Lusted
Jackie Sutton
Jacob Barker
Jacques Wingrove
James Buckle
James Cauldwell
James Cooper
James Fry
James Green
James Horan
James Lailey
James Lenoel
James Marijeanne
James Maxwell
James Mitchell
James Russell
James Stanley
James Tillman
James Vincent
James Whitston
Jamie Cawte
Jamie Ferguson
Jamie Fredericcks
Jan Alkema
Jan Hendrickse
Jan van der Crabben
Jania Moudrak
János Gáspár
Jasmine Lillywhite
Jason Bianchi
Jason Cook
Jason Dalton
Jason Fitzgerald
Jason Isaacs
Jason Levine
Jason Ong
Jason Turnbull
Jason Waller
Javier Fernandez
Jay Boor
Jef Sedivy
Jeff Atmajian
Jeff Bosco
Jeff Lowe
Jeff Moxley
Jeff Read
Jeff Van Dyck
Jeff Woods
Jen Groeling
Jennie Sue
Jeremiah Benjamin
Jeremiah Jones
Jeremy Gage
Jeremy Gapper-Towse
Jerome Grasdyke
Jerry Ibbotson
Jessica Juffre
Jide Alabi
Jigar Patel
Jill Barry
Jim Barclay
Jim Corbin
Jim Russell

Jim Woods	Krishna Thakkar	Mathew Ray	Nic Frath	Rémi Marotta	Scott Pitkethly	Thorsten Hubschmann
Jimmy Poulos	Kristy Sheppard	Mathieu Walsh	Nic Raine	Remi McKenzie	Scott Steinberg	Thorunn Egilsdottir
Jiten Patel	Krystian Godlewski	Matt Follett	Nick Abstoss	Renaud Charpentier	Sean Davidson	Tigran Aleksanyan
Joanna Taylor	Krystiana Gutbub	Matt McCamley	Nick Farley	Ric Broadhurst	Sean Pertwee	Tim Ansell
Jodie Azhar	Krystiana Maria	Matt McClure	Nick Glomski	Rich Matheson	Seb Maynard	Tim Attuquayefio
Joe Ward	Gutbub	Matt Parker	Nick Goh	Richard Aldridge	Sebastian Tiller	Tim Barnes
Joey Williams	Kyle Nelson	Matt Price	Nick Smith	Richard Batty	Shai Matheson	Tim Bentinck
Johann Tan	Kyle Tuccy	Matt Stainner	Nick Tresadern	Richard Beddow	Shan Simpson	Tim Driesen
John Aubin	Laetitia Amoros (SIDE)	Matt Van Delden	Nicolas Graber	Richard Birdsall	Shane Oakes	Tim Erbil
John Carline	Laird Malamed	Matt Zeremes	Nicolas Nottin	Richard Broadhurst	Shane O'Brien	Tim Gosling
John Hanley	Lara Sweeney	Matteo Sartori	Nicolas Stemelen	Richard Bull	Shelby Yates	Tim Heaton
John Hegarty	Larry Goldberg	Matthew Ash	Nigel Sandiford	Richard Chamberlain	Sherif Eltayeb	Tim Hough
John Holdeman	Lars Knudsen	Matthew Burns	Nikc Tresadern	Richard Curran	Shigeru Yomei	Tim Klotz
John McFarlane	Laszlo Heckenast	Matthew Davis	Nikki Bristo	Richard Diaz	Nakajima	Tim Lewis
John McIntyre	Laurence Tully	Matthew Fidler	Nino Nastasi	Richard Gardner	Shiraz Haq	Tim McKenzie
John Merlino	Laurentiu Possa	Matthew Gibbs	Norm Fricker	Richard Lagarto	Shirley Smart	Tim Perrine
John Taylor	Lee Cheramie	Matthew Hall	Odigie Johnson	Richard Lake	Shymal Raj	Tim Ponting
Jon Glover	Lee Cowen	Matthew Hunt	Ofer Yatziv	Richard Langridge	Simon Allan	Tim Regel
Jon Pederson	Lee Dunham	Matthew Marini	Olag Mirochincov	Richard Malinar	Simon Allix	Tim Rust
Jon Raftery	Lee Frohman	Matthew McCamley	Oliver Bennett	Richard Moore	Simon Dawes	Tim Shepherd
Jonathan Atherton	Lee Smith	Matthew Pawlowski	Oliver Le Sueur	Richard Pryke	Simon Greenall	Tim Vanlaw
Jonathan Davies	Leif Burrows	Matthew Ridding	Olivier Deslandes	Richard Thiang	Simon Harvey	Ting Li
Jonathan Diamond	Leigh White	Matthew Williamson	Olly Byrne	Richard Vaughan	Simon Jeffery	Ting Pong Li
Jonathan Evans	Leo Taylor	Matthew Woodley	Olya Troekurova	Richie Skinner	Simon Johns	Titus Samkubam
Jonathan Jacob	Leonor Juarez	Matthias Fischer	Omar Mostafa	Rick Blanco	Simon Mann	Tobias Persson
Jonathan Keeble	Lewis Macleod	Matthias Horn	Omar Woodley	Rick Mehler	Simon Mathews	Todd Levi
Jonathan Kydd	Liam Donnellan	Matthias Varlet	Osamu Shibamiya	Rick Ribble	Simon Palomares	Togo Igawa
Jonathan Price	Liam Donnellen	Matthieu Gueguen	Paolo Tedde	Rickard Kallden	Simon Pennington	Tom Adams
Jonathan Rooke	Lloyd Sharp	Matthijs Dijkstra	Pat Russell	Ricky Watts	Simon Ravn	Tom Bingle
Jonathan Shotliff	Lorella De Luca	Mattias Akesson	Patricia Ruscito	Riku Rokkanen	Simon Ridge	Tom Constable
Jonathon Harris	Lorenzo Piggici	Mauro Bonelli	Patricia Ryniak	Rinehart Appiah	Simon Seitz	Tom Daley
Jonti Pitt	Lothar W Zhou	MB Gordy	Patrick Keenan	Rob Bartholomew	Simon Taylor	Tom Hounsham
Jordi Varela	Luci Black	Melanie Fouché	Paul Abbott	Rob Blight	Siobhan McMahon	Tom Jarrett
Joseph Grant	Luciano Sponza	Melissa Tague	Paul Bandey	Rob Farrell	Slav Shumor	Tom Luxon
Joseph Vegh	Lucnica - Slovak	Melvyn Quek	Paul Butcher	Rob King	Slovak National	Tom Miles
Josh King	National Chamber	Michael A. Marzola	Paul Chenour	Rob Lightner	Symphony Orchestra	Tom Payne
Josh Morton	Choir	Michael Beirne	Paul Goldilla	Robbie Austrums	Smari Gunnarsson	Tom Pickard
Josh Pfeiffier	Lucy Patterson	Michael De Plater	Paul Kershaw	Robbie Stevens	Sophie Blakemore	Tom Royce-Hampton
Joshua Cavalchini	Lucy Robinson	Michael Futcher	Paul Kitchin	Robert Bradfield	Soukha Phimpasouk	Tony Alexander
Joshua Hemmings	Luis Soto	Michael H. Cook	Paul Koorländer	Robert Farrell	Stefan Aluttis	Tony Langan
Joss Adley	Luke Brown	Michael Haynes	Paul Richards	Robert Kovacs	Stefan Luludes	Tony Sinclair
Juan Valdes	Luke Carter	Michael	Paul Rogers	Robert Lambert	Stefan Seidel	Trevor Aird
Jude Bond	Luke Davis	Hülsmann (SIDE)	Paul Strong	Robert Littler	Stefano Tsai	Trevor Burrows
Juergen Wolters	Lynn Daniel	Michael James	Paul Talkington	Robert Marecek	Steffan Boje	Trevor Kite
Jukka Hiltunen	Lynn Moss	Michael Larson	Paul Thornley	Robert Moore	Stephan Grothgar	Trish Ryniak
Julian McKinlay	Mahmoud El Faituri	Michael M. Simpson	Paul Watson	Robert Stoneman	Stephane Conicord	Tristan Carree
Julie Man	Malcolm Greer	Michael Maloney	Paul Williams	Robert Thompson	Stéphane Cornicard	Tristan Lefranc
Julie Metior	Mar Nicolás	Michael Pettitt	Paulette Doudell	Robert Williamson	Stéphane Miquel	Tunde Glover
Julie Murphy	Marco Balbi	Michael Stowell	Pawel Wojs	Robin Atkin Downes	Stéphanie Collette	Tyler Jacobson
Julie Sklarew	Marco Balzarotti	Michael Wade	Pedro Castro	Robyn Silber	Stephen Berg	Tyrone Curwen
Junichi Kajioka	Marco Garcia	Michael Webb	Peer Beers	Roger Walkden	Stephen Grief	Uri Roodner
Junix Inocian	Marcus Purvis	Michal Gutowski	Penny Sweetser	Rohan McAlinden	Stephen Morgan	Uriel Emil
Justin Holst	Maria Darling	Michaud Thibaud	Pete Burgis	Roland MacDonald	Stephen Turnbull	Utano Tadera
Kahl Piotrowski	Marian Turner	Michelle Moross	Pete Samuels	Romanus Fuhrmann	Stephen Virgo	Vana Prayitno
Kare Sivertsen	Marianna Safro	Mihai Pohontu	Pete Whitfield	Ronin Traynor	Steve Dauterman	Victoria Fisher
Karen Crone	Marilena Rixford	Mike Brunton	Peter Beal	Ross Douglas	Steve Devereaux	Victoria Paterson
Kari Barth	Mario Hassert	Mike Bruton	Peter Brophy	Ross Green	Steve Fitton	Viktor Sylak
Karl Bennett	Mariusz Kozik	Mike Hayes	Peter Clapperton	Ross Manton	Steve Fleming	Ville Leppanon
Karl Learmont	Mark Burns	Mike Hill	Peter de Jersey	Roy Boateng	Steve Groll	Vincent Chai
Karoly Farago	Mark Day	Mike James	Peter Fuchs	Roy Marsden	Steve Miller	Vincent Chin
Kate Jarrett	Mark Gonzales	Mike Kaiser	Peter Hanson	Roz Hall	Steve Parker	Virgil Mihailescu
Kate Watson	Mark Healey	Mike Noble	Peter Harries	Rufus Jones	Steve Penate	Vladimir Martinka
Kathy Vrabeck	Mark Hildreth	Mike Simpson	Peter Juhasz	Ruggero Andreozzi	Steve Perkins	Vyn Arnold
Katsuna Kazumasa	Mark Inman	Mike Stern	Peter Stewart	Rupert Moss	Steven Lockett	Walter Bonacker
Kaushar Tai	Mark J. Polcyn	Mike Wade	Peter Timlett	Ruth Bristow	Stina Frost	Walter Christian Mair
Kazue Nishimura	Mark Lamport	Mikhail	Peter Vernon	Sadao Ueda	Stuart Arrowsmith	Wayne Boyce
Keith Wickham	Mark Lawson	Raspaskovski	Petr Tomicek	Saitou Yasufumi	Stuart Fenn	Wayne Forrester
Ken Drury	Mark Le Breton	Miroslaw Jakubiec	Phil Evans	Saki Kaskas	Stuart Pratt	Will Hallsworth
Ken Noland	Mark Milton	Moore Design Group	Phil Jones	Salah Sid	Sue Hughes-Taigen	Will Kus
Ken Rafferty	Mark Nutt	Moran Paldi	Philip Chadwell	Sam Carion	Sulayman Al-Bassam	Will O'Brien
Ken Turner	Mark O'Connell	Morgan Gibbons	Philip Morris	Sam Cooper	Susann Oelschlegel	Will Overgard
Kenji Watanabe	Mark Sinclair	Myron McMullen	Philip Terzian	Sam Hart	Susanna Granlund	Will Sharpe
Kentaro Suyama	Mark Strong	Nadia Albina	Philippe Smolikowski	Sam Spanswick	Susy Morelle	William Beadle
Kerri West	Mark Sutherns	Nadim Sawalha	Phillip Abram	Sam Taylor	Suzanne Panter	William Davis
Kerry Martyn	Mark Taylor	Nadine Theuzillot	Phillip Macken	Sam Townsend	Suzie Oweiss	William Hamilton
Kerry Shale	Mark Yao	Nahiyan Al-Muhaymeen	Phongtep Boonpeng	Samuel Mendez	Suzuki Tomoharu	Willie Bolton
Kevin Connolly	Marlon Grant	Naomi Dandridge	Pierre Fardel	Samuel Morgan	Sylvia Hallett	Willow Nash
Kevin Hoque	Marta Lois Gonzalez	Naomi Frederick	Piotr Andruszkiewicz	Samuel Price	Taamati Hanson-Pou	Wittawat
Kevin King	Martial Leminoux	Naoya Tsurumi	Prabha Kannan	Samuel Simpson	Takashi Sudo	Keawcharoen
Kevin Man	Martin Bradley	Naseem Ramadan	Prasant Moorthy	Sandor Nagy	Takatsuna Mukai	Yalin Ozucelik
Kevin McDowell	Martin Haynes	Natalie Bryant	R. T. Smith	Sandra Duchiewicz	Tamas Rabel	Yamanaka-Kenji
Kevin Smith	Martin Hunter Caplan	Nathalie Ranson	Rachel Farrant	Sandra Lew	Tamsin Lucas	Yaron Shavit
Kevin Stoker	Martin Montford	Nathan Hall	Rachel Streek	Sandra Picaper	Tanja Tzarovska	Yiannis Fragkoulis
Kevin Wynne	Martin Roller	Nathan Jacobs	Rado Javor	Sandro Friedrich	Tanroh Ishida	Yukiko Scott
Kieran Brigden	Martin Servante	Nathan McGuiness	Radoslav Javor	Sara Hobson	Tara Jaffar	Yuriy O'Donnell
Kim Sellentin	Martin Slater	Nathaniel McClure	Rafael Turia	Sara Lewerth	Tasio	Zach Mumbach
Kimberley Neville	Martin Valigursky	National Maritime	Raffaella Perancin	Sarah Ford	Terry Greisbach	Zahra Al Naib
Kimberly Marlis	Martyn Sibley	Museum London	Ranulf Busby	Sarah Hadland	Terry Hansen	Zaquri Foster
Kimberly Park	Mary Safro	Neil Barizo	Ray Grigg	Scott A. Steinberg	Tess Kennedy	Zaydun Khalaf
Kit Cavalchini	Maryanne Lataif	Neil Kaplan	Rebecca Attard	Scott Allen	Thibaud Michaud	Zi Peters
Kizawa Tomoyuki	Masashi Fujimoto	Neil McCaul	Rebecca Gordon	Scott Backhouse	Thomas Doig	Zoltán Attila Molnár
Kolin Tregaskes	Masato Kamo	Neil Strugnell	Rebecca Waller	Scott Dodkins	Thomas Lever	Zoltan Molnar
Kop Tavornmas	Massimiliano Lotti	Nestor Protacio	Reid Hurley	Scott Keifer	Thomas Miller	Zongyi Chen
Krishna Jaykar Thakkar	Massimo Tristano	Ngan Nguyen	Réka Sugár	Scott Lowther	Thomas Scott	Zsolt Molnar

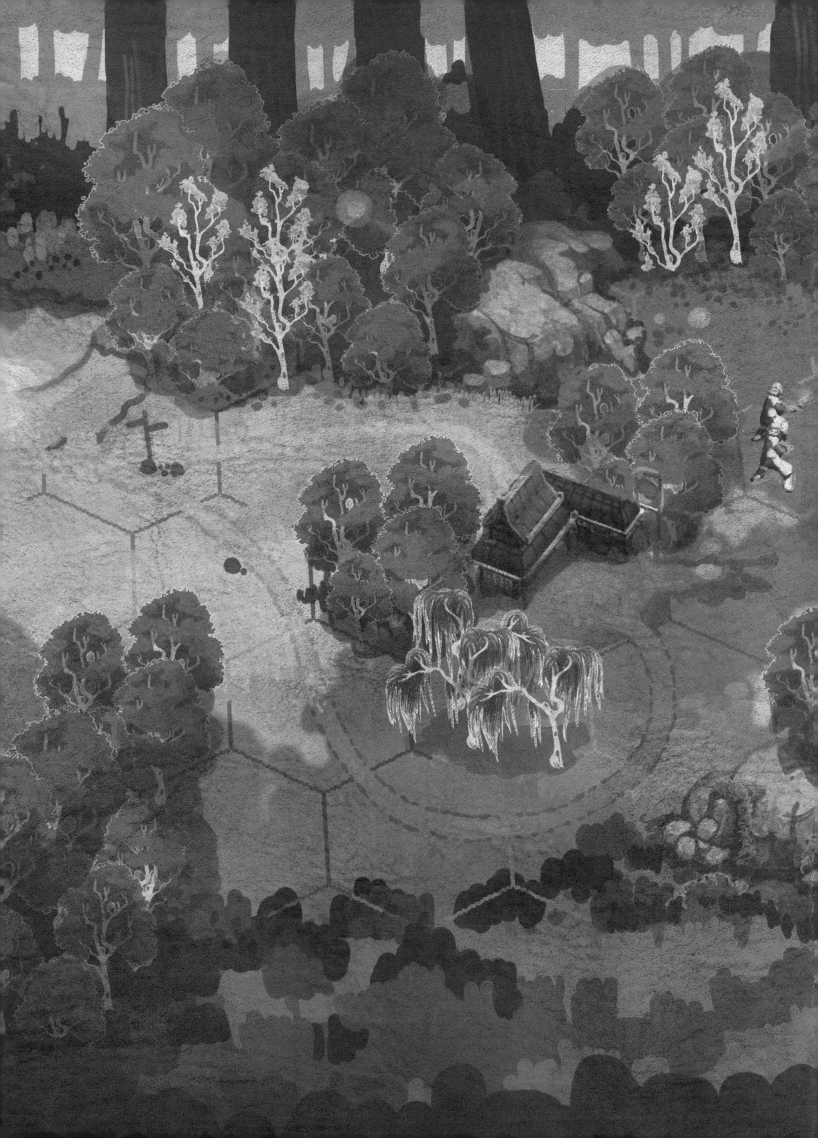